The Fifth Star

The Fifth Star

Ohio's Fight for Women's Right to Vote

Jamie C. Capuzza

The Kent State University Press

Kent, Ohio

In loving memory of my parents and Gene Apple

★

I also dedicate this book to all the unnamed and unsung suffragists who battled valiantly for the ballot, and to everyone fighting to protect that fundamental right today.

Contents

Acknowledgments

This book truly was a labor of love—a valentine to Ohio's suffragists. That love was tested, however, at many points during the research and writing process, when the project seemed more labor than love. In those instances, I reminded myself that many suffragists struggled over the course of seventy years before achieving their goal, and I should quit whining and keep writing. Their grit and resilience were a constant inspiration to me. This book also pays a debt of gratitude to all the women who fought bravely and persistently during the suffrage movement so that I can exercise my rights as a woman today.

I am also indebted to many contemporaries. Thank you to all the Kent State University Press team, including Kat Saunders, Susan Wadsworth-Booth, Mary Young, Chris Brooks, and Julia Wiesenberg. A special shout-out to Erin Holman, copyeditor extraordinaire. I am eternally grateful for her sharp eye, patience, and good humor. Each of you played a key role in making the book better, and I was so very fortunate to have you on my team. I also thank Camille Stallings for her excellent work indexing the book.

There are several people at the University of Mount Union who deserve both acknowledgement and appreciation. In particular, I offer my deepest gratitude to William Coleman for his mentorship and friendship over these many years. You taught me everything worth knowing. I also thank the feminist super sleuths working in the university library, including Gina Maida, Christine Cochran, and Abigail Noland. I also express my gratitude to the university administration for the Austin Montgomery grant, faculty research appointment, and other financial support for this project.

I am indebted, as well, to the good people at the Massillon Museum, the Toledo Lucas County Public Library, the Ohio History Connection,

the Harriet Taylor Upton House, the Western Reserve Historical Society, and the Kent State University Libraries, among many other Ohio institutions whose resources made this book possible.

On a personal level, I thank Sue and Mark Hatch (who have made Ohio better in so many ways), Sande Esposito, and Jodi Maile Kirk for suffering through the roughest first drafts of the manuscript and for their helpful feedback at that crucial stage. You were there at the beginning, and you were there at the end. Your enduring friendship means the world to me. I also thank all the other "Z" she-rowdies for their constant support throughout this process and my entire adult life. Our friendships, much like those between the suffragists written about in this book, will be a source of strength always. A special thanks, too, to Melody Lehn, for both her professional insights and her encouragement. My appreciation also goes to the Capuzza and Crites families, and to my extended family, including Rosa Masson and Ada Santucci. Last, my biggest debt of gratitude, both personally and professionally, is to Sean O'Rourke. I'm not sure if I could have written this book without you, but I do know that I would not have wanted to.

Author's Note

The first and last names of men and women are included when they first appear in each chapter. Thereafter, both men and women are referred to by their last names. Because many of the women are discussed before and after their marriages, women's names will include both their birth and married last names from the first usage to avoid confusion. On rare occasion, women such as Lucy Stone chose not to change their last names after marriage, as was the custom at the time. This choice is honored throughout the book. Women who married more than once are referred to by their birth name and the last name they held for the majority of their suffrage career.

Ohio's Rightful Place

Petitioning for Redress of Grievances

Shortly after taking office, President Andrew Jackson introduced one of the most devastating Indian removal acts in US history. This highly contested campaign motivated opponents to inundate the US Congress with antiremoval petitions. Most unusual, though, wasn't the sheer number of petitions opposing the Indian Removal Act of 1830 but that among these petitions were those generated and signed by women—including women of Ohio. "The Memorial of the Ladies of Steubenville, Ohio Against the Forcible Removal of the Indians without Limits of the United States," filed with the US House of Representatives on February 15, 1830, was among the first of those petitions. In this important document, Ohio women pleaded in the most self-deprecating and deferential tone possible: "When, therefore, injury and oppression threaten to crush a hapless people within our borders, we, the feeblest of the feeble, appeal with confidence to those who should be the representatives of national virtues as they are the depositories of national powers, and implore them to succor the weak & unfortunate."[1]

The sixty-two petitioners may have seen themselves as the feeblest of the feeble, but these women were exceedingly bold for their time. The Steubenville signatories likely were spurred to action by influential writer Catherine Beecher, credited for secretly organizing a nationwide women's petition drive against the Indian Removal Act, the "Circular Addressed to Benevolent Ladies of the United States."[2] The Ohio memorial was of historical consequence, unfortunately not because it prevented what would

become the Trail of Tears but because the state's women were among the first of their gender to petition the US government regarding a political issue. Violating social expectations of the day for women's silence on this or any other political topic, these women undertook this most controversial endeavor—generating and signing a petition of their own. US women had submitted petitions previously, but on a much smaller scale and limited to subjects of a more personal nature, often relating to the family rather than national politics such as Indian removal.[3] Initially, it was far more common for women to assist men in their canvassing for signatures rather than sign or canvass for their own petitions. At this time in the nation's history, the structure of the patriarchal system left women dependent on men to intercede on their behalf in political matters. The Steubenville women, more formidable than feeble, chose to file their own petition, and in so doing, they claimed a political voice of their own.

Women's antiremoval petitions marked a significant turning point in US political discourse. In claiming their own political voice, women of the nation were setting a rhetorical precedent. Amy Dunham Strand, a professor of women's studies and rhetoric, explains, "In the context of Indian removal, petitioning, then, was the first civil right that American women collectively justified and achieved—that is the right to political expression."[4] Without the power of the ballot, women living in the United States during much of the nineteenth century were forced to settle for the petition as their primary means of political speech. The First Amendment provided for freedom of expression and the right to petition the federal government for a redress of grievances, and strong-minded women dared to take full advantage of the one tool afforded to them constitutionally. Hundreds of other antiremoval petitions followed the Steubenville memorial. Notably, by the mid-1830s, the use of the petition intensified as more and more women demanded their calls for abolition be heard.

In this regard, the remarkable story of how US women empowered themselves as citizens to secure the right to vote began not with a demand for their own fundamental rights but with their demand for the most basic measure of justice on behalf of others. Jackson had embroiled the nation in a heated debate about race relations, but because women's voices were now part of that debate, such public discourses became increasingly gendered. Simply stated, women had to validate their political speech. For this reason, it is not surprising fully two-thirds of the Steubenville memorial advanced a justification for women's political expression while only

one-third addressed the primary objective, opposing Indian removal.[5] The petitioners' rationale was based on the commonly held presumption that women were the moral backbone of the nation. Policies regarding indigenous and enslaved peoples revealed the widening rift between how Americans perceived themselves as moral beings and the political realities of the day. Therefore, women's claim that the petition was a socially appropriate extension of their moral authority made sense rhetorically.[6]

Initially, the US Congress responded to antiremoval and antislavery petitions from both men and women similarly—essentially ignoring them. Over time, however, congressmen began diverting attention from the substance of these policy debates and shifting it to the inappropriateness of women's public discourse. It became the norm for officials to scoff at women who dared to take a political stand.[7] The following backlash against women expressing political opinions was swift and strong. For instance, in 1834, the American Anti-Slavery Society initiated a large-scale petition drive with the aid of female antislavery societies. This endeavor raised the ire of southern congressmen, and unsurprisingly, women's right to petition came under fire in the US Congress.[8] Undeterred, female petitioners mustered the wherewithal to face both private ridicule and public scandal simply for advocating the causes in which they believed. What was once hushed resolve slowly and steadily transformed into increasingly audacious political demands for abolition, temperance, and, eventually, women's rights.[9]

Ohio women played a key role in countering challenges to the right to petition and in normalizing the use of this tool for women's political expression. Correspondence shared between the Portage County Female Anti-Slavery Society and a similar group in Massachusetts suggests the catalyst for organized petitioning by women came not only from the Northeast, as is too often assumed, but also from Ohio. As further evidence, women of Cadiz, Ohio, also took up the antislavery petition process, fittingly describing this tool as a "momentous duty . . . to petition our national Legislators . . . [as it] is the only mode by which females can publicly make known their grievances."[10] To be sure, Ohio's women were among the ranks of the earliest rebels and reformers who took the first step to equip themselves with the necessary tools, skills, and acumen to engage the political process. The Steubenville and Cadiz women would be among the first in a long line of proud Ohioans devoted to advancing democracy and social justice well into the next century.

Seeds of Discontent

Nineteenth-century Ohio proved to be fertile ground for sowing the seeds of discontent. The state emerged as a key battleground for a variety of social reforms. Ohio's women took up the mantle of abolition and temperance—and eventually their own rights. Many abolitionists and temperance crusaders were women's rights reformers, and many women's rights reformers were abolitionists and temperance crusaders. The three causes shared much. The ties between and among the three social movements were especially tight in Ohio.

The state was very much at the center of the nation's painful debates about slavery and race. Ohio's Black Codes were meant to discourage African Americans from moving to the state. Despite the racism that supported these codes, slavery was illegal in Ohio and abolition found support within its borders. Many Ohio homes served as stops along the Underground Railroad, offering refuge to enslaved people making their way north. This lifesaving work became increasingly difficult and dangerous after the state's fugitive slave law controversially passed in 1839, permitting owners to reclaim their runaway slaves. Extensive efforts—those of Blacks and whites, men and women, all working together—reversed some of the Black Codes and led to an eventual repeal of the state's fugitive slave law. However, a federal measure shamefully took its place shortly thereafter.[11]

The state's antislavery work, though obviously highly commendable, should not be equated with a lack of racism. Many whites feared the end of slavery, believing that formally enslaved peoples would flee the South and take jobs from white Ohioans. Ohio had its share of white supremacists. Furthermore, in the aftermath of the Civil War, the initial devotion to universal rights for both men of color and women of all races strained beyond repair. Many white women's rights reformers harmed people of color and dishonored themselves by drawing upon the racism of the day in a misguided attempt to protect social hierarchies from which they benefited and to secure their own rights at the expense of others.[12]

The abolition movement provided early women's rights reformers with an ideology of egalitarianism that helped women to see themselves as more fully human and deserving of basic rights. The abolition movement made it clear the fight must be fought not on one but rather two fronts, including changes in legal status (be it of enslaved people or of all women) and changes in public opinion (be it about race or gender). Abolitionists

also provided women's rights reformers with an understanding of how to engage in social change, and it armed them with strategies they could use to counter their opposition. Abolition provided the first audiences for women's rights speakers at antislavery conventions and the first readers of women's rights articles in antislavery newspapers. Despite these many connections, after the Civil War, the once mutually supportive relationship between abolition and women's rights began to deteriorate, due to critical differences in priorities, strategies, and tactics.[13]

Much the same as with the cause of abolition, the temperance and women's rights movements depended on a symbiotic relationship in Ohio. Women from Hillsboro and from Washington Court House both claimed the temperance movement started in their hometowns. However, the movement actually started in the 1820s with the creation of the American Temperance Society in New England. Yet in the same decade, residents of Trumbull and Summit Counties founded temperance societies.[14] By and large, initial temperance efforts remained local and haphazard, but by the 1850s, Ohio was ground zero for the war on intemperance, with over one-third of the "crusades" and three-fifths of the "crusaders" coming from the state. Ohio's prominence in the temperance movement is attributable to not only the strength of crusaders' personal convictions but also the innovative strategies and tactics they employed, such as picketing, personal pressure, and public prayer. These novelties earned Ohio's temperance activities national and international media coverage.[15] Furthermore, because temperance did not fit into traditional political categories, the movement destabilized state politics, fragmented votes, and forced parties to address the issue.[16]

Over the years, an alliance between temperance and women's rights would prove mutually supportive at some times and counterproductive at others. Just as the relationship between abolition and the women's rights movement became strained, relations between temperance and women's rights also complicated Ohio's approach to these reforms. Differences of opinion sometimes undermined recruitment and campaign successes. Women's rights reformers were dismayed to find their ties to temperance would undermine their success, especially in states with strong liquor lobbies, like Ohio.

The temperance movement was more than the caricature of an ax-wielding Carrie Nation or holier-than-though teetotalers. Temperance crusaders exposed the dangers of domestic violence and sexual abuse in the

home as well as the unfairness of existing married women's property laws. Native Ohioan Frances Barker Gage provided a sophisticated analysis of domestic abuse, describing it as "agony of days and weeks and months and years of wretchedness" and expressing that "in the home, the sanctuary of both love and hate, that screen of both caresses and curses, the wife will become the recipient of . . . mortification, humiliation, degradation, and abuse that the world's eye will never see or hear."[17] Women realized that legally there were few options available to protect themselves or their children from intemperate, abusive husbands.

Ohio's reform culture also came to include the struggle for women's rights and did so well before the middle of the nineteenth century. In 1828, Scottish-born Frances "Fanny" Wright made history when she launched a cross-country lecture tour on abolition and women's rights from Cincinnati. She was among the first women to speak on these topics, and she did so publicly before audiences of both men and women—considered scandalous at the time. Her ideas about racial and gender equality made her years ahead of her time, and because most of the public was not yet ready to embrace ideas such as these, Wright became known as the "red harlot of infidelity."[18] Despite this gendered and personal attack, Wright was an inspiration to the first generation of suffragists. For years, Susan B. Anthony contemplated her example each time she gazed at Wright's picture hanging on the wall of her study. Eventually settling in Ohio, Wright died in Cincinnati having paved the way for generations of future reformers.[19]

The fervent support for social reform continued throughout the state during the 1830s. Growing up on a southern plantation, the Grimké sisters, Angelina and Sarah, witnessed firsthand the horrors of slavery. Beginning their reform careers as abolitionists, they soon realized their gender handicapped their progress, and thus they adopted the cause of women's rights. The sisters had strong ties to Ohio as their brother, Frederick, practiced law in Chillicothe, and he later sat as a justice on the state supreme court.[20] Eschewing expectations for women's silence, the sisters often lectured in Ohio, and Angelina became the first woman in US history to address a legislative body.[21]

The Grimkés certainly were not alone in their want of basic political rights. While touring Ohio during the latter part of the decade, Abby Kelley Foster also included the topic of women's rights in her antislavery lectures. Kelley Foster, too, quickly realized sexism hampered her antislav-

ery work, acknowledging, "in striving to strike [the slave's] chains off, we found most surely, that we were manacled ourselves."[22] Among Kelley Foster's associates was Sarah Grant Haines of Alliance, Ohio, who devoted herself to a variety of social reforms of concern at this time. Her home was on the Underground Railroad and the meeting place of the radical Anti-Slavery Society. Grant Haines also hosted open meetings for the discussion of women's rights and temperance. Her obituary noted that she "hoped to live long enough to see women's rights recognized in the matter of female suffrage."[23] Alas, she did not.

Despite the demands of domesticity imposed on them at the time, these pioneers continued to advance social reforms throughout the 1840s, and they recruited new supporters to these causes. Lucy Stone was yet another early abolitionist and women's rights reformer with strong ties to Ohio. While a student at Oberlin College, one of the few institutions of higher learning in the nation that would accept female students, Stone lectured throughout the state supporting women's rights in the latter half of the 1840s, and she would go on to found the American Woman's Suffrage Association at a convention held in Cleveland.[24]

Ohio as a Hotbed of Radicalism

While it may be hard to imagine based on today's political landscape, Ohio was once a hotbed of radicalism. A variety of factors converged to construct a culture of reform in the state of Ohio powerful enough to support multiple social movements simultaneously. Ohio reformers labored within a context that included the state's unique geography, population trends, educational system, economy, and political culture. While neither Ohio nor any other state can be considered "typical" of the entire nation, Ohio certainly was a key state. Indeed, by the mid-nineteenth century, Ohio was arguably one of the most important states, and it would come to reflect the industrialized, urbanized, and ethnically diverse nature of the country's growing population.

In many ways, Ohio was at the crossroads of the nation when granted statehood. Ohio was the first state carved out of the Northwest Ordinance of 1787. The location of the political and military headquarters of the Northwest Territory in the southern part of the state enhanced its diversity and prominence. The ordinance prohibited slavery in the new territories,

but it required escaped slaves to be returned to bondage. Ohio's border with Kentucky became the dividing line between the slaveholding South and the North.[25] When the state constitutional convention met in 1802, the issue of slavery came under debate again. The new state continued to ban slavery, but the measure to grant freedmen the ballot failed by just one vote. Citizens living in the northern part of the state often sympathized with social reforms, including women's rights and abolition. In contrast, many Ohioans living closer to the Kentucky border had Southern roots, and they viewed political issues and reform agitation from a distinctly Southern perspective that, generally speaking, meant less support for women's rights and abolition.[26]

People also commonly considered Ohio the dividing line between the East and the West. Sometimes called the "gateway to the west," the state's transportation infrastructure of canals, rivers, and roads connected eastern states and the western territories, allowing for a constant flow of people and of ideas.[27] Situated as it was at the intersection between North and South, East and West, Ohio thus became fertile ground for some of the nation's earliest reform efforts.

The rapid increase and turnover of the population of Ohio also is key to understanding how its reform culture emerged. As the first new state of the nineteenth century, its population grew incredibly fast, making it the third largest by midcentury. By the time of the first women's rights conventions, the 1850 census revealed, that of the nearly 2 million people living in Ohio, fully 40 percent of the population was born elsewhere. The fluctuating population was diverse demographically, but most nonnative peoples arrived predominantly from eastern states, especially Pennsylvania, New York, and Virginia, as well as from western Europe, primarily from Germany, Ireland, and the United Kingdom. The Western Reserve, comprising many people from Connecticut, had a special penchant for political agitation, and it was quick to embrace both abolition and women's rights. By midcentury, approximately twenty-five thousand residents of African descent lived in Ohio. After the Civil War, however, that population surged, more than doubling by 1870.[28]

By the time the fight for ratification of the Nineteenth Amendment was under way, large numbers of Italians, Poles, Hungarians, Russians, and other groups were drawn to the state's industrial cities. Southern whites from Appalachia, too, came to call Ohio home. The state's population of African Americans also grew at this time, though less consistently. As

waves of newcomers made their way to the state, anti-immigrant senti-ments led to nativism, and women's rights activists were not immune. Just as some suffragists were racists, others held biases related to ethnicity and nationality.[29]

In addition to geography and population trends, appreciating how Ohio valued and supported higher education is key to understanding its role in social reforms such as abolition and women's rights. A very signif-icant source of leadership for these movements came from the colleges and universities of Ohio. The state's willingness to grant women and peo-ple of color access to higher education early in its history distinguished it from many other states. Oxford College for Women was founded in 1830. Oberlin University, the first US college to admit African Americans, ac-cepted women into its four-year program by 1837. Oberlin hosted a public debate on women's suffrage in 1846, and it held its first public address on the topic in 1847.[30] Wilberforce University, founded in 1856, is the oldest private, historically Black university in the nation. By the time of the first women's rights conventions, these institutions regularly hosted various renowned suffragists as keynote speakers, and their graduates led social reforms at the state and national levels.[31] Furthermore, suffrag-ists credited the success of women's rights campaigns to the fact Ohio's universities admitted women earlier than those of other states. Suffrage leader Caroline McCullough Everhard penned, "The fact that better edu-cational opportunities were offered women here in Ohio than elsewhere may have made the people more aware of women's rights. Ohio occupies a unique place in the history of the woman suffrage movement for in no other state was the agitation so general at so early a date."[32]

The role of women in Ohio's economy also directly related to the gene-sis of a women's rights movement within the state. The 1830s and 1840s proved very difficult for Ohioans financially, necessitating many women to work outside the home for wages. As the state moved from an economy based almost entirely on agriculture to one grounded in manufacturing, women's limited options for employment came to include factory work. Their work contributed to the increased economic clout of the state and the strength of the nation. By 1860, Ohio was the most industrialized state in the Midwest, and it ranked fourth nationally.[33] As the state's labor market slowly opened to women and as a middle class emerged, class con-sciousness increased, influencing social identity and politics.[34] Working women, middle-class women, and wealthy women came to understand

limitations placed on them related to gender in different ways, and they desired rights for different reasons.

By the time of the first women's rights conventions, working women were all too familiar with the dangers, limitations, and challenges of the labor market. A garment factory worker in Cleveland might earn approximately $100 annually, or a woman working in a Cincinnati shoe factory might make $150. Such work was physically demanding and performed in factories without heating or cooling and that lacked sufficient light and ventilation. It was not uncommon for women to work twelve to fourteen hours a day, six days a week. Despite these challenges, many women very much wanted and needed to work outside the home.

Some women fought to improve their working conditions. For example, in Cleveland, the Female Protective Union, established in 1850, fought to increase pay and reduce hours for garment factory workers. Demands such as these generated occasional productive responses from government officials. In 1852, the state legislature limited the workday of women to ten hours per day—making Ohio the first state to do so—however, the law was seldom enforced.[35] In many respects, factory work could empower women to seek a wider range of opportunities and experiences, and this energy contributed to the women's rights movement producing political and economic gains.[36]

Naturally, in addition to its geography, population, educational system, and economy, Ohio's state politics influenced women's rights reforms. From its earliest days, Ohio's politicians eagerly leveraged the full force of the press, public speeches, and pamphleteering as they vied for power. From the beginning of statehood, Ohio's politics had a regional dimension. Ohioans favored local government, establishing a copious number of government offices and pioneering caucuses and conventions. Because the population was so diversified, no one ideology or group came to dominate government. The state became politically divided. Partisanship arose, though haphazardly, across the state. The outcome of most elections was very close, making political parties susceptible to social reformers' demands. By midcentury, Ohio politicians were leading the shift to sectionalism, and eventually they were garnering support for the Civil War. The growth of the Free-Soil Party turned established political alliances within the state upside down.[37] Operating within such a complex political system certainly complicated the early work of Ohio's women's rights activists. In addition to party politics, that Ohio also is known

as the "mother of presidents" influenced the strategies and tactics of the state's suffragists too. Eight presidents were born or resided in Ohio at the time of their election; six of these were in office during the women's suffrage movement. Suffragists across the nation came to court these Ohio presidents, usually unsuccessfully.

When the United States adopted its constitution, it made no provisions regarding voting qualifications at the federal level, leaving the power to do so in the hands of the states. Women could vote in only the most limited capacities. For example, single women owning property were allowed to vote in New Jersey between 1776 and 1807. In 1838, Kentucky allowed widows with school-age children to vote in school elections. Most states, however, only enfranchised property owners, many of whom were white male Protestants. In Ohio, article 4 of the new state constitution provided the ballot to white men twenty-one years or older who lived in the state for at least one year prior to any election and who paid state or county taxes. Between the elections of 1828 and 1840, the number of voters doubled as the population surged.[38] More men meant more minds women's rights activists had to persuade.

Though Ohio women were not enfranchised in the original state constitution, many nevertheless held political opinions, and they established political identities. The state's women were as heterogenous, and at times as partisan, as the men. Politicians may have held gender biases and expectations of women as potential voters, but they saw little evidence suggesting women would constitute a politically cohesive voting bloc. Suffragists came to understand that party politics would not necessarily support their cause because they could not promise the votes of women in large enough numbers to demand attention by party bosses. Eventually, suffragists sought power through association with already enfranchised constituencies.[39]

Ohio's geography, population trends, educational system, economy, and political system each contributed to a spirit and culture of reform; however, it would take more to give birth to a full-fledged women's rights movement. Before a movement could commence, activists would engage in consciousness-raising, forge a philosophical foundation, and find a political voice. Decades of reform work completed in Ohio would lay the foundation on which the women's rights movement could formally coalesce.

Consciousness-Raising and Citizenship

Many Ohio women wanted to advance social reforms, but like women everywhere, they found themselves disempowered, disadvantaged, and dismissed because of their gender. What today would be called "feminist consciousness-raising" was a necessary step to fomenting a women's movement.[40] In actuality, different kinds of consciousness-raising were required, since what was needed for men might differ from what was needed for women.[41] Moreover, attitudinal differences existed between women and men, among men, and among women regarding women's proper sphere. For these reasons, the evolution of equality and empowerment of women was neither simple nor straightforward, and many iterations of "the women's movement" would come to pass.

Even the most basic exploration of the social condition of women at this time would expose the hypocritical treatment of half the citizenry living in a country purporting to be a democracy. Married women—and the social expectation most certainly was that all women would marry—could not enter into a legally binding contract, own or inherit property, attend most colleges, enter into the professions, keep their own wages, file for divorce, hold custody of their children, or sit on juries. Simply speaking, married women were civilly dead because a woman's legal identity was that of her husband's.[42] She was denied access to the political system, both as a voter and officeholder. She was at the mercy of an economic system structured in a way that created financial dependency of women on men, or if enslaved, precariously dependent upon their masters. Unable to earn her bread, legally to keep it, or politically challenge these injustices, women found themselves almost completely disempowered.

Ohio's strong commitment to social reforms drove home the point that its women would never be able to do the good in the world they wished to do until gender injustices were confronted. If women were to espouse serious social reforms, they must be taken seriously. Women had to contemplate the social forces that kept them subservient, and they had to envision an alternative to a society based on their subservience. Beyond that, activists must discern what tools were available to them if they were to create that alternative. Public speaking, media publishing, and legislating were not easily available to US women at the time the movement began. Even after women claimed these tools as their own, paying a heavy price in the process, they still had to master them skillfully and strategically.

Furthermore, women activists had to learn the ways of a world to which they had been denied access, be it the halls of state legislatures, the US Congress, or the courthouses. But learn they would, and they would do so the hard way.

Ohio women were among the first in the nation to experience a feminist consciousness-raising and to advocate widening women's sphere. Advancing the causes in which they believed and challenging those who opposed women's rights required activists to break out of domestic bondage and to forge new identities. Most women activists were wives and mothers in a time when neither birth control nor modern labor-saving devices were readily available, leaving them little time or energy for political, legal, and social reforms. They came to realize their quest was nothing short of challenging how society defined what it meant to be a woman. Was she man's equal? Was she capable of rational thought? What was her proper sphere? These questions were open to debate (and because most people at the time considered debate an "unwomanly" activity, men were doing most of the debating).

Women's rights activists realized their quest required them to reimagine gender relations. Could marriages be based on gender equality? Could men and women be educated side by side? Could men and women work in the professions together? Again, these were questions open to debate, often both vehement and arduous. Women activists, in demanding their rights, would have to find within themselves, and among themselves, enough bravery and endurance to withstand decades of hostility from husbands, neighbors, journalists, media owners, judges, governors, congressmen, businessmen, ministers, and, perhaps most dishearteningly of all, other women.

To most Americans living at the time, demands by women for political, legal, and social equality with men seemed absurd at best and subversive at worst. The vast majority of people, including those of Ohio, believed that inequality among the sexes was both proper and natural, even in a democracy. Most women accepted inegalitarian gender distinctions such as these, and they did not directly question the patriarchal structures that suppressed them. Most suffragists did not seek to abandon their identities as wives and mothers. Instead, they sought to expand their identities beyond those two roles. Rather than directly challenging gender power relations or adopting masculine identities and behaviors, most suffragists sought to femininize politics. Blatantly threatening men's prerogative and

power would do little to persuade all-male legislative bodies and electorates to grant women the vote. Framing the demand for the ballot as a tool needed by women to perform improved domesticity would be more effective rhetorically.

The cause of women's rights, especially political rights, was not a popular one anywhere in the country. Most media typically depicted female women's rights activists as unfeminine, disgruntled, dangerous radicals determined to overthrow the social order, and their male advocates were depicted as henpecked, weak, and unmanly. The United States was then—and some people would argue still is—a patriarchal culture in which most media, religious institutions, legislatures, judiciaries, economies, and public opinion denied women power and normalized gender biases. Many women were socialized to believe that they occupied a "privileged" position within the family and that the "protection" men provided would be in jeopardy if they participated in politics. Those who desired to squelch women's political speech and actions argued women's sphere was the private sphere to which, many people believed, women were "naturally" better suited. This argument claimed the public sphere, with all its competition, corruption, and exploitation, would prove too much to bear for the "weaker sex," and it was best left to men to navigate. Fearing a challenge to the status quo, many women clung to the notion that social reforms related to gender would come at too great a cost, and this fear fueled suffrage opposition by many women. Other women were simply too exhausted by their daily lived experiences to concern themselves with politics or the vote. Yet others remained ignorant or indifferent to the cause.[43]

Women's rights activists came to realize their quest demanded a reconceptualization of not only gender and gender relations but also of the nature of citizenship. Were women citizens? If so, did that mean they had a right to vote? Did the votes men cast truly represent them? Again, these questions were open to debate. Arguments would take place over the course of decades, engrossing people from all walks of life, from husbands and wives as they sat around the dining room table to US Supreme Court justices sitting on the bench. Like other activists across the nation, Ohio women were willing to put their faith in a political system despite the fact it excluded them. Their belief in the promise of democracy—though they never had experienced it directly themselves—was so strong, it compelled them to overcome every obstacle, be it patriarchy, misogyny, narrow-mindedness, greed, or indifference. These women knew what they

were up against, but they chose to fight anyway. In so doing, Ohio women joined their sisters in other states to question political assumptions about citizenship, form their own political identities, and develop a critique of discriminatory governmental, legal, and cultural practices.

Many Ohioans, like activists of other states, believed the ballot was the best chance for women to empower themselves. From this perspective, the vote was a symbol of political equality. It meant that women must be recognized as having free will and that they were endowed with intelligence sufficient to be considered fit for civic duty. Demanding suffrage challenged the belief that women's interests were identical to those of men. If women wished to modify the conditions that made them dependent on men, women would need a greater voice in community affairs. Enfranchisement was more than a demand to give women a voice; it was a demand for women to have their own voices, over and above those of their fathers or husbands. In short, enfranchisement was a means of establishing independence and of challenging the patriarchal subordination of women.

Other activists saw the ballot primarily as part of a larger system of necessary social reforms. Ohioans also were among the first to recognize that a broader approach to the full range of women's rights, not only the ballot, was warranted. They knew only too well that government was not the sole source of women's oppression. The church and the home also were sites of gendered discrimination and violence. Issues of domestic violence, women's wages, sexual consent, property rights, household labor, child custody, among others, motivated many of the state's activists to address a broader agenda. As author of *Sex and Citizenship in Antebellum America*, Nancy Isenberg, explains, "limitations that had evolved in the nineteenth century curtailed women's rights to due process, redress, self-protection, and civil liberty, and rights within the home, church, and state."[44]

As reformers contemplated the relationships among gender, power, and citizenship, two contradictory philosophies developed: natural rights and womanhood. Both perspectives informed the women's movement and women's foray into electoral politics. Many suffragists grounded their arguments in the natural rights philosophy forwarded by John Locke. Adopted by the nation's founders, the natural rights perspective claimed all people are free and inalienably entitled to rights, and governments derive power from the consent of the governed. In contrast, those claiming women deserved the ballot from the womanhood perspective based their arguments

in the cult of domesticity. These reformers argued women deserved the vote because they were different from men. Women's roles as wives and mothers, and their unique qualities such as piety, nurturance, and purity, legitimized their want of the vote. Both philosophies operated simultaneously over the course of the movement, and both could be found from one state to another. Generally speaking, however, the more radical natural rights arguments were emphasized earlier in the movement, and the more conservative womanhood arguments gained favor in its later stages.[45]

Women's dependence on men was purportedly for their own good. Men, whom most people at the time believed the stronger sex, claimed responsibility for controlling economic, educational, religious, and political institutions, and they alleged they would use that power chivalrously to "protect" women's best interests. Women, especially middle- and upper-class white women, were socialized to believe their status as wives, mothers, and daughters was tied to the men in their lives, and this status afforded them protection. Women's rights reformers exposed this notion of chivalry as a veneer, revealing it as not so much altruism as a means of subordination. Many reformers argued women needed protection not from the supposed dangers of public life, but rather from violent and abusive men.

According to popularly held beliefs, the home was the proper arena in which women should wield their power. Women presumably reigned over the domestic sphere, and they were expected to use their influence to ensure the moral fortitude of their families and communities. The concept of domestic influence was an important one. Many members of the abolitionist, temperance, and women's movements argued women, in their roles as wives and mothers, were central to social reform because of their moral authority. For this reason, the rhetoric of the women's movement often was grounded in moral suasion. At the time, many Americans believed women were morally superior to men. Far from a sincere compliment, this belief became a burden for most women because it created unrealistic social expectations for women's behavior and it became a means of policing and limiting those behaviors. Yet, women's use of moral argumentation to advance social reforms such as temperance and women's rights was an effective strategy, since it capitalized on their perceived credibility in a time and place when women had little credibility on political matters. However, as US politics became increasingly partisan, moral suasion became less effective, closing off women's primary means of social influence. In addition to social reform move-

ments, women's work in benevolent societies provided a rare opportunity to have an impact on their communities, but many women became frustrated by what they perceived as the limitations of this kind of influence. For this reason, many women moved away from moral suasion and work in benevolent societies to engage more directly with electoral politics.[46]

Many anti-suffragists resisted women's direct participation in electoral politics because, they feared, it would reduce women's power. They argued women already had power to address injustices in the form of *indirect* influence—via their beauty, charm, and feminine virtues. Women were in the position of using their indirect influence over men to motivate them to resolve social ills. Anti-suffragists also argued women should not seek the ballot because, in so doing, they would lose men's respect. If they lost men's respect, they lost the power of indirect influence. Thus, anti-suffragists believed women ultimately could do more good for their families and communities without the vote.

Women's rights reformers argued this glorification of women's indirect influence was a myth. In reality, women had little to no social or political power. Women were told men put them on a pedestal, yet women weren't always—nor should they be expected to be—pure, virtuous, and obedient. Ohioan Barker Gage bemoaned:

> If there is any thing that stirs my blood with indignation it is to hear men declaring, with a silly smirk upon their faces as if they were trying to hide the lie that is falling from their tongue, that they want to place woman above them—that they always yield to woman—that beauty, smiles and tears subdue them, and all this; while they set acting the tyrant, and hoot every woman with disrespect that dares ask a place even by their side.[47]

Notions of men's chivalry and women's indirect influence reveal the often illogical and hypocritical nature of gender relations in the United States during the mid-1800s.

If women were to participate in and advance political debates, the pivotal next step would be to lay claim to the public podium, in addition to the petition. It was the social custom that women did not speak in public, especially to what was known as a "promiscuous" audience, one comprising both men and women.[48] While certain Quaker communities and many Garrisonian abolitionists supported women's leadership and encouraged their public speaking, most Americans considered women who addressed

mixed-gender audiences strange and even dangerous. The outrageous-ness of women speaking in public, of demanding anything—least of all rights for themselves, of the radical notion women were citizens and thus they should be allowed to vote—was simply too much for most people to comprehend. The social expectation was for women to stay home, con-fined to minding home and hearth.

The negative reaction to women speakers came to a head in 1837. The "Pastoral Letter of the General Association of Massachusetts to the Con-gressional Churches under Their Care" railed against women abolition-ists speaking in public, thus beginning a long and constant assault from many religious leaders against women's participation in social reforms.[49] Much like Lucretia Coffin Mott and Elizabeth Cady Stanton, Ohioan Bet-sey Mix Cowles was denied the opportunity to speak at an antislavery convention. Unwilling to accept this silencing, she responded by found-ing the women's rights movement in Ohio and continued to speak out against slavery unabated.

The effort to mute women was so intense that women speakers often were heckled and interrupted, and sometimes they faced angry mobs or discovered their speaking platforms dashed to the ground. Scheduled to address a meeting in Mount Pleasant, Ohio, in 1828, Kelley Foster was unceremoniously ordered to stop just as she began her lecture, and to ensure her silence, a team of men hastily carried her out of the building. Media coverage of women speakers also functioned to mute them. For instance, a New York newspaper once referred to Kelley Foster as "that monstrosity, a public speaking woman," and Ohio newspapers spread salacious rumors about her during one of her state speaking tours.[50]

Attitudes about women speaking in public did not improve overnight. Years later, in 1853, Barker Gage continued to face criticism for speaking in public. As she ascended to the speaker's platform to deliver a keynote address at a temperance meeting in Dayton, a line of women, arranged two by two, formed a half circle around her, and they accused her of offering an "unseemly and unchristian position," as she made herself "conspicuous before men."[51] These women protested not intemperance but the right of women to speak on behalf of temperance in front of men. They feared women would lose their purity if they addressed an audience of men. This narrative illustrates how women's oratory remained con-tested over the course of many years.

In this manner, women systematically were denied the most powerful tool available to them for forging their own emancipation or claiming political liberty—the public podium. Consequently, one of the first steps of women's emancipation was challenging the expectation of their silence. Some women were too fearful to risk ostracism, while others dared assert themselves. Women had to find within themselves both their voices and the strength to withstand public ridicule for using them. Women such as Mix Cowles, Kelley Foster, and Barker Gage did exactly that. In this regard, Ohio was the classroom in which the earliest women public speakers mastered their lessons.

Taken together, Ohio's geography, population, educational system, economy, political structure, and connections to other social reforms, such as abolition and temperance, created a uniquely fertile ground for women's rights activism. Against the backdrop of Ohio's reform culture, the state's women's rights leaders advanced consciousness-raising efforts, constructed a philosophical foundation, and mounted rhetorical advances. In so doing, they paved the way for a social movement of their own. Regrettably, most people living at the time failed fully to understand or genuinely appreciate the role Ohioans played at the genesis of the women's movement. Of course, one could argue this oversight is still true today. Far too many of the state's heroines remain unsung, and historic turning points too often remain undocumented.

A Grievous Wrong

A native of Washington County, Ohio, formidable Frances Barker Gage was one of the earliest leaders of the abolition, temperance, and women's rights movements at both the state and national levels. She also was among the first to make the case that Ohio's many contributions to women's rights were too often overlooked. One day, she had her patience worn thin when she found, yet again, people were ignoring the Buckeye State's reform successes only to glorify those of other states. Barker Gage had read a newspaper article crediting New York women as the first to demand the ballot before a legislative body. She knew this claim was false because she had made just such a demand in Ohio well before anyone in New York had dared to do so. To vent her frustration, she penned a

scathing and lengthy letter published in the *Woman's Journal* defending her home state. "Someone has done Ohio a grievous wrong," she began. She then pointed to the 1850 Ohio Constitutional Convention, to which "a memorial, sent there by a number of citizens of Stark and Columbiana Counties, asking that equal rights to the whole people, without regard to sex or color, may be engrafted as a provision of the new Constitution." She claimed that this was "probably the first memorial asking equal rights for women ever presented to any legalized deliberative body in this or any other nation." To drive her point home yet further, she reminded readers: "In the Senate of the United States, nine votes were given for the right of suffrage for woman, and of that nine from all the States of the Union, two (if I mistake not) were from Ohio." And she quipped sarcastically, "How many of those were from Massachusetts or New York?"[52] The correct answer to this question was none.

Overlooking the contribution of Ohio reformers continued until the end of the women's rights movement. Harriet Taylor Upton, another native Ohioan and a suffrage leader at the state and national levels at the time the Nineteenth Amendment was ratified, also bemoaned how the state's suffragists did not receive their fair share of prestige and honor. "Other States did more spectacular work and had larger organizations, but none finished its tasks with a stronger spirit of loyalty and love for the work and the workers," reflected Taylor Upton.[53] She claimed, "From the very beginning of the agitation of the question of woman suffrage to the end, Ohio stood well to the front." Modestly, she continued, "When the history and the philosophy of the movement is really written, Ohio will be credited with the second place, New York with the first."[54]

Indeed, the significance of Ohio's contribution to women's rights continued to be questioned even after the movement ended. Upon the twenty-fifth anniversary of the ratification of the Nineteenth Amendment, Ohioan Florence Allen, the first woman appointed to a federal judgeship in the United States, acted on her belief in the importance of women's history and her determination to set the record straight. To that end, she helped found and supported the Committee for the Preservation of Ohio Women Suffrage Records. Allen reached out to living leaders of the movement, women who wore battle scars looking much like hers. To women such as Carrie Chapman Catt, Maud Wood Park, and Taylor Upton, she posed the question: what state should be considered the host of the first women's rights convention—New York, Massachusetts, or Ohio? Taking

all sides into account, Allen agreed with Chapman Catt and Taylor Upton that New York hosted the first women's rights convention in the United States at Seneca Falls in 1848 and that Ohio's convention, held in Salem in 1850, was second.[55]

Seneca Falls, New York, is popularly regarded as the birthplace of the US women's rights movement. This origin story describes the venerable Elizabeth Cady Stanton and Lucretia Coffin Mott, denied permission to speak at the 1840 World Anti-Slavery convention because they were women, determining that they must take up the mantle of women's rights activism too. Eight years later, as the story unfolds, the opening salvo to the movement came in the form of a convention scheduled to debate the rights of women, including the ballot. Approximately three hundred people gathered at the Wesleyan Chapel in Seneca Falls, and many attendees ultimately endorsed the "Declaration of Sentiments," a document that would set the agenda for the cause for decades to come.[56]

Yet, social movements typically have multiple starting points, and they often consist of a patchwork of associations, leaders, strategies, and tactics. Taking a broader view appropriately complicates familiar narratives about the history of this movement, and it recognizes that while the Seneca Falls convention was symbolically a very important moment in US history, women—especially those working in the abolition, temperance, and labor movements—organized collectively to demand their rights well before a movement coalesced. Ample evidence exists that such was the case in the state of Ohio.[57] For far too long, scholars and others have neglected the important role Ohio played in forging one of the largest and longest voting rights campaigns in US history, as well as to the women's rights movement in general. Claims by some historians that the women's movement started later in the Midwest than the east, and that there were fewer formal organizations and social networks or less coordination in the Midwest, are simply erroneous.[58] To the contrary, Ohio did not lag behind other states in the initial call for women's rights, including the ballot. Undeniably, Ohio was on the vanguard of women's rights advocacy. Therefore, the goal of this book is to situate the state of Ohio in its rightful place within the history of the women's rights movement and the fight for voting rights.

Ohioans adopted the cause well before many other states, and support for the cause grew there faster than it did in other states. As Barker Gage claimed, Ohioans were the first to file a petition for women's suffrage to

a governmental body, and they generated the first constitutional debate about women's enfranchisement in the country. Additionally, Ohioans were among the first to emphasize the inherent connections between gender and race by linking women's suffrage to African American suffrage in their earliest petitions. Furthermore, Ohioans helped build the infrastructure for the movement by forming the nation's first state women's rights organization and by hosting two of the five earliest national women's rights conventions. Many of the movement's early leaders— Frances Barker Gage, Betsey Mix Cowles, Hannah Conant Tracy Cutler, Frances Jennings Casement, to name a few—were Ohioans.

Many Ohio activists came to national prominence, and several Ohio campaigns had consequences at the federal level. None other than Gerda Lerner, often considered the pioneer of women's history as an academic discipline, "long felt that Ohio in general, and the Salem convention in particular, had been unjustifiably placed in a position subordinate to activism in New York."[59] While many historians focus on New York and Massachusetts as the primary sites for the movement's origin, this book will document how Ohio proved to be equally fertile ground for women's rights activism.

Furthermore, Ohio's contribution to women's rights extended well beyond the movement's genesis. The state's activists continued to advance American democracy by challenging definitions of citizenship and gender as well as social customs and legislation that fettered women over the span of the entire movement. Ohioans were in it for the long haul. Over many decades of persistent work, Ohio activists managed to challenge the male stronghold on the ballot successfully only once in the 1800s, winning the right to cast votes on local public school affairs in the late 1890s. Another thirty years would pass until they won the right to presidential suffrage. In many ways, the second generation of Ohio reformers proved their endurance and love of democracy more than their sister activists in other states. Even though Ohio suffragists were among the first to demand the ballot, they saw women in other states enfranchised well before they were. Yet, these amazing women fought on, undeterred, refusing to accept injustice. In fact, Ohioans helped to fight for the ballot in other states, and they proved critical in the final push to ratify the Nineteenth Amendment.

Discounting decades of toil persuading Ohio's general assembly and its male voters prior to ratification of the Nineteenth Amendment would be shortsighted. State-level studies such as this one are important in and

of themselves, because they are an essential part of documenting each state's history. State suffragists labored within unique political environments and fought for the ballot for varied reasons, held differences of opinion on how best to win voting rights, and experienced diverse outcomes.[60] Moreover, no matter the outcome, each battle was important to the overall war. As Elaine Weiss, author of *The Woman's Hour: The Great Fight to Win the Vote,* explains, "state suffrage amendment drives were hard-fought and often futile; each new woman suffrage state, however, meant additional access to that state's congressmen and more influence for suffragists."[61] Chapman Catt, as president of the National American Woman Suffrage Association during the Nineteenth Amendment's ratification fight, regarded state-level suffrage efforts as "the most persuasive of all arguments for extending full suffrage to women" at her disposal.[62] There is no doubt that state efforts, either those aimed at their own legislatures or on behalf of the Nineteenth Amendment, made a difference at the federal level.

It is important to remember, too, that state campaigns were more than mere footholds on which the federal campaign gained traction. Corrine McConnaughy, author of *Woman Suffrage Movement in America,* argues, "The state and local politics of woman suffrage were also something more than mere stepping-stones to a federal amendment, even if nationally prominent suffrage activists viewed and treated them as if they were not."[63] The epic fight for women's rights was as much a grassroots phenomenon as it was top-down. State legislatures—including that of Ohio—debated women's enfranchisement well before a national suffrage organization even existed. Even after national suffrage organizations became fixtures in American politics, differences of opinion existed between national and state leaders. Clashes about goals, strategies, timing of legislative campaigns, and other issues were not uncommon. At times, national leaders incorrectly assumed they knew better than state leaders who had firsthand knowledge on the ground, causing further animosity. National leaders would go so far as to withhold support for state measures if state leaders refused their counsel. Thus, state-level studies are critical to a more complete understanding of the entire women's rights movement and of voting rights in the United States.

All told, suffragists advanced 480 petition and lobbying drives to get state legislatures to submit suffrage to voters, 277 campaigns to encourage political parties to include suffrage among their planks, 56 state campaigns

aimed at convincing male voters to grant women the ballot, and 47 campaigns to persuade delegates of state constitutional conventions to write women's suffrage into state constitutions.[64] The vast majority of these herculean efforts ended in defeat, yet these defeats are a critical part of history. Accounting for the *whole* story of the fight for women's rights, including the ballot, constitutes more than the national movement and more than the Nineteenth Amendment—the story also is one of individual states and their relationship to the federal effort.

Ida Husted Harper, one of the editors of the indispensable though imperfect six-volume *The History of Woman Suffrage,* once warned, "The devotion, the efficiency, the self-sacrifice of the suffrage workers in Ohio will never be known. Their strength lay in their cooperation. To give their names and their work would fill all the space allowed for this chapter."[65] The story of Ohio suffrage will be known after all, but it will take a book, not a chapter, to do justice to the subject. The first chapter of this book tells the story of Ohio's women's rights movement from its inception through the Civil War. The second explores women's rights efforts within the state during the Reconstruction Era. Chapter 3 covers the time between the end of Reconstruction and the start of the Progressive Era. Chapter 4 examines important suffrage campaigns within the state as the Progressive Era unfolded. Ohio's final state referendum and the push to ratify the Nineteenth Amendment constitute the fifth chapter. Moving chronologically, each chapter of this book details how Ohioans played a substantial role in creating the agenda, building the organizational capacity, providing the leadership, and engaging political power at both the state and national levels throughout the life of the women's suffrage movement.

Ohio women's rights activists endured seventy years of labor, including appeals made at state constitutional conventions, state referenda for full suffrage, local campaigns for school and municipal suffrage, court cases, endless petition drives, and articles and speeches too numerous to count. Nearly every attempt to gain full suffrage at the state level failed. Most partial suffrage efforts failed. Even when Ohio women won the right to school suffrage, opposition organized to repeal this smallest measure of justice. When Ohio women won presidential suffrage, that opposition organized again successfully, repealing the measure. Yet, Ohio women simply refused to admit defeat or to give up hope that justice would be theirs, and if not theirs, their daughters'.

One of the fiercest fighters of them all, Alice Paul, the chair of the militant National Woman's Party (NWP), is pictured in one of the most iconic images of the women's suffrage movement. In this photograph, she stands, unfurling a banner over the balcony of the NWP headquarters in Washington, DC, on August 18, 1920, the day the final state ratified the amendment. Keeping track of the ratification process, an NWP suffragist would sew a star on the purple, white, and gold banner each time a state adopted the Nineteenth Amendment. "We are all shouting for a fifth star on our suffrage flag to mark a new equal suffrage state," exclaimed suffrage leader Taylor Upton.[66] She lived to see the day. On June 16, 1919, Ohio became the fifth star on the NWP ratification banner.

Over the course of seven decades, Ohio suffragists had lost every state measure for full suffrage. In less than two weeks, however, Ohio passed a presidential suffrage bill and ratified the federal amendment bestowing the ballot on women. Indeed, Ohio suffragists lost most of their battles, but the lessons learned, the resolve strengthened, the dogged determination borne out of every defeat at the state level prepared Ohio's women for what it would take to ratify the federal amendment and to fight for a full range of women's rights. The strength of character; the drive; the resilience to stare down every opponent; to never give in to despair, exhaustion, or doubt, bearing every humility and degradation; to come back stronger and braver than before—that is the legacy of Ohio's suffragists. Today's feminists and voting rights advocates would do well to honor this legacy by allowing it to both inform and to inspire the unfinished work of social justice.

Ohio on the Vanguard of Women's Rights

Donning the Unmentionables

"The newspapers are beginning to talk right smart about the rights of women. It appears to us that things have got a wretched pass—so snarled and crooked up—among our male legislatures, that it is about time for the women to put on the unmentionables of office, and straighten them out."[1] These lines from 1840, drawn from the pages of the *Ohio Democrat and Dover Advertiser,* provide evidence that even before the mid-1800s at least some Ohioans were willing to rethink the "unmentionable" relationship between women and politics. There is no doubt that early in the nation's history, strong-minded Ohio women raised their voices calling for social reforms and their own emancipation, but it would take something more to combine those singular expressions into a chorus. A full-fledged social movement was needed. As historian Ellen Carol DuBois explains, for many years "women's discontent remained unexamined, implicit, and above all, disorganized. . . . The women's rights movement crystallized these sentiments."[2]

Ohio was on the vanguard of creating that movement in several profound ways. First, Ohioans built the fledgling movement's organizational capacity. All successful social movements require an infrastructure sufficiently strong to support its various functions, such as recruitment, fundraising, media management, and mobilization. As the women's rights movement began to take shape, Ohio leaders provided both form and substance by hosting a series of conventions, leveraging their ties to civic

societies, and nurturing the emerging feminist press. Second, Ohio reformers inserted themselves directly into the state's political culture by filing petitions, submitting memorials, and navigating both party and presidential politics. Third, Ohioans played a key leadership role in setting the political agenda for the nascent women's rights struggle.

During the genesis of the movement, the organizational structure emerged out of a series of conventions at the local, regional, and state levels. Between 1848 and 1860, organizers held numerous conventions in five states, including Ohio, Indiana, Massachusetts, New York, and Pennsylvania.[3] Usually, conventions were open to the public, lasting two to three days, with audiences of both men and women. Over time, a standardized format evolved that included public addresses, debates over resolutions, business meetings, and committee reports. Initially, many conventions were loosely organized and informal, with much of the work done by a coordinating committee whose membership was constantly changing.

Conventions were the proving ground for early reformers, serving as a site to showcase women's public governance, to conceive feminist ideologies, and to raise awareness of women's subordination and oppression.[4] These gatherings were a means by which women could develop essential public speaking and leadership skills, an opportunity typically denied them elsewhere. Yet another function of these events was to establish a place of mutual respect and support, a potential safe harbor in which likeminded reformers could build personal and professional relationships.

The women's rights convention held in Seneca Falls, New York, in 1848 is commemorated as the birth of the movement. Reformers gathered for follow-up meetings in Rochester, New York, later that year and in Philadelphia, Pennsylvania, the next year. However, the first statewide convention of women's rights reformers met in Salem, Ohio, in 1850. In this regard, Ohio took the lead in women's rights agitation, expanding it from the local level to the state level. If the Seneca Falls convention was the clarion call to the first women's rights movement in the United States, then, in many ways, the Salem convention was the most full-throated response.

Not surprisingly, considering the inherent connections between the two causes, the idea for the first convention devoted solely to the rights of women in Ohio originated at an antislavery convention. The state's abolitionists had met to discuss the proposed fugitive slave law of 1850. This

ongoing national public debate was an exercise in soul-searching as much as in legislation. The law would challenge notions of who Americans were as a people and what values would and would not be the bedrock on which the nation's future was built. Abolitionists in attendance at this convention embraced this debate with passionate deliberation. That passion spilled over to other social justice causes, including women's rights. In between meetings, presentations, and other business of the convention, delegates broached the subject of the role of women in public affairs, some attendees doing so tentatively and others boldly. These reformers knew all too well many people perceived them as the lunatic fringe, yet they were curious about how much support there was from around the state for women's rights. They wondered aloud whether these pockets of discontent amounted to a critical mass sufficient to foment a movement. One barometer of public support would be to send out a call for a state convention. No one knew what to expect, nor did they realize they would be securing the foundation of a social movement that would span decades.

After the antislavery convention, two friends, Betsey Mix Cowles and Jane Elizabeth Hitchcock Jones, along with several other local reformers, made the bold decision to organize a women's rights convention in Salem, Ohio.[5] Both women were born leaders. Though the general public's conception of leadership was almost exclusively masculine at this time, and most people scoffed at the idea of a woman leader, these women of Ohio, nevertheless, led. Initially, leadership came primarily from white women, but Ohio's African American women very quickly rose to the challenge after the Civil War.

Betsey Mix Cowles (1810–1876) was a most unconventional woman for her time. Born in Connecticut, she moved with her family to Austinburg, Ohio, when she was a young girl. She later became one of the first women to graduate from Oberlin College, and she devoted that education to advance her career and the social reforms in which she believed. She clearly understood the intersections of race and gender, always simultaneously addressing the twin evils of racism and sexism. Cowles defied the social expectation for women's silence over the course of many years by delivering speeches supporting abolition and women's rights at both the state and national levels. Though speech-making as a woman left her open to public criticism, her reputation reached such famous and talented fellow supporters as Frederick Douglass and Abby Kelley Foster, both of whom she counted as friends.

Beginning in the 1830s, Cowles joined several abolitionist organizations in Ashtabula County, often serving in leadership positions. She organized the Ashtabula County Female Anti-Slavery Society in 1835, serving as its secretary, and she was a member of the business committee of the Western Anti-Slavery Society, one of the nation's most radical groups. She worked closely with other activists, such as Hitchock Jones, writing articles for the *Anti-Slavery Bugle,* and she edited the *Plea for the Oppressed,* an abolitionist newspaper. She joined the Garrisonian abolitionists in 1845, going on to create and to distribute circulars challenging the Black Codes in 1847 and publishing her appeal, "Outrage upon Human Rights," the following year.[6]

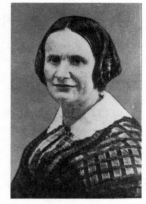

Cowles refused to condone hypocrisy. Though many of Ohio's Black Codes were repealed, the legislature proposed a new law barring African American children's access to many schools. In 1848–49, Cowles publicly objected to this racist measure, and

Betsey Mix Cowles

to meet the needs of girls and African American children, she established a number of schools throughout the state.[7] Despite complaints by white parents, Cowles taught Sunday school classes for Black and white children together. She confronted many Ohioans who would oppose slavery but not grant civil rights to African Americans in their own state.

Cowles never married, and she enjoyed a long and successful career in education, teaching in northeast Ohio and New York. In the 1840s, she established "infant schools," started public schools in Canton and Massillon, and founded normal schools in Hopedale, Ohio, and Bloomington, Illinois. She eventually advanced to serve as principal in Massillon and Austinburg and as superintendent in Canton and Painesville, a position very few women held in the mid-1800s.[8] Later in her career, Cowles shifted attention to promote higher education for women. In a letter to her sister, she encouraged her to study harder, and she reflected on women's education: "I do hope the time is not far distant when females will feel [and] act as that they are made for something more than to flutter or to serve."[9]

Though historians have not confirmed that Cowles attended the Seneca Falls convention, she undoubtedly played a key role in the genesis of the movement. Her skills and level of conviction led to a variety of

leadership positions within early women's rights organizations.[10] After organizing and presiding over the Salem convention, Cowles founded the Ohio Women's Rights Association (OWRA) in 1852. This organization sought "the extension of human freedoms, for the elevation of the [human] race, without respect to sex, color, or other conditions."[11]

Cowles's friend, Jane "Lizzie" Hitchcock Jones (1813–1896), was another important Ohio abolitionist and women's rights pioneer whose name is not well known but should be. Born in New York, Hitchcock Jones moved to Salem in June 1845 to form an antislavery society and to serve as coeditor of the reform newspaper, the *Anti-Slavery Bugle*. Hitchcock Jones also worked closely with leading abolitionists such as William Lloyd Garrison, Frederick Douglass, and Wendell Phillips. She served as secretary of the Western Anti-Slavery Society and traveled throughout Ohio, Pennsylvania, and New York speaking against the horrors of slavery. She also wrote a children's book, *The Young Abolitionist; or, Conversations on Slavery*, in hopes it would inspire young people to take up the cause.

Abby Kelley Foster convinced Hitchcock Jones to join her on an antislavery lecture tour throughout New England, Pennsylvania, and Ohio. She had a natural talent for public speaking, and she became well known for her forceful style. Soon, she began using her talent on behalf of women's rights as well. Kelley Foster was impressed with Hitchcock Jones's growth as a speaker, writing in a letter to her husband: "Indeed she is truly eloquent at times—She has learned to extemporize with great power."[12] Her reputation earned her the honor of delivering the keynote speech at the Salem convention. Like other women of her day, she faced considerable backlash for being so bold as to speak in public.

Hitchcock Jones established a prominent reputation as a leader, enduring media attacks issued from across the nation as well as personal assaults. For example, after learning an Ohio gang called the Butternuts planned to tar and feather her and her husband, the couple made a quick escape to Pennsylvania. Hitchcock Jones refused to be intimidated, and she continued to speak at several important national women's rights conventions throughout the 1850s. By the 1860s, she was promoting women's rights in New York, coordinating a major petition drive that resulted in thousands of signatures. As a member of the American Woman's Suffrage Association, Hitchcock Jones supported the Fourteenth and Fifteenth Amendments, even though they did not include women's enfranchisement. After studying anatomy and physiology with Quaker physician

K. G. Thomas of Salem, Ohio, Hitchcock Jones leveraged her talent for public speaking into a profitable lecture tour on the importance of good health and hygiene. She retired from reform work after the Civil War.[13]

Never Did Men So Suffer: The Salem Convention

Known for its free thinkers, including abolitionists and "Abby-Kellyites," Salem was a strategic choice to host this important event. Residents of this small town were not afraid to take on the day's most controversial issues. Due in large part to its Quaker heritage, Salem, Ohio, developed a reputation for moral leadership and political agitation. The Underground Railroad ran through Salem, the Anti-Slavery Society established its western headquarters there, and nationally known abolitionists such as William Lloyd Garrison and Frederick Douglass visited regularly.

While Salem was an appropriate place for a reform convention, 1850 also was the right time. Ohio voters approved a convention to revise the 1803 constitution, creating a prime opportunity for reform-minded people to forward their agendas. Even though women's rights in no way motivated the public call to convene the state constitutional convention, that event became the first battleground in the fight for enfranchisement of Ohio's women. The Salem planners were under no illusion that others commonly shared their views or that their demands would yield immediate results. These were practical women who took the long view. An editorial about women's rights reform published in the *Anti-Slavery Bugle* illustrated this fact: "Does anyone ask, 'What good will it do?' We answer, it will excite thought, promote discussion at the fireside, through the press, and in the public assembly; and though you may not, and doubtless will not, attain at once the great end which you have in view, you will at least make the task an easier one to those who shall come after you."[14] Reformers were well aware the first battle to be waged was against women's sense of futility and defeatism, to be followed by the fight against men's indifference and bias.

Mix Cowles and Hitchcock Jones, along with the other Salem convention organizers, began their planning by reaching out to Elizabeth Cady Stanton for advice about how best to construct a petition to be delivered to the Ohio state constitutional convention. She responded most emphatically, "For what shall you first petition? For the exercise of your right to the

elective franchise—nothing short of this. The grant to you of this right will secure all others; and the granting of every other right while this is denied is a mockery. It is our duty to assert and reassert this right, to agitate, discuss and petition, until our political equality be fully recognized."[15] Determined to take the work begun in New York to the next level, Ohio leaders issued a call to convene their statewide women's rights convention:

> We, the undersigned, earnestly call on the women of Ohio to meet in convention, On Friday, the 19th of April, 1850, at 10 o'clock A.M., in the town of Salem, to concert measures to secure to all persons the recognition of equal rights, and the extension of the privileges of government without distinction of sex, or color . . . feeling that the subjects proposed for discussion are vitally important to the interests of humanity, we unite most earnestly inviting every one who sincerely desires the progress of true reform to be present at the Convention. . . . Women of Ohio! We call upon you to come to this work in womanly strength and with womanly energy.[16]

The wording of the call illustrates how these women saw themselves and their cause—they were not the "weaker sex," nor were their interests trivial. Rather, women were strong and their rights vital to all humanity. The Salem reformers knew if they were to launch and sustain a social movement, recruiting new followers was absolutely essential. This invitation was among the movement's first rallying calls.

On April 19, 1850, Ohioans answered that call. Emily Robinson of Marlboro, Ohio, made history when she called to order the first statewide women's rights convention. The first day, reformers met at the Second Baptist Church, and because the crowd was larger than expected—approximately five hundred attendees—they moved the second day to the larger Hicksite Friends Meeting House.[17] Attendees quickly elected Mix Cowles as president. The convention commenced with a full agenda, including public speeches, debates on resolutions, and the reading aloud of several key documents.

Hitchcock Jones was the keynote speaker. Her address, "The Wrongs of Woman," began, "There is not, perhaps, in the wide field of reform, any one subject so difficult to discuss as that of Woman's Rights. . . . I like not the expression. It is not Woman's *Rights* of which I design to speak, but of Woman's *Wrongs*." She continued, "I shall claim nothing for ourselves because of our sex. . . . It is then *human* rights for which

we contend." She emphasized, "But tho' woman has no rights peculiar to her sex—*none* which belong to her because she is a woman; yet she has wrongs, great wrongs, which are peculiar to her wrongs political, wrongs social, aye, and wrongs religious."[18] The remainder of the speech outlined women's legal disabilities and became the basis for the convention's resolutions. Hitchcock Jones conceded, "I have already said enough to secure the disapprobation which is always bestowed upon a woman who thinks and speaks for herself," and she concluded, "I could hope that I have said something to encourage to earnest action those of my sex who feel that no length of legislation can sanction and sanctify the wrongs that have been inflicted upon them; that no social usages, however time-honored, can justify the oppressions they have been compelled to endure, that no religious creed, however sanctimonious its supporters, can find the least excuse for the inequality in the church." According to the convention proceedings, the address was "listened to with marked interest by the whole convention," and Hitchcock Jones was considered quite "able" and a "leading spirit" of the cause.[19]

The Salem convention planners invited many of the Seneca Falls and Rochester pioneer suffragists, including Lucretia Coffin Mott, Elizabeth Cady Stanton, and Lucy Stone, to participate. Unfortunately, most could not attend, because they were homebound, too burdened by the weight of domestic duties and other responsibilities to make the long trip. Instead of listening to those leaders' speeches, the audience heard their letters read aloud in absentia. Coffin Mott, who occasionally traveled to Ohio to visit family and who had delivered a lecture in Massillon just a few years earlier, sent a letter from Philadelphia, warning attendees to "not *ask* as *favor*, but *demand* as a *right*, that every civil and ecclesiastical obstacle be removed out of the way." Stone, writing from Massachusetts, urged conference-goers to "expose the atrocities of the laws relative to women, until the ears of those who hear shall tingle. So that the men who meet in Convention to form the new Constitution for Ohio, shall, for very shame's sake, make haste to put away the last remnant of the barbarism which your statute book (in common with other States) retains in its inequality and injustice to woman." Cady Stanton, writing from New York, emphasized that women's focus should be on "the exercise of your right to the elective franchise—and nothing short of this. The grant to you of this right will secure all others," and, she warned, "Men can not represent us. They are so thoroughly educated into the belief that woman's nature

is altogether different from their own, that they have no idea that she can be governed by the same laws of mind as themselves."[20]

Hitchcock Jones's address and the letters from Coffin Mott, Stone, and Cady Stanton struck an equally passionate tone, and they built an ideological bridge between the Seneca Falls and Salem meetings based on a natural rights philosophy. Similar to those at Seneca Falls, the Salem reformers sought an array of women's rights. The assembly forwarded twenty-two separate resolutions on a range of topics including political, religious, and social rights, ratifying twenty. The women of Salem, like those in Seneca Falls, also adopted comparable strategies, including setting forth a memorial, theirs to be delivered to Ohio's constitutional convention by Marian Johnson of Salem. The endorsed memorial began, "We believe the whole theory of the Common Law in relations to woman is unjust and degrading, tending to reduce her to a level with the slave, depriving her of political existence, and forming a positive exception to the great doctrine of equality as set forth in the Declaration of Independence." It continued, "Is it just or wise that woman, in the largest and professedly the freest and most enlightened republic on the globe, in the middle of the nineteenth century, should be thus degraded?"[21] Delegates appealed to an American sense of patriotism at the same time they were exposing the nation's contradiction between word and deed.

The body of the memorial described the legal conditions of married women: "The law should not make Woman a mere pensioner on the bounty of her husband, thus enslaving her will, and degrading her to a condition of absolute dependence." Further, it also expanded the argument to call for a wide range of rights: "We earnestly request that in the New constitution you are about to form for the State of Ohio, Women shall be secured not only the Right of Suffrage, but all the political and legal rights that are guaranteed to men."[22] Independence became an important and lasting theme in the rhetoric of the women's rights movement. These reformers knew one of the movement's priorities must be to establish women's legal identities separate from those of their husbands. In a time when most people believed women were not as smart, strong, or capable as men, persuading them that women could and should be independent was a difficult case to make. Yet, the Salem delegates boldly declared to all they were not the kind of women to settle for anything short of their full emancipation.

The Salem organizers knew that another initial priority must be mobilization. To that end, attendees appealed to women's self-interests and self-respect. In a key document, "Address to the Women of Ohio," delegates pleaded:

> We appeal to our sisters of Ohio to arise from the lethargy of ages; to assert their rights as independent human beings; to demand their true position as equally responsible co-workers with their brethren in the world of action. We urge you by your self-respect, by every consideration for the human race, to arise and take possession of your birthright to freedom and equality. Take it not as the gracious boon tendered by the chivalry of superiors, but as your right, on every principle of justice and equality. . . . Let us agitate the subject in the family circle, in public assemblies, and through the press. Let us flood the Constitutional Convention with memorials and addresses, trusting to truth and a righteous cause for the success of our effort.[23]

The Salem convention was of historical consequence for many reasons, not least of which was that this was the first public meeting where the convention planners, officers, and speakers were exclusively women. As the women's rights movement emerged, the role men should play, if any, became a key issue. Were men oppressors, and thus, to be considered the enemy? Were men potential allies in the fight? On the one hand, male legislators must be conciliated if they were ever to be convinced to vote on behalf of women's rights. Rhetoric alienating or excluding men would be counterproductive. On the other hand, if women were to prove they were capable of self-determination and living autonomous lives, relying on men to fight for the cause also could prove counterproductive. At the Seneca Falls and Rochester conventions, selecting a woman to chair instead of a man provoked controversy. Both Coffin Mott and Cady Stanton feared that, if a female officer did not perform her duties well, the potential for positive public reaction to the movement would be in jeopardy. These two stalwart leaders felt so strongly about the importance of "gentlemen officers" at the Seneca Falls convention that they threatened to boycott the event if men were not in charge. By the time of the Salem convention, most reformers no longer shared this concern, and women took the reins.[24]

Perhaps more radical and independent than the Seneca Falls or Rochester convention planners, those of Salem decided to prove they were strong enough to manage their own affairs and need not depend on men to fight their battles. Planners made the strategic decision to allow men to attend the event, but not to speak or to vote. Paulina Wright Davis wrote in *The History of Woman's Suffrage:* "Never did men so suffer!" She recalled, "Not a man was allowed to sit on the platform, to vote. They implored just to say a word; but no; the President was inflexible—no man should be heard. If one rose meekly to make a suggestion, he was at once ruled out of order. For the first time in the world's history, men learned how it felt to sit in silence when questions in which they were interested were under discussion."[25]

To their credit, the male spectators largely were supportive of the cause, despite the unusual situation in which they found themselves. A local resident, Daniel Howell Hise, wrote in his diary, "The Woman's Convention was a perfect jam—all enthusiasm; they did honor to their sex, cursed be the pitiful whining politicians that still press in withholding from her political rights." Organizers planned for a postconvention meeting of male supporters. These attendees engaged in a spirited discussion, and they unanimously adopted a resolution stating, "that as friends of Universal Liberty, we proclaim our detestation of that spurious Democracy which denies to human beings the Right of Suffrage on account of sex or color, and that we will never relax our exertions until a perfect equality of rights shall be acknowledged as the foundation of all our social, political, and religious institutions."[26]

Attending the conference made a lasting impression on one young man sitting in the audience, John Allen Campbell. Campbell later would become Wyoming's first territorial governor, and in that role, he signed into law a suffrage bill in 1869, making Wyoming the first place in the United States explicitly to extend equal suffrage to women—over fifty years before the federal government would do so. Two years after the bill passed, state representative C. E. Castle threatened to repeal the law. Campbell allegedly was offered $2,000 by two unknown men to support the repeal. Refusing, he implored legislators: "It is simple justice so say that the women entering, for the first time in the history of the country, upon these new and untried duties, have conducted themselves in every respect with as much tact, sound judgment, and good sense, as men."[27] Despite his urgings, the repeal passed both branches of state government. A constant and true

friend to suffrage, Campbell vetoed the repeal, and the attempt to override the veto failed by one vote. Thanks to Campbell, the women of Wyoming could continue to make their mark on state politics.

The Salem convention also was historically significant because many people living at this time considered Ohio the gateway to the American West. In this regard, the Salem convention can be credited for opening up "the West" to the women's movement and for placing Ohio at its forefront. The strong attendance illustrated a growing commitment to the cause on the part of both women and men. The event's success allowed the movement to gain traction and to create a resolve that energized early reformers. The Salem convention propelled others to raise their voices in support of women's rights in small towns across the state and beyond its borders.[28]

Convention attendees took the next step in the complicated process of developing a feminist ideology grounded in the belief of social egalitarianism and originating a language of equal rights to express that emerging ideology. Perhaps most significant was the creation of what today would be called a safe space for women to explore ideas, vocalize opinions, and cultivate bonds of sisterhood on their own terms free from men's involvement. Within this space, women, long silenced in public, could find their political voices and raise them in chorus, calling their sisters in Ohio and across the country to battle.

The Salem convention also was of historical consequence because it successfully garnered media attention for the nascent movement. A Salem newspaper, the *Homestead Journal*, carried an editorial predicting, "The subject of Women's Rights is becoming more and more agitated, and the advocates of her cause are becoming quite numerous in many parts of our country. The Convention held here will have a widespread influence. . . . We can now scarcely pick up a paper but what contains a notice of the Salem Convention, accompanied mostly by some commendatory comments."[29]

The *Anti-Slavery Bugle* provided extensive coverage of this local event of national consequence including the minutes, all twenty-two resolutions, the memorial, and the "Address to the Women of Ohio." The following week, the editors published Hitchcock Jones's speech in its entirety. The newspaper owners generated extra copies, which they sent across the country to nonsubscribers. The editors explained the antislavery movement "has done more than any thing else to arouse the public mind of this country to consideration of the Wrongs of Woman, and to prompt

Women themselves to step forth from their circumscribed 'sphere' and struggle earnestly for their own moral and intellectual elevation." They continued, "Anti-Slavery has been the school in which thousands of Women have made the discovery of their own enforced subserviency to man, and acquired the courage necessary to a successful effort to throw off the trammels."[30]

A variety of national media and reform newspapers also covered the convention. Noted abolitionist and women's rights reformer Parker Pillsbury described the importance of the Salem convention: "That meeting struck by its novelty. It jogged the wheels of society considerably. It seemed like an insurrection among slaves. Every body was astonished at its audacity."[31] The convention proceedings circulated in pamphlet form throughout the United States and England. Small town Salem, Ohio, had made a name for itself on the international stage.

Perhaps most historically consequential, the Salem convention generated the first constitutional debate about women's enfranchisement. Women acquired much needed firsthand experience engaging the political process at the state level. Nancy Isenberg, author of *Sex and Citizenship in Antebellum America,* argues that the Salem convention was more important than the Seneca Falls convention because it was more directly tied to contemporary political culture, emphasizing that the Salem activists tapped into established political channels.[32] Within just a few years of the Salem convention, Ohio was at the center of the women's suffrage movement, and the state's leaders were gearing up for the first fight at the constitutional convention.

Recruitment and local organizing would remain limited and sporadic for many years after the Salem convention. Efforts to organize meetings, speaking tours, and legislative efforts were often individualistic ones, dependent on personal initiative and audacity on the part of the movement's pioneers. Frances Barker Gage's (1808–1884) name became synonymous with personal initiative and daring. Like Mix Cowles, Barker Gage is significant because she was among the first to champion suffrage for all citizens, regardless of race or gender. Born on a farm near Marietta, Ohio, Barker Gage demonstrated remarkable mettle and an enterprising nature that made her a prominent leader of three reform movements, including women's rights, abolition, and temperance at both the state and national levels. Barker Gage had little opportunity for formal education, but she was an avid reader over her entire lifetime. Her feminist awakening began at

age ten, while she made barrels with her father. Barker Gage reported over-hearing him say, "What a pity she was not born a boy," and she described how at that young age "sprang up my hatred to the limitations of my sex."[33]

After she married, she moved to McConnelsville, where she raised eight children while writing under the pen name "Aunt Fanny" for an agricultural journal, the *Ohio Cultivator*. Her folksy tone and personal narratives added a motherly legitimacy to women's rights. She depicted the cause in a less threating, even family-friendly way, and she did much to alleviate some women's fears about the movement's bold demands. She denounced the "cult of true womanhood"—the belief that women should be deferential, obedient, pious, and confined to domestic duties. Rather, she encouraged women to see their true sphere as the "sphere of duty," including wifely and motherly duties but also those du-

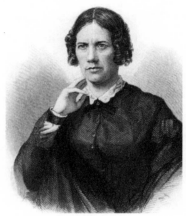

Frances Barker Gage

ties existing beyond the home.[34] As a career woman, Barker Gage practiced what she preached, becoming a role model for other women.

Her public conviction to this idea earned Barker Gage an invitation to speak at the Salem convention. Considered a natural orator, she was well known for her wit and her ability to entertain audiences. Unfortunately, she could not accept the invitation to address the convention. Instead, she sent a letter to be read in her absence that laid the blame for women's subordination on both the law and commonly held sexist attitudes. Barker Gage astutely recognized, "The laws of public opinion are now more oppressive, if possible, than the written law of the land; and I find more men ready and willing to lend the helping hand than my own sex. If women could be thrown more upon their own responsibility, made to realize their own strength and inherent power, the rest, it seems to me, would be of easy accomplishment."[35]

Barker Gage eventually moved to St. Louis, where she continued her fight for social reform. She and her family frequently received threats of personal violence or the destruction of her husband's property.[36] Locals so harassed them that they moved back to Ohio, where they began work for married women's property rights. Barker Gage traveled extensively with other leaders, such as Elizabeth Cady Stanton and Susan B. Anthony, and

she became a nationally sought-after speaker. Barker Gage held several offices in various suffrage organizations, and while vice president of the national women's rights convention in Philadelphia, she used her sway to schedule the next national convention in Cincinnati.

During the Civil War, Barker Gage volunteered as a relief worker and oversaw the welfare of five hundred formerly enslaved people in South Carolina. After the war, she moved to New Jersey, where she participated actively in the American Equal Right Association. She eventually split from the association to support the Fifteenth Amendment. She played an instrumental role promoting women's rights in Iowa, and she was the only women who did so in the Deep South, though according to the *Daily Picayune,* she drew small audiences for her suffrage speeches.

Barker Gage continued to write, including editorials, a volume of poetry, and a temperance-themed novel. Unfortunately, she suffered a stroke, and unable to travel, she could not continue her reform work with the same vigor in her later years. She managed, however, to continue to write on behalf of the causes in which she believed, her work including four more books.[37] Looking back on her long and distinguished career in temperance, abolition, and suffrage reforms, Barker Gage reflected, "To continue for forty years, in spite of all opposing forces, to press the triune cause persistently, consistently, and unflinchingly, entitles me to a humble place among those noble ones who have gone about doing good, you can put me in that place as it suits you."[38]

Just one month after the Salem convention, Barker Gage was keen to build on its momentum. Knowing the state constitutional convention drew nearer, she called her own local women's rights convention in her small hometown of McConnelsville, in rural Morgan County. Seventy women attended the gathering in the local Masonic Hall. This time, convention planners refused to allow men to even witness the event. In preparation, Barker Gage wrote a paper outlining gender-biased laws on the Ohio statute books and later read it to the attendees. She also presented the audience with a memorial to be sent to the state constitutional convention demanding the right to vote. Reflecting Barker Gage's unflinching commitment to equal rights for all, the memorial called for the words *white* and *male* to be omitted from the new Ohio constitution. Forty of the attendees signed it.[39] This was perhaps the first time a petition linking women's rights and those of African Americans was ever presented to a deliberative body. Thus, Barker Gage can be credited for

being among the first to see the important link between gender and race.[40] Considering the sexism and racism of the age, it is not surprising that this petition received a negative response. One convention delegate referred to it as "effusions of folly and fanaticism."[41]

Undeterred, Barker Gage forged ahead, calling for a second county meeting, this time in the tiny rural village of Chesterfield. After traveling sixteen miles in a horse-drawn wagon, she arrived to find the local pushback so strong that she was locked out of the church where the meeting was to be held. She and the other planners next tried, but were denied, entrance into the local schoolhouse. Eventually, with the help of a local reverend named Philo Matthews, Barker Gage convened the meeting in a barn before a crowd of over three hundred Quaker and abolitionist farmers and their families. She found the audiences "not much inclined to 'woman's rights,'" but she did not let that stop her.[42] Mustering all her passion for the cause, she climbed onto a cart to deliver what became known as her "ox sled speech." A local Quaker preacher said to Barker Gage after she ended her address, "Frances, thee had great Freedom. The ox-cart inspired thee."[43] Other men and women drew on their convictions to offer their own words, and many added their signatures to the memorial. Local newspapers such as the *Morgan Herald* and the *Marietta Intelligencer* covered Barker Gage's rural conventions respectfully.[44]

The 1850–1851 Ohio Constitutional Convention

Ohio's reformers such as Barker Gage, Hitchcock Jones, and Mix Cowles did not shy away from engaging its political culture. As in other states, a somewhat predictable pattern of strategies and tactics emerged, including gathering signatures to support petitions and memorials to state constitutional conventions and legislatures, providing testimony to government committees in support of those petitions, and seeking endorsements of influential opinion leaders and politicians. Between the Salem convention and the start of the Civil War, Ohioans sent memorials to the state constitutional convention in 1850, petitioned both houses of the general assembly from 1852 onward, provided testimony to the state legislature in 1857 and 1858, and won a measure of success pursuing changes to married women's property laws. Without the vote or the ability to run for public office, however, women everywhere still had little political clout.

The mid-1800s was an era in which many individual states called conventions to redraft their founding documents. Between 1830 and 1860, almost every state revised its constitution. Women's rights activists realized this was a prime opportunity for the disenfranchised to demand their political rights. If democracy depended on the vote of the common man—or woman—women's rights activists perceived these conventions as the best stage for casting women as political actors. Ohio activists made a dramatic entrance onto the political stage. As a result of decisions generated at the Salem convention, women took on the task of a petition drive, resulting in approximately eight thousand signatures on behalf of women's rights.[45] Petitioning was an important part of the democratic process, and it was one of the few political tools then legally available for women. Since women could not vote, their signatures on petitions were among the few ways they could communicate their political priorities.

Because of her fame and tremendous talent for public speaking, the Salem convention planners invited Lucy Stone to plead the case for women's rights at the state constitutional convention, but she declined, suggesting that an Ohioan would be taken more seriously. Urging Ohio women to proceed on their own, Stone wrote, "Now is the time, while the old Constitution is being removed and the new making, to strike for equal rights. It is an important moment. No more favorable can ever occur. I need not tell you that I am with you heart and soul. If I were one of you, I would serve you to the best of my ability."[46]

To avoid the cholera epidemic at the state capitol, the Ohio Constitutional Convention met in Chillicothe. Delegates from around the state debated a number of issues, among these adding district courts and giving more power to voters to elect state officials. The constitutional changes under consideration included extending the right of suffrage to women and to African American men. These petitions were the first call for women's enfranchisement issued in front of any governing body. Many petitions called for equal suffrage "regardless of color or sex," including those from Stark, Portage, Columbiana, Tuscarawas, and Shelby Counties. Several other county representatives filed petitions calling for "female suffrage," including Cuyahoga, Ashtabula, Muskingum, Clark, Morgan, Medina, and Warren. In total, the convention considered petitions carrying signatures from twelve counties calling for women's enfranchisement.[47]

Delegate Norton Townshend, of Elyria, led the debate in support of removing the word *white* from the state constitution's provisions re-

garding voting rights. Townshend was a young member of the Free-Soil Party, which had played a pivotal role in repealing the Black Codes that restricted African American immigration the year before. He would go on to be a US congressman, a state senator, and one of the original trustees of the Ohio State University. His argument, though both logical and moral, did not sway his fellow delegates. The final vote, seventy-five to thirteen, indicated just how determined state legislators were to deny voting rights to African American men.[48]

After the motion to remove the word *white* failed, delegate E. B. Woodbury of Ashtabula County pivoted to women's rights, proposing an amendment to remove the word *male* from the voting rights section of the state constitution. This strategy, which was used in many states for many years, strove to create gender-neutral constitutions that would ensure every citizen was equal before the law.[49] Townshend then offered a strong natural rights argument for women's suffrage, as he had for that of African Americans. He declared women equaled men in intelligence and virtue, and their participation in politics could only improve it. No one else spoke for or against the motion.[50] By the time the delegates voted, Ohio's suffragists would mark the first of what would be a long line of losses. The tally was seventy-two to seven, a resounding defeat. As with the vote for African American suffrage, all the amendment's supporters represented counties in the Western Reserve, a northeast region of the state known for its more radical politics. Adding insult to injury, Barker Gage recalled years later, the debates were "so low and obscene" that the delegates voted to drop them from the record.

Historically, petitions on behalf of suffrage were considerably more controversial than those demanding other women's rights. Most Americans saw the elective franchise as the ultimate repository of political power in a democracy. Granting the vote to women would challenge men's monopoly on that power. Demanding the right to vote was not simply a natural extension of democracy—it was a challenge to male authority. Furthermore, enfranchisement was closely associated with freedom and independence in nineteenth-century America. Women were not free, as they did not have self-ownership and they were dependent on men. Thus, women were not qualified to vote.[51] Ohio provides a case in point: the 1850 petition drive revealed that memorials for "equal rights" for women received four times the number of signatures as petitions for "equal suffrage."[52]

Women's rights reformers lost the first battle for the ballot in Ohio, as they suspected they would. Far from giving up, they soldiered on. The participation of these reformers in the 1850 Ohio Constitutional Convention succeeded in getting women's suffrage on the agenda and agitating discussion of the issue across the state. Ohio reformers also gained valuable firsthand knowledge of the petition process and the state's constitutional amendment process upon which they would draw many times.

In 1851, less than a year after the loss at the state constitutional convention, Barker Gage, fueled by steadfast determination to rekindle passion for the cause, traveled two days to host a women's rights convention in Mount Gilead, Ohio. This gathering became known as "John's Convention." Despite newspaper advertisements promoting the convention in advance, when Barker Gage arrived at the church for the meeting, not a single person was in the audience, and the church itself was ramshackle. Quick-thinking and resourceful, Barker Gage paid five local boys ten cents each to go to every house in town promoting her upcoming speech while her driver, nineteen-year-old John Andrews, helped to organize the church. The boys rounded up an audience of fifty. Barker Gage held two other sessions the same day and three the following day.[53]

Much akin to earlier conventions, participants at John's Convention forcefully demanded an array of rights. Their first resolution declared, "Resolved, That the like cause for revolution now exists among us, and we believe it high time that woman should take up the weapons of a moral warfare, in defense of the same right for herself which the mothers of the nation so nobly assisted our fathers to obtain for themselves."[54] Even though most nineteenth-century Americans conceived of war as a masculine enterprise, Ohio's early reformers invoked war metaphors to communicate a sense of urgency and emotional intensity. While women did not engage in physical combat, the strength of their moral fortitude prepared them for a battle of wills. John's Convention clearly was a call to arms.

The Salem convention was not the only one of national consequence held in Ohio as the movement coalesced. Regaining momentum after the state constitutional defeat, two of Ohio's staunchest fighters, Barker Gage and Hannah Conant Tracy Cutler (1815–1896), joined forces to organize another historically important women's rights convention, this one convened in Akron. Much like her friend Barker Gage, Conant Cutler was another early leader of Ohio's women's rights reforms who made a national impact. Conant Cutler, born in Massachusetts, moved with her family

to Rochester, Ohio, in the early 1830s, when she was a teen. The young woman studied rhetoric and philosophy on her own and Latin with the family doctor before the move to Ohio. She then hoped to attend nearby Oberlin College. However, her father refused to pay the tuition, believing higher education was unseemly for women. Instead, she married an Oberlin theology student, and she studied her husband's textbooks and discussed each day's lessons with him to advance her own learning. She was so thirsty for knowledge that when he began to study law, this practice continued. It this manner, Conant Cutler became knowledgeable about the legal restrictions women of Ohio faced. She eventually got her wish: she attended Oberlin and, along with Lucy Stone, formed an off-campus debating society for women, since university administrators refused to allow them to debate on campus. The young woman who had been denied an education was so committed to lifelong learning that in her fifties, she returned to Cleveland to study, and eventually to teach and to practice, at the Women's Homeopathic College of Medicine and Surgery. Her informal and formal education prepared her well to lead reform causes.

After a year of study at Oberlin, Conant Cutler accepted a job in Columbus, where she met Barker Gage. Conant Cutler earned a prized position as principal in the "female department" of a public high school. Though most women would not have dared risk such a position by taking on controversial feminist causes, she and Barker Gage organized a women's rights convention in Akron in 1851. The following year, Conant Cutler was elected OWRA president. She attended many of the national women's rights conventions through the 1850s, 1860s, and 1870s, delivering speeches alongside national leaders such as Coffin Mott, Ernestine Potowski Rose, and her friends Barker Gage and Stone. She held leadership positions in many organizations, including the Western Union Aid commission during the Civil War, the Ohio Delegation of the American Equal Rights Association, and the Ohio Equal Rights Society. Most importantly, she helped to form the American Woman's Suffrage Association in 1869, and she was elected its president the following year. She presented petitions to state and federal legislatures, and she helped form temperance, abolition, and suffrage organizations in Ohio, Illinois, Iowa, Nebraska, and Vermont. Over the course of two years, she worked with Alice Stone Blackwell (Lucy's daughter) and Rachel Foster Avery to combine two rival organizations into the National American Woman Suffrage Association, thus uniting and strengthening the movement.[55]

Conant Cutler crisscrossed the nation advancing the cause at the national level, joining Anthony on a lecture tour of New York state, touring with Barker Gage throughout Illinois, lecturing with Amelia Jenks Bloomer through Iowa, and speaking at numerous conventions and reform events throughout the Midwest and the Northeast. Because Conant Cutler's rhetorical style was folksy and feminine, it likely put her listeners at ease. She introduced woman suffrage concepts within a traditional and Christian framework, and she deftly folded suffrage topics into speeches about temperance, possibly suiting more conservative audiences. Her reputation and work extended to the United Kingdom, when she served as a delegate to the Worlds' Peace Congress held in London in 1851.[56]

Conant Cutler enjoyed such a positive public reputation as a leader that Stone sought her advice when starting her own career as a reformer. Conant Cutler had a clear understanding of what women were up against, and she cautioned Stone that nothing short of a social revolution, which likely would take at least a generation, was needed to make women the equals of men. Still, she also assured Stone that a single woman could make a difference "if she possesses courage enough to act up to her convictions."[57] Later in her career, Conant Cutler reflected, "Many of us have grown old in this work, and yet some people say, 'Why do you work in a hopeless cause?' The cause is not hopeless. Great reforms develop slowly, but truth will prevail, and the work that we have been doing for thirty years has paid as well as any work that has ever been done for humanity."[58]

Truth to Power in Akron

Barker Gage and Conant Cutler rallied together men and women for the Akron women's rights convention held May 28 and 29, 1851. The stifling hot Old Stone Church was so crowded that people sat in the aisles and on the pulpit steps.[59] Attendees promptly elected Barker Gage to preside. At this early stage of her career, like many other feminist pioneers, she was a reluctant leader. Barker Gage modestly confessed, "I am at a loss, kind friends, to know whether to return you thanks, or not, for the honor conferred upon me. And when I tell you that I have never in my life attended a regular business meeting and am entirely inexperienced in the forms and ceremonies of a deliberative body, you will not be surprised that I do not feel remarkably grateful for the position."[60]

With the courage of her convictions, Barker Gage overcame her trep-idation to deliver a keynote address in which she compared women's rights activism to the struggles of early US pioneers, and she acknowl-edged there were "mountains of established law and custom to overcome and a wilderness of prejudice to be subdued."[61] Barker Gage, like many of her contemporaries, adopted a natural rights philosophy: "The rights of mankind emanate from their natural wants and emotions. Are not the natural wants and emotions of humanity common to, and shared equally by, both sexes?"[62]

Barker Gage also addressed men's oppression of women, directly querying, "Where then did man get the authority that he now claims over one-half of humanity? From what power the vested right to place woman—his partner, his companion, his helpmeet in life—in an inferior position?" Again like many of her contemporaries, she did not wish to create the impression that she somehow blamed men for her subordi-nation, or that she expected men to do the work of improving women's lot. She insisted, "We fear not man as an enemy. He is our friend, our brother. Let woman speak for herself, and she will be heard. . . . I pour out no harsh invectives against the present order of things—against our fathers, husbands, and brothers; they do as they have been taught; they feel as society bids them; they act as the law requires. Woman must act for herself."[63] She understood there could be no other way—women had to fight their own battles.

The Akron agenda was a full one. Attendees debated resolutions on a variety of religious, legal, economic, social, and political matters re-lated to women's rights. The program included many public addresses and letters read in absentia. Conant Cutler both advanced natural rights arguments and disputed claims that the Bible justified denying women rights. She claimed the oppression of women violated both the laws of God and nature:

> There could be no right, no humanity, in subjecting woman to a position that induced degrading dependence, wretchedness, and crime. No thor-ough student of Christian truth would dare say that this was in accordance with either the provisions of nature or grace, and the result must be char-acters but half developed, and spirits out of tune with the high harmony of creation. Man suffered to quite as fearful an extent by this unnatural condition as woman, and the consequence must be evil and only evil.[64]

Maria Giddings of Jefferson, Ohio, presented a digest of the common laws pertinent to women's lives. Mix Cowles, continuing in her leadership role within the state and serving as an officer of the business committee, provided a report about women's labor. Emily Robinson of Marlboro, Ohio, shared a report on women's education.

The most noteworthy event of the convention was the famous "Ain't I a Woman?" speech delivered by Sojourner Truth. On the second day of the convention, a group of Methodist, Baptist, Episcopal, Presbyterian, and Universalist ministers dominated the discussion, advancing arguments based on religious scriptures to accuse women's rights reformers of immorality. Most of the women attendees and some of the men were appalled at this line of argumentation, but it was Truth who dared to command the podium in response.[65] Though the audience included racists who entreated Barker Gage not to permit an African American woman to speak, she ignored these pleas and granted Truth the floor.

Sojourner Truth

No undisputed version of Truth's speech exists, and much is written about the difficulty of establishing its textual authenticity. Depending on which version of the speech is read, a different Sojourner Truth emerges from the pages. One version, Barker Gage's, creates the impression Truth was less skilled as a speaker and undermines her rhetorical legacy.[66] Barker Gage published a version of Truth's address twelve years after the fact, begging the question as to whether Truth actually repeated the famous phrase, "Ain't I a Woman?" and leaving Barker Gage open to criticism that her description of Truth was a caricature.[67]

A second, more authoritative version of the speech exists. Marcus Robinson, an abolitionist and friend of Truth's who heard the speech, supplied the text immediately after the convention to the local Salem newspaper, the *Anti-Slavery Bugle*. The article provided a text of the speech and a brief introduction. Robinson removed any indication of dialect. Absent from the article is the question "Ain't I a woman?" or any mention of the convention's contentious atmosphere.

According to the newspaper version of her impromptu speech, Truth rebuked the ministers: "I have heard the Bible and have learned that Eve

caused man to sin. Well, if woman upset the world, do give her a chance to set it right side up again." Driving her point home, she pondered, "And how came Jesus into the world? Through God who created him and the woman who bore him. Man, where was your part?"[68] In addition to counter-arguing sexist interpretations of the Bible and admonishing the men who made them, Truth's address is critically important because it also laid bare the commonly held assumptions that all slaves were men and that all women were white. Though the speech's exact wording remains contested, there is no doubt that Truth's greatest historical contribution was her consistent reminder—to her contemporaries and to future generations—that race and gender intersect. As alliances between abolitionists and women's rights reformers became increasingly strained, Truth made clear that forcing a choice between the two was a false dichotomy. She devoted the remainder of her life to the demand of true political equality for *all* women.

According to Barker Gage's recollection, Truth's audience received the speech enthusiastically. She recalled, "Amid roars of applause, she returned to her corner, leaving more than one of us with streaming eyes, and hearts beating with gratitude. . . . I have never in my life seen anything like the magical influence that subdued the mobbish spirit of the day, and turned the sneers and jeers of an excited crowd into notes of respect and admiration. Hundreds rushed up to shake hands with her."[69] Stone described Truth as "wise, unselfish, brave, and good," and Cady Stanton wrote of "the marvelous wisdom and goodness of this remarkable woman."[70] Her forceful delivery, colloquial style, sarcasm, biblical metaphors, and personal narratives resonated with her listeners. Scholars rightly emphasize that Truth was both a real person and a symbol, and that fact must not be forgotten when her rhetorical legacy is considered.[71] In both cases, Truth's contribution to the rhetoric of the women's rights movement truly was unique because it emphasized the relationship between gender and race, and it did so consistently across her speaking career.

Later that year, what is considered the first national women's rights convention met in Worcester, Massachusetts. Ohioans attended the convention, and they served as officers, including Hitchcock Jones, William Stedman, Mary A. Johnson, and her husband and fellow editor of the *Anti-Slavery Bugle*, Oliver Johnson.[72] By the end of this gathering, a debate ensued about whether delegates should establish a national organization devoted to promoting women's rights. Many attendees opposed the idea,

and it would remain a point of contention at future conventions. Angelina Grimké Weld believed that a permanent organization would hamper the individualism women sought. Other women resisted because of their negative experiences with church hierarchy or because they wanted to avoid internal power struggles. Instead of a formal national organization, delegates established a central committee to coordinate conventions, and they appointed committees on education, employment, civil and political rights, and social relations. This decision increased the importance of state organizations. The second annual national convention also met in Worcester. Conventions, be they local, state, regional, or national, were at this time becoming the primary way the women's movement conducted business. Yet, it would be years until suffragists would found a national organization.

In 1852, Coffin Mott presided over the third national convention held in the city hall of Syracuse, New York. Ohioans Caroline Seymour Severance and Elizabeth Hitchcock Jones were among the elected officers. Hitchcock Jones addressed the assembly, first reassuring them that victory was inevitable, declaring, "This is a time of progress; and man may sooner arrest the progress of the lightning, or the clouds, or stay the waves of the sea, than the onward march of Truth with her hand on her sword and her banner unfurled." Her tone was forceful as she depicted herself as a woman of action: "I am not in the habit of talking much about rights; I am one of those who take them." She demanded the right to vote, believing like others, the ballot contained all other rights. Her remarks echoed two common arguments, both of which were grounded in the language of the nation's founders, natural rights and no taxation without representation. Hitchcock Jones pronounced, "This I claim on the ground of humanity; and on the ground that taxation and representation go together."[73] Another Ohioan, Emma R. Coe, a prominent lecturer in the movement who later became a law student, demanded "an equal control over ourselves, our fortunes, our actions, the right to 'life, liberty and happiness,' which man possesses for himself."[74]

As social movements mature, differences of opinion regarding strategies and tactics emerge and rivalries surface. The Syracuse meeting was the first national convention marred by "coarse and ribald speech."[75] It would not be the last. Time and again, unruly audiences interrupted, heckled, and threatened speakers, both male and female. Usually, speakers found ways to forge ahead with their remarks, and other speakers or

audience members attempted to reinstate civility, but on rare occasion, proceedings had to be adjourned. The hostile responses illustrated the degree to which women's rights remained controversial. Again, one hotly debated motion centered around the need to establish a national organization for women's rights. Early reformers such as Grimké Weld were against this move, arguing that formal organizations "fetter and distort the expanding mind."[76] Elizabeth Smith Miller suggested that organizations be formed at the state level, but even this compromise was met with opposition.[77]

The Ohio Women's Rights Association

In addition to the Syracuse convention, Ohio women's rights advocates gathered the same year at the Baptist church in Massillon, Ohio, for their own regional event. The attendees passed eleven resolutions, many of which illustrated the continued practice of forwarding natural rights arguments. The first resolution stated, "That in the proposition affirmed by the nation to be self-evidently true, that 'all men are created equal' the word 'men' is a general term, including the whole race, without distinction of sex." The resolutions also emphasized the movement's focus on women's independence. Resolutions claimed: "Woman has the same right to choose *her* sphere of action, as man to choose *his*" and "That since every human being has an individual sphere, and that is the largest he or she can fill, no one has the right to determine the proper sphere of another."[78]

As was the case in conventions prior, women's rights reformers did not try to challenge prevailing definitions of femininity or masculinity or the relationship between them. Audiences were assured women would continue their spousal and maternal duties even if their demands for political rights were met. One resolution explained, "In demanding for women equality of rights with their fathers, husbands, brothers, and sons, we neither deny that distinctive character, nor wish them to avoid any duty, or to lay aside the feminine delicacy which legitimately belongs to them as mothers, wives, sisters, and daughters."[79]

The Massillon convention's high point was the creation of the Ohio Women's Rights Association (OWRA), the first of its kind in the nation. Using firsthand experience in the temperance, abolition, and club movements, Ohio women's rights activists—before those of any other state—

forged their own statewide organization. With the help of Dr. L. M. Whiting of Canton, who drafted the organization's constitution, the OWRA was born.[80] Conant Cutler was elected to serve as the organization's first president. Among its provisions were the establishment of local branches, annual meetings, and membership guidelines. Though conventions were critical events in the time line of the women's rights movement, suffrage societies conducted its routine business and made local and statewide operations feasible and, eventually, provided structure for national associations.

Because of its significance, the Massillon convention received local, regional, and national media coverage. The *New-York Daily Tribune* devoted an entire column to the event: "All honorable classes were represented, from the so-called highest to the so-called lowest . . . all interested in one common cause, and desirous that every right God gave to woman should be fully recognized. . . . [T]his is the sum and substance of the Women's Rights Reform—a movement which fools ridicule and find easier to sneer at than meet with argument."[81] The *Cleveland Plain Dealer* devoted columns of newsprint to an article and an editorial. The editorial warned that "male females and female males" would soon be descending upon the city of Cleveland for the national women's rights convention to be held there the following year. While most of the nation's newspapers did not endorse women's rights, they deemed conventions such as this one to be newsworthy, and they promoted discussion of the movement's issues.[82]

From the start, much of the organizational structure of the women's rights movement was rooted in existing temperance and abolition societies. The temperance crusade began in the eighteenth century in New England, eventually becoming the largest women's reform movement of the nineteenth century.[83] In 1851, the Woman's Temperance Convention gathered in Cincinnati at Foster Hall, and by 1853, the Ohio Women's Temperance Society was in full force. Josephine Bateman, editor of the *Ohio Cultivator*'s Ladies Department, was the organization's first president. After the Civil War, Ohio's temperance crusaders became increasingly active politically.[84] Auxiliary groups quickly sprang up across the state. Ohio's temperance movement became an organizational model for the emerging women's rights movement.[85] The national Women's Christian Temperance Union, founded in Cleveland in 1874, ultimately took over the temperance crusade. In many ways, the union provided a structure for the women's rights movement.[86]

Antislavery societies also provided an organizational standard for the women's movement. The Ohio Anti-Slavery Society first met in 1835 in Zanesville. Among its founders were many prominent Ohio abolitionists such as John Ranking, Theodore Dwight Weld, and Charles Finney.[87] Some state and local antislavery societies empowered women, while others limited their contributions to recruiting, organizing, and fundraising. Many of the early women's rights reformers in Ohio were Garrisonians, perhaps because this more radical branch of the antislavery movement was more likely to respect women's leadership and participation in the cause. Some antislavery societies established separate branches for women, and these groups were numerous and active in the 1830s.[88] The abolition movement provided women's rights activists with a model for organizing speaking tours, running meetings, responding to media coverage, and facing other organizational demands.

Beginning in the 1860s, the club movement also provided organizational structure for the women's rights movement. At the heart of the club movement was the conviction women had a moral duty to influence public policy and to be active in community service. A key component of club meetings was women's "self-improvement" and informal education. Club women held discussions, listened to speeches, and wrote essays on various topics of study. Some clubs worked on behalf of suffrage, but not all did so. Despite the fact some club members did not prioritize suffrage, their contribution at times exceeded that of some suffrage organizations. Because club women had social clout, suffragists devoted a great deal of energy recruiting them to the cause.[89] The club movement became the primary means by which American women could network, learn about civic issues, and use their influence outside the home. Club members also learned about parliamentary procedure, fundraising, public speaking, and other necessities related to running an organization.

In many ways, as the power of the temperance movement began to fade, the club movement's power was on the rise by the turn of the century. Some groups were auxiliaries of men's groups, others connected to faith-based aid societies, and yet others were independent. Some women preferred to create their own organizations rather than navigate the sexism they often faced in men's organizations. Clubs became so prevalent that the General Federation of Women's Clubs was founded as an umbrella organization in 1890. African American reformers created the National

Association of Colored Women six years later.[90] Though the club movement was not monolithic, most early club members were upper-class white women who, despite their racial and economic privilege, had limited opportunities for higher education because they were women.[91]

Ohioan Caroline Seymour Severance (1820–1914) stood at the forefront of the club movement. She wrote a book documenting the voices of key club women, *The Mother of Clubs: Caroline M. Seymour Severance; An Estimate and an Appreciation,* in 1906.[92] A prominent leader, she advanced a "sisterhood of women" who could serve as a "force for their own betterment, and as a bulwark against injustice."[93] After attending the Salem convention, Seymour Severance decided to devote her life to the cause of women's rights. Born in New York state and educated at Elizabeth Ricord's Female Seminary in Geneva, Seymour Severance briefly taught at a boarding school for girls. She moved to Cleveland upon her marriage, and not long thereafter, she befriended Barker Gage. The two women began lecturing, writing, and organizing for suffrage throughout Ohio together. Because of Seymour Severance's superb leadership skills, her reform career quickly advanced from the state to the national level, spanning from Boston to Los Angeles. She served as an officer in various suffrage organizations, and she spoke at several national women's rights conventions. A born organizer, Seymour Severance joined her lifelong friend Susan B. Anthony to found the American Equal Rights Association, and she helped Lucy Stone and Conant Cutler organize the American Woman's Suffrage Association.[94]

Caroline Seymour Severance

Seymour Severance maintained a conventional view of gender, often emphasizing women's roles as wives and mothers. Though privileged as a member of the upper class, Seymour Severance came to understand women's disempowerment through an economic lens. She argued that women deserved "equal protection" and that protection was impossible if women could not develop all their faculties as men do. She was troubled over the fact women were "blighted through neglect . . . because of the mere accident of sex." Women must develop the capacity to be self-sufficient, and wives and husbands should develop "mutual thrift."[95]

After moving to Boston, Seymour Severance quickly immersed herself in organizations such as the Boston Anti-Slavery Society and the New En-

gland Hospital for Women and Children, and she also began delivering abolition lectures. Due to her husband's health, she relocated again, to Los Angeles, where she continued her reform work. She became president of the Los Angeles County Woman Suffrage League. After her husband's death, she championed Christian Socialism, Progressivism, anti-imperialism, and peace. Working with noted suffrage leader Julia Ward Howe, Seymour Severance organized the Woman's Peace Conference in London, and she became president of the Woman's International Peace Association.[96] When California's women won the right to vote in 1912, Seymour Severance, at the age of ninety-two, cast her first ballot in a presidential election after having worked to do so for over sixty years.[97] Seymour Severance's legacy doubtlessly had a lasting impact on the cause.[98]

In 1853, Ravenna hosted the first annual meeting of the newly formed OWRA. Another large and enthusiastic audience of both men and women met at the Universalist church. Because Conant Cutler could not attend, Seymour Severance presided. She also gave a short speech about the movement's past and present status. Speakers at the Ravenna meeting included nationally known leaders such as Antoinette Brown Blackwell, and the agenda included the usual resolutions asserting political equality among men and women.[99] In a notable difference from earlier conventions, those in attendance charged Seymour Severance to write a memorial requesting more rights for women, including the right to hold and dispose of property and to vote. Attendees further requested that she personally deliver the petition to the state legislature of Ohio.

Media coverage of the convention was generally positive. The *Cleveland Plain Dealer* gave it four columns.[100] The *Pennsylvania Freeman,* a Philadelphia newspaper, described the proceedings as "interesting and animated" and confirmed, "The resolutions were ably and eloquently discussed and unanimously adopted."[101] Based on Ohio's example, state organizations and conventions rapidly spread throughout other states as well.

Cleveland Hosts the National Convention

Another important event in Ohio's suffrage history that year was the first national women's rights convention to be held in the state. The fact the 1853 conference planners chose Melodeon Hall in Cleveland for the October 6–8 gathering speaks to the state's increased prominence in the movement. Ohio was a strategic choice. Earlier that year, the OWRA launched

a second petition drive aimed at the state legislature.[102] Hosting the national convention generated and focused attention on this campaign. This national women's rights convention was the largest to date, with approximately fifteen thousand attendees and delegates traveling from Connecticut, Indiana, Massachusetts, Michigan, Missouri, New York, and Pennsylvania.[103] Many key officers of the convention were Ohioans, including Barker Gage, who presided over the convention. Vice presidents from Ohio included Seymour Severance, Joseph Barker, and Emily Robinson. Cady Stanton and Henry Blackwell, both of Ohio, served as two of the three secretaries. Seymour Severance also served as treasurer.

One highlight of the convention was Ernestine Potowski Rose's speech calling into question the sexual double standard, the pervasive practice that men are excused for violations of social expectations governing sexual behaviors, whereas women are stigmatized for the same behaviors. The *Cleveland Plain Dealer* called Potowski Rose the "master spirit of the convention," quoting her speech at length. Potowski Rose asked the audience, "If the victim is cast out into the pale of humanity shall the despoiler go free?" The audience hurled thunderous "no's." When the shouting died down, she exclaimed, "And yet he goes free!"[104]

The political philosophy that guided much of the convention's debate was one of natural rights, as demonstrated by the first two resolutions:

> Resolved, That by Human Rights, we mean natural Rights, in contradistinction to conventional usages, and that because Woman is a human Being, she, therefore has Human Rights; 2) Resolved, that because woman is a human being, and man is no more, she has, by virtue of her constitutional nature, equal rights with man; and that state of society must necessarily be wrong which does not, in its usages and institutions, afford equal opportunities for the enjoyment and protection of these Rights.[105]

Similar in format to other conventions, the agenda included a variety of speeches, letters, business meetings, debates, and resolutions. The major objective of this convention was to mobilize petitioning to legislatures, demanding women's rights in as many states as possible. Over the course of the gathering, three key debates emerged. The first question was what strategies and tactics would best achieve the objective of the convention and who should make those decisions, men or women. This discussion then led to the question of who is at fault for women's sub-

ordination. Finally, a theological debate about women's subordination ended the convention.

Letters read aloud from Horace Greeley, Thomas Wentworth Higginson, and William Henry Channing specified recommendations for how best to move the cause forward. Greeley cautioned that women should be the ones to make the decisions and to fight for the cause. Blackwell disagreed. Higginson urged his fellow reformers to move beyond abstract arguments for equal rights to publicize facts and statistics about women's wrongs. He encouraged convention attendees to compose reports with data from various states on three topics: women's education, laws pertaining to women, and women's employment.[106] Channing advised the convention attendees to issue a declaration of women's rights and to write model petitions to state legislatures seeking women's suffrage, tax exemptions, equal inheritance and guardianship rights, divorce for wives of alcoholics, and the right to a trial before female jurors.[107] Coffin Mott reminded Channing of the Declaration of Sentiments endorsed at Seneca Falls, suggesting it be resurrected rather than creating yet another declaration.

A second revealing debate focused on the question of who was responsible for women's subordination. Some attendees argued that men were, in fact, to blame and that they should take responsibility for making the changes necessary to end women's subordination. Others agreed men primarily were responsible, but they believed only women could be trusted to make the necessary changes in society. Yet others believed women were at least partly to blame because many did not embrace the movement or assert themselves. Most of the women wanted to emphasize they did not blame men. Stone insisted men were friends of women's suffrage, but she later underscored, "It is not man that can loose the chains. He cannot take us up and give us a resurrection to any life. Our destiny is in our own hands."[108]

At the same time, Garrison clearly and forcefully laid the blame at men's feet: "There is such a thing an intelligent wickedness. . . . So, then, I believe, that as man has monopolized for generations all the rights which belong to women, it has not been accidental, not through ignorance on his part; but I believe that man has done this through calculation." Joseph Barker concurred with Garrison, emphasizing it "would be most unmanly to refuse women their rights" and that "the interests of woman are not safe in the hands of man . . . the position of the world

to this present hour, shows that woman has been wickedly betrayed by man, and that he has failed in his duty most egregiously."[109]

Later at the convention, Barker gave a lengthy speech discussing the use of Christian scripture as a rationale for man's superiority and women's subjection. Kelley Foster delivered another one of her fervid condemnations of preachers who used the Bible to justify women's oppression. Their speeches generated considerable media sensationalism. The *Brooklyn Daily Eagle,* warned readers, "The strong-minded she-rowdies gave the public a specimen of the kind of legislators they would make."[110]

Brown Blackwell, Garrison, and Edwin Nevin replied to Barker's concerns, offering alternative interpretations of the Bible more supportive of women's agency. The clash between women's rights and biblical interpretations ignited the crowd, which grew more and more rowdy. The incivility rose to a point that Barker Gage resigned from her position as chair of the convention because of "indisposition," leaving Seymour Severance to take charge. By the time the convention disbanded, tempers were flaring to the point that Nevin cornered Garrison in the building's vestibule and the two suffered a physical altercation.[111] Several newspapers got wind of the dispute and leveraged it to embarrass the cause.

The *Cleveland Plain Dealer,* which had previously belittled women's demand for the ballot, continued to decline an endorsement of the women's movement. However, perhaps because of its significance as local news, coverage of the Cleveland convention was generally positive and extended to ten columns. Furthermore, several newspapers, such as Chicago's *Daily Tribune,* reprinted Cleveland newspaper coverage of the convention, thus expanding the story's reach to the national level.[112]

Suffragists resumed their work at the next national convention, meeting at Sansom Street Hall in Philadelphia from October 18 to 20, 1854. Potowski Rose presided. In her first national keynote address, Susan B. Anthony urged attendees to petition their state legislatures for laws granting women equal rights. Both Conant Cutler and Barker Gage provided reports. As was often the case at these conventions, a minister argued against women's rights by claiming the Bible indicated it was the will of God that man was superior to, and had authority over, women. This time it was Conant Cutler's turn to rebuke the clergy. According to the proceedings, "Mrs. Cutler replied at length, and skillfully turned every text he had quoted directly against the reverend gentleman, to the great amusement of the audience."[113]

Memorial to the State General Assembly

After the Ravenna OWRA convention and the national convention in Cleveland, Ohio suffragists were prepared to take on the state general assembly. In 1854, as promised, Seymour Severance delivered her memorial, along with petitions signed from supporters across the state. Townshend, once again a true friend to the cause, presented the materials to the legislature. He also moved an amendment to a bill revising the procedures for admission to the state bar to allow women to practice law. Instead of being taken seriously, the latter motion roused "amusing hits" and ultimately failed.[114]

With permission of the legislators, Seymour Severance addressed them directly with thirteen demands, among them: "That marriage shall not destroy the legal individuality of woman," "That the husband shall not have power to control the personal liberty of the wife," and "That the husband shall not have power to bind or apprentice his offspring without the consent of his wife." The memorial offered both biblical and natural rights arguments. Seymour Severance quoted the nation's key democratic principle: "We hold these truths to be *self-evident,* that *all* men are created *equal,* and endowed by their Creator with certain *inalienable* rights, among which are life, liberty, and the pursuit of happiness, and that to secure these ends government are instituted among men, deriving their *just* power from the *consent* of the governed." She also quoted Jesus of Nazarene: "*All* things whatsoever *ye* would that men should do unto *you,* do ye *even so* unto them."[115]

Regardless of Seymour Severance's impassioned arguments, and despite evidence more and more people of the state supported the cause, the memorial was "laid on the table and ordered to be printed." The Ohio legislature once again rejected the plea for women's rights. Thus, the second battle ended in failure too. Others may have given up at this point, but Ohio's suffragists were as resolute as ever to continue the fight for justice. Fortunately for them and for today's voters, they did not realize then just how many more battles they would lose before winning the war.

Cincinnati Hosts the National Convention

The fifth national women's rights convention met in Philadelphia in 1854, and organizers chose to return to Ohio for the sixth national convention,

this time in Cincinnati. With standing room only, reformers met in Cincinnati's Smith & Nixon's Hall October 17–18, 1855. Martha Coffin Wright, a sister of Coffin Mott who attended the original Seneca Falls convention, presided over the at-capacity crowd. Barker Gage, Brown Blackwell, and Potowski Rose were among the noted speakers. Not without controversy, some women wore bloomers, and some men wore shawls.[116]

Earlier in the year, a sixteen-year-old enslaved girl had appeared before Ohio courts for violating the fugitive slave laws. Adeline T. Swift used the timeliness of this controversy to offer a bitter comparison between married women of the North and enslaved women of the South. She highlighted the hypocrisy of abolitionist men who fought to free enslaved people yet simultaneously kept their own wives and daughters in a type of bondage. In a series of rhetorical questions, she asked, "Who are denied the right of trial by a jury of their peers? Women and colored persons. Who are deprived of the right to control and use their own earnings? The slaves of the South and married women." She further pondered, "Who can be and are deprived in numberless instances of the care and guardianship of their own children by the mere will of the father or master be they ever so vile or wicked? The slave mothers of the south and the married women of the United States."[117]

The agenda of speakers also included recently married Lucy Stone and Henry Blackwell, a Cincinnati native. Stone's passionate response to the preceding speaker became historically significant. A male attendee spoke about gender inequality in education, complaining that America had become home to a generation of "disappointed women." Stone's retort became one of her most influential speeches, "Disappointment Is the Lot of Women." "In education, in marriage, in religion, in everything, disappointment is the lot of woman. It shall be the business of my life to deepen this disappointment in every woman's heart until she bows down to it no longer," avowed Stone. "The widening of woman's sphere is to improve her lot. Let us do it, and if the world scoff, let it scoff—if it sneer, let it sneer."[118] The *New York Daily News* reported her speech was full of "spirit and power."[119] Suffragists were not backing down; if anything, they were becoming more emboldened.

At the close of the convention, Stone circulated another petition to send to the state legislature of Ohio, which claimed: "The women of the State of Ohio are recognized as citizens by the Constitution, and yet are disfranchised on account of sex only." The petition read, "We do respect-

fully demand them for the right of suffrage, a right which involved all other rights of citizenship, and one that cannot justly be withheld."[120] Stone also paid to place suffrage petitions in Ohio newspapers, which was fortunate, because the convention generated very minimal media coverage. Even newspapers such as the *Cleveland Plain Dealer* largely ignored the convention.[121] According to *The History of Woman Suffrage,* "a brief report in the city journals, is all we can find of the proceedings."[122] Perhaps because the Cincinnati conference was largely ignored by the press, planners decided future national conventions would be held in New York until after the Civil War.

Stone and Blackwell, who had met in Cincinnati two years prior, used the occasion of their wedding earlier that year to challenge the discriminatory nature of marriage laws and to call into question power relations within that institution. At the ceremony, the couple refused to have the word *obey* in their vows. Stone kept her name, giving rise to the term *Lucy Stoners,* used derogatorily to refer to other women who did the same. The couple's challenge to conventional notions of proper gender relations was truly radical.

Before they moved briefly to Cincinnati, Stone and Blackwell issued a marriage protest. The couple declared: "This act on our part implies no sanction of, nor promise of voluntary obedience to such of the present laws of marriage as refuse to recognize the wife as an independent, rational being, while they confer upon the husband an injurious and unnatural superiority."[123] A marriage protest is a unique rhetorical act. The document served not only the couple's personal needs but also served as a public argument. Within this text, Stone and Blackwell urged, "Marriage partners should provide against the radical injustice of present laws, by every means in their power."[124] They followed their own advice by expanding those means to include the marriage protest.

Founding a Feminist Press in Ohio

In addition to hosting conventions and founding suffrage societies, women's rights activists infused the power of the press into the organizational capacity of the fledgling movement. Within the first few years of the women's rights movement, the topography of its rhetorical landscape emerged. Initially, women were obliged to argue that it was right and proper for

them to speak in public and their arguments were worthy of attention. Ever so slowly, Americans adjusted to the sight and sound of women engaged in public speech. Having staked a claim to the public podium, activists extended the reach of their voices via women's rights newspapers. Leaders of the women's movement understood the media's importance in advancing their cause, so they consistently sought positive coverage and did their best to counter negative press. Submitting news items and editorials and convincing journalists to cover their issues and events were critical steps in the effort to normalize women's presence in the public sphere. However, despite these efforts, leaders came to realize they could not rely on established media for consistent or positive coverage.

Reform leaders quickly recognized the benefits of having power over their own media. Not to be outdone, Ohio benefited from several women's newspapers. The *Genius of Liberty*, a monthly edited by Elizabeth A. Aldrich of Cincinnati and published between 1851 and 1853, was one of the first women's newspapers in the nation. Knowing consciousness-raising was the important first step of any social change, Aldrich used her newspaper to educate women about their own oppression: "Fire the mind of our sex with an energy and resolve that will mound with all daring and velocity to the very source of truth and right, then will a change come."[125] Like other reform newspapers, Aldrich's eight-page three-column monthly published a diverse range of opinion, including that of both supporters and opponents of women's rights.[126] Many readers and editors appreciated her efforts to explore multiple sides to every issue and her ability to balance piety with progressive reforms. Aldrich's impartial treatment of women's issues earned her praise. Philadelphia's *Banner of the Union* admired the newspaper for its "good logic and sound sense on important subjects." Even when Aldrich criticized the Masons for refusing to admit women, editors of the *Masonic Review* wrote that she "wields a ready and vigorous pen, her aims are high and she pushes her way toward the goal with a zeal that never tires and with an unfaltering faith that we hope may fully realize its most cherished desires."[127]

In Cincinnati, the Longley family published *Type of the Times*, a newspaper championing women's rights, abolition, and temperance.[128] Native Ohioans, Elias Longley was a reporter for the *Cincinnati Commercial* and the *Cincinnati Gazette* while Margaret Vater Longley worked as a typesetter, one of the few skilled jobs available to women in the newspaper business. Eventually, Vater Longley would serve as editor of the *Woman's*

Advocate magazine and as a reporter for a German-language newspaper, *Cincinnati Tägliche Abend-Post.*[129] She innovated the practice of typing with all ten fingers, and she published a training manual for the Remington typewriter that included feminist-themed phrases and sentences in the practice lessons—perhaps as her own small act of subversion. In her suffrage career, she was an executive committee member of the National Woman Suffrage Association, and she later served as vice president of the Ohio suffrage organization.[130] The Longleys eventually moved to California, where they continued to fight for women's suffrage.[131]

In Mount Vernon, Ohio, Jenks Bloomer and her husband, Dexter Bloomer, continued to publish a women's rights newspaper, the *Lily*. Jenks Bloomer, determined to hire a woman apprentice as typesetter, found local printers refused to train a woman.[132] By the following year, she was able to hire a woman typesetter, but doing so prompted a strike by the paper's male employees. Eventually the newspaper employed three women and two men, all hired from out of town. The Bloomers' success led to the proliferation of other women's rights publications, such as Paulina Kellogg Wright Davis's the *Una* originated in Providence, Rhode Island, and later, Anthony and Cady Stanton's New York–based *Revolution*.

Newspapers such as these played a variety of important roles in the women's rights movement. The feminist press deemed women's words and work newsworthy. Additionally, feminist publications offered an alternative to the all-too-often negative coverage of the movement generated by mainstream media. These publications also provided activists an opportunity literally to express their feminist politics on their own terms and in their own voices. Finally, reform newspapers created audiences for feminist dialogues, forging a sense of political identity that united women as activists.

Developing the Movement's Agenda

In addition to building the organizational capacity of the emerging women's movement and directly engaging the state's political process, Ohio's leaders played an important role in setting the primary agenda. From the movement's very beginning, differences of opinion divided reformers over whether to focus on suffrage alone or to seek a wider range of women's rights. Those who took the latter perspective also had different priorities

within their ranks. Most favored changes to married women's property rights. However, some took on more provocative issues such as dress reform and "free love." Ohio became the backdrop for all these controversies.

When Jenks Bloomer advanced dress reform, women had to decide whether it was worth the social stigma and ridicule to wear bloomers. The bloomer costume consisted of a knee-length dress worn over pantaloons. Stone, Cady Stanton, Anthony, and other movement leaders adopted the costume. Others eschewed the outfit, believing dress reform distracted attention from issues they deemed more important. Eventually, most of the movement's leaders abandoned the outfit. The story of dress reform is telling in that it reveals women of the mid-1800s were aware of how fashion confined and policed their bodies. It also exposes just how rigid gender roles were; if women were to do anything society considered masculine—be it wear trousers or vote, there would be a backlash. Thus, for many women, dress reform constituted an issue of personal liberty.

Ohio women also struggled with the decision of whether to support dress reform. It took courage to wear bloomers, especially in small towns. Yet twenty-seven-year-old Rosella Rice of Perrysville wrote in the *Ohio Cultivator,* "Every country girl ought to have at least two short dresses and panties to match, not to wear to church and make prudes stare, and vulgar boys 'whew!' and precise old maids blush, but to wear about home on washing days and muddy weather. . . . Just try it girls, and see how light and free and young you will feel, just as though you had always worn a long shroud till then."[133] In a letter to the editor, Barker Gage responded to criticisms lobbed at wearers of bloomers, and she called into question making "the whole battle-ground of the Woman's Rights Movement her dress. We must own ourselves under the law first, own our bodies, our earnings, our genius, and our consciences; then we will turn to the lesser matter of what shall be the garniture of the body."[134]

Even more controversial than dress reform was the issue of free love. Early reformers recognized that were a woman not granted power over her own body, then trusting her with political power would be highly unlikely. Those who favored creating space for women to explore their sexuality or to practice birth control were labeled *free lovers* or *sex-radicals.* The terms also meant an absence of legal ties, not promiscuity. An important part of the free love philosophy was support for easing legal restrictions and social stigma related to divorce. Sex radicals advocated the necessity of free-

dom from state regulation and church interference in personal relationships, preferring "free unions." The women's rights movement's inherent connections to other movements, such as abolition and temperance, were controversial enough. Association with the free love movement became the kiss of death.

By 1856, Ohio had become the center of free love agitation. The railroad connecting Sandusky, Zanesville, Springfield, and Cincinnati facilitated diffusion of sex radical ideas within the state. Some residents living in the Lake Erie community of Berlin Heights practiced free love. An itinerant lecturer and abolitionist named Francis Barry promoted Berlin Heights as an ideal location to establish a commune based on the free love philosophy. In October of that year, Barry convened a meeting of Socialists, drawing from six states and Canada, including both women and men. Those gathered decided to move forward with the plan to establish a community.[135]

Berlin Heights free lovers became fruit growers; operated a printing press, a gristmill, and a school; and attracted dozens of converts who dissolved their families and pooled economic resources to join the community. Locals reported that women wore short hair and bloomers. Many women were widows or wives who had run away from abusive husbands. Fearing negative publicity and licentiousness, locals expressed concern that unhappily married women would flock to their community. Authorities barred free lovers from sending their children to the local public school, police harassed them, and townspeople attempted to expel the group. Eventually, the free lovers were left alone by the townspeople, who came to see them as honest, hardworking businesspeople; however, many of the community members chose to relocate to Illinois, hoping for a warmer welcome.[136]

At the other end of the state, Thomas Nichols and Mary Gove Nichols moved to Cincinnati to create a utopian free love community of their own. At the time, Cincinnati was home to numerous reformers who welcomed the Nicholses. Thomas gave a lecture on free love at Cincinnati's Foster Hall. The couple eventually created an institute in Yellow Springs, Ohio, named Memnonia, which developed a reputation for free love. Horace Mann, the president of nearby Antioch College, led the opposition to the Nicholses, determined to run them out of town for what he perceived to be demoralization. Contrary to their reputation, Memnonia residents did

not lead a promiscuous life, and they only engaged in sex when partners mutually desired to conceive. The community eventually disbanded after many of its followers converted to Roman Catholicism.[137]

Report of the Select Committee

Most astoundingly, in 1857, Ohio women would come as close to obtaining the ballot as any woman could. Ever since it was established, the OWRA petitioned both houses of the state's general assembly every year for the right to vote. The association once again sent a petition to the Ohio legislature with 10,000 signatures. Allowed to address the state legislature, suffragists gathered at the statehouse and "pleaded for the right of woman to the fruit of her own genius, labor, or skill, and for the mother her right to be the joint guardian of her own offspring."[138] Senate and House members congratulated the women on their intelligent and passionate testimonials. A newly appointed special committee considered the petition and the testimony. At long last, Ohio's suffragists and their arguments were being taken seriously.

By the following year, the "Report of the Select Committee of the Ohio Senate, on Giving the Right of Suffrage to Females, 1858," an eight-page document written and signed by congressmen J. D. Cattell of Jefferson and Columbiana Counties and Herman Canfield of Medina and Lorain Counties, concluded, *"Resolved,* That the Judiciary Committee be instructed to report to the Senate, a bill to submit to the qualified electors at the next election for senators and representatives, an amendment to the Constitution whereby the elective franchise shall be extended to the cities of Ohio, without distinction of sex."[139] Men such as Chase, Cattell, and Canfield came to illustrate the important role men could play in the state's women's suffrage campaigns.

Despite the women's testimonials, the state senate defeated the bill with an equal number of nays as yeas.[140] No other state had come this close. If the legislature had passed this measure, Ohio would have had the distinction of being the first state in the union to grant women the vote, well before the territory of Wyoming did in 1869. Regardless of the excruciating loss, Ohio suffragists were heartened by the outcome, because they knew they were gaining momentum. In the span of one decade, the state legislature moved from a resounding defeat of women's rights to a

tie. Capitalizing on this momentum, movement leaders set their sights on party endorsements.

In addition to memorials and legislative testimony, suffragists addressed their opposition and engaged the state's political culture by seeking endorsements of political parties and candidates. Because of ties with abolition, reformers secured the initial support of the Free-Soil and Liberty Parties. Various political parties encouraged women to attend their state conventions. Women's attendance made conventions appear less partisan, because no one would expect a woman to run for office. Women retained their exalted position as moral superiors above the fray of dirty politics only if they remained nonpartisan. After the chaos the Free-Soil Party caused to state politics, and the eventual rise of the Republican and Democratic Parties, reformers continued to seek suffrage endorsements, but they had painfully little success doing so with any party.

As was so typical in the women's rights movement, it was one step forward and two steps back. Those who opposed expanding women's rights raised the volume of their naysaying. A variety of arguments circulated. One of the most common of these was that men represented wives, mothers, and daughters at the ballot box. Thus, women did not need the vote, as their political views were expressed by the men in their lives. Suffragists' counterarguments were based on proportionality. A man with a wife, a widowed mother, and unmarried sisters and daughters had the same one vote as a bachelor with no female relatives. They also argued that if one accepted the assumption men and women were different, then men could not represent women at the ballot box. If indeed they were more moral than men, women would be more likely to support humane legislation related to issues such as child labor and temperance.

Another common argument against enfranchising women was that they were already too overburdened by their domestic responsibilities to take on additional civic duties. The demands of housework and childrearing did not permit women time to understand fully the complexities of politics. Suffragists counterargued that there was no evidence showing large numbers of women did not have time to vote intelligently or that they would shirk their domestic duties to do so. They argued further that if women were up to date on the day's vital questions, they would be better companions to their husbands and better teachers for their sons. Suffragists regularly emphasized their acceptance and commitment to domestic duties, and they accentuated their roles as wives and mothers.[141]

Another concern was that voting would "unsex" women. People feared that if women adopted male behaviors such as voting, they would become manly. In debates and in the media, suffragists were often depicted as "unwomanly." Feminine women, it was argued, would not want the vote and they would not use it, while immodest, indelicate, troublesome women would. Thus, "the women's vote" would represent, disproportionately, unsexed women. Suffragists responded to this argument by accepting the premise that men and women were "naturally" different, emphasizing that enfranchisement was not what created these differences. Attempting to downplay this stereotype, many suffragists went to great pains to sound and appear extremely feminine and fashionable.[142]

Ohio's First Win—Married Women's Property Acts

Though the state's women did not win the ballot or make substantial headway on other key issues such as dress reform and free love, they did score one important legislative success prior to the Civil War. From the start of the movement, women's rights reformers pursued changes in the laws governing married women. Ohio leaders regularly raised this issue at their conventions and at state constitutional conventions, and they actively petitioned the state legislature.

Ohio's married women's property laws slowly changed to grant wives independent legal status. For decades, women's rights reformers sought to address legal disabilities that created an economic dependence of women on men and laws that erased married women's independent identities. The legal imbalance between husbands and wives meant married women could not own or dispose of property, make binding contracts, sue or be sued, take custody of children, or keep their own earnings, among many other legal limitations. The marriage contract obligated wives to provide domestic, sexual, childbearing, and childrearing labor. In her letter to the 1850 Salem convention, Elizabeth Wilson described the husband as "a licensed woman whipper," whose right to use force deprived wives of both dignity and liberty without due process of law.[143] One Ohio circuit court described married women's legal status thus: "Not only did her person belong to her husband, but all her property. She was as much a slave as though he had bought and paid for her and owned her absolutely, and all her belongings."[144]

Changes to Ohio laws initially came in response to the national economic turmoil of 1837. Timothy Walker, a prominent Cincinnati legal scholar who that year published the widely read text *Introduction to American Law*, described the legal relationship between husbands and wives as "a disgrace to any civilized nation."[145] Specifically, many people feared too many husbands were squandering and speculating with their wives' wealth in economically uncertain times, leaving families destitute. Walker supported codification of laws to address this problem. States started to pass debtor-protection laws, including those specifying wives' property could not be used to reconcile husbands' debts. In 1845, Ohio's laws changed, providing more protection for family assets, but they still denied women control over their own property.

In his annual address, Salmon P. Chase, then governor of Ohio, publicly endorsed the expansion of married women's rights. Following the governor's lead, and in keeping with similar laws recently passed in other states, the Ohio state legislature enacted more property rights for married women in 1857. The act forwarded three provisions. The first section stipulated, "no married man shall sell, dispose of, or in any manner part with, any personal property . . . without having first obtained the consent of this wife thereto." The second section provided, "If any married man shall violate the provisions of the foregoing section, his wife, may, in her own name, commence and prosecute to final judgment and execution, in civic action, for the recovery of such property or its value in money." The third section guaranteed, "Any married women, whose husband shall desert her, or from intemperance or other cause become incapacitated, or neglect to provide for his family, may, in her own, name, make contracts for her own labor and the labor of her minor children, and in her own name, sue for and collect her own or their earnings."[146] However, these changes still did little to give wives direct control of their own property or to recognize them as legally autonomous.

Persistent Ohio leaders continued the struggle to expand the economic rights of married women. Conant Cutler had a deep understanding of the intersection between class and gender both at the intellectual level and through lived experience. Conant Cutler's first husband died of pneumonia and wounds sustained after a mob attacked him for assisting fugitive slaves.[147] To support her family as a widow, she wrote for Ohio newspapers and taught school. Her career extended to book publishing, including two feminist books: *Woman as She Was, Is, and Should Be*, in 1846,

and *Philipia; or, a Woman's Question,* in 1886. A single working mother before that phrase came into the public lexicon, Conant Cutler knew how precarious the lives of women were within the current economic system. In an 1853 letter published in the suffrage newspaper *Una,* she wrote, "Women's interests are not safe in the hands of men, notwithstanding the gallantry so often posted," and she described the economic conditions in which women lived as "legal robbery." The issue was a matter of survival but also of trust. Conant Cutler argued that women should be fully entrusted with financial decision-making within marriage.

Hitchcock Jones also took on the cause of married women's property rights and custodial rights in Ohio. She, too, had a well-developed understanding of the implications of women's economic dependence on men. Once, in an article published in a Delaware, Ohio, newspaper, titled "Do Not Marry Young," she advised young women not to marry until later in life, as she had done, so that they could establish careers first and thus experience some measure of independence.[148] In a *Cleveland Daily Leader* editorial, she urged: "That which the wife earns by separate business shall be secure against the husband's creditors; that there shall be joint proprietorship of the common estate; and that the mother shall be constituted a joint guardian with the father, of their children with equal rights, powers, and duties.[149]

In 1861, Conant Cutler and Hitchcock Jones, along with Barker Gage, testified in front of a joint Ohio legislative session in support of married women's property law reform, including the right of a wife to keep her own earnings and to hold joint guardianship of her children. Conant Cutler argued that even an independent businesswoman could be left destitute if her property were taken by her husband's or brother's debt collectors. When a husband became ill or had no job prospects, his wife stepped in as best she could to secure the family's finances. Yet, after his death, she would find herself propertyless.[150]

In her address, Hitchcock Jones reversed the roles of man and woman, asking the legislators to imagine themselves with the legal rights of a woman recently married: "The ceremony is completed, and your identity is lost in the person of your wife. . . . Before that event you received a fair day's wages for a fair day's work, but now . . . [t]he wages are not yours— they belong to your wife. . . . You are entitled simply to food and clothing."[151] Her speech was so well received that the legislature requested permission to publish it "for the benefit of the General Assembly, and for the advantage of the cause which you wish to promote."[152]

The state's women's rights reformers flooded the Ohio legislature with petitions. The combination of petitions, effective organizing, and influential speeches motivated legislators to pass a more extensive married women's property bill. After the loss at the state constitutional convention and the rejection of Seymour Severance's suffrage memorial to the legislature, Ohio women's rights advocates finally celebrated an important win. After this success, Conant Cutler and Barker Gage championed a married women's property bill in Illinois in 1860.[153]

Women's rights reformers in Ohio, and indeed most states, gained few legislative or judicial successes by the start of the Civil War. Nevertheless, the state's leaders increased awareness of women's oppression and gender injustices, clarified the general mission and agenda of the movement, built its organizational capacity, and engaged the state's political process. For an independent women's movement to coalesce, it became necessary to transition from male reform leadership to female. Historians traditionally focus on a handful of leaders such as Elizabeth Cady Stanton, Susan B. Anthony, and Lucy Stone, from the first generation of activists, or Anna Howard Shaw, Carrie Chapman Catt, and Alice Paul, from the second generation. However, concentrating on such a small group inaccurately limits understanding of just how monumental were the tasks facing suffragists. Other pioneering women, including ingenious and indefatigable women of Ohio, rose to this challenge. Thanks to the perseverance of women such as Betsey Mix Cowles, Frances Barker Gage, Hannah Conant Tracy Cutler, Elizabeth Hitchcock Jones, and Caroline Seymour Severance, the cause of women's rights not only gained a foothold in Ohio, but it also paved the way for the movement to take hold, inspiring other women across the nation to join.

The number of citizens and legislators taking women orators more seriously increased. A feminist press emerged, and mainstream newspapers were becoming less hostile to the movement. Women gained experience with the ways of the legislature, and married women fared better than they had during the previous decade. Somehow scattered groups of women who had meager resources and who were constrained by the limits placed on their gender would create a political force capable of creating and maintaining a social movement over the course of seven decades. Activism prior to the Civil War was not in vain. Ohioans were, and would continue to be, on the vanguard of that movement.

★ CHAPTER TWO ★ ★

The Ohio Women's Rights Movement during Reconstruction

The Women of the Country Will Be Heard

The US Civil War was one of the most important events in the nation's history, and its repercussions still reverberate today. The trauma of human lives lost devasted both families and the social psyche, the economic costs nearly were incalculable, and the effects of fundamental changes made to the system of government influence the polity over one-hundred-fifty years later. Navigating state and national debates about women's rights within the aftermath of the Civil War and the ideological turbulence of Reconstruction would prove no easy task, but Ohioans once again rose to the challenge. Ohio's importance, both political and military, to the Union victory of the Civil War is well established, but women's vital contribution to that victory is seldom acknowledged. While a few women operated as spies or pretended to be men so they could fight on the front lines, most often, women's contributions took the form of medical aid or supply distribution. As a supplement to the federal government's aid to Union soldiers during the Civil War, the US Sanitary Commission (USSC) began helping the sick and injured in 1861. From large cities to small towns, Ohio's women leaders stood to the fore. Just five days after the firing on Fort Sumter, a small group of Ohio women formed the Ladies Aid Society in Cleveland, the first such organization in the nation.[1] Rebecca Cromwell Rouse, a well-established local leader of the temperance movement and of charities supporting the poor and orphaned, served as president of the organization. Apparently, Cromwell Rouse was able to balance the demands of the job with social expectations of femininity. In *Woman's Work in the*

Civil War: A Record of Heroism, Patriotism and Patience, authors Linus P. Brockett and Mary C. Vaughan described Cromwell Rouse as "earnestly patriotic, and ready to do all in her power for her country, there is nothing masculine, or as the phrase goes, 'strong-minded' in her demeanor."[2] Her Ladies Aid Society merged with other local charities to create the Soldiers' Aid Society of Northern Ohio, the precursor to the American Red Cross of Cleveland.

Frances Barker Gage continued to provide leadership at this critical juncture in the nation's history. In 1862, she traveled south from Ohio to support soldiers in Virginia, Mississippi, Tennessee, and Florida. She eventually became superintendent of a refuge for over 500 freed slaves on Parris Island in South Carolina. There, she met and mentored Clara Barton, beginning a lifelong friendship. When she returned to the North, she began a lecture tour to build confidence in the Emancipation Proclamation and share her experiences living and working among the freedmen. Touring Illinois, Pennsylvania, New York, Missouri, and Ohio, she donated all her proceeds to soldiers' aid societies and to freedmen's associations. Another noteworthy leader of the Soldiers' Aid Society of Northern Ohio, Lizzie Farr of Norwalk, originated Alert Clubs. The original club comprised young girls who raised money to purchase materials for soldiers' uniforms. Over time, adult Alert Clubs spread throughout the North. Members canvassed neighborhoods for donations, sewed slippers and quilts to donate to hospitals, and hosted various fundraisers.[3]

After the Civil War, Annie Dean proudly recalled her work and that of other Amesville, Ohio, women as members of an aid society: "I am glad there is to be a History of the Sanitary Commission prepared, that the generations to come, may know how thoroughly in earnest [we worked to] preserve our national unity." According to Dean's recounting, Amesville women donated cash, dried fruit, apple butter, beans, and sauerkraut to the Cincinnati Branch of the USSC in the fall of 1862. Dean also remembered how existing gender expectations limited how women of her generation could contribute to the war. Reflecting on her contemporaries in Amesville, she wrote, "The laws of the land, and their own feelings prevented their entering into the struggle now going on—but knowing that to comfort and cheer—was their legitimate sphere—they concluded that they could render the most efficient service by working for those who are so nobly standing—as a living wall between 'Their loved homes, and war's desolation.'"[4]

As the war progressed and casualties rose, not all Ohioans supported Union victory as devoutly as Dean and her associates. One woman living in Salk Creek, Wayne County, published a letter in the *Wooster Republican* illustrating that relief work was not always a welcoming and rewarding experience. Her letter told the story of a difficult exchange that occurred when she "asked the lady to lend us a helping hand in trying to sustain our Aid Society, but instead of giving to the soldiers she cursed them and said (using her own language) 'that she would rather give her stores to the dogs than give to a Union soldier.'" She concluded the letter: "Hoping that the cloud of rebellion which still hangs over us, may be dispersed and traitors North and South may receive a just reward, I close, by wishing health and success to our armies, and confusion to every traitor in existence."[5]

Relief work certainly was in keeping with stereotypical expectations of women's self-sacrifice and nurturance. Nevertheless, this type of work constituted more than a matter of feminine benevolence; it helped to win the war for the Union. Northerners, able to derive resources from a diversified economy, sustained their campaign of support for soldiers and managed the logistics of supply distribution in a way that Southerners, dependent almost entirely on the cotton industry, could not. The ability of Northern women to outlast Southern women in the acquisition and distribution of much-needed aid and supplies to the front lines and to hospitals helped the Union win the Civil War.

Furthermore, USSC work also proved women's mettle and provided a memorable example of how women could function as patriotic and capable citizens in the public sphere. The leadership, organizational, and fundraising skills developed through USSC work served women's rights activists well as they returned to the movement after the war.[6] Leveraging their practical experience, some relief workers also found entry into the paid workforce, and many went on to become women's rights reformers.

Perhaps because of the USSC's success, Elizabeth Cady Stanton believed it would be an effective tactical move if activists were to discontinue their women's rights work to support the war effort. She saw the potential in using the Civil War as an opportunity to expand the movement's following and to showcase its political goals. She believed that harnessing the patriotism of Northern women would go far in changing perceptions of women's proper sphere. Instead of defining patriotism as defending a prewar way of life, some leaders saw a chance to create a

new, more democratic society rooted in the principle of human equality. Instead of a vision of patriotism built on women's identities as wives and mothers, it also would be based on women's work as productive citizens.[7]

Susan B. Anthony did not concur with her friend's view of the ballot as a reward for patriotism. Arguing to the contrary, she believed they should continue their struggle for the ballot undaunted. Almost all other women's rights leaders took Cady Stanton's side in this argument, spending their energies on the important work of ending slavery and rebuilding the nation. Anthony had little choice but to stand down, and while women continued to contemplate and converse about their own enfranchisement, the active pursuit of most women's rights largely ground to a halt. Eventually, Anthony came around to Cady Stanton's position, and the two leaders organized the Women's National Loyal League (WNLL)— one of the first national women's organizations—in 1863 for the purpose of supporting an amendment to the US Constitution abolishing slavery. Impressively, members collected four hundred thousand signatures during their petition drive to support the Thirteenth Amendment. Regrettably, the WNLL comprised mostly middle-class white women, who failed to include African Americans in their new definition of patriotism.

In response to Cady Stanton and Anthony's initial call, the WNLL received enthusiastic responses from organizations such as the Ladies' Union League of Richwood, Ohio, and Ohio's Hannah Conant Tracy Cutler and Josephine White Griffing began working as paid agents for the WNLL the year of its founding.[8] Born in Connecticut in 1814, White Griffing moved with her husband to Litchfield, Ohio, in 1842. After attending the Salem convention in 1850, she quickly converted to the cause of women's rights, and she soon joined forces with other leaders, among them Lucretia Coffin Mott, Abby Kelley Foster, Lucy Stone, and Susan B. Anthony. In 1853, she was a founding member of the Ohio Women's Rights Association, and she eventually became its president.[9]

White Griffing was a leading figure in the antislavery cause, becoming a paid agent of the Western Anti-Slavery Society in the 1850s and making her home a station on the Underground Railroad. After working as a WNLL agent, she moved to Washington, DC, where she became the general agent of the National Freedman's Relief Association of the District of Columbia. One of her most significant life accomplishments was lobbying successfully to create the federal Freedmen's Bureau. She focused her attention on employment for freedmen in Northern cities.

She received support from President Lincoln to serve as the bureau's first commissioner, only to have the job given to a man. Despite this offense, she worked tirelessly to collect and distribute relief aid to thousands of former slaves, often appealing to women's aid organizations and churches in the North. While living in Washington, DC, she helped find homes for more than seventy-five hundred freed people and developed employment opportunities for them. Her work also supported soup kitchens and industrial schools that educated women and children.[10]

White Griffing traveled widely to support both abolition and women's rights. She rose to national prominence lecturing and writing on both issues. She participated actively in conventions, and she addressed the Senate Judiciary Committee in 1871. When the women's movement later split in two after the Civil War over the Fifteenth Amendment, White Griffing was among those who worked hard to mend the rift. During the national debate over the Fourteenth Amendment, White Griffing worked alongside Cady Stanton and Anthony to keep the word *male* out of the Constitution.[11] In a letter to Cady Stanton, White Griffing wrote, "Make Congress understand that the women of the country will be heard, during every session of Congress. . . . O! How I see the want for regulation in national affairs, that can never be accomplished, while [government] is administered on the *male* basis of representation."[12] However, she later joined the minority of women demanding African American rights and women's rights simultaneously, rather than supporting enfranchisement of only African American men. Many years would pass before the relationships among these women could be repaired.

Like USSC members, WNLL women such as Conant Cutler and White Griffing gained experience related to public speaking, petitioning, and organizing that later proved invaluable to the women's rights movement. In fact, the WNLL would later provide the model for the organizational structure of the National Woman Suffrage Association (NWSA). Civil War organizations such as the USSC and WNLL served as the foundation on which the organizational capacity of the women's movement would be rebuilt. Just as the nation had to rebuild itself after the Civil War, so did the women's movement. The Union preserved and slavery outlawed by the Thirteenth Amendment, the women's movement could not, realistically, simply pick up where it left off before the Civil War. The war completely altered the political context for social reforms, and much of the momentum for women's rights created before the war was lost. Most

Americans turned their attention to issues of daily survival, Reconstruction, and race relations. Little time or energy was left to contemplate the complexities of women's rights.

If the movement was to be resuscitated, the organizational capacity of the movement would have to change in significant ways. Building on the USSC and WNLL, leaders envisioned a move toward national organizations such as the American Equal Rights Association (AERA). However, state women's rights organizations would continue to play a vital role in the movement. Connections to the temperance movement strengthened as ties to abolition weakened, but not without serious, long-term complications. Ohio was the stage on which these dramas unfolded.

During Reconstruction, Ohio also continued to provide leadership at both the state and national levels. The state's reformers recommitted to their pursuit of a varied agenda relating to women's education, professional opportunities, and, of course, the ballot. Eventually, leaders would focus attention primarily on enfranchisement, transforming the women's rights movement into the women's suffrage movement. Staging lecture tours, petitioning, providing legislative testimony, and seeking key political endorsements remained mainstays for the movement. Three primary strategies to gain enfranchisement emerged during Reconstruction: opposing the addition of the word *male* to the Fourteenth Amendment, casting ballots (claiming that the newly passed Fourteenth Amendment permitted women to do so legally), and petitioning for a separate amendment to the US Constitution bestowing the vote on women.

Ohio and the Reconstruction Amendments

Though freedom did not lead to equality for millions of enslaved people, the Civil War commenced an intense constitutional debate about the struggle for political rights that, in many ways, came to define the nation. Women's rights leaders saw this as a prime opportunity to advance their agenda. Against the backdrop of the Reconstruction amendments—Thirteenth, Fourteenth, and Fifteenth—suffragists and abolitionists, many of whom were one and the same, formulated and disseminated a fully developed philosophy of universal rights, seeking to secure justice for *all*. These activists offered a different approach to Reconstruction—one grounded in universal human rights, which sought to focus Reconstruction debates on

fundamental questions related to human equality. They envisioned a country where rights were not based on race or sex. Instead, these supporters believed the foundation on which the nation should be reconstructed was its shared humanity.[13] These visionaries equated emancipation with equal rights, and they expected to extend those rights across race and gender lines. This philosophy proved far more expansive than that of many political leaders tasked with amending the US Constitution in the years after the war. Over time, some of these reformers would maintain an unwavering pursuit of universal rights, while pragmatic others recognized a series of compromises might be the most expedient way to secure those rights.

Ohioans played a key role in formulating the Thirteenth and Fourteenth Amendments. During the Civil War, US congressman James Ashley of Ohio was the first representative to call for an amendment to the US Constitution that would outlaw slavery. His initial idea formed the basis of the Thirteenth Amendment.[14] By the end of the war, most Ohioans supported this amendment, and in 1865, both houses of the general assembly ratified it with significant majorities. Dozens of versions of the Fourteenth Amendment were drafted and rejected before legislators turned to a proposal offered by Representative John A. Bingham of Ohio. Though the US House ultimately rejected his version of the bill, Bingham became the primary author of the equal protection clause.[15]

Many Ohioans also initially approved of the Fourteenth Amendment—particularly members of the Union Party, a group of Ohio's Republican Party, and prowar Democrats. Former Peace Democrats objected. After the Thirteenth Amendment passed the general assembly, radical Republicans in Ohio increased pressure on party leaders to support political rights for African Americans. Fearful of alienating a large portion of its voters, that leadership refused. At the other end of the political spectrum, Democrats unapologetically pronounced their opposition to African American suffrage. They gained control of the general assembly, which led to an attempt by the Ohio legislature to revoke the state's endorsement of the Fourteenth Amendment. Only the Ohio Supreme Court prevented the enactment of a new law to disenfranchise anyone of African American ancestry, and the US secretary of state deemed the withdrawals illegitimate.[16]

When the Fifteenth Amendment—prohibiting disenfranchisement on the basis of race, color, or previous condition of servitude—was submitted to the states, Ohio's legislature rejected it. Following modest Republican

gains in the next election cycle, the amendment passed the legislature by just two votes in the House of Representatives and a single vote in the Senate. Disturbingly, the state did not remove the word *white* from the voting qualifications listed in the state constitution until the twentieth century.[17]

Across the North, legislators wrestled with the explosive issue of enfranchising freedmen as a potential means of reuniting the country peacefully. In Ohio, many Republicans believed that Reconstruction required African American suffrage.[18] Some state legislators supported universal rights. In 1867, Henry C. Houston of Clark County submitted to the legislature a joint resolution for universal suffrage, but it was tabled and died on the floor. Three months later, Elias H. Gaston of Butler County attempted to kill a resolution supporting African American men's suffrage by proposing the word *male* be stricken, and the words *or she* to appear after "he," pandering to sexist legislators. The final vote in the state general assembly was thirty-six yeas to fifty-three nays, leaving the ballot far out of reach.[19]

Women's Rights and the Reconstruction Amendments

Early drafts of the Fourteenth Amendment introduced the word *male* into the US Constitution for the first time. This wording created two incredibly complex challenges for the women's movement. First, gendering the US Constitution in this manner gave tacit legitimacy to discrimination based on sex. Now well into the second decade of the women's rights movement, people could no longer pretend, as the founders had, that "we the people" meant "men." Women would be either implicitly included in the US Constitution or explicitly excluded. Linguistic confusion plagued the cause. Even the terms *universal suffrage* and *universal rights* were used to refer only to men in some instances and to all humankind in others. Using the word *male* to define a citizen raised the legal question of whether women were even citizens.[20]

Second, suffragists presumed—as most Americans did at the time—that the US Constitution gave states the power to establish the electorate. Suffragists assumed the fight for the ballot would be won or lost at the state level for this reason, and they had not anticipated an epic battle over the US Constitution. Although states did not consider women as voters, in 1865, there was no constitutional barrier for state-granted suffrage. Inserting the word *male* in the US Constitution meant that situation would

change fundamentally. Women would no longer be able claim that state constitutions limiting suffrage to men violated the US Constitution.

The same year the US Congress passed the Fourteenth Amendment, 1866, suffragists presented petitions bearing ten thousand signatures on behalf of an amendment prohibiting disenfranchisement based on sex. Anthony and Cady Stanton led the fight to prevent the gendering of the US Constitution, but that strategy failed. After states ratified the Fourteenth Amendment in 1868, the word *male* appeared three times in its text.[21]

In response to the Fourteenth and Fifteenth Amendment debates, women's rights reformers reached out to abolitionists hoping to create a united front on behalf of universal rights. The core mission of antislavery societies achieved, redirecting the expertise and energy of these activists toward other social reforms was a strategic move. In 1866, at the close of the Eleventh National Woman's Rights Convention, Coffin Mott, Frederick Douglass, Anthony, and Cady Stanton formed the AERA, pledging to achieve suffrage for all women and all African Americans. The membership elected Coffin Mott as president, and Ohio's White Griffing as first vice president.

The infrastructure of the women's movement took a dramatically new form, one of a distinctively national stature. The AERA essentially became the first national organization to call for women's suffrage, its mission "to secure Equal Rights to all American citizens, especially the right of suffrage, irrespective of race, color or sex."[22] The AERA met for the first time in 1867. Its members saw universal suffrage as the promise of a new day. They found purpose in the often-quoted resolution, "the ballot, alike to the woman and the negro, means bread, education, intelligence, self-protection, self-reliance, and self-respect."[23] Local AERA groups quickly formed across the United States, including in Ohio.

Though AERA members shared a commitment to universal rights, differences of opinion about priorities challenged the organization. Debates over whether to push for universal rights or to prioritize either African American or women's suffrage were particularly divisive. A deep rift among those who once had common cause emerged. These differences of opinion were complex and nuanced, and they did not fall neatly along racial or gender lines. Ohio's Frances Barker Gage did her best to emphasize the importance of pressing for universal rights by highlighting the twin injustices facing African American women and by arguing they needed political rights to protect themselves from both racism and sexism. Historian El-

len Carol Dubois explains, "More than any other white leader of the Equal Rights Association, she [Barker Gage] was immersed in the life of the black community."[24] Barker Gage announced her commitment to the "cause of woman, without regard to color" in a letter to the editor of the *Standard,* and she reached out to African American women promoting the cause.[25]

In a climate of fear over the citizenship and rights of freedmen and immigrants, AERA rhetoric continued to spotlight the plight of African American women and the false choice between enfranchisement of African American and of white women. The rhetorical substance of the women's rights movement took the form of a direct comparison between slavery and women's oppression. Women's rights reformers had infused this analogy into the movement's rhetoric years before, but the language of bondage and emancipation became all the more powerful after the Civil War.[26] Deep inconsistencies emerged even as white women's rights reformers increasingly argued African American and white women could only be emancipated by full citizenship and voting rights. More often than not, white suffrage leadership's devotion to African American women's rights presented itself as more word than deed. Some white reformers opportunistically embraced a racist ideology that reinforced rather than challenged social hierarchies.[27] Use of the woman-as-slave analogy became increasingly sensationalistic, eventually degenerating into outright racist discourse.[28]

Many women's rights reformers were deeply hurt by what they perceived to be abandonment by some of their oldest allies. Barker Gage joined other movement leaders in blaming old abolitionist friends such as Wendall Phillips for not standing firmly by their sides: "When they were a weak party and needed all the womanly strength of the nation to help them on, they always united with the words 'without regard to sex, race, or color?' Who ever hears of sex now from any of these champions of freedom?"[29] She also bemoaned, "in those early days the sons of Adam crowded our platform . . . but of late years we invite those whose presence we desire. Finding it equally difficult to secure the services of those we deem worthy to advocate our cause, and to repress those whose best service would be silence, we ofttimes find ourselves quite deserted by the 'stronger sex' when most needed."[30] Ironically, as the United States began the arduous process of stitching back together a war-torn nation during Reconstruction, members of the suffrage and abolitionist movements stood precariously at the edge of a great chasm of their own making. After

it became clear that an effort to merge the women's movement and the American Anti-Slavery Society would fail, and hope for universal rights was exhausted, the AERA's future was bleak.

As debates regarding the Fifteenth Amendment ensued, women's rights reformers once again faced a dilemma, both moral and strategic: should they oppose enfranchisement of freedmen in order to argue for those of all women? As the US Congress debated the amendment, the mutual support of African American men's suffrage and women's suffrage became undone, resulting in further antagonism and a deepening schism within the women's rights movement. Most AERA members supported the Fifteenth Amendment, but Anthony and Cady Stanton opposed the amendment unless it was accompanied by a Sixteenth Amendment guaranteeing suffrage for women. Otherwise, they feared, the Fifteenth Amendment would create an "aristocracy of sex" by giving constitutional authority to the belief that men were superior.[31]

In 1867, Cady Stanton and Anthony made a lecture tour agitating and recruiting through the Midwest. They found exuberant audiences in Ohio. Dayton hosted a mass meeting of suffragists. An attendee named Sallie Joy described the gathering: "The west is evidently wide awake on the suffrage question. The people are working with zeal almost unknown in the East. . . . The two-day convention at Dayton was freighted with interest. Earnest women were there from all parts of the State." Whenever national leaders came to Ohio, as Sarah Langdon Williams, a local journalist who wrote a weekly column about women's rights for Toledo's *Sunday Journal,* expressed, "it was like the match to the fire all ready for kindling . . . the air seemed magnetized with reform ideas."[32]

Cady Stanton and Anthony found Ohio's women eager to take on the cause and open to the immediate demand for a constitutional amendment enfranchising them. However, most of the state's women were not willing to oppose an amendment that might enfranchise African American men first. Barker Gage wrote in the *Woman's Advocate,* "Keeping [African American men] out, suffering as now, would not let me in all the sooner, then in God's name why stand in the way?"[33] Ohio women also were not enamored with Cady Stanton's and Anthony's anti-Republicanism nor by what they considered Anthony's militant position on the need to reform divorce laws. In response to midwestern women's reactions, Cady Stanton and Anthony quit their attack on the Fifteenth Amendment, instead focusing on a Sixteenth Amendment enfranchising women.

Cady Stanton and Anthony called for a convention of the AERA. Stanton kicked off the convention with a rousing speech calling for support of a Sixteenth Amendment that would grant women the ballot. Exhausted and embittered, her discourse became increasingly racist. She and Douglass had a heart-wrenching and ugly public exchange about who needed the vote more desperately, women or freedmen. The convention ended as a painful divorce. Cady Stanton and Anthony led a walkout to form a new organization focused solely on women's suffrage. Ohioan Margaret Vater Longley left the convention dismayed, reporting that midwestern suffragists were frustrated because they had "supposed that they were going to a women's rights meeting . . . and that equal rights meant the equal rights of women with men."[34]

The Fifteenth Amendment, ratified in 1870, enfranchised African American men, a measure of justice too long deferred. Yet, American women of all races still languished without the most basic expression of citizenship, and the work in front of them seemed as onerous as ever. Just months after the Fifteenth Amendment passed through the US Congress in 1869, both the NWSA and the American Woman's Suffrage Association (AWSA) launched, forever changing the infrastructure of the women's movement.

In a watershed moment, the split in the women's rights movement resulted in two rival national organizations, each pursuing its own goals, strategies, tactics, and policies. A volley of recriminations worsened the great schism, making it difficult, if not impossible, for the movement's two wings to continue productive work together. Delegates from nineteen states appointed Cady Stanton as the NWSA's first president. Headquartered in New York, the NWSA concentrated its efforts on the passage of a constitutional amendment providing the ballot to women. Considered the more radical group, the NWSA promoted a broad spectrum of women's rights beyond suffrage—including equal pay, divorce, and birth control—and it excluded men from leadership positions. The NWSA published the *Revolution,* one of the most important feminist newspapers of the time.

Not to be outdone by the NWSA, Stone and Antoinette Brown Blackwell joined other prominent advocates, such as Julia Ward Howe, Mary Livermore, Henry Ward Beecher, and others in Cleveland, Ohio, for the AWSA founding convention. Meeting in Case Hall, delegates devoted the convention to forming the organization rather than planning specific strategies and tactics. Ninety-four delegates representing twenty-one states wrote

a constitution, approved bylaws, and elected officers, including Thomas Wentworth Higginson as chair of the convention. Still believing men could serve as allies, the AWSA allowed them to be members and to hold leadership positions. Not everyone attending the convention supported this decision. From the floor, Olivia Hall, a Toledo suffragist, protested the appointment of a man as the organization's first president. Higginson won the vote anyway, and he declared in his opening remarks:

> It is eminently fit and proper that this Convention should select for its place of meeting the great State of Ohio, which takes the lead in the woman suffrage movement, as well as in other good things. It was the first to organize a State Woman Suffrage Association, and the first in which a committee of the Legislature recommended extending to woman the right of suffrage. It is befitting, then, that this Convention should desire Ohio as the steppingstone from which an American Suffrage Association shall rise into existence.[35]

Much to everyone's surprise, Anthony attended the AWSA founding meeting. When an associate from Chicago asked that she be honored with a seat on the platform, Higginson "hesitated, stumbled in speech, and it was fully three minutes before he could utter the name of Susan and invite her to the place of honor." When Anthony took the platform, the audience welcomed her with loud applause. Not only did she attend the first convention sponsored by the rival organization, but she also accepted an invitation to speak at the close of its final session. In her speech, she urged those present to pursue a Sixteenth Amendment for women's franchise.[36]

Based in Massachusetts, the AWSA was the more conservative of the two groups and thus grew its membership faster than the NWSA did. Members fought first for universal suffrage, but they eventually accepted African American men's suffrage as the priority. The organization maintained close ties with both the Republican Party and friends who had previously been abolitionists. The AWSA focused efforts on state referenda campaigns for women's suffrage while supporting the Fifteenth Amendment. Taking a more grassroots approach, members traveled all over the country establishing local and state suffrage organizations, lecturing, distributing literature, seeking media attention, and publishing their own reform newspaper, the *Woman's Journal*. The AWSA also was willing to consider smaller-scale efforts, such as school or municipal suffrage.

The women's rights movement that had for so many years resisted the idea of creating a national organization ironically now found itself with not one, but two. The focus on a federal amendment and the need for more coordinated battles convinced reformers of the practicality of a national office, even if the rank and file would have preferred one organization. For twenty years, residual bitterness fed the schism between the two organizations. The relationship between the national organizations and the state or local organizations was complicated from the start. Many midwestern women, disgruntled by their failed attempts at suffrage through state legislatures and constitutional conventions, took leadership positions in the national organizations, though many states still preferred their independence. State organizations depended on the coordinating power, guidance, and financial support of the national organizations. Most suffragists at the state level were frustrated by the infighting between the NWSA and the AWSA, and many individual suffragists tried to negotiate a relationship with both organizations simultaneously.[37] Most Reconstruction-era suffragists avoided the partisanship that characterized rivalry between the two national organizations.

Ohio was no exception. It should be noted that Ohio suffragists tended to favor the AWSA, and most chose only to speak at AWSA conventions, thus reflecting the conservative leanings of the state.[38] Many local organizations took root in the late 1860s, including those in Cuyahoga County, Cincinnati, and Toledo. The Toledo chapter, founded by Rosa Klinge Segur, eventually would earn the distinction of being the longest-lasting women's rights group in the state, holding regular meetings over the course of fifty years.[39] Most local organizations would merge with the state association to work on both the federal and state constitutional amendments as well as other women's issues, such as child custody and property rights.

While debates over the Reconstruction amendments divided the nation, the work of individual women's rights mavericks forged ahead. Complementing the efforts of the state and national organizations, one-woman campaigns took the lyceum circuit by storm. The lyceum circuit proved to be an important part of the women's rights movement infrastructure. The US lyceum began in the 1820s in New England as a nonprofit, local, civic institution aimed at self-improvement. Members of local communities provided educational speeches for free. However, the lyceum, commercialized by the late 1840s and 1850s, eventually offered

economic incentives to speakers. Before the Civil War, few women pursued paid lecturing. Afterward, however, women worried about economic survival, and they often were compelled to find means of financial support for themselves and their families. The lyceum provided a viable employment option. Its changing nature and growth benefited women orators and the cause of suffrage alike. Often, women orators would use the topic of suffrage as a springboard for their careers. By the end of the 1860s, the sheer number of people speaking about women's rights was so impressive that the *Dayton Women's Advocate* published a list featuring no fewer than 105 speakers' names.[40] When the lyceum's popularity decreased during the 1880s, one outcome was a decline in the vibrancy of suffrage oratory. During Reconstruction, these one-woman campaigns had done more to energize the cause than the increasing tensions among women's rights organizations.[41]

State and Federal Women's Suffrage Measures during Reconstruction

As would be expected, the organizational capacity and agenda of the women's movement changed after the Civil War, but activists' determination to engage the political process did not. Over twenty years of women's rights activism finally resulted in a women's suffrage measure at the federal level. In 1866, US senator Edward Cowan of Pennsylvania introduced a suffrage amendment for the women of Washington, DC. Debate on the floor lasted three days; the final vote was nine yeas and thirty-seven nays. Benjamin Wade, a senator from Ohio, went on the record as wanting women's suffrage as much as he did African American men's suffrage.[42] He wrote an emphatic letter to Susan B. Anthony: "I am now and ever have been the advocate of equal and impartial suffrage for all citizens of the United States . . . without any distinction on account of race, color, or sex."[43] The US House considered a similar question, also resulting in a defeat.

At the state level, prior to the outbreak of the Civil War, the Territory of Washington narrowly defeated a women's suffrage measure, in 1854, by one vote. After the war, Nebraska, became the first state to hold a referendum vote on the topic. The measure failed in 1867, as did a similar one in the Dakota Territory. But all was not lost. By the end of that year, the Territory of Wyoming granted women's suffrage, and the Utah Territory

did so the following year.[44] From this point forward, a steady stream of state referenda on women's suffrage flowed from one state after another, including Ohio.

Upcoming elections spurred Robert Gordon, a representative from Auglaize County, to propose a resolution striking out the word *male* from the Ohio State Constitution, stipulating that "in all precincts in the State, there shall be a separate poll, at which all white women over 21 years of age shall be permitted to vote, and if the votes cast be a majority of all the white women, the constitution shall be amended." The Cincinnati Equal Rights Association, founded the year before, debated the merits of this resolution. Some members supported the resolution while others believed the wording was problematic because it implied twenty-one-year-old white women would decide the vote rather than all voters. Fearing that enough white women of that age would not support the measure, and a loss would stall the movement for years to come, members of the association unanimously agreed to share their concerns with Gordon, politely requesting he reword his resolution.[45]

The state assembly began consideration of HJR 101 in January 1869. Legislators offered amendments, and they tabled the measure off and on for three months. Supporters invited Stone to address the House on the question of women's suffrage, and she accepted the invitation. The *Journal of the House of Representatives of the State of Ohio* detailed her visit: "After thanking the House for its kindness, she delivered an elaborate and a lengthy Address on behalf of her sex and in favor of female suffrage."[46] The journal did not include the text of her speech, and no vote was taken afterward.

In March, Ohio's Miriam Cole, an important suffrage leader in the state, also was invited to address the House on behalf of Proposition 101. A friend of Stone and Brown Blackwell, Cole was the editor of the *Woman's Advocate* before it was absorbed into the AWSA's *Woman's Journal* in 1870. She also later served as president of a statewide suffrage organization.[47] Cole's speech was described in the House records as "an eloquent and stirring Address on behalf of her sex, and in favor of female suffrage," though the records did not include the text of her speech.[48]

The persuasive power of Stone and Cole was insufficient to sway the state legislature. The vote for Proposition 101 resulted in twenty-two yeas and fifty-nine nays, another painful defeat for Ohio suffragists.[49] After

building momentum so successfully before the Civil War, the repeated failures of men in the state and federal legislators to recognize the injustice of denying women the ballot must have been exasperating beyond description. Yet, suffragists found within themselves the endurance to persist.

Refusing to give up, Vater Longley, returning from a NWSA meeting in New York, issued a call for a convention to be held later that year to promote the cause of suffrage in Ohio.[50] Answering the call to convene, large, enthusiastic audiences gathered at Cincinnati's Pike's Music Hall in September 1869. Vater Longley presided, and Stone was the star speaker. In her lecture, "Women's Rights," Stone reminded the audience:

> Our fathers did not say that governments derive their just power from the consent of the male sex, they did not say from the consent of the men, black or white . . . they made the broad statement that governments derive their just power from the consent of the governed. There is where we base our claim, and by consent, the people all mean the same thing—simply suffrage; it is the right to vote . . . so that it follows by our theory of government that every person capable of rational choice is rightfully entitled to vote.[51]

For many years during the start of the women's movement, the opposition argued that women did not need the ballot because they already were represented by men. The idea that a woman might not have a father, husband, brother, or son in her life never occurred to many people any more than the idea women could be independent. Stone, as well as many other supporters, countered, "It is no representation at all, for no human being can represent another—no human being can discharge another's duty."[52] Stone's speech also illustrated how suffragists regularly leveraged patriotic slogans from the Revolutionary War in their public discourse. Imbuing core principles on which the founders built the nation—"no taxation without representation" and "governments derive their just powers from the consent of the governed"—into suffrage rhetoric challenged audiences to question the hypocrisy of expecting women to pay taxes and obey laws over which they had no say.

The stiff resistance to women's enfranchisement in the state continued unabated. The *Cleveland Plain Dealer* took issue with Stone's speech, and it declared its opposition to the cause. Like many other media outlets and the public in general, the newspaper's editors were convinced appeals

for suffrage meant the masculinization of women, and they declared the vote would change women into "political swaggerers . . . with a love of wine, whisky and lager beer," as if alcoholic beverage were part and parcel of the political process and off limits to all women everywhere.[53] Fears of women usurping masculine prerogatives intensified each time women demanded their rights.

In 1868, Senator Samuel Pomeroy of Kansas and Representative George W. Julian of Indiana introduced the first ever proposed amendment to grant equal suffrage to men and women. US Senate Resolution 180 proposed, "The basis of suffrage in the United States shall be that of citizenship, and all native or naturalized citizens shall enjoy the same rights and privileges of the elective franchise."[54] Pomeroy had campaigned on a platform of universal "impartial" suffrage: "I have gone boldly—fearlessly—Into the movement! And it must succeed!"[55] Julian, too, was a staunch defender of women's suffrage his entire career, and he had worked with Ohioans such Barker Gage and Cole on the cause.[56] Despite its sponsors' enthusiasm, the measure was quickly tabled.

The presidential election of 1868, the first after the Union victory, presented an important opportunity for suffragists to advance their agenda. Nineteenth-century Americans granted Ohio considerable political clout. Republicans unanimously selected Ohioan Ulysses S. Grant as their candidate. The Democrats initially supported another Ohioan, Salmon P. Chase—chief justice of the US Supreme Court who was a former Republican—with the intention of pitting him against yet another Ohioan, George Pendleton. Suffragists decided to court Democratic support for their cause, and Chase became their prime target. As Ohio's governor, Chase earlier had supported married women's property acts and other feminist causes, so the choice seemed logical. Anthony and Cady Stanton sent a memorial to the Democratic national convention pleading for their cause. The memorial was ignored by some and ridiculed by others. Ultimately, both Ohioans lost the nomination and the Democratic Party remained divided. Grant won, permitting Reconstruction to continue and starting an impressive line of presidents from Ohio.

Grant supported the suffrage effort, but he made no move to intervene on its behalf. To his credit, Grant did change federal policy permitting women to work as postmasters, and he awarded the position to nearly five thousand. Prior to his reelection campaign, Anthony visited Grant in

the White House to urge him on behalf of the NWSA to include women's suffrage as one of his political planks. He refused to make such a promise. Anthony would go on to cast an illegal vote for Grant anyway.[57]

The Counter Movement Takes Form in Ohio

When the states ratified the Fifteenth Amendment in 1870, many suffragists realized that the fight ahead would be difficult. From 1870 to 1910, thirty-three states would mount 480 campaigns to submit suffrage measures to voters. Of those attempts, only fifty-five led to popular votes, and only two won.[58] The movement suffered from declining momentum in the 1870s, and it became increasingly more conservative.[59] At this time, Ohio had thirty-one local suffrage societies, and it was one of a few states with its own association, though it had a slow start.[60] Suffragists were not the only ones creating a structure for their movement—so were their opponents.

Though religious leaders, legislators, judges, and journalists were among those who openly condemned women's suffrage for over twenty years, no one had yet formed a countermovement. After the Wyoming and Utah territories enfranchised women, anti-suffrage efforts became more organized, but did so primarily individually and locally. In Ohio, small local anti-suffrage groups—mostly white women from well-to-do families—met informally to plan their counter-maneuvers. In 1870, the principal of Oberlin's Ladies Department and 140 other married women from Lorain County presented a letter to the state legislature protesting women's enfranchisement. The letter began, "We acknowledge no inferiority to men," however, it insisted that suffrage "cannot be performed by us without the sacrifice of the highest interest of our families and of society." It concluded, "We do, therefore respectfully protest against legislation to establish woman suffrage in Ohio."[61] Anti-suffragists all over the nation quoted the letter for years to come. Propagandists for the countermovement were just getting started.

Many anti-suffrage arguments emerged in the first few decades of the movement. Religious leaders argued women's demands for political rights violated biblical authority. Some citizens believed women were ruled by their emotions and were too illogical or unintelligent to understand politics or to cast a ballot. Other citizens argued women did not need the vote because the men in their lives represented them. Yet other

citizens claimed that if women engaged in politics, it would threaten the family, diverting women's attention away from domestic duties. Still others saw women's enfranchisement as a dangerous threat to tradition, especially the male-headed family. Opponents declared that the foundation of the state was the family, and enfranchising women would lead to family discord and competing interests, thus undermining social stability. In addition to arguments such as these, the opposition feared women would become "unsexed."

As time passed, those opposed to the expansion of women's rights added new arguments to their repertoire. For example, in response to some of the successes during Reconstruction, anti-suffragists argued enfranchising women threatened local self-rule—often code for white supremacy. The color of anti-suffragism was white.[62] As African American men's suffrage was being undermined, some Southerners made the case that women's suffrage would threaten not only male authority in the family but also states' rights and local self-government, a euphemism for propertied white men. Southern anti-suffragists emphasized the relationship between abolitionists and women's rights reformers, often framing the topic as Northern interference.

Additionally, people already concerned about the increase in the number of voters after African American men were enfranchised argued that granting women the ballot would double the vote, including the "ignorant" vote, and the costs associated with elections. Suffragists argued that the matter was not simply of doubling votes without changing results but also of broadening the perspective brought to bear on public issues and expanding patriotism. They also argued that increasing the number of voters was no evil in itself and that the cost of elections was a small fraction of the government budget.

Suffragists also had to contend with stereotypical media images and political propaganda developed to undermine their authority and the public's support for women's enfranchisement. Opponents often depicted suffragists as ugly, mannish old maids or neglectful mothers and nagging wives. At other times, suffragists were portrayed as threats to America's social fabric. The Brooklyn Daily Eagle once described them as "strong-minded she-rowdies."[63] Journalists sometimes mocked suffragists or wrote condescendingly of them. Occasionally, journalists were quite shocked to see and hear a suffragist who challenged these stereotypes. A Northern Kentucky Tribune reporter, dispelling with the usual stereotypes, surprised

readers with a description of Stone as "a lady pleasing in appearance and agreeable in voice, whose utterances, marked as they were by the evidence of refined thought and culture, and delivered in a manner singularly natural and engaging, commanded the undivided attention of the audience."[64] Still, "compliments" such as this one illustrate how women were then, as they all too often are now, judged more by their appearance than their logic or rhetorical skills.

Ohio and the New Departure

After the failure to win support for women's enfranchisement in the Fifteenth Amendment or to win an endorsement for a women's suffrage plank in the 1868 election cycle, the women's movement, still loosely structured, was ripe for new leadership and a new strategy. After nearly a decade of divisiveness and defeats, suffragists knew they must map out an alternative route to political empowerment. Ohioans did their best to keep the state on course throughout the 1870s, mobilizing behind opportunities such as hosting national suffrage conventions, a third state constitutional convention, and the growth of the temperance movement. New Ohio personalities such as Victoria Claflin Woodhull and Martha McClellan Brown would lead the way. These reformers knew the journey would prove arduous, but they could not turn back now.

Attorney Francis Minor, of Virginia, framed a novel legal interpretation of the Fourteenth Amendment that reenergized the movement. When officials refused to put Virginia Minor's name, "wife of Francis," on the list of registered voters, the couple sued. They advanced the case all the way to the US Supreme Court.[65] Minor claimed women were, in fact, already eligible to vote as citizens, arguing that section 1 declared, "All persons born or naturalized in the United States . . . are citizens of the United States," and "No state shall make or enforce any law which shall abridge the privileges or immunities of citizens of the United States."[66] Since women were born or naturalized in the United States, they were citizens and thus had the right to vote. This strategy became known as the New Departure. The NWSA quickly adopted it, as did many midwestern women, including those in Ohio.

In yet another significant blow to women's suffrage, the US Supreme Court ruled in *Minor v. Happersett* (1875) that while women were indeed

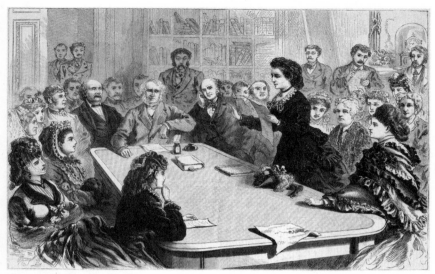

Victoria Claflin Woodhull

persons and therefore citizens, they had no right to vote. They maintained that suffrage was not necessarily one of the privileges or immunities referenced in the Fourteenth Amendment. The ramifications of this ruling were significant: women would have to obtain the ballot through the states or through an amendment to the US Constitution. Both prospects seemed daunting, though perhaps less so to a woman such as Claflin Woodhull.[67]

Victoria Claflin Woodhull (1838–1927), one of Ohio's and the nation's most famous women's rights activists, advanced the New Departure strategy through the legislature rather than through the courts as Francis and Virginia Minor had tried to do. Claflin Woodhull was born in rural Licking County in Homer, Ohio, raised in an unpainted wooden shack, and with only a few years of formal education, hers became a household name. Over the course of her unconventional life, she took on many roles, including suffragist, clairvoyant, reproductive rights advocate, publisher, stockbroker, and presidential candidate, but one term described her best—*radical*.

During her childhood, Claflin Woodhull's father exploited young Victoria and her sister, Tennessee, promoting the two girls as clairvoyants throughout the region. By age fourteen, she had found herself impregnated by her own father. The doctor who diagnosed her condition offered to marry her, and she readily accepted to escape her abusive household.

Her father refused to relinquish control of her, motivating the couple to elope. A philandering alcoholic and drug addict, her new husband was not much of an improvement over her father. The couple eventually divorced. The troubled eleven-year marriage produced two children, one born with severe brain damage. The experience created within Claflin Woodhull a keen understanding of women's oppression, fueling her feminist drive for the remainder of her life. Overcoming an impoverished background and abuse, she used every means possible throughout her life to create opportunities for herself and to sustain her children.

Claflin Woodhull remarried; her second husband was a Civil War hero who left his wife and child to wed her. She returned to presenting as a clairvoyant, believing that Demosthenes, the great Greek orator, was her spirit guide. She credited him for urging her to begin a career in New York City, partnering with Tennessee as "spiritualist physicians." The sisters met Cornelius Vanderbilt, and the millionaire magnate was so charmed by them that he bankrolled them as the nation's first female stockbrokers. When the sisters opened their brokerage firm in 1870, the city newspapers donned them the "queens of finance."[68] The same year, the sisters extended their sphere of influence by publishing *Woodhull & Claflin's Weekly*. This publication advocated women's suffrage, sexual freedom, marriage reform, and spiritualism, among many other controversial issues.

After a suffrage amendment stalled in the House Judiciary Committee for over a year, Claflin Woodhull issued the committee a petition demanding women's enfranchisement. Her petition stated, "'No taxation without representation' is a right that was fundamentally established at the very birth of our country's independence; by what ethics does any free government impose taxes on women without giving them a voice upon the subject or a participation in the public declaration as to how and by whom these taxes shall be applied for common public use?"[69] Claflin Woodhull introduced herself to committee members, including Benjamin Butler of Massachusetts. The two became intimate, and, working together, they developed a plan to move the amendment forward. Butler arranged for a hearing to be chaired by Republican John Bingham of Ohio.[70] She traveled to Washington, DC, to testify, the first woman ever to address the US Congress.

Claflin Woodhull addressed the committee, beginning in a shaky voice that soon gained power, to argue not that women should be granted the vote but rather that they already had it. Based on the Fourteenth Amend-

ment, she contended, "One portion of citizens have no power to deprive another portion of rights and privileges such as are possessed and exercised by themselves. The male citizen has not more right to deprive the female citizen of the free, public, political expression of opinion than the female citizen has to deprive the male citizen thereof."[71] She linked voting to expanding the power of federal authority. Since the Fourteenth Amendment limited states' abilities to restrict voting rights based on race, color, or condition of servitude, at least some power to govern voting rights had transferred to the federal government. Since the Fourteenth Amendment declared "no State shall make or enforce any law which shall abridge the privileges or immunities of citizens of the United States," she claimed on constitutional grounds that women are inherently citizens, and because citizens have the right to vote, women had the right to vote.

During the discussion period following her address, Bingham affronted Claflin Woodhull, bluntly declaring, "Madam, you are not a citizen." Unflappable, she deftly quoted his own words back to him, "All persons born or naturalized . . . are citizens." In previous public statements, he had granted that women were people under the Due Process Clause, whether married or single. He read the words again, conceded, but stubbornly refused to change his interpretation of the law.[72]

Claflin Woodhull's performance was so impressive that fellow Ohioan President Ulysses Grant invited her to meet with him at the White House. Suffrage leadership, crammed into the hearing to witness the historic event, eagerly urged her to attend their convention, which was meeting in Washington, DC, that week. This event became known as "the Woodhull convention." Many suffragists were not quite sure what to think of Claflin Woodhull because she was so unlike most other suffragists—not middle class, not a member of a suffrage organization, not even an attendee of a suffrage convention up until that point. Anthony and Cady Stanton were impressed by her boldness; both women were beginning to lose power to the next generation of younger suffragists, many of whom favored a more modest approach. Anthony believed in boldness, and she saw in Claflin Woodhull a more vibrant alternative whose celebrity status had the potential to reenergize the movement.[73]

Claflin Woodhull's historic address generated extensive media coverage, but most of it focused on her appearance rather than her argumentation. The *Philadelphia Inquirer* wrote, "Mrs. Woodhull is of very prepossessing appearance, with light brown hair, worn short. She was dressed in

navy blue cloth, trimmed with black gross grain, and made with postillion basque; very high crowned broad rimmed black felt hat, with velvet band around the crown completed the unique costume of the Wall street brokeress."[74] Perhaps begrudgingly, the *New York Herald* admitted, "there is no disguising the fact that women suffrage advocates are making headway in Washington."[75] Claflin Woodhull quickly became a media darling, and throngs of people clamored to hear her speeches.

When the House Judiciary Committee officially responded to her petition, Bingham, playing with semantics, claimed women were not citizens, but rather they were "members of the state."[76] Moreover, he counterargued that voting was not a privilege as defined in the Fourteenth Amendment and it was up to the states whether to allow women's suffrage. Like the US Supreme Court, Congress determined this was a matter of jurisdiction. Claflin Woodhull and other suffragists responded by asking the US Congress to hold public hearings on women's rights. The House refused to do so. In fact, Bingham passed a resolution essentially allowing Congress to ignore women's rights.[77]

Bingham wasn't the only congressman who opposed Claflin Woodhull and women's rights. One reporter noted representatives "seemed to regard the whole thing as a good joke."[78] Furthermore, Congress was not the only source of opposition. Approximately one thousand women, many of whom were wives of senators and representatives, signed a petition requesting Congress *not* to give women the right to vote. Claflin Woodhull requested an opportunity to respond to her opposition by addressing the House of Representatives as a whole, but her request was denied.[79]

Claflin Woodhull's testimony was a significant win for the cause of women's rights because it shifted how women lobbied Congress and how suffragists were depicted in newspapers. The famous etching of Claflin Woodhull directly addressing Congress did much to counter the stereotypical mannish images of suffragists too often characterized in political cartoons. Perhaps more importantly, by issuing an invitation to Claflin Woodhull, the US House of Representatives granted both her and the cause of women's rights credibility. While Claflin Woodhull did not break the marble ceiling, she did crash through the marble walls of the Capitol Building. Women were now talking the talk and walking the walk within the halls of Congress. Theirs was now legitimate speech in the realm of US politics at the national level.

Claflin Woodhull's natural charisma and unconventional past made her famous and infamous. Because of her controversial reputation, NWSA membership fell off so drastically that it was impossible to host a full-scale convention the next year, and fourteen of the fifteen state suffrage organizations voted to become auxiliaries of the AWSA instead. Most NWSA leaders were forced to cut ties with Claflin Woodhull, especially after Anthony found out she planned a takeover of the 1872 NWSA convention as a nominating meeting for her presidential campaign. Anthony was so worried about this possibility that she ordered a janitor to douse the gaslights should Claflin Woodhull take to the stage.[80]

Capitalizing on her fame, Claflin Woodhull moved forward, creating the Equal Rights Party, which nominated her as its US presidential candidate at its meeting in New York's Apollo Hall. She boldly announced her candidacy in 1872 in a letter to the *New York Herald,* making her the first woman to run for the nation's highest office. In her announcement speech, she explained she was running "chiefly for the purpose of bringing home to the mind of the community woman's right to fill any office in America, from the Presidency down."[81] Ironically, Claflin Woodhull would not be eligible to cast a vote for herself. She received less than 0.1 percent of the popular vote, but who knows how many she could have had if women were allowed to cast ballots?[82] Ohio, often known as the "mother of presidents," would not be including Claflin Woodhull as part of that claim to fame.

Over time, Claflin Woodhull took on more and more controversial causes. She proposed radical economic reforms in addition to gender-related social reforms. She widened her audience to include not only women's rights advocates but laborers as well. After *Woodhull & Claflin's Weekly* became the first media outlet to publish *The Communist Manifesto* in the United States, Claflin Woodhull came to embrace Marxism.[83] She endorsed an eight-hour workday, redistribution of wealth, and licensure of prostitution.

Claflin Woodhull took on the subject of sexual politics, arguing that marriage too often was a form of legalized prostitution in which a woman is forced to sell herself out of economic necessity rather than out of mutual respect and love. She wanted to strike a blow against the double standard that allowed married men to be unfaithful but ostracized married women for the same behavior. Claflin Woodhull and her supporters argued that reproductive freedom was the key to women's empowerment, and the free expression of female sexuality was a prerequisite for individual fulfillment.

At a Western Woman's Emancipation Society meeting in Ravenna, Ohio, members affirmed that a woman's first right "is the Right to Herself." If women were to be considered independent of men, then they had to claim ownership of their own bodies. Perhaps in her most audacious pronouncement ever, she shocked audiences: "Yes, I am a free lover. . . . I have an inalienable, constitutional, and natural right to love whom I may, to love as long or as short a period as I can, to change that love everyday if I please, and with that right neither you nor any law you can frame have any right to interfere."[84] Unsurprisingly, this outcry led to her public castigation. Most infamously, she was caricaturized as "Mrs. Satan" in an 1872 political cartoon published in *Harper's Weekly*. Claflin Woodhull's radicalism and the public's reaction to it contributed to the founding of the Anti-Suffrage Party in 1871.

In response to pressure regarding her support of free love, Claflin Woodhull let loose a barrage of scandalous facts about extramarital affairs of famous men who criticized her, including Henry Ward Beecher. A massive national scandal ensued. Claflin Woodhull was indicted for publishing "obscene literature," and she served six months before the case was dropped. The scandal ended her career as a reformer, and her marriage ended in another divorce. She moved to England and married for a third time, eventually promoting a variety of social causes related to the British reform movement. She returned to the US speaking circuit, but with a demeanor more philosophical than defiant. The woman many labeled the devil incarnate from small-town Ohio died in England in 1927 at the age of ninety-one.[85]

The Ohio Temperance Movement and Women's Rights

In the years after the Civil War, the connections between women's rights and temperance continued and eventually deepened. Without a doubt, the temperance movement had considerable impact on suffrage in the Midwest for over two decades. Members of both suffrage and temperance organizations recognized the moral force of women as a potential source of social power, and though the movements certainly were not completely alike, members tended to be white, middle class, religious, conservative, and often rural. Generally speaking, the suffrage movement came to adopt the more conservative tone of the temperance movement.[86]

To be sure, the temperance movement's mission extended beyond saloon closures, and it was most certainly feminist in nature. Many crusaders openly questioned and debated male domination. They went to court on behalf of domestic abuse survivors and wives abandoned by drunken husbands. Since most wives were financially dependent on their husbands, they and their children lived precariously if their husbands spent earnings on liquor rather than domestic necessities.[87] Expecting empathy and legal remedy, crusaders were laughed at in the courts, and in the rare instances in which cases were decided in their favor, this judgment was thrown out on appeal. It did not take long for these reformers to realize that, as women, their power was quite limited.

The relationship between the two movements became increasingly political. The Prohibition Party, convening in Columbus, Ohio, endorsed a suffrage plank in 1872. This endorsement can be considered the first national success of the movement. Both temperance crusaders and suffragists submitted petitions on behalf of their causes at the state's third constitutional convention.[88] Members of both movements also took issue that a large number of German-speaking immigrants and other groups with traditions of drinking beer had moved to the Midwest to open breweries and bars. Displeasure with this economic and cultural shift resulted in a shared nativism among some crusaders and suffragists that infected their politics.[89]

Many Ohio suffragists were temperance crusaders. Suffragists Eliza Daniel Stewart, a founder of the Ohio State Equal Rights Society, served as a crusader for the temperance movement. Rebecca Smith Janney, prominent Ohio suffragist from Columbus and chief coordinator of the suffrage petition drive for the 1873 constitutional convention, presided at the first organizational meeting of the Columbus Crusade for Temperance. Individual suffragist crusaders such as these did not hide their want of the ballot, but they did not commit the crusade as a movement publicly to the cause of women's enfranchisement. Smith Janney once confided to Stone's husband, Henry Blackwell, that this strategy was deliberate, "I do not approve of saying anything about suffrage publicly in connection with the prayer movement—but privately the subject is frequently discussed—and many are ready for it—indeed I shall not be surprised if there should be women who will pledge themselves to go to the polls and canvass for the anti-license ticket."[90] Anti-suffrage temperance

crusaders and anti-temperance suffragists did exist, but most activists supported women's emancipation.

Hillsboro, Ohio, became well known for its devotion to temperance activism. Large numbers of religious women distributed crusade kits to churches in five hundred towns across the state; these included copies of a temperance pledge, petitions to be sent to the Ohio legislature, and a press release announcing the start of a local campaign.[91] In 1873, women marched through the town, stopping at every saloon to pray for the souls of the bartenders and their customers and to demand owners sign a pledge to stop selling alcohol. Within two years, crusaders in 130 other towns followed this example. The Hillsboro women inspired a full-fledged grassroots temperance movement known as the Women's Crusade, and their strategy became so impactful that city governments in Columbus, Cleveland, and Cincinnati were compelled to pass ordinances forbidding such marches. Many local ministers castigated the marchers for being unladylike.[92]

Despite this pushback, women from local chapters gathered in Cincinnati the following year to create the Ohio Woman's Christian Temperance Union. Temperance reformers successfully closed many of the state's saloons. The entire town of Westerville, Ohio, went dry. Westerville became nationally known for temperance when the Anti-Saloon League relocated its headquarters there from Washington, DC, in the early 1900s.[93] Throughout the 1870s, Ohio had more local Women's Christian Temperance Union (WCTU) chapters than any other state, and it grew its membership of five thousand to twice that number in the years between 1876 and 1892. Under the direction of Frances Ensign, the Ohio WCTU primarily focused on prohibition.[94] The influence of the state chapters waned as the male-dominated Anti-Saloon League flexed its muscles during the 1890s.

Ohio once again provided both the leadership and the infrastructure to sustain and grow the women's movement. Martha "Mattie" McClellan Brown was one such leader. Born in 1840 in Maryland, she moved with her parents to Cambridge, Ohio, when she was two years old. McClellan Brown and her sister were orphaned, both raised by neighbors. In 1862, McClellan Brown graduated from Pittsburgh Female College at the top of her class. She began her temperance career in 1861, and by 1874, she helped found the Women's Temperance Association of Ohio. A temperance handbill announcing her lecture described McClellan Brown as "One

of the Most Cultured and Entertaining Lady
Speakers in the United States."[95] She developed
an international speaking career, addressing
audiences numbering in the thousands in the
United Kingdom and Europe throughout 1873.
In addition to her public speaking credentials,
McClellan Brown later served as editor of the
Monitor, a weekly newspaper in Alliance, Ohio,
with her husband. The couple was active in the
Prohibition Party, and the pair fought hard for
the inclusion of women's suffrage in the Prohi-
bition Party's platform. When the party refused
to adopt the cause, the Browns left it. With her

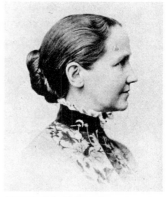

Martha McClellan Brown

husband, McClellan Brown moved to New York City to assume the man-
agement of the newly organized National Prohibition Alliance.[96]

National and state leaders alike reached out to McClellan Brown for
support of suffrage. She attended and spoke at suffrage conventions reg-
ularly. For example, she spoke at the NWSA meeting in 1881, delivering
a lecture titled "Accident of Sex," and the following year, she gave another
address for which the convention's minutes described her as "a woman of
fine presence, pleasing manners and a well trained voice that can fill any
hall. Her address was one of the best in the convention and all felt that in
her we had a valuable acquisition to our Association."[97] She attended suf-
frage marches in Cleveland and Washington, DC, donated money to the
cause, and participated in fundraising. In the 1880s, McClellan Brown
became vice president and professor of art, literature, and philosophy at
Cincinnati Wesleyan Women's College.[98]

Ohio was the birthplace of yet another important national reform or-
ganization. Women from eighteen states gathered in Cleveland to found
the national WCTU. Evidence suggests McClellan Brown wanted the
presidency of the new organization, but her strong support for women's
suffrage worked against her, and the job instead went to the more conser-
vative Annie T. Wittenmyer. McClellan Brown did not participate in the
WCTU very much from that point forward, though she stayed active in the
women's suffrage movement and the women's club movement. This orga-
nization quickly gained membership and power, becoming a strong build-
ing block in the infrastructure of the women's movement. Many suffrag-
ists attended the Cleveland convention, hoping the WCTU would agree

to include a suffrage plank. However, this did not materialize. It would take another year for the two causes to merge completely. Some suffragists resented the attention paid to temperance crusaders and their perceived moral superiority. A letter from Ohioan Miriam Cole illustrated this frustration: "If the 'woman's war against whisky' had been inaugurated by the woman suffrage party, its aspect, in the eyes of newspapers, would be different from what it is now." She continued, "If women would only see this and demand the exercise of their right of suffrage with half the zeal and unanimity with which they storm a man's castle, it would be granted."[99]

Suffrage Propositions 211 and 222

By the early 1870s, civic-minded individuals and groups began to push for a third state constitutional convention in Ohio. In the twenty years since the last convention, the population of the state had grown dramatically, and the economy moved from one based primarily on agriculture to one based more on industry. Citizens were concerned about a wide variety of issues. The Civil War had been a catalyst for tremendous commercial and manufacturing growth in Ohio, so some citizens believed there was a need for greater legislative power to control corporations. Lawyers and judges wanted to revise the court system.[100] And, of course, many Ohio women again called for enfranchisement and temperance.

On the issue of suffrage, the delegates considered extending the ballot to women, people of color, and immigrants who had declared their intentions to become citizens. As might be expected, this issue had both support and opposition from all parts of the state. Of the 330 speeches made at the convention, only 20 were about women's suffrage.[101] Still, delegates considered the subject carefully, even suspending the rules to permit women's suffrage speakers three hours to address a packed gallery.[102]

Smith Janney, the chief organizer of the suffrage petition campaign, succeeded in collecting eight thousand signatures across thirty-three counties. Over fifteen Ohio counties sent petitions to the delegates requesting female suffrage or the removal of the word *male* from elective franchise laws. The petitions with the most signatures came from Hamilton, Wood, and Summit Counties. Delegates did their best to ignore these petitions. The Committee on Elective Franchise "beg[ged] leave to report back said propositions and memorials, without recommendation, and ask to be dis-

charged from their further consideration," thus necessitating the creation of the Select Committee on Female Suffrage to handle the work with which the regular standing committee could not be bothered.[103]

After two major losses before the Civil War and the defeat of Proposition 101 after the war, Ohio suffragists were cautiously optimistic this campaign would finally prove victorious. However, when the committee offered Proposition 211, which extended the ballot to women, an immediate backlash erupted. Opponents offered multiple, though tired and old, arguments: women's character would be degraded by participating in politics; voting would make women "mannish"; women would lose traditional means of influence such as love and tenderness; women would lose respect for men; women would lose the deference men gave them and they would fall from their elevated position in the home; women weren't entitled to the franchise; women did not want the right to vote; and, finally, women were already represented by men.

Thomas Powell, a delegate from Delaware County, read a thirty-three-page statement into the record, claiming: "But these women who advocate woman's suffrage differ materially from their good sisters . . . but with equal force do the good domestic women—our good mothers and wives—return the compliment by saying, they were only a kind of masculine women, who possessed very little of the genuine female character."[104] Powell, like many opponents, called into question suffragists' femininity, and he tried to pit women against each other. Other opponents invoked the Bible to deprive women of the ballot and claimed they worried for women's safety if they entered boisterous and unseemly polling places. To these points, the overlapping rhetoric of the temperance and women's movements proved a useful defense.[105] Temperance women had a public reputation for piety, and yet they regularly ventured into the dangerously masculine space of saloons and emerged unscathed. Could not the same women enter and exit polling places and live to tell the tale?

In the footsteps of other pro-feminist men, Alvin Voris, delegate of Summit County and chairman of the Special Committee on Woman's Suffrage, carried the day. He valiantly addressed the opposition in what was described as "a masterly speech of two hours, during which the attention was so close that a pin could be heard to drop." Voris's arguments on behalf of women's suffrage claimed: women are entitled to the ballot based on natural rights; since women are citizens under the Fourteenth Amendment, they should be permitted to vote; men were made more dignified

and respected via the act of voting, and the ballot would have the same elevating effect on women; letting women vote would decrease political corruption; if women were trusted to raise children, they should be trusted with the vote; and a family really cannot be unified if the wife is not equal to the husband.[106]

Voris's rhetorical skills must have been considerable. In another agonizingly small margin of defeat, Proposition 211 lost by only two votes.[107] Ohio's suffragists faced another remarkable razor-thin loss akin to the tie before the Civil War. Yet, they held out hope. During the discussions, several delegates expressed support for submitting the question to women alone for a vote. A unique proposition, number 222, provided "the General Assembly at its first session after the adoption of this constitution, shall cause a registration to be taken of all the women in this state, 21 years of age, who would, if males, be legal voters." After a spirited two-day debate, this proposition failed as well, forty-nine yeas and forty-one nays, thus falling short by four votes to secure the majority of delegates.[108] Ohio suffragists took comfort in the fact that the defeat was by a small majority, and by the fact that, even if women's suffrage received more votes, it would not have mattered legally; the proposed constitution sent to the Ohio electorate in 1874 failed resoundingly.

Grassroots Ohio Suffragism

National leaders of the women's movement routinely toured Ohio on their public speaking campaigns. As examples, Claflin Woodhull delivered her standard speech on a woman's right to vote in Cleveland to an audience of 5,000, and Cady Stanton delivered her stock lecture, "Our Girls," at the Massillon opera house in 1875.[109] However, the story of women's suffrage in Ohio, or any other state, for that matter, is not limited to those who became household names such as Cady Stanton or Claflin Woodhull. Scores of nameless and often-forgotten men and women did the vast majority of the day-in, day-out work of advancing a social movement over the course of decades. The historical record leaves few clues about the specifics of their contributions, yet their persistence and passion are nonetheless obvious. One story especially captures the essence of the grassroots suffrage spirit that lived in the heart of the "average" Ohio suffragist, that of the bold women of South Newbury, in Geauga County.

The work of women's rights may have started in this hamlet when local resident Anson Reed petitioned the Ohio legislature to grant married women property rights. Additionally, five decades before they could do so legally, nine daring women attempted to vote for governor in 1871. Leading the charge was Ruth Fisher Munn, an early advocate of the state's dress reform movement in Ohio.[110] Notably, her bold move predated Anthony's infamous 1872 arrest for voting in Rochester, New York, that landed her in a US federal court.[111] Raised from a footnote in *The History of Woman Suffrage* to grace this page, the names of the first women voters of Ohio were Lima Ober, Lovina Greene, Hophni Smith, Perleyette Burnett, Sophia Allen, Mary Hodges, Lydia Smith, and Sarah Knox.[112] Perhaps unsurprisingly, the women's ballots were "lost" while being delivered to the local board of elections, but their hope was not lost.

Undeterred, the women returned to vote on local issues the next year. However, the opposition anticipated their arrival and organized in advance to keep the women at bay. Some of the male politicians paid boys to smoke tobacco pipes, assuming the smell would fill the room and force the suffragists to retreat before they could cast their ballots. The plan backfired. The boys became ill from the tobacco, and the women, local lore has it, denied the men "marital privileges." The suffragists eventually received apologies from the men who instigated the smoke-out, and within a year, the invincible South Newbury women were granted equal municipal suffrage.[113]

To advance their cause, the women of South Newbury created the Newbury Woman's Suffrage and Political Club in 1874, believed to be the country's second-oldest club of its type. Members met in the South Newbury Union Chapel and hosted regular programs often built around readings, essays, addresses, and discussions of civic issues. Originally constructed in 1858, the chapel became a bastion for free speech, often used as a speaking venue for suffragists including Anthony, Stone, and others.[114] On July Fourth, club members planted an oak tree in honor of the US centennial. South Newbury's spirit of reform became an important lasting source of inspiration for suffragists across the state. Over the years, especially after major defeats, Ohio suffragists made pilgrimages to the oak tree and to the chapel, symbolically recommitting themselves to the cause.[115]

From 1876 onward, the South Newbury suffragists, year after year, attempted to vote at state and presidential elections only to be refused every time. Eventually, some of the more reform-oriented men joined with the

South Newbury suffrage procession

women in protest. The names of these noble men—Amplias Greene, Darius Allen, Ransom Knox, Apollos Greene, and Wesley Brown—deserve to be raised from the footnotes of history as well.

Toledo's grassroots suffragists were initially more tentative than the ladies of South Newbury. A group of citizens decided it was time for women finally to be represented in the local library's management. As described in an 1869 letter to the *Revolution,* the proposition "not only of allowing women to vote, but of giving them offices, was a bombshell in the camp of conservatives, and every influence that could be, was brought to bear against this ticket." The idea of women voting was too much for some to contemplate, but the notion that women actually would serve in office was beyond the pale for many. Yet, the Toledo suffragists won the right to vote for and to serve on a local library board. Small as this inroad into the bastion of male power was, the win was nonetheless meaningful to the women of the community. The same letter, describing the first time women voted for library directors, quipped, "It was interesting to note the firmness with which the women walked to the ballot-box. No trembling was perceptible. They carried the ballot with ease, deposited it with coolness. . . . The deed was done."[116] A win was a win, and eventually, enough of these smaller wins could increase momentum for the larger movement.

Still, decades would pass before married women could possess their own library cards in Toledo. In 1877, the Toledo Public Library board of

trustees held a special meeting, at the request of the president of the Toledo Woman's Suffrage Association (TWSA), to consider allowing married women to obtain library cards. The trustees recognized existing laws unjustly discriminated against women, but they explained they could only extend loan privileges to widows and unmarried women, since only husbands could be held legally responsible for damaged or lost books borrowed by married women. Married women would have to wait even longer for this small demonstration of fairness.[117]

Ohio Women's Suffrage at the Centennial

The nation's centennial in 1876 sparked the spirit of patriotism in many US citizens. Suffragists capitalized on the public relations potential of this key event in the country's history in varied ways. Anthony and Matilda Joslyn Gage disrupted the official centennial program at Philadelphia's Independence Hall, presenting the vice president of the United States with a "Declaration of Rights for Women." In Ohio, more conservative reformers reserved space at the Centennial Exposition in Columbus for the purpose of distributing suffrage literature. A more confident TWSA, asked to participate in the city's centennial celebration, politely declined: "While the members of the association fully appreciate the generosity of the men of Toledo, and feel grateful for the implied recognition of their citizenship, yet they manifestly have no centennial to celebrate, as the government still holds them in a condition of political serfdom, denying them the greatest right of citizenship representation." They further professed, "In equal degree we feel it inconsistent, as a disfranchised class, to unite with you in the celebration of that liberty which is the heritage of but one-half the people."[118]

Some Ohio suffragists were growing impatient and pushing back more firmly. The decision to decline this invitation made the local news, resulting in a condemnation of their perceived lack of patriotism and their "needless irritability." The *Toledo Blade* and the *Cincinnati Commercial* both published hostile responses. The suffragists defended themselves with a letter to the editor: "Women are told by those who are in the full enjoyment of all the privileges which this government can confer, to rejoice in what little they have, and wait patiently until more is bestowed. Wait we must, because they have the reins of power, but to wait patiently

with the light we have to perceive our relative condition, would be doing that for which we should despise ourselves."[119]

The women stood firm in their convictions, boycotting the event and hanging a banner with the phrase, "Woman Suffrage and Equal Rights," across one of the streets the centennial procession passed. The TWSA also started a new reform newspaper, the *Ballot Box*. The editors declared, "We women citizens of this nation protest against calling the present centennial celebration a celebration of the independence of the people of the United States."[120] Instead of celebrating the nation's independence, the TWSA declared women's independence, calling on women to no longer consider themselves bound to obey laws in whose making they had no say.

The centennial also brought the Republican Party to Ohio for its national convention. The Republicans, initially supportive of women's rights, instead aligned with the cause of freedmen's suffrage, thus drawing abolitionists closer while pushing away some women's suffrage supporters. Still, party officials granted the NWSA ten minutes to address their national convention, held in Cincinnati. Sarah Jane Spencer delivered a memorial on behalf of Anthony calling for women's enfranchisement, and in so doing, she became the first woman to address the Republican National Convention. George Hoar, a congressman from Massachusetts, presented the memorial, and he invited Spencer to the stage. She began her speech by reminding her audience that plank 14 supported women's rights, but "yesterday, when Gen. Logan, who voted for us in the United States senate, forgot to mention us, I reminded him of it. He said, 'I forgot the women.' I said, 'Beware, lest ten millions of women in the United States, with the ballot in their hands, forget you.'"[121] Spencer's implied threat was not lost on the women of Cincinnati.

The centennial was an election year. Another Ohioan, Rutherford B. Hayes, assumed the presidency as the nation turned its attention away from Reconstruction. Suffragists had lobbied for his endorsement of a women's suffrage plank to no avail, and he successfully avoided the issue throughout his campaign. Lucy Webb Hayes, First Lady of Ohio and the nation—the first First Lady to have earned a college education—was a vocal supporter of civil rights and devout enforcer of temperance. She attended a suffrage lecture offered by Stone, and she had some pro-suffrage sympathies. Anthony and Cady Stanton tried to gain the president's ear by using the First Lady as a conduit. Whether she did not believe in the cause or preferred not to contradict her husband, she never took a

public stance on women's enfranchisement. In fact, she once entreated the Woman's Home Missionary Society, a civic organization in which she held membership, to refrain from introducing suffrage resolutions. Both the president and the First Lady did not believe women sufficiently educated to be voters.[122] To his credit, President Hayes did sign a bill in 1879 allowing female attorneys to argue cases before the US Supreme Court.[123]

After twelve tumultuous years, Reconstruction as a distinct time period came to an end with the infamous Compromise of 1877. The struggle for women's rights after the Civil War continued as intently as it had before the war, yet suffragists' determination, political acumen, and rhetorical savvy were insufficient to win Ohio's women the ballot during these incredibly challenging times. The promise of a more democratic society that lay at the core of Reconstruction prompted a conservative backlash, dashing the hopes Ohio suffragists had for Propositions 101, 211, and 212.

Against the backdrop of the three Reconstruction amendments, and the divisions within the women's movement at the national level, Ohio remained fertile ground for consciousness-raising and recruitment, serving as the birthplace of both the AWSA and WCTU and as the host of national conventions such as those of the AERA and the Republican Party. The movement finally had a national organizational structure, with much of its architecture built in Ohio. The state's small grassroots efforts began to bear fruit. Ohioans such as Claflin Woodhull and McClellan Brown made national names for themselves. The wins were few and challenges many, but each year brought more political experience and more resolve for Ohio's suffragists. Perhaps more clearly than ever, suffragists saw at the end of Reconstruction that their war—the war for enfranchisement—which had now spanned almost thirty years, would require a new battle plan.

The Ohio Women's Rights Movement during the Gilded Age

When residents of Jackson, Ohio, woke up on January 24, 1878, to read the local newspaper, the *Jackson Standard,* they noted the National Woman Suffrage Association (NWSA) convention made the front page. Writing from Washington, DC, the unnamed correspondent explained, in anticipation of an upcoming vote in Congress, that the object of the convention was to debate a proposed amendment to the US Constitution conferring suffrage without distinction of sex. The division within suffrage ranks regarding strategy—to either support the federal amendment or to continue to pursue state legislation—may have been the topic of the news story, but the characterization of suffragists consumed the majority of the nearly three-column article. The author confessed, "I have been surprised to hear fashionable ladies, whom one would never fancy give a thought to anything beyond the frizzles of their hair, speak out strongly and well in favor of woman suffrage." The correspondent went on to describe other convention goers as "women quacks" who flocked to the convention "with their little vanities and their little axes to grind." Other descriptions, including "feminine bummers," "hybrid females," and "pantalooned ladies," indicate the level of disdain still reserved for suffragists.[1]

The Susan B. Anthony Amendment

Later that year, Senator Aaron Sargent of California introduced Senate Resolution 12, also known as the Susan B. Anthony amendment. The

resolution stated simply, "The right of citizens of the United States to vote shall not be denied or abridged by the United States or by any State on account of sex. Congress shall have power to enforce this article by appropriate legislation."[2] Suffragists came to the capitol to testify and to file petitions with thirty thousand signatures in support of the amendment. Later that year, the Committee on Privileges and Elections chose to ignore the suffragists and their petitions, recommending consideration of the issue be "indefinitely postponed." In this instance, "indefinitely" translated into decades, as it would be another forty years before the Nineteenth Amendment passed the US Congress. The nation would ratify another three amendments to the US Constitution before women would have their turn. The fight was not yet halfway over. Members of another entire generation of suffragists would devote their lives steadfastly to the cause of justice. Persistent as always, suffragists made sure that the Susan B. Anthony amendment pended continuously, introducing it in the same form every succeeding year.

As the Reconstruction era ended, the fight for a federal women's suffrage amendment began to take center stage across the nation. Ohioans held differences of opinion regarding the movement's agenda at this time. Some Ohioans joined the federal campaign, but many continued to pursue enfranchisement at the state level by maintaining their focus on its general assembly. The battle for the ballot now occupied two fronts, federal and state, thus complicating the movement more than ever before. Western states won the first battles for women's enfranchisement—Wyoming in 1890, Colorado in 1893, and both Utah and Idaho in 1896.[3] Ohio's importance to the success of the overall movement began to wane as western states granted the vote to women before the Buckeye State did. Ohio could no longer claim to be on the vanguard. Furthermore, several failures between the end of Reconstruction and the start of the new century further delayed Ohio's progress. Those disappointments, however, shaped the movement as much as its victories, and Ohio remained an important testing ground for women's rights from the late 1870s through the 1890s.

Industrialization, urbanization, immigration, and technological advancements characteristic of the Gilded Age transformed the US economy, resulting in extremes of materialism and want, wealth and poverty. Political corruption and imperialism challenged the nation's moral capacity. The suffrage movement thus confronted how best to achieve their goal in a radically shifting environment. The last years of the 1870s

brought important changes to the women's suffrage movement's leadership, agenda, organizational capacity, and political engagement. At both the national and state level, new leaders emerged, the agenda came to reflect an increased commitment on the part of some to a federal amendment, the infrastructure reconfigured a stronger connection between suffrage and the Women's Christian Temperance Union (WCTU), and the political debate over women's enfranchisement was situated within the context of US expansionism.

Home Protection

In 1879, Frances Willard began her WCTU presidency by inextricably linking suffrage and temperance. Work on behalf of both causes had often coincided, especially in Ohio, where the WCTU was founded, but Willard's rhetoric took the relationship to a new level.[4] In her book, *Glimpses of Fifty Years: The Autobiography of an American Woman,* Willard described the moment, while in prayer in Columbus, Ohio, that she heard the voice of God speak to her, "Upon my knees alone, in the room of my hostess, who was a veteran Crusader, there was borne in upon my mind, as I believe, from loftier regions, the declaration, 'You are to speak for woman's ballot as a weapon of protection to her home and tempted loved ones from the tyranny of drink.'"[5] Based on this revelation, Willard developed her home protection argument. Treading lightly, she cautioned that the Home Protection Ballot was less about women's rights than a means of protecting the family claiming, "Home Protection" is the general name given to a movement already endorsed by the WCTUs of the eight states, the object of which is to secure all women above the age of twenty-one the ballot as one means for the protection of their homes from the devastation caused by the legalized traffic in strong drink."[6] Framing arguments for the ballot as home protection within the context of domesticity widened the base of the movement, since this argument appealed to socially conservative women. In keeping with midwestern values typically held at this time, many Ohio suffragists did their best to agitate for a woman's right to vote while avoiding the topic of gender equality.

Shortly after Willard took the leadership role, the WCTU endorsed suffrage, and for over twenty years, the organization strengthened the infrastructure of the suffrage movement, functioning as a key part of

its grassroots. State and national suffrage leaders relied on local WCTU chapters to distribute information, host speakers, and perform other essential functions.[7] The Ohio Women's Temperance Society created a franchise department to support the cause in these ways. Willard's connection between temperance and the ballot became both a blessing and a curse for Ohio suffragists. The WCTU's organizational structure and growing membership strengthened suffrage ranks; however, the liquor lobby emerged in response as the strongest suffrage opponent in the state. Ohio's brewers and distillers feared that women armed with the ballot would vote them out of business.[8]

Suffragists' arguments also changed in relation to the shifting global political landscape. The 1870s began a period of US expansionism, both westward and overseas. By the end of the decade, as the United States became a larger player on the world's stage, suffragists' arguments for women's political power transformed. As Allison Sneider, author of *Suffragists in the Imperial Age: U.S. Expansion and the Woman Question, 1870–1929,* explains, "The process of creating new territorial constitutions, whether in the continental west or overseas, forced national conversations about the meaning and content of national citizenship, and between 1870 and 1930, many US suffragists intended to make voting rights crucial to the definition of American citizenship."[9] For decades, the general consensus had been that voting rights were a matter for the states to decide. Yet, expansionism was the purview of the federal government, and that process invited public dialogue about who was and was not a citizen and who could and could not vote. This larger debate provided an opportunity to advance the cause of women's enfranchisement at the federal level.

Within this context, Cincinnati hosted the Tenth Annual American Woman's Suffrage Association (AWSA) convention in 1879. Fifty-three delegates representing nine states and Washington, DC, met at Melodeon Hall. Key leaders converged on the city, including Lucy Stone, Henry Blackwell, Frederick Douglass, and other aging stalwarts of the movement. As usual, the convention brought an opportunity to recommit to the cause and to provide mutual encouragement. The first speaker, Reverend W. C. Wendte, offered much-needed words of inspiration, "Step by step they are climbing up, and soon the time will come when American people will rise up in new-found manhood and say: 'my sister, we will not ask you to receive the ballot from our hands as a condescending privilege, but will ask you to go forward and take it as your inalienable right.'"[10]

Ohio delegates and conference organizers raised their voices to reinforce this sense of determination. Frances Barker Gage, too weak from injuries sustained in a wagon crash, sent a letter to the assembly to be read aloud in support of the cause. Several other Ohio speakers took the platform, including Hannah Conant Tracy Cutler. Stone was the final speaker of the convention. In her address, she described how disenfranchisement and degradation created helplessness among women, which, in turn, weakened the nation.[11] Stone's words sought to create within the hearts of the women delegates an appropriate resentment for being denied what they saw as the most important tool for their own self-empowerment. Another decade ended without enfranchisement. Could conference attendees and suffragists everywhere channel the resentment that had been festering for over thirty years to fight on?

A New Generation of Ohio Suffrage Leaders

The off-again, on-again consideration of the federal women's suffrage amendment, stronger relationship to the WCTU, and US expansionism continued into the 1880s. The new decade would result in few successes for suffragists at the national level or in Ohio. Established leaders such as Susan B. Anthony, who had spoken at the South Newbury Chapel in 1879, continued to reach out to Ohioans, sending numerous letters and petitions to state conventions and in support of the federal amendment, all to no avail.[12] During this time, Ohio's suffrage movement was marked by changes in its leadership, organizational capacity, agenda, and political strategizing. The new generation of the state's leaders included groundbreakers such as Rosa Klinge Segur, Elizabeth Greer Coit, her daughter Belle Coit Kelton, and Frances Jennings Casement.

Born in Hesse, Germany, Rosa Klinge Segur (1833–1906) founded the Toledo Woman's Suffrage Association and served as an officer, including president, for many years. She worked as a schoolteacher, wrote a column for the *Toledo Blade,* and took over her husband's business after his death.[13] A friend of Susan B. Anthony, Klinge Segur led the fight to change Toledo's public library policy to allow women their own library cards. She also successfully promoted hiring women physicians in state institutions and hiring police matrons across Ohio. Among her other successes, she lobbied the state government to extend married women's

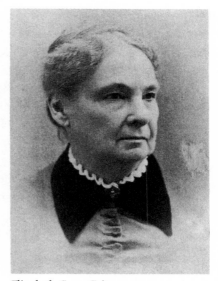

Rosa Klinge Segur *Elizabeth Greer Coit*

property rights.[14] Fellow suffrage leader Elizabeth Hauser described Klinge Segur as a woman who would "unflinchingly have faced the cannon's mouth for her cause."[15] She wrote a memoir about her activism titled *A History of Woman Suffrage in the Maumee Valley.*[16]

The League of Women Voters of Ohio Honor Roll described Elizabeth Greer Coit as, "president of the first suffrage society of Columbus, a lecturer on Woman's Rights and one who fought valiantly for political education for women through the very early days of the struggle for equal rights."[17] Born in Worthington, Ohio, a daughter of Irish immigrants, Greer Coit worked as a teacher until she married, and she developed her administrative skills during the Civil War while leading the Columbus Soldier's Aid Society. In 1884, she and her adult daughter Belle attended a state suffrage conference. A week later, she created the first women's suffrage organization in the capitol city. She hosted meetings in her home for many years and served as treasurer of the state suffrage association for fifteen years.[18] At the 1898 suffrage convention in Cincinnati, Greer Coit delivered a paper about what it was like to be a suffragist for fifty years. She reflected, "The attitude of communities has changed. People formerly burlesqued the suffragists; now women who have espoused the cause receive the utmost consideration."[19]

Her daughter, Belle, was teased at school because of her mother's ardent and outspoken support for women's rights. One day, eight-year-old Belle, with tears in her eyes, asked her, "Mother are you strong-minded and do you wear pants?" The question obviously reflected the stereotypes of her time. Greer Coit responded, "Well, my dear, I hope I am strong-minded. I should be very sorry to have had children if I were feeble-minded."[20] Belle would become a strong suffrage leader in her community, following her mother's example, and though Greer Coit did not live long enough to see women win the ballot, her daughter did.

Born in Painesville, Ohio, Frances Jennings Casement (1840–1928) supported both abolition and women's suffrage with encouragement from her father, Charles Jennings, a well-known abolitionist. She was a prime example of local suffrage leadership that came to influence the movement at state and national levels. In 1884, Rachel S. A. Janney called a convention in Columbus, but so few suffragists attended that it was thought best not to create a permanent statewide organization. Nevertheless, the group elected Judge Ezra B. Taylor president and Jennings Casement vice president. Taylor declined the position because of responsibilities as a representative in the US Congress, leaving Jennings Casement to take over. Jennings Casement decided initially to establish the Painesville Equal Rights Association in the following year instead of a statewide organization.[21] A true pragmatist, Jennings Casement chose the organization's name carefully. She realized that many of the most articulate opponents of women's suffrage were women themselves. She also knew many women and men did not agree on universal suffrage. Therefore, she chose a name that would be less likely to alienate potential members. Her strategy worked, enabling her to expand the organization throughout all of Lake County. She encouraged members to be active recruiters. Membership tripled the first year. Eventually, the membership grew to over two hundred, spread across three branches.

Frances Jennings Casement

Jennings Casement delivered one of her early speeches on behalf of women's rights, "Why Farmers' Wives and All Other Women Should

Have the Ballot," at the Farmers' Institute in Lake County, Ohio. Her address began with a lengthy list of quotations from famous men who supported women's suffrage. She assured her audience that voting would not be compulsory. Those women who did not want to vote would not have to vote. She emphasized that thousands of petitioners did want the ballot, as mothers, to protect themselves and their families. Jennings Casement then called for greater organization within the state, using the Painesville Equal Rights Association as an example. She emphasized that women's domesticity and gender equality were not contradictory wants, "For we are women with pleasant homes, good husbands and children, and have as much to make life desirable as any women . . . but we believe in this, we believe that woman should stand equal before the law with men. We believe it is our duty to do what we can and to lend our influence in bringing about this equality."[22]

This organization's membership included mostly wealthy women who met regularly in each other's homes for parlor talks to discuss important social questions. Jennings Casement believed the organization should serve as a discussion forum and educational haven for the town's progressive women. She once wrote in her diary, "There is a real need for a society in which women could come together and talk of the questions of the day and inform themselves upon those questions and do what they might for the education of themselves and their sisters. . . . The time will soon come when men and women will stand as equals and have an equal voice in the government of our nation."[23] Often she would share an article from Lucy Stone's suffrage newspaper, the *Woman's Journal*, before leading a discussion of the issue it addressed. The range of issues the Painesville Equal Rights Association devoted itself to also extended beyond suffrage.[24]

The parlor talks evolved into petitioning the Ohio General Assembly, and the group's meetings moved from members' homes to city halls and county courthouses. At one rally, Jennings Casement organized at the Lake County courthouse, she gave a particularly blunt speech calling on the Ohio General Assembly to allow women to control their dowries and earnings and to retain guardianship of children after divorce. Many men in the audience responded with hostility.[25] Jennings Casement refused to back down, and she was politically savvy enough to know that she needed to court the support of prominent men. She enlisted her husband, John, to give a speech about the importance of equality between men and women. John was an avid and lifelong supporter of women's rights. In his speech,

he encouraged the reform-minded men of Painesville to support women's suffrage. When the couple temporarily moved to Wyoming for his work on the transcontinental railroad, John became a territorial representative working successfully on behalf of both statehood and women's suffrage. After returning to Ohio and before his work took the family to Costa Rica, he lobbied for voting rights for women as an elected representative to the state assembly.[26]

During Reconstruction, most Ohio suffragists tried to avoid the partisanship characterizing the AWSA and NWSA rivalry. However, the Casements were good friends with Anthony, Elizabeth Cady Stanton, and Stone. Unlike presidents of other suffrage societies in Ohio, Jennings Casement reached out to the leadership of both national suffrage associations. Cady Stanton stayed at their home for a week in 1885 during one of her many campaigns through Ohio. Anthony regularly sent letters of advice regarding suffrage work in Ohio. Stone shared free copies of the *Woman's Journal* and other suffrage literature with Jennings Casement, and she helped her to compose the organization's constitution. That Jennings Casement was able to negotiate cordial and productive relationships within the two rival national suffrage organizations was a testament to her diplomacy skills.

Stone was so impressed with Jennings Casement's association that she invited her to speak at the Sixteenth Annual AWSA convention, in Chicago, in 1884. Jennings Casement loathed public speaking, and she considered herself ineffectual.[27] However, she regularly mastered this aversion to fulfill her role as a suffrage leader. Having accepted Stone's invitation, Jennings Casement spoke about Ohio's suffrage work, but her speech was most noteworthy because it made a strong argument for the need to set aside differences between the leadership of the AWSA and the NWSA for the sake of the movement. She rightly pointed out that these differences had become quite small and that a merger could strengthen the movement's infrastructure. Her call for unity predated the unification of the two organizations by six years, and it reflected the sentiment of most local suffrage organizations. At the same convention, Conant Cutler delivered a touching speech of tribute to Barker Gage, who had passed away shortly before the meeting.

Anthony also was impressed with Jennings Casement's leadership in Ohio. In 1888, she sent Jennings Casement a letter encouraging her and her followers to "carry the agitation of our question into your 27 Dis-

tricts."[28] Two years later, after the AWSA and NWSA merged into the National American Woman Suffrage Association (NAWSA), in her role as honorary president of the new organization, Anthony wrote to Jennings Casement that she wished the latter to take over the Ohio organization.[29] Jennings Casement did become president of the state organization, and in 1907, John and Frances both became NAWSA life members. Leaving her mark on the movement, Jennings Casement fortunately lived long enough to see ratification of the Nineteenth Amendment.[30]

Founding of the Ohio Women's Suffrage Association

If Ohio suffragists were to continue the fight, they would require a pragmatic outlook and a more efficient organizational structure. By the 1870s, there were thirty-one different women's suffrage organizations operating in Ohio.[31] Some were short-lived, such as the Woman's Suffrage Association of Dayton, which lasted one year before it disbanded. Others lasted decades, among these the Toledo Woman's Suffrage Association, the oldest continuing operating society in the state, which started in 1869 and was in operation after 1912.[32] In 1885, Jennings Casement decided it was time for a statewide suffrage organization, and she set up headquarters of the Ohio Women's Suffrage Association (OWSA, not to be confused with the Ohio Women's Rights Association, which was founded in 1853) in Painesville, her hometown.[33] She served as president of the first statewide suffrage organization in Ohio, from 1885 to 1888, and laid the foundation upon which the future of the state movement would be built.

Many of the state's existing suffrage clubs joined as autonomous OWSA members. Avoiding partisanship, the founding members decided not to affiliate with national suffrage associations or political parties. The OWSA adopted a wide variety of strategies and tactics to advance their cause, including public lectures, fundraising events, media campaigns, literature distribution, petitions, and letter-writing campaigns. OWSA presidents following Jennings Casement came from across the state. They included Martha H. Elwell of Willoughby (1888–91), Caroline McCullough Everhard of Massillon (1891–98), Harriet Brown Stanton of Cincinnati (1898–99), Harriet Taylor Upton of Warren (1899–1908, 1911–20), and Pauline Perlmutter Steinem of Toledo (1908–11). OWSA annual convention locations, which crisscrossed the state, were held in Warren, Salem,

Delaware, Cincinnati, Ashtabula, Alliance, Akron, and Athens.[34] Until the 1890s, Ohio local associations remained small and scattered, with the majority headquartered in small towns and rural areas in the northeast. Most OWSA members were white middle- and upper-class women. As in the rest of the nation, the connection between women of color and working-class women to the suffrage movement grew slowly in Ohio.

Women's Suffrage during Social Upheaval

The political and economic landscape of the United States changed remarkably by the 1880s. Industrialization, urbanization, and immigration combined to challenge how people made sense of the world and their place in it. The nation's working class was transformed from one predominantly native-born to one almost entirely immigrant. In Ohio, the majority of immigrants arrived from Ireland and Germany. Women participated in national debates on topics ranging from the Chinese Exclusion Act of 1882 to the Dawes Act ("Indian allotment") of 1887. Immigration debates such as these often intersected with suffrage debates, and all too frequently, suffrage leaders strategically incorporated nativism to create space for suffrage arguments about citizenship and the ballot. Even suffragists and WCTU members who rejected blatant nativism patronizingly characterized their work as "saving" immigrant women and women factory workers.[35]

In addition to economic challenges, political corruption and pandering to special interests exacerbated social problems, causing many people to lose their trust in government's ability to address these crises. During this time, from the US Congress to city governments, political patronage was the order of the day. For example, after the bloody riot of 1884, in which the Cincinnati courthouse burned down and many people died in mob violence, George Cox emerged as one of the nation's most powerful city bosses, ruling through a system of bribery and political favors.[36] In response to this period of uncertainty, support for third-party candidates increased, posing at least a temporary threat to the power of Republicans and Democrats.

One third party, the Prohibition Party, continued to support women's enfranchisement because of the close tie between temperance and suffrage. This party's influence grew more at the state level than the national, but Cleveland was invited to host the national Prohibition Party conven-

tion in 1890.[37] The WCTU and the Prohibition Party aligned their goals for obvious reasons. Just as the WCTU's infrastructure was essential to the suffrage movement, it also was a critical part of the early Prohibition Party success. The two entities created a formal alliance in 1882. The WCTU helped the party grow its voter base in the 1884 election. Not long thereafter, the relationship between the two organizations diverged due to differences in opinion about how best to achieve prohibition.[38] Moreover, many male prohibitionists believed women's roles should be downplayed and the party should distance itself from women's suffrage to compete successfully with other major political parties.[39] Considering it a political liability, the Prohibition Party did little to advance women's suffrage.

Suffragists hoped to capitalize on the fact 1880 was an election year—if they could tap into the political machinery, then perhaps they could spur action on the Susan B. Anthony amendment. They knew support from a major party was crucial, so movement leadership sent individual appeals to organizers of the major parties' conventions urging them to include a suffrage plank, and they requested the opportunity to address delegates directly. Anthony wrote letters to each party's presidential candidates asking that they openly endorse women's suffrage. Only Ohio's James Garfield could be bothered to respond, and in his letter—the politest of brush-offs—he indicated he had not yet reached an opinion regarding whether it was in the best interest of the nation for its women to vote.[40]

Cincinnati continued to play a significant role on the national stage by hosting the Democratic Party's convention. Convention organizers allowed NWSA representatives to attend. Further, they permitted Anthony to ascend to the platform but not to address the audience herself. Instead, a male clerk presented the memorial, and he read a text of her speech aloud.[41] The Republicans also gave a nod to suffragists at their convention that year. Suffragists' endeavors to change attitudes about women and US politics were slow going. Still, the fact that two of the major parties acknowledged them at national conventions indicated they had crossed an important threshold: candidates running for office realized the day may come when they would have to consider women's political opinions.

A series of razor-thin presidential victories, including those of Ohioan James Garfield of Moreland Hills in 1880, Grover Cleveland in 1884, and Ohioan Benjamin Harrison of North Bend in 1888, complicated suffrage politics. Because of these highly contested elections, presidents lacked mandates, and they thus held little power. Ohio suffragists courted the

support of each president, especially those from their home state, only to be generally ignored. None of these presidents had the power to influence the US Congress to support women's enfranchisement, even if they personally supported the cause, though most did not.

By the time Garfield won the presidency, his position on women's enfranchisement became clear. He stood in opposition, and his wife shared his stance. Garfield attacked members of women's clubs for neglecting their families, maintaining, as many did, that self-fulfillment and self-improvement were selfish goals for women. First Lady Lucretia Garfield was a member of Ohio's anti-suffrage association.[42] Yet, when she discovered that one of her husband's doctors was paid less because she was a woman, she insisted the situation be remedied. After Garfield's assassination, President Chester B. Arthur also avoided the topic of women's suffrage. Arthur's sister Mary served as First Lady during his term. She was a member of the Albany Association Opposed to Women's Suffrage.[43]

Arthur's successor, Grover Cleveland, also did not support women's suffrage. After he left the White House, Cleveland pronounced, "Sensible and responsible women do not want the vote."[44] First Lady Frances Cleveland concurred with her husband's position, believing women were not intelligent enough to vote. She served as vice president of the New Jersey Association Opposed to Woman's Suffrage and as president of the Princeton anti-suffrage chapter. The decade closed with Harrison in the White House. This Ohioan held a favorable view of women's issues. However, like his predecessors, he successfully avoided the topic of women's enfranchisement. Notably, by appointing presidential secretary Alice Sanger, Harrison became the first in office to take a cautious step toward increasing female representation in the federal government.[45] First Lady Caroline Harrison believed in the power of women, and she encouraged women to take an active part in the public sphere and to be educated. She openly expressed her interest in women's issues, though she did not take a public stand on suffrage.[46]

The federal government's work on women's suffrage throughout the 1880s took place in a series of fits and starts. In 1882, suffragists across the nation raised their hopes when the US Congress formed the Select Committee on Woman Suffrage.[47] However, the following year, the US Senate renewed the select committee, but the US House of Representatives' Committee on Rules refused to follow suit. After several representatives opposed renewing the select committee, Speaker Warren Keifer

of Ohio defiantly decided to present the question directly to the House. He offered a strong plea in support of women's rights, "There are considerations due to the women of this country which ought not to be lightly thrust aside. For thirty-five years they have been petitioning and holding conventions and demanding that certain relief should be granted them, to the extent of allowing them to exercise the right of suffrage."[48] His patience, and that of suffragists across his home state, was wearing thin.

In 1884, both the Senate and the House finally issued reports, but again no votes were taken. Among the members of the House Judiciary Committee supporting the amendment were Ohio's Ezra B. Taylor, Thomas Reed of Maine, Moses McCoid of Iowa, and Thomas Browne of Indiana.[49] This small band of allies, doing their best to induce a response from their colleagues, advanced a parallel argument in their minority report: "No reason on earth can be given by those who claim suffrage as a right of manhood which does not make it a right of womanhood also. If suffrage is to be given to man to protect him in life, liberty and property, the same reasons urge that it be given to woman, for she has the same life, liberty and property to protect." Their report concluded, "Every reason . . . which bestows the ballot upon man is equally applicable to the proposition to bestow the ballot upon woman."[50]

In 1886, the Senate Select Committee on Woman Suffrage favorably reported the Susan B. Anthony amendment to the full Senate, but again no action was taken. The following year, the Senate relented, granting a hearing on the issue. At last, suffragists could detect some forward movement. The committee included two Ohioans, George E. Seney and Ezra B. Taylor. The latter, along with W. P. Hepburn of Iowa, Lucien Caswell of Wisconsin, and A. A. Ranney of Massachusetts, issued a report supporting the cause. The special committee provided several reasons for its support of women's suffrage, including, "Because their own good demands it. . . . The ballot is a powerful weapon of defense, sorely needed by one too weak to wield any other," and "Woman's vote is needed for the good of others. . . . Politics must be purified, or we are lost. To govern this great nation wisely and well is not degrading service; to do it, all the wisdom, ability, and patriotism of all the people is required. No great moral force should be unemployed."[51] This report, coupled with the WCTU's two hundred thousand signed petitions supporting the Susan B. Anthony amendment, still was not enough to motivate the US Congress to vote. At long last, the measure came to a vote by the full Senate in 1887. Patience was not a

reward as the measure failed, sixteen to thirty-four.[52] Ohio's senators were divided: John Sherman voted in favor of the amendment, and H. B. Payne voted against. Suffragists had waited for nearly a decade for this vote, only to have their hopes dashed at a 2:1 margin. Certainly, this loss was the worst of the movement to date, and it was a crushing blow to even the most resolute suffragists across the nation.

The US Senate issued four favorable majority reports in 1882, 1884, 1886, and 1889, but it voted on the measure only once, in 1887, resulting in a massive defeat. The US House of Representatives issued one favorable majority report in 1883 and two adverse majority reports in 1884 and 1886, but it never scheduled a vote on women's suffrage during the entire decade. Efforts to obtain the ballot through the US Congress seemed increasingly futile. Embattled suffragists knew they must regroup and keep their issue in the public eye despite the federal amendment's defeat. It was now the fortieth anniversary of the Seneca Falls convention. Knowing a prime public relations opportunity when they saw one, Cady Stanton and Anthony organized an anniversary celebration. Their goal was nothing short of moving the debate into an international spotlight, so they invited delegates from a number of other countries where women were fighting for their rights to join them in Seneca Falls. This anniversary event led to the founding of the International Council of Women.[53] US suffragists strived to impress upon their male governmental representatives the fact that if other nations were granting women rights, it would be embarrassing for the United States, as a democracy, not to do the same.

Ohio's 1880s Suffrage Agenda

The majority of resistance to women's rights in Ohio, and much of the nation, was in response to the demand for the ballot and the political power it represented. Politicians and the public were more agreeable to economic demands than political demands. More women, especially those who were white, made their ways into universities and the professions, but the vote continued to elude them. Throughout the 1880s, Ohio's suffragists advanced a wide repertoire of efforts to enfranchise women. One strategy suffragists continued to employ was the removal of the word *male* from the state constitution. They also sustained their labor

on behalf of a separate state constitutional suffrage amendment. Additionally, Ohioans maintained support of the federal amendment. Finally, they begrudgingly decided to consider partial measures such as school or municipal suffrage.

The previous battle to enfranchise Ohio's women at the 1873–74 Constitutional Convention ended in a loss by two votes. Not until 1888 did suffragists again convince the state legislature to submit another amendment for full suffrage to voters. OWSA President Elwell sent a memorial to the chair of the Joint Commission on the Revision of the Ohio Constitution, Charles Townsend, requesting that the word *male* be stricken from the constitution.[54] The OWSA sought and gained permission to address the legislature. Elwell gave a brief address and presented the resolution in person. Sarah Winthrop Smith, of Cincinnati, also addressed the joint legislative committee that day, "You, gentlemen, have been appointed to decide whether the Constitution of Ohio needs any revision. As representatives of one-half of the people, you cannot justly ignore all consideration of the rights, privileges, and immunities of the remainder. . . . as it now stands, deprives one-half of the State of the fundamental rights in the government."[55] Once again, Ohio's legislature rejected both the logic and passion of suffragists' arguments. The measure did not pass. And in yet another blow, the following year, the state senate rejected a second full suffrage resolution, nineteen to nine.[56]

In response to these back-to-back losses, Ohio's suffragists restructured their agenda to include municipal suffrage. In 1888, Representative E. J. Kennedy of Cuyahoga County supported a bill that would allow women to vote for municipal officers but not to run for office themselves. Elwell invited women from all parts of the state to come to the Hall of Representatives to support the bill. Leaving no stone unturned, suffragists wrote every member of the Ohio General Assembly asking for support, and every auxiliary Ohio suffrage association sent memorials to Governor James Edwin Campbell.[57] In addition to Ohio supporters, national leaders such as Anna Howard Shaw, one of the most powerful leaders of the women's movement at the time, spoke on behalf of the Kennedy municipal suffrage bill in front of the legislature early in 1889.[58] Regrettably, this coordinated advance fell short; representatives rejected even this partial measure.

Swallowing their pride yet again, Ohio's suffragists lowered their sights to focus on school suffrage, bestowing the right of women to vote on school

issues and to be elected to local school boards. Previously, Albert Munson of Medina had first urged Ohio's Judiciary Committee to consider school suffrage in 1873; however, his proposal was buried in committee. In 1880, George Clement, of Lake County, had introduced a school suffrage bill, but it, too, was buried in committee.[59] Ohio's legislature continued to ignore suffragists' demands and to stonewall the movement at every turn. Five more years passed before Ohio suffragists dared make another attempt at school suffrage. In 1885, supporters managed to get a vote on the measure, but once again the state legislature denied them this victory. If this defeat were not enough, yet another school suffrage bill ended in a loss the following year. Two failed attempts to get the measure out of committee, and two failed votes between 1873 and 1886, did little to inspire hope in Ohio's suffragists, who already believed they were settling for a significantly compromised goal. Full suffrage must have seemed as far off as ever to Ohio's exhausted and demoralized reformers. In total, twenty-one states granted women school suffrage before Ohio did so.[60]

The inertia of the state general assembly matched that of the US Congress. Despite decades of activism, most of Ohio's male politicians were as determined as ever to shut women out of the political process. All in all, the 1880s were a decade of defeat for Ohio's suffrage movement: four constitutional amendment failures, two school suffrage losses, and two municipal suffrage losses. Suffragists had tried every angle, but Ohio legislators refused to give an inch. The all-male power structure was as impenetrable as ever. Ohio's women remained, despite multiple and varied attempts to win the ballot, largely as disempowered politically as before the fight began. In this battle of wills, could suffragists match politicians with a sufficiently unrelenting determination of their own?

There was one ray of hope: Ohio's reformers of the 1880s won an important economic right that had political implications. In 1884, the Ohio legislature passed a law granting married women the right to sue and be sued, thus establishing their autonomous legal identity. Even more dramatically and importantly, in 1887, married women of Ohio were essentially emancipated from their husbands' control.[61] The act explicitly created the legal right for wives to hold and dispose of their own separate property, for the most part abolishing husbands' legal control. Husbands and wives, widows and widowers, now enjoyed equal property rights. Decades of activism and the fact other states had started to grant similar rights finally generated a win for Ohio's women's rights reformers.

This important stride decreased some women's economic dependency on men, and, more notably, the resulting political implication meant married women now had independent legal identities. This act was an essential first step toward the recognition of women as autonomous human beings who have ownership of their own bodies. If women's rights reformers grounded their arguments in the notion that women were independent, a law establishing separate legal identity was crucial to that case. Additionally, even though eligibility for enfranchisement no longer legally depended on property ownership, as it had through most of the nation's early history, an act permitting wives to own separate property improved perceptions of their social status as political beings.

The 1890s brought important changes in the leadership, organizational capacity, agenda, and political engagement of Ohio's activists. African American and immigrant women claimed leadership roles. The movement's infrastructure adapted in response to the increased connection to the club movement, the merger of the two national suffrage organizations, and the formation of anti-suffrage organizations. The movement's agenda continued to focus on school and municipal suffrage, but it also prioritized women's officeholding and countering anti-suffragists. Populism changed the nature of politics at the state and national level, and this transfigured body politic profoundly changed the context in which Ohio suffragists operated. As the meaning of women's political power continued to evolve, one thing remained the same as the century ended—suffragists still faced misogyny and indifference at every turn.

Early Contributions of African American Women to Ohio Suffrage

That Ohio admitted people of color to universities earlier than the rest of the nation meant the state attracted a treasure trove of leadership talent. However, racism and nativism continued to plague the women's movement as it had before the Civil War and during Reconstruction. Many white middle- and upper-class suffragists still feared that including working-class women, immigrant women, or women of color in their efforts would prevent passage of suffrage legislation. Carrie Chapman Catt's 1894 Iowa speech is a case in point: "This government is menaced with a great danger. . . . That danger lies in the votes possessed by the males in the slums of the cities and the ignorant foreign vote which was sought

to be brought by each party, to make political success. . . . There is but
one was to avert the danger—cut off the vote of the slums and give to
women."[62]

Sharing this concern, but unlike many other women's rights organiza-
tions at the time, the OWSA did not directly discriminate against African
American or immigrant membership and participation. Cleveland suf-
fragists made sure to print their publicity posters in multiple languages
to reach out to all voters.[63] The state's leadership also sought suffrage
speakers in multiple languages for the same reason. Such efforts were
too often inconsistent, however.

There is evidence that some OWSA leaders may have worked closely
with African American community leaders. For example, African Ameri-
can women ran the suffrage information booth in downtown Dayton one
day per week, which indicates a level of cooperation within that chap-
ter.[64] In fact, Dayton actively sought support from working-class, Afri-
can American, and immigrant women. The inclusive nature of the city's
suffragists might have been unique. While Dayton suffragists believed a
broader base of support was necessary for women to win the vote, most
national suffrage leaders saw such support as a disadvantage. The Day-
ton suffragists also faced opposition to their inclusiveness from the state
level. One OWSA president wrote in an undated letter, "I believe colored
women should have the same rights as white women and colored men.
But I do wish this crowd could have held off a little longer. There is no
use of incensing Southern Senators. If they had held off we would have
gotten it for all of us[;] now their pressing may make us lose it. The suf-
fragist's row is a hard one."[65]

African American communities at this time actually expressed a grow-
ing interest in women's suffrage. Despite the Fifteenth Amendment, Af-
rican American men were disenfranchised in various ways as a culture
of segregation and racism expanded across the nation. African Ameri-
can men and women came to see the ballot as a very necessary means
of protection for the race.[66] Many African American women leaders
stepped forward to claim their rightful place within the suffrage move-
ment. Some of these leaders shared their talents as members of WCTU
chapters, church groups, suffrage clubs, and other civic organizations.
Although most of these groups were segregated, especially in the South,
a limited number of state and national suffrage events did bring together
women of various races.

Women of color, mostly educated and middle class, marshaled other significant organizational efforts on behalf of women's rights in Ohio and across the nation, whether in partnership with white suffragists or, as was more often the case, as an independent force.

Like white suffragists, African American leaders sought to establish an equal voice in US politics, but they also saw the ballot as a means of racial uplift. Mary Church Terrell, Ida B. Wells-Barnett, and Frances Watkins Harper, among others, founded the National Association of Colored Women's Clubs (NACW) in 1896. The association brought together more than a hundred African American women's clubs to pursue the goal of achieving equality for women of color.[67] Both Church Terrell and Watkins Harper had connections to Ohio. Born to former slaves in Tennessee, Church Terrell (1863–1954) moved to Ohio in 1871 to attend school, first at Antioch, in Yellow Springs, and later at Oberlin, where

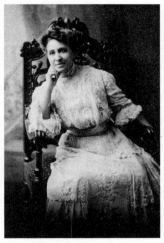

Mary Church Terrell

she enrolled in the "gentleman's course" of studies in classics. After earning both her bachelor's and master's degrees, she took a position teaching at Ohio's Wilberforce University before moving to Washington, DC. Her father became one of the first African American millionaires in the South.

Church Terrell's Ohio education served her well in both her career and her activism.[68] A renowned speaker and writer, she campaigned extensively on behalf of both antilynching and suffrage throughout the United States to both Black and white audiences. She participated in parades and picketed the White House in support of suffrage. Her motto for her work with the NACW was "Lifting as we climb." Church Terrell was an active member of various reform organizations, including the NAACP and NAWSA. She was a close friend of Susan B. Anthony, and she delivered several speeches in support of African American women's voting rights at suffrage conventions. In 1904, Church Terrell was the only African American woman invited to speak at the International Congress of Women in Berlin. In German, French, and English, she gave her speech about the challenges facing women of color in the United States, receiving a standing ovation. Before she passed, she published an autobiography, *A Colored Woman in a White World.*[69]

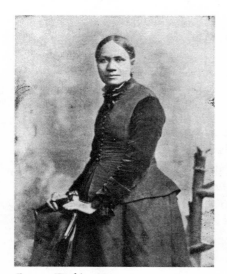

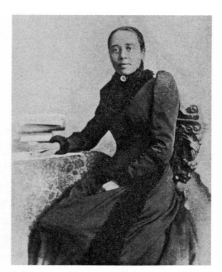

Frances Watkins Harper *Julia Anna Haywood Cooper*

Frances Watkins Harper (1825–1911) moved from her birthplace in Baltimore, Maryland, to Columbus, Ohio, in 1850 to teach domestic science at Union Seminary. She later moved to York, Pennsylvania, where she both taught and published poetry. While living in Philadelphia, she worked with the Underground Railroad. For eight years, she lectured throughout New England, the Midwest, and Canada on abolitionism. In 1860, she returned to Ohio to live with her husband on a farm near Cincinnati and to start a family. At this time, she retired from public life. After the Civil War and the death of her husband, this intrepid reformer left the state to join the lecture circuit, addressing African American rights, temperance, and women's rights. Watkins Harper was a member of the AWSA, the American Equal Rights Association, and the WCTU. Before she died in 1911, she published several novels.[70]

Julia Anna Haywood Cooper was well known as an African American leader of the women's rights movement who had close ties to Ohio. Born in 1858 in Raleigh, North Carolina, to an enslaved woman, Haywood Cooper began her educational career as a young woman on scholarship to North Carolina's St. Augustine's Normal School and Collegiate Institute, which was created to provide educational opportunities to newly freed African Americans. While at St. Augustine, she fought for the right to study Greek, a subject reserved for male theology students. She excelled in her

studies, earning a scholarship in 1881 to attend Oberlin College. Because she sought a more rigorous academic challenge, she fought to complete the "gentleman's course" instead of the two-year "ladies' course." During her undergraduate studies, Haywood Cooper lived with the family of a white college professor. A friendship offering both mutual support and intellectual stimulation grew between Haywood Cooper and the Churchill family that lasted a lifetime. She completed her degree, graduating with honors in 1884, and the university administration authorized her to deliver the commencement address that year.[71]

After graduation, Haywood Cooper began a lifelong teaching career, starting at Ohio's Wilberforce University, a historically Black institution, where she briefly taught modern languages. She then took a teaching position offering Latin and mathematics at a preparatory high school for African Americans in Washington, DC. Committed to furthering her own education, Haywood Cooper returned to Ohio to earn a master of arts degree in mathematics in 1887, again from Oberlin College.[72]

Haywood Cooper was very active in racial and gender reforms, including the Black women's club movement. She held a leadership role in the Washington Colored Woman's League that eventually became a part of the NACW. Among her many professional accomplishments, she helped to establish the Colored Women's League in 1892 and the Colored Young Women's Christian Association in 1904. Haywood Cooper ended her career as president of Frelinghuysen University, a college whose mission was to provide academic, vocational, and religious education for African American working adults.[73]

Haywood Cooper believed education was the most important means of improving conditions for African Americans, and, in particular, the education of women. The titles of her countless speeches reveal her commitment to this cause; for example, "Womanhood: A Vital Element on the Reintegration and Progress of a Race," "Higher Education of Women," and "The Needs and the Status of Black Women." In such speeches, she typically argued that women were the moral conscience of the country, and she insisted they were intelligent enough to help solve the nation's problems.

Haywood Cooper also countered the notion that educating a woman reduced her eligibility for marriage and motherhood. She argued education was a means of improving women's ability to manage households and to ensure marriages based on equality.[74] She urged her audiences, "Let us insist . . . on special encouragement for the education of our

women and special care in their training. Let our girls feel that we expect something more of them."[75] Haywood Cooper certainly expected a great deal of herself, and her reputation as a teacher, scholar, orator, and activist grew at the national level as a result. She was the kind of woman who met personal and professional challenges head-on. At age fifty-seven, she adopted her nephew's five orphaned children, and while raising them, she worked ten years to complete her dissertation on French policies regarding slavery. She graduated from Paris's Sorbonne, earning her PhD at the age of sixty-seven.[76]

Haywood Cooper is most well known for her book *A Voice from the South,* published in 1892 by Aldine Printing House in Xenia, Ohio. Like her speeches, the book argued that African American women had an essential role to play in racial uplift. Many scholars consider this the first book-length volume of Black feminist thought in the United States, and many call her the "mother of black feminist thought."[77] Haywood Cooper wrote most famously, "Only the BLACK WOMAN can say when and where I enter in the quiet undisputed dignity of my womanhood, without violence or special patronage; then and there the whole Negro race enters with me." Like Sojourner Truth before her, Haywood Cooper used every opportunity to challenge white suffragists to be more inclusive. Once, while speaking to a group of white suffragists, Haywood Cooper asked, "Is not woman's cause broader, and deeper, and grander than a blue stocking debate or an aristocratic pink tea?"[78] In response to what she saw as racism within the movement, she insisted, "It is not the intelligent woman versus the ignorant woman, nor the white woman versus the black, the brown, and the red. It is not even the cause of woman versus man. Nay, tis woman's strongest vindication for speaking." Continuing, she implored, "The world needs to hear her voice. Hers is every interest that has lacked an interpreter and a defender. Her cause is linked with that of every agony that has been done, every wrong that needs a voice."[79] Her 105-year lifetime of activism, teaching, and scholarship made a lasting impact on her students and the women's movement, and she lived long enough to see the Nineteenth Amendment pass.

Hallie Quinn Brown—known to most as "Miss Hallie"—was another trailblazing African American woman with ties to Ohio who contributed significantly to the cause of women's suffrage. Born in Pittsburgh, Pennsylvania, to formerly enslaved parents, Quinn Brown became a world-famous orator and social reformer. Her family moved first to Canada,

and in 1870 to Wilberforce, Ohio, so she and her brother could attend the university. Quinn Brown enjoyed a lifelong career as a scholar-teacher.[80] Like Haywood Cooper, she believed in the power of education to uplift woman and her race. She devoted her life to the teaching profession, focusing on increasing literacy of formerly enslaved children.

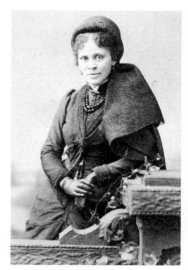

Hallie Quinn Brown

The first school at which she taught, on Sonora plantation in Mississippi, was in much need of repair. She was unable to persuade school officials to improve the conditions; however, convinced her students deserved better, she took matters into her own hands. Her can-do attitude led her to recruit the services of two of her larger male students. She mounted a mule and rode together with the two boys to a local gin mill, where she obtained cotton seed, mixed it with earth to form a mortar, and pasted the holes in the building shut with her own hands.[81] After the school project ended, Quinn Brown set her sights on converting one of the plantation's shacks into a proper church. After that, she added teaching Sunday school to her duties.

Despite her successes, Quinn Brown left the community after hearing the horrific news of two local lynchings.[82] She relocated next to the swamplands outside Columbia, South Carolina, where she was shocked to find even worse living conditions than in Sonora. At that point, Quinn Brown took a position as dean of Allen University, an African Methodist Episcopal college in Columbia, from 1875 to 1887. Eventually, she returned to Ohio to teach in the Dayton public schools. She petitioned the local board of education to open a night school for the town's migrant adults, and she served as one of its teachers.

After teaching and serving as dean of women at the Tuskegee Institute in 1892, she returned to Ohio a third time, to work as a professor of elocution at her alma mater. She completed a course in the art of speech and oratory, and she used her experience as an elocutionist in her teaching.[83] Her education career led her to write several prose collections in which she used African American dialects, both to honor her heritage and to illustrate the difficulties created for language learners denied an education.

Quinn Brown's interest in suffrage began when she attended a lecture Anthony delivered at Wilberforce University on the topic of civil liberties. Based on this inspiration, she participated in numerous conferences on racial and gender equality throughout her life, including the World's Congress of Representative Women at the Chicago World's Fair in 1893, the Woman Suffrage Congress in 1893, the World Women's Christian Temperance Union in 1895, and the International Congress of Women in 1899. At this last event, held in London that year, she noted no women of color were slated to speak. Determined to remedy this oversight, she rose from the floor to detail the daily barbarity of discrimination and lynching in the United States. The audience was spellbound, and the convention organizers were so impressed that they invited her to join them at tea with Queen Victoria and to address future conventions.[84]

These experiences and her administrative expertise led to leadership positions within the women's movement. Quinn Brown avoided association with the NAWSA and the National Woman's Party, instead focusing on African American women's clubs. She founded the Colored Women's League of Washington, DC, in 1893, and later she helped to merge this league with the National Association of Colored Women. She served as this organization's president for four years and later headed its suffrage department. She also was president of the Ohio Federation of Colored Women's Clubs for many years and was elected vice president of the Ohio Council of Republican Women.[85]

Quinn Brown became an internationally known speaker on temperance, educational reform, and women's suffrage; she emphasized her perspective as an African American woman for all three topics. She spoke on hundreds of stages to tens of thousands of people, often making them laugh and cry in the same speech. Her voice was described as magnetic, and many British newspapers praised her as one of the finest female elocutionists in the world.[86] Using her experience and expertise as a powerful orator, Quinn Brown wrote *Elocution and Physical Culture* to emphasize the importance of teaching rhetorical skills, and she published *Homespun Heroines and Other Women of Distinction,* among other works.[87] Her passion for reform carried her abroad for speaking appearances in Germany, Switzerland, France, and the United Kingdom. Quinn Brown's voice became a source of inspiration for anyone committed to making the world more just.[88] She once stated, "To the women of the country I would say it is the last fight that wins the battle, the one march more that wins the

campaign. Women step forward and the victory is yours."[89] After a life spanning longer than a hundred years, she died having witnessed the passage of the Nineteenth Amendment.

The 1890s were a period of transition in the suffragist movement's leadership, not only in terms of its diversification, but also because the first generation of suffragists was well past retirement age. In 1895, Anthony, at seventy-five years old, conducted a six-month cross-country tour promoting women's rights. Her tour itinerary included a stop in Ohio that generated national press coverage. Cady Stanton was slated to speak at the National Council of Women's meeting at Lakeside. However, because she was too fatigued from her suffrage work to attend, Anthony volunteered to serve as her replacement. In front of a large crowd, she suddenly collapsed after delivering her speech. She either fainted from exhaustion or had a small stroke; she described the ordeal as "the whole of me coming to a sudden standstill," and as "like a clap of thunder under a clear sky."[90] Some national publications erroneously announced she would not make it through the night, and others went so far as to claim she already had died. One Chicago editor instructed a reporter to write, "5,000 words if still living; no limit if dead." Louisa Southworth, a close friend from Cleveland, took Anthony to her Lakeside summer home, where Anthony recovered over the course of the next month, reading her obituaries and musing over the fact that so many people who condemned her in life extolled her virtues in death.[91]

Though Anthony recovered and resumed extensive travel to support the cause, it was clear to all that the first generation of suffrage leadership would soon pass. A new generation would take the helm in Ohio. Caroline McCullough Everhard (1843–1902) stepped forward as another Ohio proponent of women's rights whose career spanned both state and national campaigns. Born in Massillon, Ohio, she became highly respected for her indefatigable work on a variety of social causes including women's rights. Betsey Mix Cowles, the organizer of the Salem convention and one of McCullough Everhard's teachers, likely cultivated a feminist consciousness in her pupil at a young age.[92]

McCullough Everhard's father was on the board of directors of the Union National Bank, so she grew up in a well-to-do and well-connected family. After her father died, the bank's board of directors begrudgingly named McCullough Everhard to his seat, making her the first woman bank director in Ohio. The other board members were concerned they would

become the laughingstock of the state, but because McCullough Everhard had inherited so much stock, they had little choice but to accept her leadership.[93] Though she came from a privileged background, she offered an important critique of economic class and its impact on women's rights: "Society women will never learn to stand as members of the human race and demand that no rights or opportunities or privileges be denied them on account of sex. It is the women who rise above the necessity of constant amusement and who put a strong hand to the work of the world who develop the highest capabilities of womanhood." She went on to reflect, "I have the constant feeling that I am *in* society here in our own town and yet not *of* it."[94]

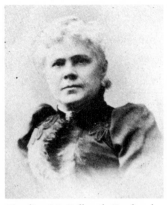

Caroline McCullough Everhard

McCullough Everhard supported the creation of local suffrage organizations. Speaking at the founding of a Canton suffrage society, she assured her audience, "Women will retain all the characteristics that are distinctively womanly. . . . Their homes, surrounded and protected by just and equal laws which they themselves have helped to make, will be dearer to them than ever before." She continued, "Women ought not to be helpless; they ought to have the same opportunities for self-help that men have."[95]

In addition to her banking career, in 1901, McCullough Everhard took over the presidency of the OWSA, and she served in that position for ten years. She was chair pro tem of the 1892 NAWSA convention, the last convention Cady Stanton and Stone attended. In preparation, McCullough Everhard visited her Canton friend and future president William McKinley to request his support of school suffrage.[96] She documented, "He expressed himself as personally in favor of woman suffrage, and he would gladly speak of it in the inaugural if he were convinced the Republican party would sustain him."[97] McKinley had been a proponent of the cause since he was a young man. In 1868, at age twenty-five, he had advocated enfranchising women at a debate held at the Canton YWCA.[98]

Also in 1892, the Judiciary Committee of the US House of Representatives invited suffragists to testify at a hearing on the federal suffrage amendment. Their testimonies again fell on deaf ears. Anthony asked McCullough Everhard to testify in front of the House Judiciary Committee again in 1896. In her address, McCullough Everhard tried to deflect two

common misconceptions about suffrage: women did not really want the ballot and suffragists neglected domestic duties and family life. Addressing the congressmen, she pondered, "You probably wonder, even if you have not asked, why we are not at home looking after our families instead of coming to Washington to pester you. It is just because we want to take better care of our homes that we have come." Further, she asserted, "I for one pay enough in taxes every year to buy a farm and yet I have no right to say how they shall be collected or how expended. It is a mistake to say that women do not want the ballot, for in Ohio, [women] have been educated into being full-fledged suffragists."[99] McCullough Everhard's words chipped away at the bedrock of resistance to women's political empowerment. Slowly, Ohio's male legislators began to contemplate the injustice of taxation without representation and to believe women actually did want to have a say in political affairs. Unfortunately, McCullough Everhard died in 1902 without having a chance to vote in a national election.

One of the strongest voices for women in Ohio history, Harriet Taylor Upton (1853–1945) also rose to power as the century closed. Born in Ravenna, she later moved with her family to Warren. Surprisingly, Taylor Upton initially did not support enfranchisement of women. When she discussed her doubts about suffrage with her father, Ezra, he chastised her, "You little goose, I am in favor of it." Ezra Taylor, a lifelong suffragist, was elected president of the OWSA in 1884. However, he declined the position because of his time-consuming duties as chair of the House Judiciary Committee.[100] Taylor Upton started rethinking her position, and after meeting Jennings Casement, she converted to the cause. Reflecting on her long career as a suffragist, Taylor Upton later wrote, "She [Casement] bombarded me with letters and pamphlets and helped me see the light about the need for woman's suffrage."[101]

Taylor Upton was hardworking and gregarious, known for her distinctive booming laugh, folksy tone, and talent for winning friends to the cause. She was exceptionally well connected, and she was not above leveraging her friendships with Presidents Hayes, Garfield, Harrison, McKinley, and Harding

Harriet Taylor Upton

on behalf of women's enfranchisement. Taylor Upton was one of "Aunt Susan's girls," and Anthony valued her finely honed political radar as well as her organizational and networking skills.[102] Anthony was quick to see the full potential of Taylor Upton's talents, and she wished to see her play a larger national role. Anthony went so far as to write to Jennings Casement, "I wish you were well and could be at the head of the Ohio society so as to relieve Mrs. Upton from that office. She has so much National work to do that she is overcrowded all the time."[103]

Taylor Upton served as OWSA president longer than any other woman. In many ways, Ohio suffrage became synonymous with her name. For eighteen years, from 1899 to 1908, and again from 1911 to 1920, she steadfastly guided the Ohio women's suffrage movement through its many challenges. Her well-placed connections benefited the OWSA in many ways.[104] As Taylor Upton emerged as the voice of suffrage in the state, public speaking became a way of life for her. She said it took years of constant practice before she was "not accompanied by that same paralyzing fear."[105] Her speaking style was straightforward, often filled with humor and stories. In addition to her skills in oratory, Taylor Upton was also a writer. She wrote for magazines and newspapers, and she published two books about northeast Ohio: *A Twentieth Century History of Trumbull County* and *A History of the Western Reserve*.[106]

Taylor Upton emerged as a leading figure in women's suffrage, enjoying a meteoric rise in the national organization. She was elected treasurer in 1894, after just four years of membership. Her longevity within the organization was surpassed by only two other members, Anna Howard Shaw and Alice Stone Blackwell.[107] In some ways, Taylor Upton bridged the divide between the federal amendment and the state legislation strategies, and she gave a sense of continuity and permanence to the movement.[108] At a time when the national organization still had no permanent headquarters, Taylor Upton convinced the NAWSA to hold offices in Warren between 1903 and 1909. Though Howard Shaw was the organization president, Taylor Upton was the actual executive for the first five years of her term. During Taylor Upton's tenure, she arranged the yearly conventions, paid bills, and solicited donations. She also edited the NAWSA monthly journal, *Progress*.[109]

In 1908, Howard Shaw accused Taylor Upton of usurping her power, resulting in an internal feud.[110] In 1913, Taylor Upton's leadership within

the state and national organization earned her a nomination for president of the NAWSA, but she lost overwhelmingly to Howard Shaw.[111] Taylor Upton then took over the OWSA, but she continued to play an active part at the national level. After Ohio ratified the Nineteenth Amendment, she worked relentlessly in other states to secure the vote. In fact, she became one of Chapman Catt's chief aides during the monumental battle in Tennessee that finally won the war.[112]

Not one to rest on her laurels, after ratification of the Nineteenth Amendment in 1920, Taylor Upton became the first woman to serve as vice chair of the executive committee for the Republican National Committee. After four years in that position, she resigned to run, though unsuccessfully, for a seat representing the Nineteenth District of Ohio in the House of Representatives.[113] After she worked briefly as an assistant campaign manager for the Ohio Republican Party, in 1928, the governor appointed her special representative to the Welfare Department. As the first woman in that role, she played an instrumental part in passing child labor laws and prison reforms. Taylor Upton's only elected position was as the first woman on Warren's board of education. Sadly, during the Great Depression, Taylor Upton faced financial ruin, losing almost everything. She had no choice but to leave her home in Warren and to move to California to live with family.[114] Taylor Upton died in 1945 at age ninety in California. Her remains were later moved to her home in Warren, which is now a suffrage museum.[115]

Organizational Mergers

The WCTU continued to provide structure to the suffrage movement. By 1890, the organization had broadened its agenda to address many different issues in addition to temperance and suffrage, and much of its strength came from its decentralized structure. At the national level, however, the most paramount change to the movement's infrastructure was unification of the two national suffrage organizations. After two years of fraught negotiations, the rival organizations finally merged into the NAWSA in 1890. The merger created the largest and most important suffrage organization in the country, the parent organization of hundreds of smaller local and state groups. The organization's mission was to advance women's suffrage

legislation at the state and local levels and to push for a federal amendment. After the merger, the OWSA became an auxiliary of the NAWSA.

The movement's organizational structure was strengthened further by the women's club movement. The start of this movement is largely credited to Ohio's Caroline Seymour Severance. Though this movement started before the Civil War, it grew throughout the 1870s and 1880s, and it came into full bloom in the 1890s. Ohio became one of the leading states, as its number of clubs and membership both grew at an astonishing rate. To accommodate this growth, the Ohio Federation of Women's Clubs formed as an umbrella organization in 1894, coordinating the efforts of forty-one clubs. Shortly after the turn of the century, the state federation expanded to include 289 clubs with membership totaling over ten thousand.[116]

Club members worked on a variety of reform efforts, ranging from child labor laws to suffrage. Several cities supported more than one club. For instance, Cincinnati suffragists were dispersed across three local clubs, including the Central Suffrage Committee, the Twentieth Century Club, and the Susan B. Anthony Club. To support suffrage efforts, members organized a variety of activities, including open-air public rallies, speeches given from horse-drawn carriages, and other novel ways of reaching out to audiences throughout the state. Women's clubs were an important complement to the suffrage movement, providing opportunities to grow membership, increase leadership experience, and illustrate that women could be a vital part of the public sphere.[117]

Racial policies of women's clubs varied between communities. Most women's clubs were segregated by race; seldom did white organizations welcome women of color or suggest integration. Instead, women of color were encouraged to form their own clubs. In 1896, Mary Church Terrell, Ida B. Wells-Barnett, and Frances Watkins Harper joined other strong African American women to found the National Association of Colored Women's Clubs, an organization created to assist African American women in attaining equal opportunities and rights.[118] The organization grew quickly during the late 1890s.[119] Carrie Williams Clifford founded the Ohio State Federation of Colored Women's Clubs, one of three hundred such clubs established across the nation. The Ohio chapter supported the right of African American men and women to vote, and it supported the women's suffrage movement two years before the predominantly white General Federation of Women's Clubs did so.[120]

Women Officeholders

Leaders of the women's movement expanded their agenda to incorporate officeholding rights for women. Pursuit of low-level offices proved to be an essential foundation on which to build arguments on behalf of granting women more powerful positions within the government. Ohio typified the effort to support women's officeholding and, in fact, earned national media attention when the Ohio Supreme Court, in *Warwick v. Ohio,* ruled women could be appointed as deputy clerks since that role was "ministerial" and not "judicial." The most infamous case that garnered national news headlines was that of Nellie G. Robinson, an 1893 graduate of Cincinnati's Law School. Robinson rejected the title "woman's rights advocate," and though she was not an active member in any suffrage organization, she did speak out publicly in support of the cause.[121]

Robinson sought to become a notary public, believing that the job's function was more administrative than judicial. She successfully passed the notary exam, filed the proper paperwork, and secured the required bond. After she sent her application to Governor William McKinley, it was returned to her with a rejection letter. The attorney general concluded that women were ineligible for this position. In 1895, Robinson sued McKinley for rejecting her application, and she appealed to the state supreme court, representing herself in the case.[122] In 1896, the justices ruled that to qualify for the position, notaries must be electors, and women were not electors. Robinson did not give up. In Washington, DC, she attempted to persuade the US Supreme Court that her issue was a federal one. Despite generally supportive news coverage, the court ignored her. Unfortunately, the century ended with yet another Ohio loss for women's rights. In 1898, the Bartelow Act finally permitted women to be notary publics, but the Ohio Supreme Court struck down the law.[123]

Advances in Anti-Suffragism

The agenda of the women's rights movement also began to focus more directly on anti-suffragism. Though anti-suffrage sentiments circulated since the very start of the women's movement, the first national anti-suffrage newspaper, the *Remonstrance,* headquartered in Boston and published annually, and later quarterly, by the Massachusetts Association Opposed

to the Further Extension of Suffrage to Women, did not begin publication until 1890.[124] The first statewide anti-suffrage organization, the New York Association Opposed to the Extension of Suffrage to Women, was not founded until 1895. Much like pro-suffrage organizations, it held parlor meetings, distributed literature, and gathered signatures on a legislative petition submitted to the state constitutional convention in 1894 to prevent a suffrage amendment.[125] These early organizations coordinated with each other and with men's anti-suffrage campaigns.

Opponents often pointed to the existence of anti-suffrage associations as evidence that large numbers of women did not want the vote, even though this count was very small compared to women organized in support of suffrage. Opponents used the low voter turnout rate among women for the first Ohio school vote as evidence they would not use the full ballot. Suffragists countered that school elections are smaller than municipal, which are smaller than state, so proportionally fewer women voters should be expected to turn up at the polls. They also argued that just because some women did not want enfranchisement, there was no reason to deny it to those who did. Anti-suffrage arguments held sway by tapping into the fear of change and existing sexism, misogyny, and patriarchal attitudes.[126]

Suffrage during Populism

At the national level, the US Senate and House of Representatives made little progress on the Susan B. Anthony amendment. The Senate did not schedule a single vote on a women's suffrage amendment in the 1890s. Nor did the House. The proposed Sixteenth Amendment repeatedly stalled.[127] Throughout the 1890s, suffragists laid the groundwork in many ways for their success in the twentieth century, making this an important time of rebuilding, recruitment, and preparation for new initiatives.

Again, movement leadership recognized the talent and devotion of Ohio suffragists at the national level. Louisa Southworth, of Cleveland, was appointed superintendent of the national drive for a permanent petition for women's suffrage. The drive's purpose was to answer the tiresome objection that women did not want the vote by gathering tens of thousands of names from across the country. Leadership in each state encouraged suffragists to canvass neighborhoods for signatures, affirming support for women's suffrage at both the national and state levels. Signatures were amassed in book form to serve as a permanent petition.

Southworth organized this gigantic, time-consuming project from her home, and she personally paid thousands of dollars to cover the costs of the project. In her role as chair of the Committee on National Enrollment, Southworth reported forty thousand names of adult citizens who favored equal suffrage—nine thousand of these signatures came from Ohio.[128]

The growth of populism offered improved opportunities to extend the rights of the nation's women. Populism sought to address a wide variety of political, economic, and moral challenges facing the United States. Both the agrarian and labor movements contributed to the short-lived Populist Party. Agrarian reforms such as the Farmers' Alliance and the Grange were devoted to improving economic conditions for farmers through public advocacy and cooperatives. The labor movement sought to protect the common interests of workers; to improve working conditions, particularly those in the industrial sector; to increase pay; and to end child labor, among other reforms, predominantly through unionizing. Suffragists sought allies from both these movements, and they eventually won the support of the Populist Party. Women played a large role in the Populist Party, their responsibilities ranging from organizing meetings to speaking at rallies, from writing media articles about the party platform to fundraising.[129] Frances Willard strategically attempted to bring together the Populist Party and the Prohibition Party for the 1892 presidential election—both had supported women's suffrage—but her attempt failed.[130] By this point, support for suffrage had begun to fade in both parties.

The number of presidents elected from Ohio illustrates how the state was at the center of the political landscape during the Gilded Age. The populist movement in Ohio was crucial for the plan to create a national party that could challenge Democrats and Republicans, both of which largely proved ineffectual at addressing the nation's challenges.[131] The influx of immigrants into the state meant large numbers of Irish and Germans changed the state's demographic and political makeup. Ohio had been a Republican Party stronghold since the Civil War, but its growing immigrant and native working class leaned toward Democratic and third-party candidates, thus creating the potential for growth that the Populist Party sought. Because Populists tended to pull from Democrats, Republicans could weather the challenge. Both Democrats and Republicans eventually adopted many populist ideals.[132]

In Ohio, populism was more an urban affair than an agrarian one. In the absence of severe economic challenges, most of Ohio's farmers had been too conservative to change political parties, and they believed working

through the existing parties offered the best chance for reform.[133] Populism took root in Ohio, instead, as a response to the economic crises in the cities, especially Cleveland, Columbus, and Cincinnati. After a catastrophic national economic collapse in 1893, Ohio businessman Jacob Coxey proposed the "Coxey's Good Roads Bill," urging the US government to hire people for work on public infrastructure projects. On what would become the first march on Washington, Coxey's group of unemployed men and women marched to the nation's capital to present the plan, departing from Massillon in the spring of 1894 and adding marchers along the way. Upon their arrival, Coxey's daughter Mamie led the march, riding atop a white Arabian stallion. Not only were their pleas for federal aid ignored, but police also violently descended on the marchers with clubs, and Coxey was among those arrested.[134]

The march motivated other unemployed men and women, an estimated ten thousand individuals, to join "Coxey armies" across the country. These armies comprised a diverse population, including "respectable" women and people of different races living in camps together. The march also drove more people to support the Populist Party, of which Coxey was a member. Coxey began speaking out in favor of women's suffrage in the 1890s. It would be 1913 before the next march on Washington, when five thousand women took to the streets in the first national women's suffrage parade.[135]

Populists drew votes from Harrison in the 1892 presidential election, helping to install Grover Cleveland into the White House for a second term. While Cleveland did not speak against suffrage, he continued to remain silent. The 1896 presidential contest between Ohioan William McKinley and William Jennings Bryan was particularly heated. McKinley expressed a general sympathy for women's rights, whereas Bryan was adamantly pro-suffrage. Once McKinley was in office, both he and his wife, Ida Saxton McKinley, spoke publicly in support of women's higher education, a controversial topic at the time.

Ohio's 1890s Suffrage Agenda

By the 1890s, activists embraced a widening agenda, working to promote suffrage, improve schools, prohibit alcohol, regulate child labor, and support union women. The decade began with yet another attempt to add a women's suffrage amendment to the Ohio constitution. National leaders

such as Anthony and Howard Shaw lent their voices and expertise to the state effort, drawing large crowds wherever they campaigned. Anthony earnestly requested the OWSA vote itself auxiliary to the NAWSA, and the delegates did so. Later that year, however, Stone sent a letter asking the OWSA to abandon its efforts for a constitutional amendment in Ohio, as she believed the effort would fail and set back the cause. She also indicated that Anthony was of the same opinion, and she believed "efforts ought to be directed against laws operating unjustly against women." The OWSA minutes indicated that "this was objected to."[136] OWSA forged ahead as planned in pursuit of the state constitutional amendment, trusting its own instincts rather than the advice of Stone or Anthony.

The 1890 House vote resulted in fifty-four yeas to forty-seven nays—a hard-fought battle, but sadly still not enough to meet the required constitutional majority. Unfortunately, Stone and Anthony's prediction came true. Refusing to take no for an answer, suffragists petitioned for the ballot again the following year, but they yielded no better results.[137] Even though votes for full women's suffrage had come close three times—one tie, one loss by two votes, and one favorable vote that was short of the constitutional majority—the two additional consecutive losses were enough to test even the strongest hearts and minds. The men of the Ohio legislature gripped onto political power as tightly as ever.

As in several other states in which suffragists endured multiple defeats, the women of Ohio swallowed the bitter pill, deciding to lower their sights by seeking partial suffrage. It was again time to make a play for school suffrage. In 1892, Representative E. W. Doty of Cleveland introduced a bill to the House allowing women to serve on school boards. Even this compromised measure lost, this time by seven votes. The state's suffragists faced another demoralizing loss, but they found the wherewithal to continue the fight.

Representative Gustavus Wood of Delaware County introduced yet another school suffrage bill in 1894.[138] Ohio suffragists mounted a tremendous letter-writing campaign aimed at every member of the general assembly; circulated petitions to collect tens of thousands of signatures; and sent invitations to national movement leaders to plead their case in-person at the House of Representatives. To apply face-to-face pressure, the OWSA officers personally interviewed members of the state congress. Katherine Trotter Claypole, founder of the Akron Woman's Suffrage Association and cofounder of the Akron Women's Council, as well as secretary

of the OWSA, played a critical role in this effort.[139] When the bill came before the House for a vote, the measure met harsh opposition. Despite the tremendous work Ohio suffragists such as Trotter Claypole brought to bear on the cause, the bill failed, forty-seven yeas to forty-three nays—five votes short of the constitutional majority required.[140] Despite Ohio suffragists' valiant efforts to slowly chip away at the bedrock of patriarchy, it remained all but impenetrable.

Over two decades had passed since school suffrage for Ohio's women was first proposed, and almost just as much time had passed since women in other states had received this right. Refusing to accept defeat and determined to turn the tide, McCullough Everhard made an earnest appeal to Senator William Clarke to introduce the same bill again. With his sponsorship, the bill passed in the Senate, twenty yeas to six nays. The House then passed the bill fifty-five yeas to twenty-six nays. Senator Clarke telegrammed the NAWSA: "Woman suffrage bill a law, truth is mighty yet."[141] For a brief moment, Ohio suffragists did feel mighty and believed truth was on their side.

Imagine the exasperation and offense to Ohio's women when even this partial victory was challenged. The idea women could vote, even in this limited capacity, was so controversial that the opposition attempted to repeal the law through the courts. Columbus's Ida Earnhart, wife of Senator M. B. Earnhart, was one of the first women to register to vote in a school election. An election official instructed the Columbus Board of Elections to strike her name from the rolls, but it refused to do so because of the act passed the previous year granting women school suffrage.[142]

A test case, *Burt F. Mills v. the Board of Elections of the City of Columbus and Ida M. Earnhart*, pended in the state supreme court. Lawyers argued that the act was invalid because it violated rules outlined in the state constitution specifying the qualifications of electors. Senators Clarke and Earnhart defended the act, arguing that school offices were not created by the state constitution, and therefore, the legislature could specify qualifications. Much to the relief of suffragists, the state supreme court determined that the women's school suffrage act did not violate the state constitution.[143]

Ohio's suffragists barely had time to utter a sigh of relief when Representative A. J. Hazlett, upon the encouragement of Cleveland's board of elections, introduced a House bill to repeal the school suffrage law. Certain Ohio legislators were as determined as ever to preserve Ohio politics as a bastion of male power. In response, the OWSA organized an impres-

sive defense. First, McCullough Everhard called on all the state's suffrage clubs to write letters of appeal to any prominent persons they knew to stand against it. Second, the organization collected petitions with more than forty thousand signatures denouncing the attempted repeal; these were sent to the Ohio legislature.[144] Third, its representatives appeared before the House Committee on Elections to speak against the bill. The report was filed without recommendation, and it was brought to a vote out of courtesy to Hazlett, a member of the House Committee on Elections. During the ordeal, McCullough Everhard confessed, "It is so hard to beg of the lawmakers to give us that which we ought to have without asking, but justice sits not in our courts, nor wisdom in our legislative halls. Men do not admit that they are all the time depriving women of what in the case of their won sex they call priceless rights and women themselves as a class are afraid to claim their rights."[145]

The suffragists' defensive maneuvers saved the day—a vote of seventy-six yeas to twenty-two nays thwarted the repeal.[146] Women maintained their small foothold on Ohio politics. After fifty years of suffrage activism, the state's women had their first and only suffrage win of the 1800s. Ohio women born or naturalized in the United States, age twenty-one and older, who were residents of the state for one year, could now vote for school boards, though not for superintendents or for bond issues. Their names appeared on a separate registration of voters, and they used a separate ballot box.

Approximately thirty thousand women voted in the state's first school board elections. In truth, few women registered; some because they lost interest, and others because they saw the measure as a token gesture. With indignation, these women held out for what they saw as a "real" vote. However, this first suffrage victory, small as it was, strengthened other Ohio women's resolve. Among them was McCullough Everhard, who reminisced in her diary, "Have just returned from the primary election where I cast my first vote, only for a school director to be sure, but then it was a vote. I considered it a very important event and was just as excited as though my future depended upon the result."[147] While it is true that the first concrete victory of Ohio's suffrage movement generated little political power, the symbolic value of a victory should not be undervalued. Furthermore, women not only voted at their first opportunity, but they also ran for office. In Xenia, Mary Moore and Eliza Carruthers campaigned door to door for positions on the school board, and they won.[148]

Ohio women enjoyed other legislative gains at the state level in the 1890s. For example, by 1893, married women could act as legal guardians.[149] By the following year, they could act as executors of estates. The Ohio legislature also slowly addressed the desperate need to reform "age of protection" laws. The age of sexual consent for girls was raised from ten to twelve years old in 1894 and to sixteen years old in 1896. At the 1894 OWSA convention, the program included a discussion of the state's preposterous consent laws, using the topic as yet another reason women needed the vote.[150] Utilizing the rhetoric of motherhood, the argument followed that if women were to perform their maternal duties, they must have the ballot to protect their children, both boys and girls, from sexual abuse, child labor, and other horrors. Consent laws are perhaps the best example of how the decades-long campaign to obtain the ballot was always about something more. The ballot was a means to an end, in this case, ending legalization of child rape.

Partial suffrage efforts and other legislative campaigns related to guardianship, consent, and property ownership provided an important training ground for Ohio's activists as they prepared to take on larger campaigns in the next century. The incredible work completed during the nineteenth century, "the massive activity necessary for pressuring male politicians to share some of their offices and power with disfranchised women," as McCullough Everhard wrote, was made all the more difficult because, "Every obstructionist tactic possible was used to keep [the bill] from passing, and once passed, to challenge its legality." Though these hard-fought legislative wins fell far short of the ultimate goal of full suffrage, they were important stepping-stones. These moderate reforms eventually made more controversial changes politically palatable. McCullough Everhard remarked, "For women, the skills, fighting spirit, and organizational clout developed in the countless skirmishes provided the necessary know-how and stamina for the larger struggle for suffrage."[151]

As the century drew to a close, Ohio's women's rights activists reflected on their years of activism, appreciating educational and economic gains for some but also resenting the reality that over fifty years of work on behalf of their own enfranchisement bore so few results. Another century would begin, and with it, a new band of suffragists as determined as their predecessors would carry the torch. The first generation of suffragists passed away without having reaped the fruit of their labors, trusting justice would prevail someday for their daughters. Klinge Segur, writing the

minutes of a Toledo Woman's Suffrage Association meeting, captured this sentiment: "Undaunted by our slow progress, and the apathy of our legislature, we shall as usual present our annual petitions, praying aside from enactments granting us citizenship for the protection of our young daughters. In the future as in the past we propose to battle, according to the best light with which we are endowed, for equal rights."[152]

The Ohio Women's Rights Movement during the Progressive Era

Ohio women began the new century voting, albeit still only for the school board. The *Cleveland Press* reported in its 1900 election coverage, "Cleveland women put Cleveland men to shame. . . . In all, 9,172 women registered and 7,342 voted. Only 1,830 remained away from the polls."[1] Apparently, far fewer eligible male voters made their way to the polls than female voters eager to cast their ballots. The only win the state's suffragists could claim from the previous century was school suffrage, and the 1900 election illustrated how seriously many Ohio women took their voter eligibility. Though Ohioans, once on the cutting edge of women's rights activism, were no longer at the forefront of these efforts by the early twentieth century, this fact did not distract from the enthusiasm with which they voted.

Though the number of women voters consistently fell off with each election cycle, men slowly grew accustomed to seeing women at the ballot box, eventually normalizing the image of the "woman voter." Indeed, the traditional public image of women started to change considerably over the course of the Progressive Era. The cult of true womanhood's expectation of a passive, pious, domestic woman slowly gave way to the "modern" woman of the new century. Many people started to accept the idea that expanding women's roles in public could represent progress if women were allowed to bring their uniquely feminine morality to bear on challenges facing society. This changing attitude, buttressed by increases in the number of college-educated women and women's partic-

ipation in the paid labor force, created space for political and rhetorical inroads by the women's rights movement.[2]

This is not to say that women were no longer judged by traditional measures of beauty, femininity, and marriageability. A common griev-ance about suffragists still centered around the degree to which they were "fashionable." Suffragists of the 1800s such as Amelia Jenks Bloomer, Lucretia Coffin Mott, and Susan B. Anthony were castigated for their lack of fashion sense, and stereotypes of suffragists as mannish old maids abounded. Editors still limited much of the news coverage of the movement to the society pages, and journalists still felt compelled to discuss suffragists' appearances. However, eventually articles imparted information about contemporary issues and women's thoughts of them. The *Canton News Democrat* emphasized women's intelligence in a story about a suffrage meeting: "For the National, State and County officers, all of whom were present, were neither crabbed, cranky, homely nor un-married. . . . In fact, the women who took part in the procedures were a decidedly handsome lot, and as for intellectual capacity, it is extremely doubtful if any Canton pulpit has heard as much good intelligence in it for a long time."[3] At long last, some Americans started to accept the no-tion that a "modern" woman could be both moral and intelligent enough to cast a ballot, though it certainly helped if she also was "fashionable."

To be sure, by the turn of the century, the nation's suffragists could claim the arduous work of the previous fifty years had made a difference. Whether fashionable or not, more women could speak in public, testify in court, preach from the pulpit, earn an education, work in some of the professions, manage their wages and property, and win custody of their children. In many ways, reformers had made good on the promises of the Declaration of Sentiments, the blueprint for the movement adopted at the 1848 Seneca Falls convention. One goal remained elusive, however. Those without full suffrage in the state of Ohio were limited to "idiots, insane, felons, soldiers, sailors and marines in U.S. service, and women."[4]

Yet, suffragists' tenacity revealed how men's grip on the elective fran-chise was starting to slip. Women could now cast ballots in four west-ern states, including Wyoming, Colorado, Idaho, and Utah. The idea of women voting seemed less preposterous throughout the American West. Conversely, the East stubbornly maintained its opposition and indiffer-ence. Could the start of a new century usher forth a new era of politi-cal power for US women? Embracing this possibility, Ohio's suffragists

advanced new leaders, modified their agenda, restructured their organizational capacity, and applied all they had learned in fifty years of activism to navigate the state's political culture. The 1912 Ohio campaign for Amendment 23, a measure granting full suffrage to women as part of a constitutional convention special election, cast a national spotlight on the leadership of Ohio's suffragists.

Suffrage Leadership for a New Century

The new century brought the passing of key movement leaders. Lamentably, in 1902, Elizabeth Cady Stanton succumbed to heart failure. Four years later, her dearest friend and movement pioneer Susan B. Anthony passed as well. Though these deaths truly marked the end of an era, it was not the end of the movement. Carrie Chapman Catt served as president of the National American Woman Suffrage Association (NAWSA) from 1900 to 1904 and from 1915 to 1920. Chapman Catt was an expert administrator, but she often demanded conformity that many state suffragists resisted. The NAWSA tended to focus efforts on states with presidential or full suffrage measures, largely ignoring those states seeking partial suffrage.[5] Furthermore, all too often, the NAWSA characterized midwesterners as ignorant and disinterested on the issue of women's enfranchisement.[6] Maintaining good relations between the NAWSA and the Ohio Women's Suffrage Association (OWSA) was at times challenging, even with an Ohioan, Harriet Taylor Upton, serving on the NAWSA executive board.

Anna Howard Shaw, whose talent for oratory exceeded her administrative abilities, assumed the presidency between Chapman Catt's terms. Taylor Upton, NAWSA treasurer at the time, had little faith in Howard Shaw's abilities to oversee the organization's finances, and she issued indirect warnings to that effect. Other officers were all too happy to add to Taylor Upton's complaints about Howard Shaw's administrative skills. Howard Shaw faced challenges to her leadership on multiple fronts, but Taylor Upton instigated internal conflict, and she worked with others to oust Howard Shaw. Though Howard Shaw and Taylor Upton had once been friends, the level of trust shared between the two deteriorated. Eventually the tension led to Taylor Upton's resignation from her position. She was convinced Howard Shaw's presidency would be the end

of the organization. Despite these differences, the OWSA continued to support the NAWSA's work, collecting signatures for two national petition drives and participating in a national fundraising bazaar at Madison Square Garden, among other initiatives.[7]

In some ways, Ohio's fight for women's enfranchisement mirrored that of the national effort at the turn of the century. The twentieth century's first decade brought no legislative wins at the federal level or in Ohio. However, unlike the NAWSA, now stagnating and suffering from infighting within its executive board, the OWSA executive committee in large part was able to avoid the internal conflicts facing the national organization.[8] When the OWSA met in Springfield in 1901 and Cleveland in 1902 for annual conventions, members found much to agree on. Ohio suffragists set the foundation for several significant changes that would position them as stronger contenders for future battles and that paved the way for a decade of profound change.

Before her resignation, Taylor Upton was the central force of the national organization in charge of its day-to-day affairs, thus putting Ohio administratively at the center of the suffrage movement.[9] Taylor Upton took on considerably more work above and beyond her leadership role in the OWSA or as treasurer for the NAWSA. Her additional responsibilities included editing and distributing NAWSA publications and managing the huge amount of organizational correspondence. From the start of the decade, Taylor Upton's Warren office sent out fourteen hundred letters and six thousand pieces of suffrage literature annually. By the end of the decade, the rate was up to thirty thousand letters a year and a thousand pieces of literature per day.[10] In many ways, it was Taylor Upton who brought stability and continuity to the movement during this transition in leadership. A significant number of other Ohio women also stepped forward to become the next generation of leaders, each with her own unique style and ideas for forging a path to victory. These women were predominantly, though not exclusively, white, educated professionals from among the middle and upper classes. However, more African American women would take their rightful places within the movement, providing state and national leadership during the Progressive Era.

African American women most certainly were among the new breed of "modern" women pursuing their rights. Born in Chillicothe, Ohio, in 1862 and raised in Columbus, where she graduated from a racially integrated school, throughout her lifetime, Carrie Williams Clifford was

a noted suffragist, orator, poet, and advocate for African American and women's rights. After working as a teacher in Parkersburg, West Virginia, she married William Clifford, future member of the Ohio House of Representatives. The couple moved to Cleveland, where she started the Minerva Reading Club to bring together African American women in conversation about important social issues. This work led to the creation of the Ohio State Federation of Colored Women's Clubs in 1901. Williams Clifford founded this organization, and she served as its first president. The club's mission was to attain equal rights and opportunities for African American women.[11]

Williams Clifford was instrumental in getting the club to champion women's suffrage, and she also lent her support to the NAWSA, participating in its demonstrations and parades. She circulated with other notable African American leaders and feminists such as Ida B. Wells-Barnett, Mary Church Terrell, and Hallie Quinn Brown. Williams Clifford also served as editor of the Women's Department of the African American *Cleveland Journal*. In her poetry and writings, she documented women's participation in the suffrage movement, among other social causes. She organized countless meetings around the topic of women voting, and she both debated and delivered speeches about that subject in numerous cities.[12] Williams Clifford believed men and women were different but that difference would improve the quality of political decision-making. A Women's Christian Temperance Union (WCTU) member and a follower of Booker T. Washington, Williams Clifford held generally conservative social and political views.[13]

Carrie Williams Clifford

In 1908, she followed her husband to Washington, DC, after his appointment to the US Treasury Department. The couple developed a reputation for hosting important social functions and became known as "the Ohio set" because of their generous hospitality.[14] The Cliffords were well connected. Williams Clifford's views of race relations evolved after she befriended W. E. B. Du Bois, who asked her to create a women's auxiliary of the Niagara Movement (which paved the way for the founding of the NAACP in 1909). Williams Clifford served as the assistant recording sec-

retary of the National Association of Colored Women (NACW), and she published books of poetry such as *Race Rhymes* and *The Widening Light*.[15]

Williams Clifford found herself all too often challenging the marginalization of African American women by white suffrage leaders. Alice Paul, president of the National Woman's Party (NWP), organized a massive protest march the day before President Woodrow Wilson's inauguration in 1913. Originally, she had reached out to local African American women leaders such as Williams Clifford to participate, but when Southern suffragists threatened to pull out of the event if African Americans were included, Paul caved to their pressures. African American women refused to be denied. Women such as Wells-Barnett, Church Terrell, and Williams Clifford marched to provide inspiration for other African American women and to prove to white Americans that women of color were determined to have the vote as well.[16] While many people believed the African American delegation deserved a public apology for this mistreatment, Williams Clifford wrote in the NAACP's magazine, the *Crisis*, that the African American marchers should be congratulated for demonstrating the "courage of their convictions" and that even though they were not encouraged to participate, they received "courteous treatment on the part of the marshals" and "no worse treatment from bystanders than was accorded white women."[17]

African American women also pushed the NWP to recognize their need for the ballot by putting the issue on the agenda at the national convention. Williams Clifford encouraged African American women to send letters and telegrams from Virginia, New York, Pennsylvania, Indiana, New Jersey, and Ohio urging the NWP to push the issue. When Paul remained unmoved, Williams Clifford and others threatened to picket her just as the NWP picketed the White House during the Wilson administration. Eventually, NWP convention planners allowed Church Terrell, as the NACW leader, to present a statement on behalf of African American women's rights at the convention. Over fifty years earlier, Sojourner Truth had called for a commitment to racial diversity and inclusion within the women's rights movement, yet the second generation of suffragists had yet to learn this important lesson.

In 1917, while the US Congress considered the Dryer antilynching bill, Williams Clifford helped to organize a silent parade through Washington, DC, in support of the measure. The lynchings and race riots that had

occurred in East St. Louis were the catalysts for the parade. The protest drew almost ten thousand participants. According to the *Evening World,* "Hundreds of colored mothers, dressed in white, carrying children in their arms, marched in the line. . . . There were nearly as many women and children as men."[18] Williams Clifford went on to write two poems about this event: "Race-Hate" and "Silent Protest Parade." Even though the Senate failed to pass this federal antilynching legislation, Williams Clifford helped to lay the foundation for the civil rights movement and women's role in it.

Even after the Nineteenth Amendment passed, Williams Clifford continued to fight for the inclusion of African Americans in the women's rights movement. When the League of Women Voters held its national conference in Cleveland in 1921, she wrote to Maud Wood Park, then president of the organization, calling upon her to welcome African American women into the league. Wood Park indicated that the league would be happy to listen to NAACP members and to have their participation. Williams Clifford died in 1934, having devoted her political life to denouncing the horrors of lynching and to fighting for the dignity of African American women.[19]

Jane Edna Harris Hunter (1882–1971), another influential social reformer at the state and national level, also pursued racial and gender justice simultaneously. Born on a South Carolina plantation, Harris Hunter left her humble roots to study nursing in South Carolina and Virginia, before making Cleveland her hometown. Because there were so few opportunities for African American nurses at the time, she struggled searching for employment. Eventually, she found a position working for the Cuyahoga County coroner and for an African American doctor. Later in

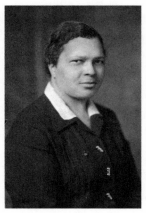

Jane Edna Harris Hunter

life, Harris Hunter attended the Western Reserve University and earned a degree from the Marshall Law School. She passed the Ohio bar in 1926.[20]

Due to racism, she faced not only employment discrimination but also housing challenges. She initially sought, but was refused, housing at the YWCA. This experience so impressed her that it inspired her career in social activism. Because of their difficulties finding safe and affordable housing, she and several friends founded the Working Girls' Home Association, charging dues of one nickel per week. Its board of trustees was unusual for the times, comprising both white and African

American officers. One cofounder initially lamented, "Poor people like us can't do anything." Harris Hunter countered, "It's only poor people like you and me who can do anything. . . . We've all of us been poor motherless children, and the Lord is going to help us build a home for all the other poor daughters of our race."[21] This organization provided job training, housing, and recreation primarily for women moving north from the South. Eventually named the Phillis Wheatley Association, the organization grew to include chapters across Ohio, and it expanded into other states. In addition to running the association, Harris Hunter held leadership positions in the NACW and the Republican Party's Colored Women's Committee. She was a founding member of the Women's Civic League of Cleveland, and she was an active member of the NAACP.[22]

Inspired by Booker T. Washington, Harris Hunter believed she was improving the community by preaching self-sufficiency. Like Williams Clifford, Harris Hunter held a traditional view of femininity, and she often focused quite conservatively upon the importance of women's public reputations. Though suffrage was not Harris Hunter's first priority in the fight for women's rights, she became an important connection between suffragists of different races, and she participated in events such as the 1914 suffrage march in Cleveland. She emphasized, "Now it became my duty to harmonize these interests and unite these two dreams—the purposes and series of my people and the politics of the white friends whose material support we sought."[23] Harris Hunter's sincere concern for women motivated her to join other African American leaders, such as Mary McLeod Bethune, at the White House to discuss women's issues with First Lady Edith Roosevelt.

Harris Hunter published an autobiography, *A Nickel and a Prayer*. After she retired, she created the Phillis Wheatley Foundation, an organization devoted to raising money for college scholarships. Not one to rest, Harris Hunter also spent her retirement delivering motivational and political speeches across the country and writing several newspaper columns.[24] Before her death in 1971, she donated most of her estate to the scholarship fund, and she became one of the first inductees into the Ohio Women's Hall of Fame.[25]

A contemporary of Williams Clifford and Harris Hunter, Jewelia Ann Galloway Higgins (1873–1955) provided support for the state suffrage campaigns from her hometown of Dayton. Galloway Higgins's great-grandmother had attended the 1851 Akron suffrage convention, at which

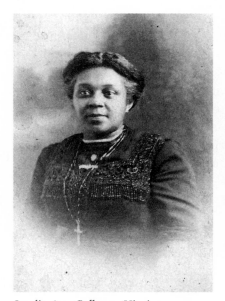

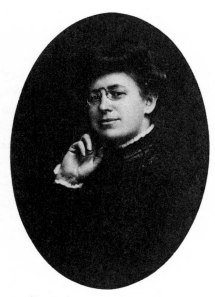

Jewelia Ann Galloway Higgins *Pauline Perlmutter Steinem*

Sojourner Truth delivered her famous "Ain't I a Woman?" speech. Her great-grandmother's spirit for social justice burned in Galloway Higgins's heart as well, motivating her to follow in her footsteps. She joined the Dayton Woman's Suffrage Association in 1912, and under her leadership, African American women distributed literature at the downtown suffrage booth on Mondays throughout the year.[26] She also coordinated a variety of community gatherings and regularly spoke on behalf of the federal suffrage amendment. Like Harris Hunter, she did her best to bridge the racial divide within the suffrage movement.

Galloway Higgins became one of the first African American Red Cross nurses in the city. For many years, in addition to her career in healthcare, Galloway Higgins worked alongside her husband in the YMCA. Seeing the benefits the YMCA offered, and seeing similar needs existed among African American women, she helped found the African American affiliate of the YWCA in Dayton. She served as the organization's president for more than twenty-five years. She also led the Holloway Colored Orphans' Home and was an officer in the Colored Citizens Protective League. After a life of dedication to community leadership for the causes of suffrage and civil rights, Galloway Higgins died in 1955.[27]

Pauline Perlmutter Steinem was one of the strongest leaders of the Ohio women's movement in the Progressive Era. In 1914, when a reporter for the *Toledo Blade* asked why she was a suffragist, she answered, "Men and women are the same in essence, differentiated only by the outer garments, the bodies they temporarily wear, and that therefore they have certain duties and certain responsibilities shared by all beings alike."[28] Born in Russia, Perlmutter Steinem moved as a young girl with her family to Germany, where she earned a teaching diploma. After the birth of their first child, she immigrated to Toledo with her husband.[29] Perlmutter Steinem lived her Jewish faith, and it inspired her social activism. This motivation, combined with her administrative skills, led her to take on a variety of leadership positions; among these, she became president of the Toledo section of the National Council of Jewish Women, national chair of the Sabbath School Committee, president of the Hebrew Associated Charities and Loan Association, president of the Toledo Federation of Women's Clubs, and a member of the Ohio Board of Charities. After her husband died, she used her small pension to rescue relatives from Nazi Germany.[30]

In 1904, Perlmutter Steinem became the first woman elected to the Toledo school board. She ran her campaign on $126 and won in almost every precinct. Local women banded in groups to collect signatures to get her name on the ballot, commonly withstanding harassment to do so. Her win was all the more impressive when one considers that police tore down "Vote for Mrs. Steinem" banners.[31] Gangs of local men and boys sexually harassed women as they entered polling places, and there were reports men were preventing their wives from registering to vote.[32] She also organized women to go to the polls safely in pairs or in groups, and she called on men to take responsibility for their own behaviors: "If the polls are places too terrible for women to venture into, then it's up to men to clean them up."[33] She received over sixteen thousand votes—the most of any school board candidate on the Toledo ballot that year.

Perlmutter Steinem's unlikely victory is attributable to several factors—beyond her own intellect, work ethic, and talents. She earned the endorsement of a local newspaper and the support of the Socialist Party, and the novelty of being the first female candidate certainly generated considerable free press coverage. She tirelessly canvassed the city and spoke at numerous mass meetings. In a speech to the YMCA, Perlmutter Steinem pondered, "Isn't municipal government nothing but a household on a larger scale? Women are altruistic and it is not sentiment but a sense of duty that

impels them to wish to vote." She continued, "To bring mother's influence into public life is the object of the woman's suffrage movement." While Perlmutter Steinem cloaked the ballot in the respectability of motherhood and homemaking, she also emphasized: "It won't do for our fathers, husbands and brothers to do the thinking for us." The *Dayton Herald* described her as "one of America's most intellectual women."[34] Perlmutter Steinem believed the vote was the next step in social evolution. She did not run for a second term but instead ran for the only other civic position then open to women, becoming a Toledo Public Library Board of Trustee.[35]

Perlmutter Steinem's leadership extended to the women's suffrage movement at the local, state, national, and international levels. She founded several Toledo women's clubs and philanthropic organizations. As president of the OWSA from 1908 to 1911, she advocated for a wide variety of women's rights. In 1908, she traveled as one of two delegates to the International Council of Women.[36] The next year, she created a committee to lobby the Ohio legislature for co-guardianship of children, and in 1911 she campaigned across the state to add suffrage to the 1912 constitutional convention platform. When that measure failed, Perlmutter Steinem joined suffrage efforts in Wisconsin.[37]

Perlmutter Steinem was an active member of the NAWSA. A staunch believer in nonpartisanship, she argued in her 1909 NAWSA convention speech: "The same forces which have brought about the growth of democratic ideals and non-partisan politics are also responsible for the advancement of women."[38] She joined other suffragists marching in Washington, DC, in 1913, the day before Wilson's inauguration. She testified in front of the US Senate about the violence women experienced that day and about the absence of police protection for marchers. While chairing the NAWSA Committee on Education, Perlmutter Steinem wrote four hundred school superintendents and twenty-six textbook publishers surveying them about the inclusion of women. She documented how history and civic textbooks used in public schools ignored women's contributions. She concluded, "the masculine point of view had dominated civilization," and expressed concern the textbooks created the impression that "this world has been made by men for men."[39]

Perlmutter Steinem did not need to study textbooks to arrive at this conclusion. She had firsthand experience. She had planned to discuss women's suffrage at the Ohio State Teachers' Association meeting in 1910 but was denied the opportunity to speak. Not one to back down, she ar-

gued with the president of the association, demanding her right to address the meeting. Apparently the exchange became heated enough to warrant coverage in the local newspaper.[40] She wrote a few years later, "People say: 'Women cannot succeed in certain fields.' How do we know what women can do, when we have never yet allowed them to try? No man knows what woman would do, if she were free to develop the powers latent within her, nor does she herself know as yet."[41] In the 1960s, one woman would come to know herself sufficiently to realize that power, and she would show a generation of women what feminist consciousness-raising looks like. Perlmutter Steinem's granddaughter, Gloria Steinem, was born in Toledo and is nationally recognized as one of the founders of the feminist movement in the late 1960s and continues to be a spokeswoman for women's equal rights today.[42]

A contemporary of Perlmutter Steinem, Florence Allen (1884–1966) arguably was one of Ohio's most brilliant legal minds and best suffrage lobbyists. Her parents raised Allen in Utah, but when she turned twelve, the family moved to Cleveland. Her father, a classical languages professor, ensured that Allen was proficient in both Greek and Latin at a young age and that she was ready for college. At age sixteen, she entered the Women's College of Western Reserve University.[43] As a teenager, she attended a lecture by Susan B. Anthony, which sparked her lifelong commitment to activism. Her mother, active in the women's club movement at the local, state, and national levels, also proved to be an important influence on Allen's commitment to the cause.[44]

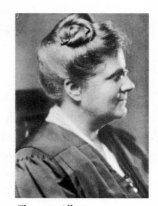

After graduation, Allen traveled to Berlin, Germany, with her mother, who had been invited to address the International Council of Women. Allen stayed for two years to study music in hopes of becoming a concert pianist. After a nerve injury ended her practice, she returned to the United States to become a music critic for the *Cleveland Plain Dealer*. Allen also worked as a teacher of Greek, German, history, geography, and grammar at the Laurel School, a private school for girls. Eventually, she earned a master's degree in political science, and she entered law school. Because Western Reserve University Law School did not yet admit women, Allen studied at the University of Chicago—where she was the only female law student—and eventually

Florence Allen

graduated from New York University. While studying in New York, she worked at the New York Protection of Immigrants League and held a part-time job working for the National College Women's Equal Suffrage League, where she made important connections.[45]

Although Allen graduated second in her law school class, no New York law office would hire her, so she returned to Cleveland. When no firm there would hire a "woman lawyer" either, Allen opened her own general practice and volunteered at the Cleveland Legal Aid Society.[46] Many suffragists became Allen's paying clients after working with her on the state's 1912 and 1914 suffrage campaigns. Unlike many other women of her time, Allen did not shy from the spotlight, boldly delivering countless speeches in auditoriums, street corners, soapboxes, and the court room. Allen led the way in the city charter effort to win women the vote in municipal elections. She even defended this win in the Ohio Supreme Court. Work such as this earned her considerable name recognition.[47]

Within five years of opening her own law office, Allen was appointed assistant prosecutor for Cuyahoga County.[48] Professionally, she was a woman of many firsts. She became the first woman assistant county prosecutor in the United States, the first woman elected to the bench in Ohio, the first woman in the nation selected to a state supreme court, and the first woman appointed to a federal appeals court. Shortly after the Nineteenth Amendment passed, Allen became Cleveland's first female judge. Though her colleagues tried to relegate her to divorce court, she stood fast on her decision to rule on criminal cases. Several of her cases made headlines, including one involving a mob boss upon whom she imposed capital punishment despite receiving her own death threats.[49]

Setting her sights yet higher, Allen ran for and won a seat on the Ohio Supreme Court. She had made so many connections while fighting for the ballot that her friends and admirers formed Florence Allen Clubs across many Ohio counties to work for her election to the court.[50] Though neither the Republican nor Democratic Parties gave her its backing, she beat a popular war hero by more than forty-eight thousand votes because of these clubs' successful efforts. After Allen ran unsuccessfully for the US Senate and US House of Representatives, Franklin Roosevelt appointed her to the Sixth Circuit Court of Appeals. She famously ruled on the New Deal's Tennessee Valley Authority case, which granted the federal government the right to build dams and waterways and to sell electric power. Allen read her ruling to a standing room–only courtroom, and the US

Supreme Court upheld her decision. Roosevelt, among other presidents, also seriously considered her for the US Supreme Court.[51] Allen never had the opportunity to rule on women's rights cases. She was not a supporter of the Equal Rights Amendment. Like many Progressives, Allen favored protective legislation for women workers, and she feared the amendment would undermine those hard-fought protections.[52]

After retirement, Allen published several books, including a memoir, *To Do Justly*. Allen shared her life with two long-term female companions, Susan Rebhan and Mary Pierce. These domestic partnerships cannot definitively indicate Allen's sexuality, but if she were homosexual, she likely would not have identified as such, considering the probable social repercussions.[53] Over her lifetime, Allen broke many gender barriers and became a role model for future generations of women lawyers. Allen died in Mentor, Ohio, in 1966 and was inducted into the National Women's Hall of Fame in 2005.[54]

Elizabeth Hauser (1873–1858), a Girard, Ohio, native, started her journalism career after high school at a local newspaper, the *Girard Grit*. Time and again, she would prove her grit as a key leader of the state and national suffrage movement. Over her career, Hauser worked for more than ten years at the *Warren Tribune Chronicle* and other local newspapers. She also worked as secretary to Cleveland mayor Thomas L. Johnson and edited his autobiography. Her publications included the booklet *The Woman Suffrage Movement in Ohio*, released in 1908.[55]

Elizabeth Hauser

Hauser's devotion to women's suffrage began very early in her life and spanned decades. At the age of sixteen, she attended her first suffrage meeting, in Salem, and soon joined the cause. She worked closely with Taylor Upton in Warren in a variety of capacities, including press secretary, corresponding secretary, and executive secretary. She also used her journalism skills to help Taylor Upton edit the state suffrage newspaper. Hauser worked with other national suffrage leaders as well. In 1906, she took over the entirety of the national press work for the NAWSA. In 1909, when the NAWSA headquarters moved to New York, she relocated from Ohio, transitioning to vice chair of the National Press Committee. In 1910, she served as NAWSA president Carrie Chapman Catt's personal assistant.

At Taylor Upton's request, she left that position to assume leadership of Cleveland's suffrage campaigns.[56]

Back in Ohio, Hauser organized the Cuyahoga County Women's Suffrage Association. She began by calling an open meeting in Cleveland's Hotel Hollenden, where she announced the organization had two objectives: to elect delegates to the upcoming state constitutional convention who were suffrage supporters and to enlist thousands of new members in Cuyahoga County Women's Suffrage Association.[57] To increase the status of the cause, she invited local socialites to attend suffrage lectures and luncheons, and she persuaded them to permit her to use their names in her publicity work. The association eventually became the Cuyahoga County Women's Suffrage Party, the state's first suffrage political party.

Hauser helped to organize the local wards and precincts, building strong grassroots support for the 1912, 1914, and 1917 state campaigns. She conducted statewide speaking tours, lobbied Ohio legislators, debated anti-suffragists, and made myriad other efforts on behalf of securing the ballot for Ohio women.[58] After the Nineteenth Amendment passed, she joined other suffrage leaders to form the League of Women Voters, and she became a national officer in the organization and the cofounder of the Cleveland chapter. She also wrote on behalf of disarmament after World War I, and she continued her career as a journalist writing editorials for the league's publication. She died in Girard, having lived long enough to vote.[59]

Zara "Zadie" DuPont, who worked closely with Allen and Hauser, is a further example of Ohio suffrage leadership during the Progressive Era.

Born into the wealthy DuPont family in 1869, Zara grew up in Kentucky and attended private schools in Philadelphia. She was a lifelong advocate of child welfare and was active in both the women's suffrage and labor movements. As an early indicator of her strong personality and independent mind, DuPont refused to "come out" as a debutante, as was the custom of daughters born to wealthy families. As a young woman, she served on the board of the Children's Free Hospital in Louisville, Kentucky, before moving to Cleveland to help her widowed brother raise his children. DuPont also raised her deceased sister's daughter.[60]

Zara DuPont

After moving to Ohio, DuPont took up the women's suffrage cause, working with a variety of other Ohio suffrage leaders. A dynamic duo,

DuPont and Hauser led the 1910 effort to amend the Ohio state constitution to provide women the ballot. Their teamwork led to the creation of the Woman's Suffrage Party of Greater Cleveland. Further, during 1911, DuPont traveled across the state speaking on behalf of women's enfranchisement as a member of the Cuyahoga County Women's Suffrage Association. Throughout 1914, she led suffrage speaker groups throughout the state, and she eventually became a vice president of the OWSA.

Her speaking style was quite emphatic: she told—not requested—people to support women's rights. DuPont was partially deaf, but she used that to her advantage. When she didn't want to answer hecklers, she either ignored them, pretending not to have heard, or she dramatically lifted her "ear trumpet" and asked them to speak louder. Most hecklers had enough sense not to take the bait.[61] DuPont was a daring woman. While many other Ohio women shied away from open-air speaking, she boldly faced all audiences. Although less audacious local women turned their backs to journalists' cameras, Hauser and DuPont posed for a full-face photograph publicizing the Votes for Women pageant and parade in New York City. After winning the franchise, DuPont moved to Massachusetts, where she became active in the labor movement, taking up pro-labor policies in the boardroom of the Bethlehem Steel Company and signing a proxy statement against Montgomery Ward's labor policies. DuPont died in 1946, a voter.[62]

Though Taylor Upton is credited, legitimately, for being the primary driving force behind Ohio's battle for the ballot, women such as Williams Clifford, Harris Hunter, Galloway Higgins, Perlmutter Steinem, Allen, Hauser, and DuPont distinguished themselves by their contributions to the movement's organizational capacity at a pivotal time. Each leader made a name for herself navigating the political challenges and opportunities of the Progressive Era, and each played a significant role in amending the ever-ambitious agenda of the women's movement in the new century. Ohio suffragists continued to push for both federal and state suffrage legislation as well as women's officeholding. These leaders also reconstructed the movement's organizational capacity by adapting new strategies for membership drives, fundraising, and networking appropriate for a new century. While the state's suffragists continued to engage electoral politics and counter anti-suffragists, they also devoted themselves wholeheartedly to a new and important opportunity, the 1912 state constitutional convention and its special election.

Organizational Capacity Building for a New Century

At the turn of the twentieth century, suffragists faced challenges such as decreased membership and limited funding. Their lobbying in DC was inconsistent at best. The national organization was divided on whether to continue the push for a federal amendment or to focus more often on state campaigns. The NAWSA also was divided about whether to abandon its "southern strategy." Dating to the late 1800s, Southern politicians were convinced that they could protect white supremacy by giving white women the ballot. Many white suffragists were convinced by statistical and, too often, racist arguments that the South must be conciliated if women were to win the ballot. Taylor Upton initially went along with this approach by signing a NAWSA statement endorsing the idea that states should be free to develop their own woman suffrage positions in 1903. This view essentially condoned white supremacy in the South.[63] However, in 1906, she wrote, "I have often thought that the southern women might be enfranchised before the northern women because of the solution of the colored question, but we meet the indifference of southerners at every turn."[64] NAWSA efforts in the South ended in most states, and suffrage clubs were defunct or disbanded until the end of the decade. Eventually the NAWSA realized the southern strategy clearly was not working, politically or morally, and Howard Shaw openly opposed the strategy both before and during her NAWSA presidency.[65]

In its place, between 1900 and 1904, Chapman Catt instituted the "society plan," which redirected recruitment efforts toward college-educated, privileged, and socially influential women. Taylor Upton did not support the society plan; she wanted to keep the focus on the rank and file, arguing successfully on behalf of lowering annual membership dues to a dollar so anyone who supported the cause could afford to join the NAWSA. She warned that putting the organization at the mercy of society women who controlled the purse strings was a recipe for disaster. However, expanding the number of wealthy women of social standing increased the organization's reputation and fundraising capabilities.[66] In fact, this strategy proved immensely successful. From 1906 to 1910, affiliation increased to almost 117,000 dues-paying members, and the organization's treasury swelled. Nevertheless, it is important to note that the society plan continued marginalization and ignored the potential contributions of working-class women

and most women of color. Membership remained largely white, middle class, and conservative.[67] The changing demography of the state and the nation related to immigration and industrialization required better efforts to diversify membership after the turn of the century. To build a broader base of support, new organizations and alliances would be necessary.

Ohio successfully did its part to increase membership in the movement, though its inconsistent efforts to diversify that membership fell quite short. After the 1890s school suffrage victory, organizational efforts lagged, and the lack of any suffrage group in Toledo, Cincinnati, Columbus, Dayton, or Cleveland indicated a dramatic potential for growth. OWSA leadership expended a great deal of energy creating and maintaining local clubs or chapters. Starting in the spring of 1900, Taylor Upton traversed the state, visiting fifteen towns to organize suffrage groups. Then she adapted her strategy by focusing on growing established clubs rather than increasing the number of new clubs overall.[68] Ohio suffragists also concluded that they could more successfully recruit and mobilize locally by using suffrage speakers and professional organizers. Happy to oblige, several NAWSA leaders took a monthlong organizational tour through Ohio counties in 1900. The OWSA also strategized to gradually concentrate recruitment in urban areas, thus enabling them to reach larger numbers of people more efficiently. Mirroring the effort to urbanize recruitment efforts, the OWSA began scheduling its annual conventions in larger cities to gain greater visibility. These changes produced results. In the first two years of the new century, organizational membership doubled.[69]

Membership growth continued throughout the rest of the decade, though unevenly. Toledo led the way: by 1904, the city had four organizations, including the Toledo Woman's Suffrage Association, the Washington Club, the Bay Shore Political Equality Club, and the East Side Club. By 1906, Toledo boasted eight suffrage organizations.[70] Cincinnati had three, including the Susan B. Anthony Club, Twentieth Century Club, and Hamilton County Woman's Suffrage Association. Dayton had one suffrage organization, but it had disbanded before the turn of the century. In 1912, local reformers established another. After local leader Elizabeth Greer Coit died, membership in the Columbus society lagged until her daughter, Belle Coit Kelton, and Alice Heckler Peters organized the Columbus Equal Suffrage Association. Cleveland's Cuyahoga County Women's Suffrage Association grew minimally.[71] To reach rural communities,

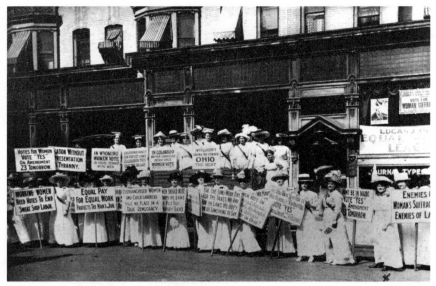

Toledo Woman's Suffrage Association, 1912

the OWSA relied on existing WCTU chapters, thus reducing the expenditure of both time and money on travel.

Racism, nativism, and classism all hindered the process of social reform. Generally speaking, the movement was less racist, nativist, and elitist in the Midwest than in the Northeast, but Ohio was not immune to these prejudices and discrimination.[72] Try as it might, the majority white middle- and upper-class state and national leadership could no longer ignore the nation's changing demographics. Ohio experienced another rapid growth in population, swelling to 5 million by 1910, and as a result, the state faced all the challenges associated with increased industrialization and urbanization. Southerners and Europeans, in search of employment and a better way of life, continued to be the primary newcomers. Many upper- and middle-class suffragists did not want to extend the vote to working-class immigrants because the majority of them believed immigrants opposed women's suffrage. Many native-born opponents expressed concern that granting women the vote would "double the immigrant vote." Suffragists often cited statistics to show that native-born women outnumbered immigrant men and women combined. Even if all gained the ballot, the votes of the native-born would still amount to more than the total for immigrant men and women.[73]

By 1914, South Dakota, North Dakota, Minnesota, Wisconsin, Michigan, Indiana, Illinois, and Ohio allowed foreign-born men to vote even before they became citizens. Many women in these states were angered by the idea that men new to the country, who had yet to contribute anything to society, would get the vote before they did.[74] That frustration led to increasingly nativist rhetoric on the part of movement leadership.[75] The NAWSA often blamed immigrants for suffrage defeats, especially Germans, whom they assumed would oppose the cause because of a perceived link to prohibition.[76] The NAWSA never adopted an official policy regarding the recruitment of immigrant women, nor did it develop targeted strategies and tactics to organize or mobilize them. The national organization did recommend that midwestern suffragists not waste their time, energy, and funding promoting the cause among immigrant communities, which they believed too "ignorant" to support women's enfranchisement.[77]

Most midwestern activists, including those in Ohio, did not follow the advice of the national organization.[78] In a limited capacity, the OWSA did try to reach out to German-speaking populations in parts of the state. Taylor Upton explained in a letter she sent during the 1912 suffrage referendum campaign, "The German lady of whom I wrote is Mrs. Clara P. Laddey. . . . We have instructed her to go to Cleveland where she will be for a week. . . . She speaks German beautifully and is a very charming lady."[79] Attempts such as this, however, were inconsistent and seldom successful.

Despite nativism, the women's movement expanded across international borders. A global network of organizations and conferences developed, including the 1904 formation of the International Woman Suffrage Alliance, presided over by Chapman Catt. The WCTU expanded internationally, too, becoming the world's largest women's organization. In fact, the WCTU deserves credit for the first national suffrage victories—New Zealand in 1893 and Australia in 1902. Though these successful attempts to expand voting rights are certainly laudable, historians describe these efforts to forge a global sisterhood as "imperial feminism," an ideology of Western women who would provide "uplift" for women living in underdeveloped parts of the world.[80]

Racism plagued the suffrage movement as much as nativism did. When African American women applied for NAWSA memberships, most were politely refused or ignored. According to historian Sarah Hunter Graham, "From the viewpoint of the NAWSA leadership, the inclusion of black

women would cost the organization members, money, internal harmony, and a positive public image."[81] A few NAWSA groups permitted individual African American women to join or provided for African American auxiliaries, but most did not. In many states, including Ohio, the effort to reach African American male voters happened primarily through Black churches and civic organizations. Additionally, African American suffragists organized an independent effort because segregation was the order of the day. For example, Martha Kline of Lucas County, Ohio, created the Washington Club, an African American suffrage organization, in 1903.[82] Rarely would African American and white suffrage groups combine forces. More often than not, the paths of white suffragists and those of color ran parallel rather than intersecting.

The state's white suffragists' efforts to reach across to the African American community typically were more educational than political, including high levels of literature distribution and letters to local clergy.[83] The OWSA created literature targeted specifically to African American communities. In a letter to another suffragist, Taylor Upton asked, "Have you any colored voters in your county? If so, drop me a postal card and I will send you some of the enclosed leaflet, which is a special one."[84] In this regard, patronizing white suffragists seemed to regard African Americans as a community in need of education—and as whites, they were the obvious choice to provide that education—rather than as political partners in the struggle for enfranchisement.

Dayton provided an important example, at least of an attempt, of racial inclusivity within the Ohio suffrage movement. Dayton Woman's Suffrage Association members worked closely with African American leaders, and the organization had at least four members active in the upper echelons of the administration. The city's white suffragists delivered speeches before African American audiences, and African American women independently ran the suffrage information booth downtown one day per week. Some of the city's more prominent African American women, such as Galloway Higgins and Quinn Brown, conducted the majority of suffrage work in the city.[85] Even though this was an important part of the state's movement, it received less attention than work performed by white suffragists. Media coverage occasionally documented this contribution. As a case in point, the *Dayton Daily News* reported about an "open-air assembly" where "Negro citizens [held] a suffrage meeting" and a "colored

speaker" named Elmon Terry emphasized, "the ballot needed woman more than woman needed the ballot."[86]

Caught up in the larger national ideological debates over race, a complicated relationship between regional, class, and educational differences within the Ohio population created a tension between the well-educated, northern-born, prosperous African Americans and the struggling migrants from the South who did not have the benefits of strong education. Harris Hunter, for example, believed that many African American club women, who faced different struggles than new migrants, undermined her efforts to create affordable and safe housing for Southern women moving to the state. While elite African American women demanded integration into the YWCA that served white women, Harris Hunter made a case for creating a separate boardinghouse. She persisted and, as the realities of segregation became all too painfully apparent, eventually won over her original opponents.[87] Rather than promote inclusivity, the local YWCA's white leadership supported Harris Hunter's efforts to create a separate space for African American women by helping her to raise funds. As the Great Migration increased after World War I broke out in 1914, the housing shortage in Cleveland worsened. Harris Hunter played a vital role in fundraising in both African American and white communities to expand available housing.[88] By and large, however, far too many white Ohioans feared "doubling the negro vote" and allowed racism to undermine moral arguments for women's enfranchisement.

The predominantly white and middle- to upper-class movement leadership also failed to capitalize successfully on the potential of working-class membership. The NAWSA did not consistently recruit trade union women, and its leadership never instituted an official policy for this group of potential members. Elite women held parlor meetings in their homes, to the exclusion of women in different economic classes. Many wealthy women, in fact, worried the ballot would end up in "the wrong hands"—those of the working class. Pro-suffrage elite women maintained that the influence of the wealthy over government and society should be increased and enfranchising women of that class would be one way to accomplish that goal. Anti-suffrage women argued "ignorant and irresponsible" women—those of the working class—would get the vote, too, thus decreasing the elite class's power. Yet others assumed the working class would defer to elites, creating a spirit of cooperation among women.[89]

Not until the last fifteen years of the movement did leadership reach out to support poor working women. In 1905, for example, the OWSA affirmed "the right of all wage-earning women to organize for the purpose of protecting their industrial interest."[90] Occasionally, the state received the national organization's support to mobilize trade union women. During the summer of the 1912 suffrage referendum, NAWSA president Howard Shaw hired Rose Schneiderman, one of the most prominent—if not *the* most prominent—working-class suffragists in the nation, to tour Ohio with the goal of building support among working-class communities. Thus, the battle for suffrage was never simply one against misogyny and patriarchy; it necessitated a fight against nativism, racism, and classism.

Women's rights activists in Ohio did claim one victory related to economic class. The movement's agenda expanded to include the most basic financial support for poor women and children. Progressives were concerned about the potential negative effects to young children if their mothers worked outside the home. During the 1910s, numerous states enacted mothers' pension laws. Illinois was the first state to do so in the Midwest, but other states, including Ohio, soon followed. In 1913, the Ohio legislature voted in support of mothers' pensions, providing destitute mothers whose husbands were disabled or jailed or had deserted the family with a meager subsistence allowance.[91]

Membership recruitment certainly was not the only challenge facing suffragists. The lack of funding for their campaigns proved a constant concern. Ironically, the OWSA started the 1912 constitutional convention campaign for a suffrage plank, what would become Amendment 23, with $23 in its coffers. Taylor Upton worked diligently to raise an impressive war chest of $40,000 for this campaign.[92] Additionally, that year the NAWSA gave more money to that campaign than any other, over $5,600, thus proving the point that "Ohio's battle was the nation's battle."[93] In truth, though, a significant part of that funding paid NAWSA speaker fees and salaries. To counter opposition from the liquor interests, OWSA spent more money in Cincinnati, a national center of breweries and distributors, than in any other city. However, in Ohio, the German American Alliance and the Personal Liberty League, as well as two liquor-lobby groups, initially allotted $500,000, and later another $120,000, to defeat suffrage.[94] Ohio suffragists' $40,000 budget was no match.

Suffragists from other states contributed money as well, and several prominent speakers came to Ohio without charging fees or came to support fundraising efforts.[95] For example, the Woman's Taxpayers' League hosted Belva Lockwood, the first woman to argue in front of the US Supreme Court. She delivered an address to an audience of ten thousand in Columbus's Olentangy Park, raising money for Ohio campaigns.[96] Occasionally, the state's suffragists would benefit from a wealthy benefactor. Daytonian John H. Patterson did his best to relieve some of the financial pressures facing suffragists in his hometown. Patterson, one of the owners of the National Cash Register Company, noticed that while men had many male-only places to socialize and network, women did not have the same. With his help, Marie Kumler, president of the Dayton Federation of Women's Clubs, successfully purchased a women's clubhouse.[97] Patterson was an ardent supporter of women's suffrage, writing in a telegram dated July 30, 1912, "Woman's Suffrage is right and in the end must win."[98] Patterson backed his rhetoric with his wallet, donating thousands of dollars to women's suffrage associations to help cover campaign costs. When funds were tight, he offered the local suffrage organization free office space in the Schwind Building in downtown Dayton.[99] After the Nineteenth Amendment was ratified, he sponsored civic classes for Dayton's women voters. Patterson consistently stood ready to provide moral and financial support, and Dayton suffragists were always quick to offer their thanks.

Networking and seeking public endorsements for the cause was another priority item on the Ohio suffrage movement's agenda. Some long-established affiliations, such as that with the YWCA, continued to maintain the movement; other affiliations, such as with the WCTU, frayed, while entirely new partnerships emerged. The Ohio Woman's Taxpayers' League (OWTL) could be counted among the new friends of Ohio suffrage. Founded by Anna Quinby, the OWTL was independent of the OWSA but regularly advanced the suffrage cause. The league hosted symposiums and sponsored national speakers on suffrage. League members secured thirty-six thousand signatures in support of the 1912 suffrage amendment. Quinby, who served as the organization's first president, taught elocution and oratory at Denison University and used her law degree to become the first woman from Ohio permitted to argue before the US Supreme Court. She lectured on behalf of women's suffrage in every county in Ohio, and she edited the state's suffrage newspaper.[100]

Quinby also contributed to OWTL's own publication, the *Equal Franchise Bulletin*. Within the pages of the bulletin, members would share their reasons for supporting suffrage. Ella Saur of Napoleon wrote, "We women tax payers demand a full application of the principle for which our forefathers fought and died, NO TAXATION WITHOUT REPRE-SENTATION," and Mary Tipton of Logan wrote, "7,000,000 working women in this country are the many reasons for enfranchisement."[101]

The NAWSA encouraged Ohio suffragists also to create and support a chapter of the College Equal Suffrage League (CESL). Wood Park and Inez Haynes Irwin founded the organization in 1900. The CESL provided a means of reaching out to the ever-increasing number of young, educated, middle-class women by recruiting college women and alumnae. Since Ohio led the nation in educating women at the college level, the state was fertile ground for such an endeavor. CESL leadership traveled to Ohio to organize three chapters, in Cleveland, Columbus, and Cincinnati. Eventually, other university towns formed chapters as well.[102]

Affiliations with men's groups also proved to be an important part of the state suffrage network. The Men's League for Equal Suffrage, established in 1912 in Cleveland at a meeting run by future mayor Newton Baker, was the first to support the cause. In its first few months, almost fifty men joined the league. The following year, Ohio State University professor J. V. Denney founded a chapter of the league in Columbus. Membership grew to approximately seventy-five members, including many of the city's prominent religious leaders, lawyers, and educators.[103] The Cincinnati Men's League formed the same year, and its membership grew to approximately two hundred members, led by Judge William Littleford. This group sponsored a variety of events, among them conventions, banquets, and a rally at which NAWSA's Howard Shaw spoke at Emery Auditorium to increase support for the 1912 suffrage referendum.[104] Each man paid a dollar in membership fees, and most were middle or upper class.

Men's leagues also formed in smaller cities such as Salem, Springfield, London, Youngstown, and Canton.[105] Men's groups held no official party affiliation. They sponsored fundraising campaigns, supplied newspapers editorials, interviewed political candidates on their suffrage positions, and bridged communications between women in the suffrage organizations and male-dominated political parties and government offices. The Men's League of Ohio advocated passage of the suffrage amendment by sending a petition to the state constitutional convention and a telegram to the

chairman of the convention, asking that it be read aloud before a vote on the question was called.[106]

As Ohio suffragists worked to strengthen the movement's organizational capacity, they constantly scanned the horizon for networking opportunities with new organizations such as the OWTL, CESL, and men's leagues. The relationships among core members of the suffrage movement and peripheral supporters created an important synergy that energized the movement. Links between organizations such as these and suffrage leadership helped to ensure the movement's longevity and flexibility. However, similar to recruitment efforts, networking priorities included middle-class taxpaying women, educated women, and well-connected men over people of color, the working class, and immigrants.

The Suffrage Agenda Meets the Progressive Agenda

Throughout the Progressive Era, citizens came not only to recognize the incredible social problems facing the nation but to conclude that the government was their best hope for addressing those pressing ills. While some Ohioans amassed staggering fortunes, the majority of the working class struggled. Suffrage once again became engulfed in an increasingly complex political environment in which a wide variety of issues competed for the government's and the citizenry's attention. Following the many defeats of the previous half century, Ohio women continued to press for incremental changes to their political rights, both as voters and as officeholders. Suffrage leaders knew they had to adjust the movement's agenda and how they presented it. The popularity of suffrage increased, but different groups favored women's enfranchisement for different reasons. In Ohio and elsewhere, property-owning women, rural women, elite clubwomen, and religious women, among others, all had their own reasons for supporting the cause.[107] Movement leaders knew they also had to change their strategies and tactics for these different audiences.

Progressivism demanded government intervention, but it also increased the desire for a system of governance in which people could participate more directly as a challenge to the existing web of nepotism and corruption on the part of party bosses. Suffragists understood that framing their arguments within the ideology of Progressivism could help make their case since, essentially, they, too, were asking to participate more fully

in the system of governance as voters.[108] The new view of government as caretaker of the citizenry aligned with stereotypes of women as nurturers. Many people also assumed women voters would support Progressive causes because of its focus on the human condition.[109]

Women campaigned for such issues as protective labor legislation, mothers' pensions, a juvenile criminal justice system, and public health programs, and they claimed doing so made them better and more responsible mothers. Leaders strategically chose these maternalistic initiatives because they did not challenge the conventions of existing gender norms. The temperance movement and the club movement shared this agenda, and because neither adopted a truly feminist approach, the commitment to gender equality and women's political empowerment became diluted. Feminist sisterhood was one source of mobilization for social reforms, but it was never the primary one nor was it sufficient to achieve the vote.[110] Such alliances among women's organizations helped, but the ballot was consistently subordinated to the larger Progressive agenda.

Conservative "home protection" rhetoric gave way to equally conservative "municipal housekeeping" rhetoric. Instead of arguing women needed the ballot to protect themselves and their homes, they began to argue that the squalor, illness, waste, crime, and corruption facing their cities had negatively affected their families. Many suffragists claimed women's enfranchisement was fundamental to cleaning up politics and mending the tears in the social fabric of America. This work gave women practical experience in politics, and it gave male government officials opportunities to see the potential value of women's participation in public life. Municipal housekeeping spread from the women's clubs of the East and Midwest to the western frontier, where women's demand for public roles translated into "civilizing" the Wild West.[111]

The year 1900 marked a presidential election, a prime opportunity for suffragists to showcase their cause in the national spotlight and to push candidates of all political parties for an endorsement. Unfortunately, this opportunity failed to materialize, even with the help of the First Lady, Ida McKinley. In a rematch, Republican president and Ohioan William McKinley faced Democrat William Jennings Bryan. Bryan was on the record supporting women's suffrage. McKinley had supported the cause as a young man, even taking the affirmative side of a YMCA-sponsored debate about women's enfranchisement.[112] However, as an elected offi-

cial, he avoided taking a position on the issue by emphasizing repeatedly it was the party's role to take a stand, not his.

Ida McKinley, another native Ohioan, strongly believed in the suffrage cause. Her support was rooted in the mentoring she had received from her father and a teacher, suffrage pioneer Betsey Mix Cowles.[113] While her husband was governor, she encouraged him to bring Elizabeth Cady Stanton and Victoria Claflin Woodhull to the state to speak about suffrage. In the White House, she became the first First Lady to support the cause. During her third year in this position, she allowed her views on the topic to become more public by permitting her name to be used for a NAWSA fundraiser. She even went so far as to donate a doll she sewed clothing for and named "Carrie Catt McKinley" to sell at this event.[114]

In her fourth year as First Lady, Ida diplomatically communicated her support for the cause. She would not come downstairs when an anti-suffrage delegation met with the president at the White House. However, when Anthony and other suffragists visited the White House while in Washington, DC, for their annual convention, she invited them to her private suite. At the end of this visit, the First Lady gave Anthony a huge bouquet of lilies, imploring her, "When you go to the Suffrage Convention, I want you to tell them that this is from me, as a gift to all of you."[115] Anthony later chronicled, "I carried the beautiful lilies to the convention that evening and held them up before the vast audience and said 'Mrs. McKinley shakes hands with you all spiritually.'" The bouquet stayed on platform during the convention as a sign of her support. Anthony and McKinley maintained a connection. Anthony reportedly gifted a copy of *The History of Woman's Suffrage* to McKinley.[116] After her husband's assassination, McKinley no longer had the position of First Lady to leverage on behalf of the cause, though she continued to believe in its importance.

Fortunately, the next White House occupant also was a proponent of women's rights. By the time President Theodore Roosevelt took office in 1901, he already had expressed his support for women's suffrage. His views on women's roles were at some times remarkably progressive, and at others, conservative. During a commencement ceremony at Harvard, Roosevelt read an excerpt from his thesis, "Practicality of Giving Men and Women Equal Rights."[117] However, like many other politicians who supported women's rights privately, he remained painfully neutral publicly while running for office. For much of his career, he believed it was up

to the states to provide women the ballot. Not until he ran for president again in 1912 on the Bull Moose Party ticket would he openly support the federal suffrage amendment.[118] First Lady Edith Roosevelt did not come out as a public supporter of suffrage until the Nineteenth Amendment seemed likely to pass.[119]

Next in office, President William Howard Taft, a native Ohioan, most certainly was not a suffrage advocate, having even been hissed at once by suffragists while addressing their convention.[120] Taft believed women were too emotional to vote: "On the whole, it is fair to say that the immediate enfranchisement of women will increase the proportion of the hysterical element of the electorate."[121] Those running Taft's presidential campaign did not believe women's suffrage would necessarily bring him votes. Both the Republicans and Democrats made symbolic gestures toward women, such as appointing a few token women to posts within the party organizations, but during this election cycle neither presidential candidates nor parties made sincere efforts to advance the federal suffrage amendment.[122]

During this time, party politics became increasingly complicated, and the state's suffragists did their best to adjust to a dramatically different political landscape. In addition to support from the Populist Party and the Prohibition Party, the suffrage movement gained the endorsement of the Socialist Party from its founding at the turn of the century. The Socialists' most prominent leader, Eugene Debs, was a consistent and vocal advocate of women's enfranchisement, unlike many other presidential candidates. During the final month of the 1912 suffrage campaign, four airplanes flying over Toledo distributed leaflets supporting Debs for president.[123] Despite Debs's efforts in the state, Socialism had limited success and thus did not advance the cause of suffrage. One party supporter wrote in the *Progressive Woman*, "In New York, Ohio, and Illinois, Socialists are almost lifeless in the advocacy of woman suffrage. These three states should be in the vanguard." The writer bemoaned, "Many men members of the Socialist party do not seem to be aware of the equal suffrage plank in the platform of the Socialist party, and forget that it is there for a purpose—a constructive purpose—a purpose which has in view the unity of both men and women that they made stand together in their work and aspirations for economic freedom."[124]

Support from the Socialist Party actually made the cause all the more controversial.[125] Ohioans supported Progressivism more than Socialism. This fact created a double bind for Ohio suffragists. If they repudiated

Socialism, they risked alienating working-class women; if they touted the benefits of Socialism, they risked alienating social elites, among others.[126] In this regard, Progressivism and presidential elections brought both opportunities and challenges to the movement. Ohio's leaders did their best to navigate these unchartered waters. Lecture tours and annual conventions continued to be the mainstays of the state suffrage movement. The overall structure of the conventions did not differ from previous years, and resolutions issued between 1900 and 1910 continued to cover a wide array of topics, among them prostitution, child labor, and taxation without representation. As the first decade of the new century unfolded, the state's suffragists eventually adopted new and increasingly dramatic methods to obtain their goals.

The national leadership encouraged novel and more forceful tactics. Mary Hutcheson Page and Harriot Stanton Blatch, upon their return from the United Kingdom, reinvigorated the movement by imploring US suffragists to embrace daring tactics such as open-air meetings, parades, and public debates. The time was ripe for newer, bolder actions. In 1908, Britain's Bettina Borrman-Wells, the first woman to hold an open-air meeting in the United States, spoke in front of Cincinnati's city hall and Cleveland's Public Square. The outdoor audience in Cincinnati included approximately five hundred men who "heard their sex get terrific jolts and stings from the women, who, from the seat of a dilapidated express wagon, expounded 'The Burning Question.'"[127] Martha Gruening, a militant suffragist from New York, was the first to introduce soapbox oratory to Cleveland. Ohio women, including Hauser, accompanied Gruening to distribute pamphlets while she delivered a speech in front of Philadelphia's Public Square. They were impressed that a speech so "unladylike" could be well received.[128]

Many Ohio women felt uncomfortable addressing audiences in the open air, and for good reason. In a special Sunday edition, the Medina newspaper published a feature story about this unique approach, describing the jeers and taunts telling women they "ought to stay home." Despite these hostile responses, a variety of Cleveland women bravely took up soapbox speaking. Some reveled in the boldness of the tactic, while others wished no one would be in the audience when they spoke.[129] Local suffrage leaders considered this tactic a godsend since it spared spending money on renting halls, generated larger audiences, and reached listeners who might not otherwise plan to attend a suffrage event. It also directed

national attention on the state. Generally speaking, however, suffragists rhetoric tended to be very conservative, even if their methods were not. Most open-air speakers maintained women needed the ballot to protect hearth and home. OSWA executive committee members, including Taylor Upton, Perlmutter Steinem, Hauser, and others, became Chautauqua speakers on the topic of suffrage, and this strategy also increased the national reputation of Ohio's leaders.[130]

Suffragists in the East were more willing to adopt "unladylike" tactics than the more conservative Ohio women, but even these midwesterners saw the need to employ such methods. They knew that public education alone would be insufficient unless combined with increased political activism and agitation. Ohio women began to speak at picnics, country fairs, family reunions, circuses, beaches, factories, country stores, schools, and anywhere people would listen.[131] To prepare reticent speakers, the Women's Suffrage Party began organizing "suffrage schools" in Cleveland, Columbus, and Cincinnati as early as 1909.[132] Suffrage schools served a dual purpose of educating the public and training activists by offering lessons in elocution, debate, and oratory and eventually in campaigning, finance, press relations, and other topics. Many women were eager to enroll.[133] Suffrage schools typically charged one dollar per course or twenty-five cents per session, though some suffrage schools began offering courses free of charge so that the average working-class woman could attend.[134] Training such as this emboldened Ohio suffragists, changing both the pace and style of their activism.

Obviously, the primary focus of the state's leaders remained on its legislative agenda. In 1904 and 1905, the state's suffragists asked "legislators to submit to the voters an amendment giving full suffrage to women." The resolution failed to make it out of committee either year. In 1908, suffragists tried again to advance full suffrage for women. This time the measure was reported out but no vote taken. In 1910, Ohio suffragists made a similar attempt, only to have the amendment defeated on the floor of the state senate.[135] In all, the last half of the 1890s and the first decade of the 1900s was a dry spell for the entire suffrage movement. Leaders could claim no new legislative wins, and most politicians at both the national and state level remained impervious. The US Congress went through the motions of holding committee hearings every few years. Not one new state granted the franchise to women between 1896 and 1904. Women's rights reformers ran six state campaigns during this time. Each one failed.[136] Some his-

torians describe this period as "the doldrums," while others argue it was a time of regrouping and preparation for new initiatives.[137] Either way, the first decade of the new century, which suffragists had looked to with hope in their hearts, brought only continued disappointment.

The Anti-Suffrage Movement in the Progressive Era

Anti-suffragists continued their fight during the Progressive Era too. Typical of the sentiments circulating among the opposition, Ohioan James Stubbs wrote an open letter to the state legislature urging its members to reject suffrage petitions: "In your honorable body there are no sissy men, no squaw men, no female men, no half men."[138] Stubbs clearly, like most other anti-suffragists, questioned the masculinity of men who supported women's enfranchisement, and he warned manhood was jeopardized by suffragists who threatened the social stability patriarchy represented.

Outbursts such as Stubbs's eventually coalesced into a full-fledged countermovement at the national level. Josephine Jewell Dodge, an original proponent of day care centers to support working mothers, led the National Association Opposed to Woman Suffrage.[139] Like suffragists, opponents organized events, conducted state campaigns, and published periodicals such as the *Woman's Protest*. Most members were wealthy women, Catholic clergy, distillers and brewers, Southern congressmen, and corporate leaders, but public education campaigns often targeted workingmen's economic interests and desires to protect their families. The organization's goal was to legitimate family-based suffrage in which husbands voted on behalf of the entire family.[140]

Not all anti-suffragists were wealthy women seeking to protect their own self-interests. Some anti-suffragists were devoted reformers who supported gender-based protective labor legislation and feared political equality might weaken women's labor laws, which would result in a loss of protections for workingwomen. Southern women worried the Susan B. Anthony amendment might increase federal scrutiny of the state ballot boxes and lead to an increase in African American votes. Other anti-suffragists were nativist, fearing women's enfranchisement would increase immigrant votes.[141]

Ohio's anti-suffragists organized formally in 1911 using many of the same strategies and arguments they had used as individuals and as small

pockets of opposition. During the 1912 campaign, the anti-suffrage slo-
gan became "23 Skidoo—Vote No for Woman Suffrage."[142] Most Ohio
anti-suffragists continued to be among the state's wealthiest families.
Maria Longworth Storer, for example, founded Rookwood Pottery, and
she was the granddaughter of a wealthy businessman in Cincinnati.
Though Rookwood was a rare example of a woman-owned business, and
Longworth Storer made a special effort to hire women, she was an ardent
anti-suffragist who argued from her position of privilege that women did
not need the ballot.

Two of most influential anti-suffragists during the 1912 state referen-
dum campaign were Susan Platt Hubbard and Florence Goff Schwarz.
Platt Hubbard was born into a well-to-do mercantile family in Columbus.
A niece of President Rutherford B. Hayes, she also was well connected
politically. She supported a variety of cultural and civic organizations,
including the Columbus Art Association, the children's hospital, the Hu-
mane Society, and the Columbus Symphony Association, among others.
Platt Hubbard was elected the first president of the Ohio Association
Opposed to Woman Suffrage (OAOWS).[143]

Throughout the campaign, she vigorously rebutted her opponents'
arguments, claiming, "It is by educating public opinion rather than by
voting that social and political reforms have been brought about." She
continued, "Individualism is the cry of the age," but she warned, "the in-
dividualism of woman in these modern days is a threat to the family."[144]
Platt Hubbard also denounced claims that voting was an inherent right,
women were physically and intellectually as capable as men to vote, or
women were being taxed without representation.

Platt Hubbard's administrative style was confrontational. During the
ratification campaign for the Nineteenth Amendment, in a letter to the
editor of the New London Day, she fanned the flames of anti-immigrant
sentiments, questioning whether it was wise, in a time of war, "to increase
the electorate and double the number of voters who have not been born
under our flag and therefore do not feel the same responsibility towards
upholding America and American institutions."[145] Later in the ratification
campaign, she raised the threat of Socialism: "The whole country will be
in danger of Socialism, Bolshevism, and anarchy . . . the working man is
always dissatisfied and would be only too glad with the help of his wife to
overthrow the government."[146]

Even after the amendment's ratification, Platt Hubbard's views about votes for women and about their role in public office did not evolve. In a story about Platt Hubbard's pro-suffrage nemesis Lucile Atcherson Curtis, the *Columbus Dispatch* reported the latter had become the first woman to serve in the US Foreign Service. The reporter noted, "Most persons had supposed that the National Association Opposed to Woman Suffrage would cease to function when suffrage became a fact, but it appears that the association is being kept very much alive and that one of its purposes is to 'knock' whenever it is suggested that a woman be appointed to office."[147]

Florence Goff Schwarz, born in Hillsdale, New York, and a graduate of New York University, taught school in Plattsburgh, New York, briefly before moving to Cincinnati in her early twenties. Goff Schwarz became the most recognizable anti-suffragist in Ohio, and she achieved national recognition as an opposition speaker. Goff Schwarz's reputation as a charismatic leader garnered her invitations to spearhead opposition campaigns in Wisconsin, Tennessee, and Pennsylvania. In Ohio, she served as the leader of the Hamilton County Anti-Suffrage Association and eventually as president of the state organization. She zealously addressed men at factories and businesses throughout Cincinnati, calling on them to prevent women's enfranchisement.[148] Goff Schwarz invited anti-suffragists from out of state, including officers from the national organization, to speak throughout Cincinnati.

Goff Schwarz also worked as a member of Mayor John Galvin's War Committee during World War I. During the war, she objected to the continuation of suffrage campaigns. In her role as the business secretary of the OAOWS, she stated in an article published in the anti-suffrage *Woman Patriot*, "Our association has ceased its propaganda. We have not held a single meeting since America entered the war."[149] She underscored her impression that suffragists were unpatriotic. Goff Schwarz also served as president of the Women's Press Club in 1929–30.

Goff Schwarz was a published poet.[150] Some of her poems explored gender roles. "Is Woman Man's Equal?" begins, "Is Woman Man's Equal? / Can she cull from the forest and mines and shape / a ship that will stand the gale? / Or fashion a monster of steel and steam / to write o'er the polished rail?" In the majority of her poems, she asked similar questions about "men's work"; for instance, "Can she dig and delve while her brow reeks sweat / in the bowels of a fetid mine ? / Can she face the power and

the shot and ball / for the enemy's firing line?" The poem ends with an emphasis on women's "special" power, "Far greater than man, made immortal by prowess, or chisel or pen, is she who approaches Death's portal that we may have soldiers and men."[151]

In addition to anti-suffragists, Ohio's reformers had to contend with the well-funded liquor lobby, a far stronger opponent. The liquor industry quickly realized it could leverage the politics of anti-suffragism to benefit itself. A strike against suffrage was a strike against prohibition. The liquor lobby operated mostly behind the scenes, seldom taking suffragists head-on. Instead, it sent anti-suffragists to do its bidding. Much to the frustration of Taylor Upton, anonymous leaflets linking suffrage with prohibition were distributed throughout the state. The OWSA offered a $100 reward for any information that would reveal who circulated the anti-suffrage propaganda. The authors were never discovered, but anyone could guess it was the liquor lobby.[152]

The anti-suffragists' rhetoric continued to advance the claim that women did not need the ballot and their enfranchisement would make little difference in state affairs. The opposition also continued to base its arguments in fear appeals. During the 1912 referendum campaign, anti-suffragists argued, "Political responsibility will eventually work great harm to women, and through them cause a marked deterioration of the race," and urged men to "protect us as far as they can."[153] During the campaign, the Hamilton County Association Opposed to Woman Suffrage published a pamphlet, *Comparison of the Laws of Ohio and Colorado*, that argued Colorado's voting women had not helped the state advance progressive legislation most suffragists supported. In a different pamphlet, *Suffrage and Socialism: The Deadly Parallel*, the association advanced fear appeals based on the Red Scare and labor unionization.[154]

Arguments made by suffragists of the twentieth century included those made in the nineteenth century as well as novel ones. Supporters of the cause continued to make the case that government should depend on the consent of the governed and voting would make women more broadminded, which, in turn, would make them better wives and mothers. Instead of questioning anti-suffragists' assumption that women's priorities should be home and hearth, suffragists leveraged domesticity as a political and moral virtue. Rather than argue men and women were equal, they stated that women deserved the ballot because they were different than men, and society needed women's moral superiority to progress. The

repertoire of arguments expanded. Granting women the ballot would increase the proportion of educated voters, because high schools of every state graduated more girls than boys and more women were attending college.[155] Twentieth-century suffragists also pointed to the fact women were voting in four states and in other countries, resulting in not one of the many horrible outcomes anti-suffragists fearfully predicted.

The 1912 Ohio Constitutional Convention

Living under an antiquated state constitution, written in 1851, Ohio voters overwhelmingly approved a measure for a twenty-two-week state constitutional convention to commence in January 1912.[156] Progressive Era reformers of all stripes began to formulate plans. The state's suffragists saw this as a prime opportunity, since referenda coming out of the constitutional convention would allow suffragists to go directly before the voters rather than lobbying the state assembly. At the 1911 OWSA convention in Dayton, attendees eagerly voted to petition the convention to submit a woman suffrage proposition. The job ahead was staggering and the time to do the work extremely limited. In preparation, the OWSA established a campaign committee and opened headquarters in Toledo, home of OWSA president Perlmutter Steinem. Perlmutter Steinem organized the annual convention and distributed literature, while Taylor Upton, OWSA treasurer, directed the constitutional convention work.[157] As the organization's elected president, Taylor Upton continued this work in 1911.

OWSA executive committee members met to strategize. They decided on the slogan, "Ohio the Sixth"—which later became "Ohio the Seventh," after California passed a state women's suffrage amendment in 1911.[158] The leadership also decided to change the organization's format. Following New York's lead, Ohio women determined they should organize a "full-fledged political party with a machine working much the same as that within the Democratic or Republic parties."[159] Hauser led the effort. According to the *Cleveland Plain Dealer*, the goal of each party was to "form an army, rank and file, and march solidly into the camp of the enemy, capturing said enemy and afterward converting him to the woman's cause."[160] Taylor Upton urged, "We must meet them [politicians] with their own weapons. We must have a strong party and force them to vote for that amendment. If any of you know a politician, go after him. Get him. But

we must have the people with us too."[161] Within a year of its founding, the Ohio Woman Suffrage Party boasted a membership exceeding a thousand.[162] The party grew rapidly in Cleveland especially, making the city a hub of urban suffrage work.

A new energy spread across Ohio as the convention approached, resulting in a dramatic increase in the number of suffrage organizations.[163] More and more women wore small blue-and-gold buttons featuring a six-sided star and the slogan "Ohio Next."[164] Not until this time did Cleveland women organize for the vote, creating a local branch of the National College Equal Suffrage League in 1910.[165] The largest Ohio suffrage club was Warren's Political Equality Club, with over two hundred members. Springfield's Civic League, London's Woman's Elective Franchise Society, and Cincinnati's Susan B. Anthony Club each had over a hundred members.[166] The "average" suffragist attended meetings and lectures, distributed literature, participated in events at the local and state levels, attended fundraisers, and worked to raise awareness for the cause. To achieve the latter goal, suffragists mailed postcards to legislators, awarded prizes for successful state chapters, created high school displays and student essay contests, and worked on myriad other promotions.

The Harriet Taylor Study Group, named in honor of the OWSA president, also organized in 1910 under Martha McClellan Brown's and Mary Sherwood's leadership. This was the only suffrage club to be admitted to the Ohio Federation of Women's Clubs. The federation's constitution banned affiliation with any political or religious groups, and suffrage clubs were political. Thus, the word *study* must be included in the group's name.[167] The federation avoided the topic of suffrage for years, but for the first time, attendees at the fifteenth annual convention, held in Oberlin that year, broached the topic. The discussion resulted in little change, and the OWSA failed to convince the federation to support the cause.[168] Clara Snell Wolfe, the OWSA recording secretary from 1905 to 1909 and a CESL member, became the corresponding secretary of the Ohio Federation of Women's Clubs in 1911. She played a role in the campaign for the 1912 constitutional convention, visiting women's clubs all over the Midwest, organizing support, and fundraising.[169] She also joined an attempt by Cleveland and Toledo suffragists to pass a suffrage endorsement at an Ohio Federation of Women's Club meeting in 1911, which failed.[170]

Ohio's suffragists were quite busy during the summer of 1912, and most believed they had good reason to be optimistic. Allen alone trav-

eled to sixty-six Ohio counties, addressing anyone who would listen, from farmers' groups to union workers and from circus audiences to those attending band concerts.[171] As the convention was called to order in Columbus, suffrage organizers sponsored an open meeting in the chamber of commerce building. Hauser opened headquarters in the same building, staying eight weeks and working without a salary to coordinate the battle plan. By spring, suffragists were staffing three campaign centers—in Cleveland, Columbus, and Cincinnati—and by summer, the number expanded to include Toledo, Akron, Springfield, Canton, Dayton, Warren, and Youngstown. Some fledgling chapters, such as those in Canton and Youngstown, were quite active in the campaign. Most of the new groups, however, found it difficult to establish themselves in time for Election Day. The state was organized to an unprecedented degree, and house-to-house canvassers obtained the necessary signatures to support the OWSA petitions.[172] The call for a petition drive to place suffrage on a referendum ballot contributed to the significant increase of interest in the issue.

In addition to petitioning, Ohio suffragists doggedly lobbied convention delegates and legislators. The WCTU and Ohio Woman's Taxpayers' League also joined OWSA to lobby the legislature. Taylor Upton joked with the press, "This time we're not being given the cold shoulder. There's nobody sliding down mail chutes or climbing out coal holes to get away from us." According to William Kilpatrick of Warren, chairman of the convention's Equal Suffrage Committee, "no better organized lobby ever haunted the Capitol corridors than that of the Ohio Woman's Suffrage Association."[173] Suffragists were not above exploiting their appearances or feminine wiles for the cause. The OWSA sent the most charming young women it could find as representatives to interact with delegates at the convention, countering the prevailing stereotype of suffragists as homely old spinsters.

The OWSA estimated that 56 of the 119 elected delegates to the state constitutional convention supported submitting a woman suffrage amendment to the electorate. Though sixty-one votes would be needed, Ohio suffragists were optimistic. The *Woman's Journal* reported, "Now there is a wholly new spirit in Ohio. . . . 'Progress' is the cry; and this progressive wave includes women."[174] This hopefulness increased tenfold when Herbert Bigelow, a member of the suffrage association's advisory board, was elected convention president. Suffragists contacted him within an hour of his election to suggest a list of delegates who supported the cause and thus would make ideal committee members.[175] Bigelow created the Equal

Suffrage and Elective Franchise Committee, and William Kilpatrick of Warren, another longtime supporter of suffrage, became chair. Of the committee's twenty-one members, twelve were Democrats and nine were Republicans; almost all of them favored submission of a women's suffrage referendum.[176] Reformers had a direct impact on the committee. In fact, suffragist and Tiffin native Dora Sandoe Bachman helped to draft the platform.[177]

During the first month of the convention, delegates held pro- and anti-suffrage hearings. Members of the OWSA convened at the state capitol in February for the hearings in the Senate chamber. Approximately fifty women attended, and nine from various cities across the state testified during the pro-suffrage hearing. Emma Perkins, dean of the Women's College of Western Reserve University, gave the primary address, arguing women were different from men, who, therefore, could not represent them appropriately.[178] The male delegates who later spoke in favor of women's suffrage echoed the women's arguments. They consistently argued women were the equals of men and the right to vote was a natural, inalienable one. Some delegates also encouraged support of women's suffrage as a means of promoting prohibition.[179]

Suffragists' efforts to get on the referendum ballot did not go unchallenged. Platt Hubbard led the assault. She submitted a petition to the constitutional convention:

> We, the undersigned women, citizens of Ohio and residents of Franklin County, hereby respectfully protest and remonstrate against any modification of the constitution of our state that seeks to impose upon women the duties and responsibilities involved in suffrage. We believe that women can and do exercise their full share of influence and responsibility for the public welfare without the ballot. We are confident that only a small minority of the women of the state desire the franchise and we respectfully submit that to impose the responsibilities of the franchise upon an unwilling electorate is unfair to the individual and dangerous to the state. We therefore respectfully object to any and all measures having that end in view.[180]

A small group of approximately thirty Columbus women made the first formal attempt in the state by a women's organization to block suffrage.[181] Well-educated and well-spoken Platt Hubbard testified before the Equal Franchise Committee, emphasizing voting was not a right but

a privilege, which carried duties and responsibilities many Ohio women did not want. Opponents also argued that women's enfranchisement was contrary to the Bible's teachings, and there was a link between women's suffrage and liquor licensing.[182]

Over three hundred people rallied after the anti-suffragists' hearing, but ironically, more than half in attendance were suffragists. The rally had backfired. Writing in the *Woman's Journal*, Columbus suffragist Jeannette Eaton explained, "The opposition of the Antis has created a political issue, which has greatly increased our earnest sympathy and has given the whole movement immense publicity and impetus."[183] Platt Hubbard's testimony actually advanced suffrage support among the delegates, and it resulted in an increase in the number of members in both the Columbus suffrage group and the Men's League.[184] Taylor Upton asserted there was never any real threat by the statewide anti-suffrage association, and she emphasized the real enemy was the liquor lobby.[185] The next year, in an address published in the *Ohio Journal of Commerce*, Platt Hubbard continued her assault: "It is by educating public opinion rather than by voting that social and political reforms have been brought about," she continued, "the individualism of woman in these modern days is a threat to the family."[186]

By the time of the constitutional convention, Ohio suffragists had incorporated a variety of new strategies and tactics in addition to petitioning and lobbying to ensure that the special election would include a suffrage referendum. The CESL hosted a stereoscopic slide show at a local theater, and it produced suffrage plays. Cleveland women planned a series of trolley excursions and open-air meetings in Medina, Bedford, Willoughby, Oberlin, Norwalk, Chagrin Falls, Painesville, and East Cleveland. They persuaded Wood Park and Allen to join the first event in Medina. Forty Cleveland suffragists and press reporters set out in a private trolley covered with large signs calling for "Votes for Women."[187] Wood Park did most of the speaking while the others distributed leaflets.

Ohio women expanded their repertoire to include public debates. Bertha Lane Scott, a leader of the National Association Opposed to Woman Suffrage who was born in Cincinnati, and Wood Park both happened to be visiting Cincinnati at the same time. They agreed to a public debate.[188] The event gathered an audience of four hundred people, and it received much-hoped-for press coverage. The debate illustrated commonly held social definitions of gender. Most women and men perceived suffrage as a destruction of traditional gender roles, marriage, and motherhood. Often,

anti-suffragists contradicted themselves in their speeches and debates. The same women who claimed women lacked the psychological and biological capacity to vote spent long hours campaigning away from their families to prevent enfranchisement. Further, women who said they did not want to vote regularly voted at anti-suffrage meetings and conventions.

Throughout the Midwest, citizens formed numerous debating societies to dissect the problems facing the nation and to advance possible solutions. These events became hugely popular during the Progressive Era, providing an important way for the citizenry to become more engaged in the political process. Because debates often brought men and women together in the same spaces, this gender inclusivity afforded a chance for people to see women genuinely concerned and knowledgeable about public affairs and how they had their own ideas about how to solve social problems.[189] Suffrage was often among the women's rights issues debated.

The Ohio suffrage movement benefited from the assistance of outside supporters as well. The 1912 campaign received needed media attention when Emmeline and Sylvia Pankhurst, mother and daughter suffrage militants from the United Kingdom, visited the state. In a lecture tour organized by the CESL in 1911, Sylvia spoke in Cleveland, Columbus, Cincinnati, and Toledo.[190] The same year, Emmeline spoke in Cleveland, drawing capacity crowds. This event was unique in that it was the first to charge admission; tickets sold for a dollar each. The *Toledo Blade* described the occasion as "fashionable," noting that one-fifth of the audience members were men. Pankhurst persuaded many to adopt the cause, and socialites who attended the lecture paved the way for rebranding the cause as socially respectable. In a letter to her friend Alice Morgan Wright, Emmeline reflected, "Ohio meetings are very good & I think suffrage work promises well in the future."[191]

The day of reckoning had arrived. Suffragists across the nation held their collective breath, hoping and praying to leap the first hurdle in the race to make "Ohio Next." The Equal Franchise Committee of the constitutional convention met on February 14, 1912. Finally, suffragists enjoyed the sweet taste of victory. The committee voted to pass a women's suffrage amendment: sixteen affirmative, one negative, and four abstentions.[192] The lone opponent on the committee was Allen Marshall of Coshocton, who delivered a long diatribe denouncing the evils of women's suffrage, describing it as a "fatal leap from the highest pinnacle of the pedestal

of creation down to its base, alighting in the seething cauldron of political corruption."[193] Ignoring Marshall's rantings, Ohio suffragists were thrilled. The local press called the vote a "suffrage valentine."[194]

Perhaps unsurprisingly, the convention's conservatives would not concede. Opponents tried three times to pass a proposal that would have required a preliminary referendum among Ohio women. If passed, this measure would mean that only if a majority of women voted in favor of suffrage would the amendment be presented to the male voters for ratification in the special election. Fortunately for suffragists, delegates tabled the proposal every time. When this maneuver failed, opponents—specifically the liquor interests—played up the connection between enfranchising women and prohibition. The die was cast. The issues of prohibition and suffrage would be inextricably linked throughout Ohio's suffrage history. Try as they may to convince the public to judge their case for enfranchisement on its own merits, the state's suffragists could never separate the issue in voters' minds.

Opponents then attempted to undermine the success of the suffragists' campaign by emasculating African American men, asserting that if they voted on behalf of women's suffrage, they would "be tied to women's apron strings."[195] The African American press, which largely supported women's suffrage, called the proposed amendment a "wise and shrewd move" to gain the African American vote.[196] Additionally, delegates passed a proposal requiring the word *white* be removed from the Ohio Code, to conform, finally, to the Fifteenth Amendment to the US Constitution. The proposal was designed to hurt support for woman suffrage by race-baiting.[197]

In addition to the ballot, Ohio's suffrage leaders continued to prioritize officeholding. The Ohio Federation of Women's Clubs submitted a proposal to delegates of the state's constitutional convention to remove the provision requiring officeholders be electors, paving the way for women to run or to be appointed. This measure, which became Proposal 163, received support from a variety of organizations from across the state. Over the course of the convention, the delegates received and filed documents from the Girard Political Party club, Woman Suffrage Party of Cleveland, Men's League for Woman Suffrage, CESL, Ohio WCTU, National Council of Women, Hamilton County's Hawthorne Literary Club, Snow Monday Club of Cleveland, and the Women's Congregational Club of Cuyahoga County—all in support of the proposal.[198]

During the constitutional convention debate over Proposal 163, some delegates believed the measure did not go far enough to provide opportunities to women. As expected, other delegates felt the opposite. While the debate was not particularly contentious, one delegate who opposed the measure exacerbated the situation by lamenting on the "incongruity in a woman becoming president of the United States or chief justice of the state of Ohio."[199] This delegate need not have worried about what he considered to be a dire prediction. It would take eighty years before a woman would occupy even one of these positions.[200] Eventually, delegates narrowed the wording of the proposal to provide women officeholding opportunities only in capacities commonly associated with the interests of women and children. The narrowed measure passed, providing for "the appointment of women who are citizens, as notaries public, or as members of boards, or to positions in those departments and institutions established by the state or any political subdivision thereof, where the interests or care of women or children or both are involved."[201]

Originally officeholding and women's suffrage were to be forwarded as a joint measure, but after the debate, delegates chose to divide the two issues into separate votes. Some suffragists hoped separating the two issues would make it more likely voters would advance women's rights by passing at least one of the amendments during the referendum. However, as legal scholar Elizabeth Katz explains, "Other women's rights proponents found this proposal unwise. If women obtained the franchise, they were presumably eligible for all elective and appointive offices, rendering an expanded appointive office amendment unnecessary. And if women lost on suffrage, the same attitudes might defeat this expanded officeholding amendment."[202] The Ohio Public Office Eligibility for Women Amendment, designated Amendment 36, made its way on to the 1912 referendum ballot.

When full debate of the measure by the entire convention began, Chairman Kilpatrick argued the ballot was a fundamental right and essential to democracy, especially for working women. His speech ended, "The opportune time for democracy in this state . . . is now and here."[203] Delegate Hiram D. Peck, from Cincinnati, was one of the most ardent supporters. He gave long speeches about the benefits of granting women the vote. At the constitutional convention, he argued, "Gentlemen, if you want clean streets in your cities, let the women vote. If you want your streets and highways kept in repair and your cities kept sanitary, let the women vote.

If you want your school houses kept in order and made sanitary, let the women vote." He reassured his fellow delegates, "They will keep them in order. If you want your schools run right and your school teachers kept up to the mark, let the women vote. They will take care of that. If you want playgrounds for the children, let the women look after it by their votes."[204]

The suffrage question received two days of debate. However, a stipulation limiting speeches to three minutes passed, indicating an unwillingness on the part of many to engage the issue. Frustrated supporters pointed out that delegates spent two weeks discussing a bond issue related to road construction but only two days on women's suffrage. The debate also revealed that delegates feared that the women's suffrage amendment could sink the full constitutional convention project, and so they agreed that the amendment should stand on its own merits.[205] Ultimately, delegates put every amendment forward for an independent vote in the referendum election.[206]

The time for debate was over, and suffragists once again held their breath during the roll call. Delegates returned a vote of seventy-six to thirty-four in favor of including the measure in the upcoming special election.[207] Much relieved, Ohio suffragists were now over the second hurdle. Amendments 23 and 26, two of the forty-one potential changes to the state constitution, were now on the ballot. It was time to prepare for the next battle.

The Battle for Amendments 23 and 26

Many suffragists believed the 1912 federal election results offered new political opportunities, as the US Senate changed hands for the first time in two decades. Ohio was a battleground state, so its suffragists found themselves again in the national spotlight. The state's campaign had great significance to the national suffrage movement. At this time, the nine states providing for women's enfranchisement were all west of the Mississippi River. For many years, the national movement's leaders had strategized a battle plan to breach that threshold. After the state constitutional convention, Ohio suffragists began the fight for suffrage Amendment 23 and officeholding Amendment 36 with great enthusiasm, knowing that their state could be the first east of the Mississippi to vote on universal suffrage. The campaign slogan became "Ohio Will Unlock the East!"[208]

Six states considered women's suffrage referenda in 1912, and many people believed Ohio's campaign was the most important, since voters cast ballots in September, while the other five states did not cast ballots until November. In this regard, Ohio became a test case. A favorable outcome in Ohio could create momentum for wins in the other five states. One suffragist stated in the *Woman's Journal*, "I believe every vote won in Ohio is almost equivalent to a vote next November in each of the other three states."[209] Ohio suffragists, feeling a great deal of responsibility, intensified their efforts.[210]

With the Amendment 23 campaign officially under way, "suddenly it seemed as though all the women were in politics. . . . Women prominent in the social life of the city gave up their summer vacations and all their social affairs to work for suffrage—or against it," said one local supporter.[211] Initially, the OWSA set up campaign centers in Columbus, Cleveland, and Cincinnati, and by the end of the year it expanded to include offices in Akron, Canton, Dayton, Springfield, Toledo, Warren, and Youngstown.[212] Suffragists mobilized the state, north to south and east to west. Allen traversed the state delivering over ninety speeches and organizing women in all 88 counties.[213] Allen often used what was considered ladylike humor to disarm her detractors.[214] Virginia Darlington Green was often at Allen's side. As representatives of the OWSA, both women traveled throughout the state preaching the gospel of women's suffrage to all who would listen. Like Allen, Darlington Green would use this experience in a run for office. After the campaign, she was elected to the Cleveland public school board.[215]

Other women's organizations also played significant roles in the campaign. The YWCA was especially active in 1912, as were the OWTL and the Ohio State University's College Women's Club. Leaders of these various organizations attempted to coordinate their efforts, though this goal was not always achieved. In 1912, Florence King of New York's Woman's Suffrage Party traveled to Cincinnati to meet with Ohio suffragists to discuss moving away from a fractionalized approach based on individual women's clubs and individual efforts to a more unified strategy akin to the Women's Suffrage Party structure.[216] Several Ohio cities, including Cleveland, opened party offices. When the headquarters opened on Euclid Avenue, it became a common occurrence for men to stand in the entranceway pointing to the organization's sign and wisecracking, "Where's the party, girls?"[217]

One of the more noteworthy events of the 1912 campaign was the women's suffrage picnic at Cedar Point amusement park. Hauser and DuPont were among those who planned the event, and they made a particular effort to invite women of high social standing to increase prestige. Unfortunately, overcast weather meant only two hundred of the twelve hundred invitees attended. Still, planners considered the gathering a successful kickoff to the summer campaign because it was the "most fashionable demonstration in the history of the suffrage movement in Ohio." According to newspapers' society pages, "the women were politely enthusiastic but insistently disinclined either to be excited or militant. . . . They were willing enough to wear 'Votes for Women' buttons which were sold for 10 cents each, but they refused to wave 'Votes for Women' flags provided for the occasion."[218] Apparently, wearing buttons was socially acceptable for Cleveland's upper crust, but flag waving crossed a line.

Over the months prior to the special election, Hauser visited as many of Cleveland's "first families" as she could, hoping prominent women would add their names to the campaign. She was generally successful, though many women were still reluctant to involve their families with the cause. Mr. A. J. Gilman supplied a chauffeured seven-passenger red Winton touring car, from which suffragists made speeches with the top down. A Yale college student hired to drive the car was desperately embarrassed to be seen with suffragists. At one stop outside Cleveland's Public Square, suffragists speaking from the back of the car were confronted by an inebriated man who kept raising his hand with a question. They tried to ignore him, but he kept waiving furiously. With dread, they called on him, only to have him ask, "Say, lady, can I go home now?" Another source of publicity came from out-of-state suffragists taking long driving tours across Ohio. One team traversed the state in an Amish horse-drawn cart, and a Rosalie Jones gained notoriety for traveling in a yellow wagon.[219] Many people considered women traveling without male chaperons so dangerous and unconventional that it was deemed newsworthy, and thus many local newspapers covered these escapades.

Ohio's suffragists became willing to try anything and everything. Cleveland suffragists stood in store windows and on street corners displaying one pro-suffrage sign after another. Suffragists in other states quickly imitated these "voiceless speeches" or "wordless sermons." The Ohio State Fair sponsored a Woman's Day, and movie theaters projected slide shows

about suffrage before the main feature. Many women started to answer telephone calls not with "hello" but, rather, "votes for women."[220] The Cleveland School of Art gave a suffrage play. To many people's shock, several society women wore sandwich boards reading "Votes for Woman" outside a fashionable hotel.[221] Women covered the cities in posters with captions such as, "Wanted—Just One Good Reason Why I Am Not Entitled to a Voice in the Government." Some suffragists took on house-to-house canvassing; others drove throughout rural Ohio to post handbills on billboards, telegraph poles, and store windows; and some even trudged through fields to talk to farmers directly.

To counter the stereotype of suffragists neglecting their families, some wives organized cooking contests.[222] Other supporters hosted fundraising dinners, garden parties, and teas. To raise money, clubs sponsored bazaars and bake sales. Since suffrage activism and personal sacrifice often went hand in hand, supporters all over Ohio embraced "Sacrifice Week," in which instead of buying sodas, nail polish, movie tickets, or other small luxuries, women donated the money to fund the movement.[223]

New York City hosted one of the largest suffrage parades of 1912. Determined not to miss out on this opportunity, Ohio sent a float. Sporting the official hats of the parade marchers, DuPont and Grace Treat of the Cleveland suffrage association boldly posed, front forward, for newspaper pictures. Other members of the Cleveland suffrage group were camera shy, instead turning their backs and gazing at the window of the New York suffrage headquarters. Further evidence of the conservative nature of many Ohio women at the time comes from a huge controversy over whether the float's horseback riders should sit astride or side saddle. Some riders feared sitting astride would be scandalously unfeminine. The debate between riders became so heated that they came close to withdrawing the float. In the end, each decided for herself how to sit. Emboldened by experiences such as these, Ohio suffragists set out to plan their own parade in hopes of rivaling New York's.[224]

As part of the celebration of the Columbus Centennial, August 27 was declared Ohio Woman Suffrage Day. Suffragists decided at this occasion— with the help of Stanton Blatch, who had organized the New York affair, to sponsor Ohio's own parade. The parade marked the culmination of the campaign, complete with floats, bands, banners, flags, a woman dressed in a full suit of armor depicting Joan of Arc, and six horse-drawn chariots representing the six states forwarding suffrage campaigns that year.[225] Alice

Littlejohn, the director of the physical education department at the Ohio State University, was the grand marshal.

An estimated twenty-five hundred to three thousand women and over fifty men from all over the state participated, and thousands of spectators crowded into the streets along the three-mile parade route.[226] The organizing committee voted to integrate African American marchers into the parade rather than have them march as a separate delegation. African American suffragists sponsored two floats, one of President Lincoln signing the Emancipation Proclamation and another with a banner that read, "The white man freed us in 1861. We propose to free women in 1912."[227] Organizers assigned over forty women to carry soapboxes and pause along the parade route to evangelize the cause.[228] Later that day, NAWSA president Howard Shaw delivered a speech to an audience of three thousand in Memorial Hall.[229]

The local press made much ado about the fact many of the state's well-heeled women planned to abandon the comforts of their cars to walk the parade route. The *Salem News* remarked, "Daintily shod feet will tread over the rough streets of the capital city. . . . The practice among society women to forsake their automobiles is becoming a mania in Columbus." The journalist added, "A cordial invitation has been issued to all Ohio men who believe in suffrage to participate in the procession with their suffrage sisters."[230] The *Columbus Citizen* heralded the event as "Woman's Suffrage Parade Greatest in State's History."[231] The state's newspapers were very sympathetic to the cause. It was the work of the press chairman, Mary Gray Peck, to motivate newspaper managers to support the amendment editorially and to cover suffrage issues and events. The vast majority of English-language newspapers wrote in favor of suffrage. Generally speaking, foreign-language newspapers provided less support. Yiddish and Italian newspapers were more favorable than the German ones in most, but not all, cities.[232]

This ever-widening range of publicity tactics worked. Suffrage finally received important endorsements from organizations as varied as the Methodist General Conference, the Ohio Bar Association, the Ohio Grange, and the Ohio Federation of Labor. Even the Ohio Federation of Women's Clubs finally endorsed enfranchisement after years of refusing to do so. For the first time, the Ohio WCTU elected a president who was very committed to the cause. Florence Richards called on her members to help gather signatures for the suffrage petitions.[233]

Ohio suffragists realized they needed all the help they could get to promote Amendment 23. State leadership gladly accepted offers of out-of-state help. The Ohio-born chair of the Boston Equal Suffrage Association, Mary Hutcheson Page, and Gertrude Halladay Leonard helped organize the Ohio campaign.[234] Montana's Jeanette Rankin, the first US congresswoman, visited Ohio to support the cause as well.[235] For several months, Margaret Foley and Florence Luscomb, both from Massachusetts, gave open-air speeches in Ohio as part of a multistate lecture tour. Both women had traveled the year before to England to be trained by British militant suffragists. The *Dayton Herald* newspaper described Foley as having a "a fine voice which enables her to compete successfully with street cars, the tooting of automobile horns and the many noises that place other open air orators at a disadvantage" and as possessing a good sense of humor.[236] Despite her fine reputation, she was not spared hostile responses from Ohioans. Five suffragists, including Foley, attempted to address attendees at an annual picnic of firefighters and police in Dayton. Foley stood atop a table to deliver her suffrage address when someone threw a loaf of bread at her, knocking off her hat. Maintaining her composure, Foley bravely continued. A man then threw a ham sandwich, and it landed on her face. Even that humiliation was insufficient to silence her. Foley persisted, until "finally, banana skins, chicken bones, lemon rinds, and other refuse from the table came in a regular torrent."[237]

Louise Hall, a career suffrage organizer of state associations in Massachusetts, Rhode Island, Pennsylvania, New Hampshire, Connecticut, and Ohio between 1912 and 1918, spent a great deal of energy on the 1912 campaign as well. Before becoming a suffragist, Hall taught math and science in Ohio, among other states. She was always game to try new tactics, and she became an expert at drawing media attention. In Akron, she became the first woman in the nation to ride in an airplane dropping suffrage leaflets from the air. Once she landed, she gave a speech on a street corner to a crowd of a thousand, lasting more than ninety minutes. The *Akron Beacon Journal,* which covered both the publicity stunt and the speech, quoted her, "The nation was not a democracy because all did not vote and thus all were not represented."[238] Despite her antics, Hall emphasized feminine virtues and domestic responsibilities. In Cleveland, she acknowledged, "Men are coming to realize the government needs certain feminine attributes," and in Hamilton she said, "The woman in

the home needs the vote as much as any other class of women, in order to look out for the interests of the home, to manage her home properly and make it meet the needs of her husband and children."[239]

Hall joined forces with another nationally renowned suffragist, Rose Schneiderman. During the 1912 referendum campaign, Howard Shaw hired Schneiderman to tour Ohio's industrialized cities to recruit more support from the working class. In 1911, striking textile workers in the state had received little support from suffragists. They learned from this mistake and the following year gave striking female streetcar conductors the support they deserved.[240] A Jewish immigrant standing four feet six inches tall with blazing red hair, Schneiderman was one of the few working-class immigrant NAWSA speakers to tour the country. She had been a cap maker and a union organizer at a local factory. With that experience, she was particularly well suited to speak directly with union workers.[241] Advertisements for one of Schneiderman's Ohio speeches read, "Gifted Young Lecturer Presents Woman's Question from the Industrial Point of View." From one of her Cleveland speeches came her famous sentiment: "What the woman who labors wants is the right to live, not simply exist—the right to life as the rich woman has the right to life, and the sun and music and art. You have nothing that the humblest worker has not a right to have also. The worker must have bread, but she must have roses, too. Help, you women of privilege, give her the ballot to fight with."[242]

The state had never seen or heard any activist quite like Schneiderman. One observer remarked, "No one has touched the hearts of the masses like Rose Schneiderman. . . . Strong men sat with tears rolling down their cheeks."[243] Schneiderman spoke in union halls, in theaters, on streets corners, and anywhere else she could find an audience, crisscrossing the state for weeks. "My argument to them was that if their wives and daughters were enfranchised, labor would be able to influence legislation enormously," Schneiderman wrote after her tour.[244]

The NAWSA also sent one of their "flying squadrons" to unorganized parts of the state with the goal of invigorating less active suffrage groups.[245] It was not uncommon for these suffragists to face unusual obstacles. For example, Wood Park, traveling as part of one flying squadron, received permission to join a circus parade in a car decorated with streamers and "Votes for Women" placards. Unfortunately, her position was directly behind the elephants. Later, when she attempted to give her suffrage stump

speech, she was drowned out by a group of trained dogs in the ring next to her. Nonplussed, Wood Park enlisted two clowns to distribute her suffrage leaflets, and the show went on.[246]

Various men's leagues offered additional support too. Judge William Littleford, president of the Men's League for Woman Suffrage in Ohio, imparted, "There is no direct opposition now, merely indifference. We will have a fight, of course, but women will vote in Ohio, after January 1, 1913, just as surely as they are now voting in California."[247] The Cincinnati Men's League, with a membership of approximately two hundred, sponsored a rally at which NAWSA president Howard Shaw spoke.[248] Her reputation as an inspiring speaker brought a capacity crowd. She opened her remarks with a Mother's Day tribute focusing on why mothers needed the vote. She then offered an impassioned plea highlighting the needs of working women: "Men who do not want women to vote advance the argument that politics would take them out of their homes . . . [they] forget the 8,000,000 women workers who are out of their homes all day because of an unjust industrial system."[249]

The state's suffragists left nothing on the table. The time for campaigning came to an end. The nation's suffragists held their collective breath, anticipating the results of Ohio's special election. In another devasting loss, on September 3, 1912, the electorate rejected eight of the forty-one proposals—including the two that would have granted women's suffrage and officeholding. Women's suffrage received more votes than any of the other amendments on the ballot, and the measure received more favorable votes than had been cast in favor of suffrage in any campaign in the nation to date. However, even these record-breaking numbers were insufficient to win the day. Amendment 23 was defeated by a vote of 336,875 to 249,420.[250] Only twenty-four of Ohio's eighty-eight counties carried the measure, but it lost by less than three hundred votes in eleven counties. More telling is that women's enfranchisement lost in four of the state's largest cities. Cincinnati crushed the measure by a three-to-one margin. Suffragists anticipated this loss in Cincinnati, but they hoped the vote counts in Cleveland and Columbus would offset it. The measure failed in Cleveland by 47 percent, while Dayton and Columbus both lost by 53 percent. Toledo was the largest city to report a favorable result.[251]

Voters also rejected Amendment 36, the Ohio Public Office Eligibility for Women Amendment, 261,806 yeas to 284,370 nays.[252] Holding political office remained a pipe dream for the state's women until after

the Nineteenth Amendment passed.[253] The amendment to eliminate the word *white* from the state constitution also failed, and it would take Ohioans until 1923 to align the state constitution with the federal constitution in that regard.

The 1912 Ohio Suffrage Campaign Postmortem

Arizona, Kansas, and Oregon won their campaigns that year, but their Ohio sisters and those in Wisconsin were not so fortunate. Despite assistance from sources outside the state, improved statewide organization, positive media coverage, and highly visible publicity tactics, the 1912 Ohio campaign ended in defeat. Naturally Ohio suffragists were beyond disappointment privately, but they would not give the opposition the satisfaction of seeing their anguish. Taylor Upton wrote a letter to suffrage supporters after the heartbreaking loss, doing her best to emphasize the positive: "To Ohio belongs the distinction of having polled more votes in favor of woman suffrage—by some tens of thousands—than have ever been cast for the proposition in any other state. Approximately a quarter of a million men voted 'Yes' on the woman suffrage amendment at the special election September 3, 1912. With such backing, the women of the state would be remiss indeed if they should relax their efforts to secure 'that right protective of all other rights'—the ballot," and she emphasized, "And yet it is not 'rights' with which we are concerned, but rather the opportunity to do our duty." She continued, "The campaign for woman suffrage in Ohio must go on. The question will be probably submitted again to the voters in 1914."[254]

In a letter to a friend, Luscomb reflected on the significance of women's political power: "It makes me realize what a big thing V. for W. [Votes for Women] really is. If it just meant votes it would hardly be worth working for—neither would it require much work, for the progressive men of Ohio would accept it as a readily as the other progressive ideas." She also recognized, "But they didn't accept it, so it must be that it stand for a more significant change than just the casting of votes. It symbolizes equality."[255]

Understandably, once the shock of the painful blow subsided, Ohio's suffragists began to analyze why they lost. If they were to continue the fight, they needed to do so from an informed position. Beyond obvious answers—such as sexism and lack of money—suffragists and political analysts identified several other key factors that negatively influenced the

campaign outcome. Ohio represented the first opportunity for President Roosevelt to follow through on his professed support for the cause, but he did not say a word about suffrage when campaigning in Ohio.[256] This had been a missed opportunity to sway the state's male voters.

Second, Ohio suffragists also partially blamed immigrants for the loss.[257] Taylor Upton reported that the president of the German American Alliance, John Schwab, had boasted at a meeting in Youngstown that his organization defeated Amendment 23. However, a closer analysis reveals that foreign-born voters may not have had the impact suffragists claimed. Many immigrant men voted for Amendment 23, and many native-born men voted against, and there were far more native-born than immigrant men registered to vote.

Third, though they may not have admitted it, divisions within suffrage ranks likely contributed to the loss. Leaders of Cincinnati's various suffrage organizations did not always see eye to eye. Relations between Taylor Upton and Howard Shaw became increasingly strained over money issues and whether the suffrage measure should have been fought for as a separate question or collectively among the special election referenda.[258]

Fourth, many people blamed apathetic women. The *Cleveland Plain Dealer* wrote, "Suffragists have their chief work to do, not among the men of Ohio, but among the women. What they have chiefly to fear is not the hostility or indifference of the men, but the lack of interest now apparent among the great majority of women."[259] The newspaper's sentiment reflected anti-suffragists' timeworn argument, and it failed to recognize that women could not vote for Amendment 23, and thus they reasonably could not be held responsible for the election outcome. Yet, Taylor Upton agreed with the editors' assessment. She lamented that Ohio suffragists had to contend with both the liquor lobby and apathetic women: "Two enemies are working against us—a band of ignorant and futile women, very few in number and the federated forces of evil. The former makes no impression, the other is powerful and will grow more powerful as the days advance."[260] Compared to the liquor interests, she did not consider the OAOWS, with its membership of "fashionable names," to be serious opposition.

Fifth, some people pointed to a lower-than-anticipated voter turnout to explain the loss. Both the length of the ballot and the weather may have kept voters away. A common conclusion was that a very light voter turnout in rural areas of the state, which tended to support women's suffrage and temperance, may have contributed to the negative outcome. The li-

quor lobby's primary power lay in the cities, and it had been hoped that the rural vote would counter that influence. In fact, however, both rural and urban counties defeated suffrage.[261]

Sixth, the role of the anti-suffragists' campaign must be considered. After the 1912 loss, OAOWS president Platt Hubbard took credit for beating her opponents. Her coconspirator, Goff Schwarz, did as well, declaring, "Scarcely had the polls closed until we began to realize that our faith in the men of Ohio had not been misplaced. We made a hard fight and fought against great odds."[262] Despite comments such as these and the election's outcome, few Ohio suffragists credited the anti-suffragists' operation with the amendment's defeat.

Finally, the underhanded tactics and liquor-lobby bankroll became the most cited explanation for the failure of Amendment 23. While suffrage lost by 87,455 votes, 52,392 of those came from three liquor strongholds: Hamilton, Cuyahoga, and Montgomery Counties. However, approximately the same number of "wet" and "dry" counties defeated the amendment. Of the sixty-four counties defeating the women's suffrage amendment, thirty-three were wet and thirty-one dry.[263] There can be no doubt, however, that the liquor industry's ability to outspend suffragists helped to maintain negative stereotypes about—and needless fears of—women's enfranchisement.

Still, reformers learned a great deal that would prove useful in future campaigns, including who the real enemy was: the liquor lobby. The majority of Ohio's suffragists wanted to get enfranchisement back on the ballot as soon as possible. Now was the time to take advantage of the momentum. In the past, they would have had to lobby the state legislature to do so, but one of the successful amendments provided an option to go directly to the voters. Suffrage leaders took advantage of this constitutional amendment, which allowed initiatives and referenda. However, there was still a great deal of confusion over the proper legal means by which to do so. Suffragists lacked clarity about technicalities of the new law related to the petitioning process. Both the secretary of state and the attorney general agreed suffragists could move forward, but the suffragists' attorney suggested they wait for more direction from the legislature. After a year, the attorney general gave permission to circulate petitions.[264] Once again, Ohio women would mount a heroic effort. As Mary Horton King, president of the Franklin County Woman's Suffrage Association, asserted after the referendum election loss was announced, "As for the suffragists, they have only begun to fight."[265]

The Fifth Star Rises

On President Woodrow Wilson's Inauguration Day in 1913, readers of the *Washington Post* learned "miles of fluttering femininity" embodied by 8,000 marchers had paraded through their city streets the prior evening.[1] Ohio Woman's Suffrage Association (OWSA) president Harriet Taylor Upton led the delegation from Ohio. Half a million spectators witnessed the march in person. Alice Paul of the National Woman's Party (NWP) organized the protest as a bold and definitive demand for support of the federal suffrage amendment by the new administration. Shockingly, two hundred people were injured in violent attacks by those opposed to women's political empowerment, while police officers did nothing to stop the mayhem.[2] Clearly women's suffrage was still a hot-button issue, even after decades of activism.

Ohio faced its own challenges. The Great Flood of 1913 cost hundreds of lives and thousands of homes. Many people considered this natural disaster the worst in the state's history. Suffrage leaders realized canvassing for signatures to petition legislators for a second referendum as originally planned would be all but impossible with so much of the state focused on recovery. As if the 1912 referendum special election loss was not devastating enough, Ohio suffragists were left no choice but to delay their fight for justice another year.

The new plan was to release a small army of suffragists who would earn respect and public support for their cause by coming to the aid of those people devastated by the flood. Leveraging social expectations for wom-

en's self-sacrifice and caregiving, suffragists illustrated their worthiness for the vote by coordinating relief efforts across the state. Taylor Upton believed the governor should declare his support publicly for the cause since so many of her OWSA members helped with relief work. In a letter to a friend, she wrote, "For instance, in Canton the Woman Suffrage Party gave the entire contents of its treasury, fifty dollars, to the relief fund; in Cleveland, the Woman Suffrage Party donated and made 1,400 children's garments and sent them out through the Red Cross Society. The suffragists responded nobly to the Governor's call for help, and he ought to be feeling rather kindly toward us."[3] Time would tell if these public works could improve the image of suffragists and indebt the powers that be.

The Concluding Agenda

After the waters receded, Ohio suffragists returned their attention to their primary goal. They had no way of knowing victory would be theirs in less than a decade. Fortunately, they also did not know the full extent of the staggering obstacles they would face as they crossed the finish line. In 1914, Ohio suffragists took their cause directly to the voters yet again via a referendum campaign. In 1916, they pursued municipal suffrage. In 1917, they returned their focus to the state's general assembly, seeking presidential suffrage. In 1919, they focused on the federal suffrage measure in yet another major campaign of national consequence. Along the way, they forced the issue in the courts more than once. And is if that were not enough, Ohio suffragists expended their very last reserves of patience, perseverance, and patriotism on the ratification campaign for the Nineteenth Amendment, both in their home state and that of others. The state movement's agenda was as full as ever, and the drive to pursue it was more intense than ever.

Suffragists faced several unique challenges as they geared up for the final battles. World War I broke out in Europe, naturally diverting attention from the cause. After the United States entered the war in 1917, many suffragists remained divided over about how best to respond. Some believed they should suspend the movement during the war, just as their predecessors had during the Civil War. At a meeting of the National American Woman Suffrage Association (NAWSA), the executive council voted to prioritize the war effort. The only opponents to this decision were two

Ohio women and a Friends Equal Rights Association representative.[4] To be sure, however, the majority of Ohio's suffragists supported the war effort by volunteering in the Red Cross, participating in liberty loan drives, and conducting food conservation work.

The war effort created a new urgency in the fight for the vote. Out of sheer necessity, more women joined the workforce while men battled on the front lines. Women's successes in the public sphere made claims against their ability to vote more and more difficult to justify. Furthermore, many other nations granted women the ballot during the war, including Russia, Canada, and various Scandinavian countries.[5] These international successes added pressure to support women's enfranchisement at home if the United States was to establish itself as a modern leader of global politics.

An additional challenge, the role of militancy, divided opinions among the US public and within the movement. In 1910, Anna Howard Shaw had formed a lobbying arm of the NAWSA called the Congressional Committee. The committee's purpose was to raise support for the federal amendment within the US Congress. When Alice Paul and Lucy Burns assumed leadership of the NAWSA Congressional Committee, they sought to change tactics dramatically. In contrast to Howard Shaw, this younger generation of suffragists was more political than polite. Most militants were convinced the NAWSA's long-standing nonpartisanship had reached its limits. In 1916, differences of opinion and power struggles within the NAWSA leadership drove Paul and Burns to break away, creating the Congressional Union for Woman Suffrage (CU), later named the National Woman's Party (NWP).[6]

Once again, the suffrage movement faced a schism between two national organizations. When Paul applied for auxiliary status within the NAWSA, Howard Shaw chastised the CU in the press, but other executive council members believed the CU deserved that status. Taylor Upton wrote, "Letters are begging me to vote for the reinstating of the Congressional Union. These are unnecessary for I so voted immediately."[7] The NAWSA remained conservative in its approach, and the NWP became increasingly militant. NWP leadership continued the struggle for the ballot even after the United States entered World War I, adopting the most controversial and "unladylike" practice yet: picketing the White House. These picketers adopted silence as a new rhetorical strategy. Rain or shine, the "Silent Sentinels"—as they became known—endured harassment from

passersby and intimidation from police for months on end. Ohio women were less inclined to embrace militancy, though Elizabeth Stuyvesant of Cincinnati was among fourteen women arrested for unfurling a suffrage banner in front of the White House on a trumped-up charge of obstructing traffic.[8] Stuyvesant continued to picket even after serving jail time, and her commitment to the cause remained steadfast even after she was attacked by a mob, blouse torn from her body, while police officers looked on and did nothing to intervene.[9]

To protest the US Senate's inaction on the Susan B. Anthony amendment, NWP members set up cauldrons outside the White House and in Lafayette Park, and each time Wilson made a speech claiming the United States was making the world safe for democracy, they literally fanned the flames of discontent, burning copies of those speeches, and in one case, an effigy of the president. These "Watchfires of Freedom" burned day and night. Tactics such as these led to the arrest and imprisonment of NWP members. In what became known as the "night of terror," the women were tortured and brutally beaten. All of the women went on a hunger strike, and many would be, horrendously, force-fed.[10] Other US suffragists were compelled to spend valuable time and energy staving off public criticism of militancy and managing strained relationships within the movement. Leaders across the Midwest strove to build bridges between the two national organizations despite these different commitments, just as they had between the American Woman's Suffrage Association and the National Woman Suffrage Association in the previous century.[11]

Throughout 1913 and 1914, some Ohio suffragists initially supported the CU. One reason may have been the positive impression made by British militants, among them Emmeline Pankhurst as she toured Ohio's five largest cities delivering speeches on behalf of the cause. Audiences responded enthusiastically, yet, fearing a backlash, no local OWSA chapters formally endorsed her lecture tour.[12] Taylor Upton told the press that Ohio suffragists preferred to do without militant ideas, and later, at a NAWSA convention, she went so far as to introduce a resolution renouncing the CU.[13] Taylor Upton was among those who had once thought the CU had something to offer Ohio, and she had praised the CU's work in local newspaper editorials. She knew the state movement needed all the help it could get, and thus she extended auxiliary status to the CU in Ohio. Taylor Upton even appealed to the CU to send money or workers to assist in organizing Ohio's rural counties.[14] The CU considered opening headquarters in

Columbus and organizing militant tactics throughout the state; however, it never advanced a full-blown ground game in Ohio.[15] NAWSA president Carrie Chapman Catt, displeased with the decision to embrace both national organizations, claimed that the OWSA leadership had "lost its senses," and she urged its members not to reach out to the CU anymore.[16]

Over time, OWSA leadership changed its position regarding militancy, and Ohio suffragists largely sided with the NAWSA's conservative approach. None of the NWP's high-level leadership came from Ohio.[17] The chair of the Ohio CU, Dorothy McCrea Mead, worked with local women's clubs, organized mass meetings and receptions, and assigned Ohio CU members to meet face-to-face with their local congressmen to demand support for the cause. She also targeted Ohio congressman Warren Gard, an antisuffragist, and joined other CU members on a publicity tour, traveling on a train known as the "suffrage special" through western states in which women already won the ballot. Efforts such as these raised the ire of the Woman's Suffrage Party of Greater Cleveland, whose members opposed the CU.[18] Before the 1916 presidential election, Chapman Catt forced OWSA members to choose between the NAWSA and the NWP. It did not take long for Taylor Upton to decide.[19] The strategy to engage in partisan politics against Woodrow Wilson further distanced most Ohio suffragists, many of whom feared militancy would tarnish their reputations and partisanship would weaken their chances to obtain the ballot. Taylor Upton warned, "If the Congressional Union carries out this plan in Ohio, we simply are ruined."[20]

The OWSA was as committed to nonpartisanship as ever. Taylor Upton also telegraphed the Woman's Suffrage Party of Greater Cleveland, most emphatically stating, "We do not believe in militant methods and do not countenance them. We need only appeal to fair-minded men of Ohio to win our cause."[21] Sharing in this opinion, Sarah Siewers, a leader in Cincinnati, presented a successful measure to the OSWA convention delegates: "Resolved, That it is the sense of this meeting that we condemn the partisan policy of the Congressional Union for Woman's Suffrage, and indorse the nonpartisan policy that the National American Woman's Suffrage Association has always maintained."[22] Most NAWSA leaders worried that playing partisan politics, as the CU was doing, would undermine the ability to achieve a two-thirds majority needed to pass a constitutional amendment. In this regard, most Ohioans joined the NAWSA in the view that militancy undercut the potential effectiveness of the US women's suffrage movement.

Despite mounting challenges and growing schisms within the movement, it slowly picked up momentum. Illinois women could vote for president as of 1913, and women in the Territory of Alaska were granted full suffrage the same year. The women of Montana and Nevada won full suffrage in 1914.[23] Motivated by these examples, Ohio suffragists stepped up their efforts, determined to lay the groundwork for a successful campaign. In so doing, they expanded the ranks of the state leaders. Those ranks grew to include the fresh perspective and energy of remarkable women and men new to the leadership team.

The Winning Leadership Team

Jesse Leech Davisson was a leading figure during Ohio's suffrage referenda campaigns. Born in Pittsburgh, Pennsylvania, in 1859 and raised in Dayton, she became the principal organizer of the women's suffrage movement in that city. In 1912, Leech Davisson had worked on behalf of Amendment 23. In 1915, her participation in the movement increased further when she became a member of the OSWA executive committee and of the advisory committee for the CU.[24] She also assumed the presidency of the newly formed Woman's Suffrage Party of Montgomery County, later called the Woman's Suffrage Association of Dayton and Montgomery County. By 1914, the organization had swelled to more than five hundred members. The group distributed literature, sponsored parades, and even supplied men with pancakes in return for signatures on petitions at local fairs.[25]

Jesse Leech Davisson

Leech Davisson was very highly respected, not only by Daytonians but also by Taylor Upton, who trusted her with many secrets that she did not share with other committee members. When women finally won the right to vote, Leech Davisson responded simply, "Oh, glorious."[26] After ratification of the Nineteenth Amendment, Leech Davison helped found a local chapter of the League of Women Voters, and she served as its first vice president. She remained active in the organization, as well in as in music, literary, and art organizations, for many years until her death in 1940.[27]

Lethia Cousins Fleming, an important Cleveland leader, taught school in West Virginia before moving to Ohio at age thirty-five. Cousins Fleming chaired the board of lady managers of the Cleveland Home for Aged Colored People, and she worked for the Cuyahoga County Child Welfare Board. This veteran reformer also fought for votes for women of all races.[28] She became active in the African American women's club movement and worked diligently to secure its endorsement of women's suffrage. She also joined the predominantly white Cleveland Women's Party to support the cause. When over ten thousand Ohio suffragists marched in Cleveland in 1914, she proudly stood alongside other African American women leaders.[29]

In 1920, following ratification of the Nineteenth Amendment, Cousins Fleming gained national recognition when she was appointed as a delegate to the Republican Presidential Convention in Chicago. Her husband, Thomas "Tom" Wallace, the first African American city councilman in Cleveland, was well connected within the Republican Party. She lobbied among African Americans for the nomination of fellow Ohioan Warren G. Harding, and she agreed to head the National Republican Women's Bureau, an organization created to recruit African American women voters into the party. Harding's was the first of five presidential contests in which Cousins Fleming would lead the effort to recruit women of color to the Republican Party. In 1929, Fleming attempted a run for her husband's seat on the Cleveland City Council after his imprisonment for having allegedly taken a bribe. Later, Cousins Fleming worked at the national level as the first grand commissioner of education in the Department of Civil Liberties.[30]

Cousins Fleming always believed women's suffrage had the potential to challenge a range of injustices. She wrote to the *Cleveland Plain Dealer,* "This is a new day. After the many wars in which the negro men have laid down their lives for the democracy of the world, they have been treated inhumane[ly]. . . . We, the colored people of America are not going to ask for alms any longer; rather we are going to demand some of the things that are due to us, and one of the first that we are demanding is a square deal."[31] She knew women's suffrage was part of that square deal, and she challenged the suffrage movement's "southern strategy" for its racism. Unfortunately, Cousins Fleming did not live long enough to see the end of Southern disenfranchisement of people of color.

Lucia McCurdy McBride was another leading Ohioan during the final push for women's enfranchisement. Born into a well-to-do family that made its money in steel and iron production, McCurdy McBride was a Cleveland socialite turned activist. She came to the movement as one of Elizabeth Hauser's many recruits. "I was embarrassed to have Miss Hauser call on me," said McCurdy McBride, continuing, "I was reluctant to involve my husband and his family in the suffrage movement."[32] Despite this hesitance, she joined the College Equal Suffrage League.[33]

McCurdy McBride held a variety of leadership positions at the local, state, and national levels within the movement, including the Woman's Suffrage Party of Greater Cleveland, the OWSA, and the NAWSA. She was a founder of the Women's City Club of Cleveland. At times, she expressed her frustration and outrage about the lack of progress within the party system, declaring, "The men in the inner circle don't care a nickel for us. They don't take us seriously. . . . There is not a bit of sense in our standing like beggars at the outer court."[34] Despite her frustrations, she went on to organize the League of Women Voters of Cleveland after ratification of the Nineteenth Amendment and served as its president two different times. McCurdy Mc-

Lucia McCurdy McBride

Bride was a founding trustee of Cleveland's first birth control clinic, the Maternal Health Association, which later became Planned Parenthood of Greater Cleveland.[35]

McCurdy McBride also supported the peace movement and the labor movement. During World War I, she was vice chair of the women's committee of the Ohio Council for National Defense, but she soon pivoted to the peace movement, serving on the executive board of the Cleveland Council for the Prevention of War. Additionally, McCurdy McBride testified on behalf of a minimum wage at the state capitol and publicly condemned child labor.[36] She founded the Union League of Cleveland. Among her other civic causes, McCurdy McBride served on the board of education for Cleveland Public Schools, and she was the only female member of the City Planning Commission in 1946. McCurdy McBride's work also extended to the arts. She was a board member of the Cleveland School of Art as well as the Cleveland Playhouse and a member of the advisory committee for the

Cleveland Museum of Art. McCurdy McBride died in Cleveland in 1970, having had the opportunity to vote for half a century.[37]

Vadae Harvey Meekison also devoted her commitment, courage, and creativity to the ultimate suffrage victory. Credited as the first woman to practice law in Henry County, Harvey Meekison worked alongside her husband and fellow lawyer, George, in Napoleon, Ohio. At her graduation from law school at Valparaiso University in Indiana, she delivered a speech, "The Law and the Lady," in which she made the case that women's equality was especially critical for women lawyers.[38] After moving to Ohio, Harvey Meekison regularly corresponded and worked with suffrage leaders. She began her suffrage career during the 1912 campaign, riding beside Florence Allen in a horse and buggy. While Allen drove, Harvey Meekison carried her baby girl in the passenger seat. The women stored a soapbox in the back of the buggy, and they would stop throughout the county to give speeches in support of giving women the ballot.[39] Her suffrage career took off in 1914 when she became the lead organizer, petitioner, and speaker for Henry County and the liaison between the county chapter and the OWSA. Taylor Upton once referred to her as "the only live wire" in Napoleon.[40] During World War I, she also founded the Napoleon chapter of the Red Cross. After women won the right to vote, Harvey Meekison used her professional and personal connections to support the promotion of women lawyers, judges, and other elected officials. She passed the Ohio Bar in 1926, and she became a member of the National Association of Women Lawyers. Harvey Meekison lived to be ninety-seven years old and to vote.[41]

Not all the leaders of Ohio's suffrage movement were women. Well-connected men occupying key political positions also led. While these men may not have played a direct role in setting the agenda or building the movement's organizational capacity, they did lead other men to the cause. Newton Baker was among the vocal and steadfast supporters of the Ohio movement. Born in 1871, he graduated from Johns Hopkins University in 1892 and earned a law degree from Washington and Lee University in 1894. He moved to Cleveland, and he eventually became the city's law director. In that position, he persuaded prominent Clevelanders to support women's suffrage. He founded the city's Men's Equal Suffrage League and encouraged women to run for office, among them Florence Allen. As Cleveland mayor from 1912 to 1915, Baker organized the Woman's Department in the city's employment bureau and advocated for a Woman's Police Bureau in front of the city council.[42] Baker insisted,

"Ohio women should vote because Ohio is now recognized as one of the most progressive states." He stressed, "This is not a man's government, but a people's government."[43]

Under the Wilson administration, Baker became US secretary of war from 1916 to 1921. Though he disliked the idea of women working on army bases, he fully understood the potential contribution women could make to the war effort.[44] Setting aside his own opinion, he ultimately sent almost twenty-five thousand women overseas as social workers and nurses. He organized the Committee on Women's Defense Work alongside Howard Shaw, to leverage the strength and patriotism of US women during this time of crisis. Baker also exchanged letters with Chapman Catt and was credited for playing a role in Wilson's conversion to support the Susan B. Anthony amendment.[45] In 1921, he left Washington to return to his Cleveland law firm. He would go on to advocate for the League of Nations and to write the book *Why We Went to War*. Baker appeared on the front cover of *Time* magazine in 1927, and he was slated for the US presidency at the 1932 Democratic National Convention but lost the nomination to Franklin Roosevelt. Just five years later, Baker died in Shaker Heights.

James Cox also was among the ranks of pro-suffrage men who played an important role at this stage of the movement. Cox started his career as a teacher but eventually built a successful media empire. He became the first three-term governor of Ohio, and he served in the US House of Representatives for one term.[46] In 1920, he won the Democratic presidential nomination with running mate Franklin D. Roosevelt. In his acceptance speech, Cox pronounced, "They [women] helped win the war. . . . they are entitled to the privilege of voting as a matter of right and because they will be helpful in maintaining wholesome and patriotic policy."[47]

Cox signed every women's suffrage bill that came his way as governor, including the state's 1919 presidential suffrage bill and the ratification of the Nineteenth Amendment. He encouraged other states' legislators to support women's suffrage as well. On his first day as a presidential candidate, he sent a telegram to the head of the Democratic State Committee of Louisiana encouraging members to reconsider their recent rejection of the federal suffrage amendment.[48] He also encouraged Tennessee's legislators to support the federal amendment.[49] Cox took the heat from anti-suffragists with aplomb, never allowing it to sway his devotion to the cause.[50] Unlike many candidates, he was willing to meet with more militant leaders such as Alice Paul. Paul was pleased Cox openly supported the

cause, and she made her expectations regarding Ohio's role in securing the Nineteenth Amendment clear when she said, "the result will depend entirely upon the efforts of Governor Cox and Senator Harding and the national parties." She added, "The real battleground is not in Tennessee but in Ohio."[51] After Cox lost to fellow Ohioan Warren G. Harding, he ran his media businesses until his retirement.

Though Taylor Upton continued to be the primary point person for executing the state's suffrage agenda, women such as Leech Davisson, Cousins Fleming, McCurdy McBride, and Harvey Meekison, and men such as Baker and Cox played pivotal roles in creating and maintaining momentum for the movement during its critical last stage. These leaders also were a driving force for expanding the movement's organizational capacity when it was most needed.

Building Organizational Capacity for the Final Push

Working on several different fronts simultaneously during the final stage of the struggle—including municipal, state, and national campaigns— meant restructuring the movement. Moreover, raising enough funds was a perennial problem for Ohio's suffragists. Although the 1912 campaign received money from outside supporters, the 1914 campaign did not fare so well. Many chose instead to concentrate their donations on the revived national campaign on behalf of the Susan B. Anthony amendment. The NAWSA sent little money to support the 1914 campaign in Ohio. Taylor Upton was irate when she discovered cash had been earmarked for Ohio, but because many eastern suffragists thought Ohio was a hopeless case, the NAWSA had not forwarded it to the state.[52] Competing with the well-to-do anti-suffragists and the deep pockets of the liquor lobby remained a very serious obstacle.

In 1917, the economic troubles facing the entire movement were eased considerably when Miriam Follin Leslie bequeathed $2 million to fund suffrage campaigns upon her death. Chapman Catt managed the Leslie Woman Suffrage Commission. Ohio benefited from Taylor Upton's selection for a seat on the commission's board of directors. She clearly understood the significance of the generous donation, as she remarked after the federal amendment was ratified, "I sometimes wonder if we would still be going up to the Capital if Mrs. Leslie had not made that bequest."[53]

Ohio suffragists did their best to raise funds during the last decade of the struggle, trying everything from holding white elephant sales to hosting a suffrage gala. Clevelanders even went so far as to prepare and sell lunches out of the kitchen in their headquarters on Euclid Avenue.[54] Suffragists believed so passionately in their cause they were willing to sacrifice family heirlooms to fund the enterprise. Taylor Upton movingly recounted a story of one unknown benefactor who wrote to her explaining, "I am sending you by American Express a diamond solitaire ring. It is the only jewel I possess. If I had money, I would send that and keep this . . . but I have none so I send you what I can. I want Ohio to win equal suffrage this fall more than anything else I know." The donor signed off, "A lover of justice and a believer in my sex."[55] These donations certainly could not match the Follin Leslie bequeathment, but they were equally meaningful to Taylor Upton.

Suffrage leaders continued to reach out to the state's working-class women, though in limited ways. The Cleveland Foundation of Labor invited Taylor Upton to address it at its Labor Day event, and the Ohio Federation of Labor voted to support the 1914 suffrage measure.[56] Anna Twitchell gave more than five hundred speeches to factory workers during the 1914 campaign, and Ethel Vorce and Rose Livingstone toured for six weeks, speaking three times nearly every day.[57] Livingstone conducted OWSA lectures throughout forty Ohio counties that year explaining the dangers of girls being led into sex work.[58] These speakers drew large audiences and received positive feedback such as, "The general testimony was they were able to stir people as they had never been stirred before."[59] However, the movement still primarily comprised middle- and upper-class women as most of their working-class sisters had little time to pursue political activities.

In the final decade of the suffrage struggle, the national movement failed to address the regional disenfranchisement of African Americans. Yet, to some degree, the liquor lobby's organized opposition to the movement brought together African American and white suffragists in parts of Ohio.[60] The majority of African American contributions continued through the auspices of the National Association of Colored Women chapters rather than through the mostly white national suffrage associations that, in large part, remained indifferent to the plight of women of color.[61] Suffragists also failed to address nativism.[62] In fact, nativism increased after the United States entered World War I as more and more

people professed anti-German feelings. Because most of Ohio's alcohol manufacturers were of German ancestry, and the liquor lobby was anti-suffrage, many of the state's suffragists adopted anti-German sentiments, and they assumed promoting their cause among this immigrant community would be fruitless.

In addition to funding and recruitment, Ohio suffragists strove to be more self-supporting as they rebuilt their organizational structure. Far fewer out-of-state workers traveled to augment the work of Ohio's suffragists during the 1914 campaign, leaving more weight on the shoulders of inexperienced local women. To compensate, the OWSA transformed between 1915 and 1917. With a clear focus on strengthening its grassroots, OWSA's mantra became "A leader in every ward, a captain for every precinct."[63] The leadership established a chair in each congressional district and appointed county presidents. Each district devoted itself to both state and federal legislation.

Communication among Ohio suffragists improved with two weekly publications. Sara Swaney and Mary Toole edited *Everywoman,* a Columbus-based publication that eventually became the OWSA's official newspaper. Anna Quinby, who later founded the Ohio Woman's Taxpayers' League in

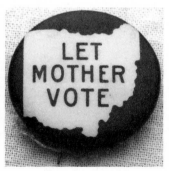

Pin distributed by the Ohio Woman's Suffrage Association

Columbus and spoke at the state constitutional convention on behalf of enfranchising women, edited the *Ohio Woman.*[64] According to Cleveland's president, Minerva Brooks, the suffrage party enjoyed good press relations, reporting that every newspaper in the state but one endorsed the 1914 campaign.[65] Hal Donahey of the *Cleveland Plain Dealer* supplied sympathetic political cartoons. Unfortunately, positive press coverage did not generate an increase in support for the cause. This was a time in which the general readership questioned the authority of news media. Taylor Upton explained, "In Ohio we had hardly a newspaper of any standing which was not for us and yet this did not do us any good because the rank and file have ceased to trust the editorial utterances of the press."[66]

Suffrage speeches and literature offered essentially the same arguments as they had during the 1912 campaign, with one significant excep-

tion. Because of the developing situation in Europe, the topic of war and women arose as a common theme. Just as they had during the Civil War, suffragists began to emphasize women's strength, sacrifice, and patriotism in a time of national crisis. Ohio suffragists also employed many of the same tactics they had just two years before, including open-air speaking, automobile and trolley tours, slide shows, and plays, among other promotional activities.[67] Their repertoire expanded to include new tactics, too, such as stamping "Votes for Women" on checks and dollar bills, sending suffrage valentines, and promoting a college suffrage band.[68] One of the more significant publicity events included a pilgrimage to Salem, Ohio. Taking full advantage of its symbolism, the OWSA organized a trip to where the first state women's suffrage convention had taken place to readopt the 1850 resolutions.[69] Those in attendance endorsed the following proclamation be sent to the US president:

> Whereas, sixty-four years ago, Ohio women, realizing that war, human slavery and woman's disfranchisement all menaced the family and the state, called a woman's convention in this city and demanded the changing of laws and the readjustment of customs in words so strong as to fill us with emotion as we now reread them, and Whereas, for more than half a century since, Ohio women have reiterated these demands and worked unceasingly for their enfranchisement; Be It Resolved, That we, the women of 1914, reverently cherish the memory of those great souls who saw the light, who heard the voice and where led by both, and further; Be it Resolved, that we consecrate ourselves anew today to finish their task so courageously begun, never ceasing until all women are politically free.[70]

Fortifying the organizational capacity of the state movement started to pay off. For the first time, the National Education Association, various church associations, and the Ohio Federation of Women's Clubs all endorsed woman suffrage. Organizations such as the Ohio Federation of Labor, State Grange, the Women's Christian Temperance Union, and the National Association of Colored Women's Clubs, among others, reendorsed their suffrage planks.[71] The Ohio Men's League for Women Suffrage continued championing the OWSA, providing speakers, conducting fundraisers, lobbying politicians, generating publicity, and offering moral support as allies. By this point, more than twenty men's leagues operated throughout the state.[72] Endorsements

and closer relationships with allies further strengthened the organizational capacity of Ohio's movement as suffragists prepared for an intense series of political campaigns that would deliver the final victory.

The 1914 Ohio Suffrage Campaign

By 1914, seven states were voting on suffrage referenda, Ohio among them. The pressure concentrated specifically on the state in 1912 again rested on the shoulders of Ohio's suffragists, as they launched another new campaign of national consequence. The Ohio referendum was so important that the editors devoted an entire issue of the *Woman's Journal* exclusively to the state's battle. Chapman Catt, then president of the International Woman's Suffrage Association, underscored Ohio's importance to the cause when she asserted, "The state of Ohio is worth more to us than all the other campaign states."[73]

The state's leadership was optimistic about its referendum because it had worked behind the scenes to gain assurances from the Anti-Saloon League that it would not offer a competing prohibition amendment. This pact was designed to ensure voters would not be distracted or associate prohibition with suffrage.[74] That agreement fell through. Unfortunately, three amendments were submitted to Ohio voters in the 1914 election at the same time, including women's suffrage, full prohibition, and a repeal of the local option law known as "home rule." Despite the best efforts of Ohio's suffrage leaders, their measure once again became entangled in the "wet" versus "dry" battle. The fact that suffragists could not disassociate their cause from that of prohibition so as to afford voters a chance to consider enfranchisement on its own terms rather than in the shadow of another controversy would once again prove impossibly complicated. For this reason, many people believed the 1914 campaign was doomed from the start. Even though they knew the odds were very much against them, Ohio suffragists tried again to beat those odds.

A series of conferences led up to the OWSA convention in Cincinnati that year. The goal of each was to prepare every suffragist, to the fullest extent possible, for the upcoming battle. Chapman Catt arrived in Ohio to run the first conference. Topics ranged from "galvanizing the rural community" to "how to reach the man on the street."[75] Organizations in Cleveland, Columbus, Dayton, and Canton continued to offer public speaking

classes for local women. The OWSA later officially promoted these at the state convention.[76] Movement leadership had not given up on the idea that women's voices could still make a difference. These classes, essentially suffrage bootcamps, illustrated the determination of the movement's leadership to guarantee Ohioans were combat-ready.

After receiving the green light from the OSWA lawyer to proceed with canvassing on behalf of a suffrage referendum, over two thousand Ohio women—all volunteers—took up the incredibly tedious and time-consuming task of gathering signatures. This army of canvassers came from various walks of life, ranging from club women to factory workers, from doctors to public school teachers. Canvassing was not only a means to an end. Petitions were required to generate a referendum, but they also provided an opportunity for face-to-face persuasion, thus allowing canvassers to evangelize the gospel of suffrage. Some volunteers started as early as 5:00 A.M. standing on street corners asking for support as people commuted to work. Other suffragists waited outside local courthouses, parks, movie theaters, churches, factories, and anywhere else they could think of, often enduring snubs and harassment, to obtain the required 10 percent of the electorate's signatures. Decades into the movement, women still relied on the petition as one of the few available tools to them for political expression.

Canvassing generated support within the capitol city. The *Woman's Journal* reported a significant change of heart among the Ohio State University's women over a four-year period. A 1910 survey indicated suffragists were a ten-to-one minority among the population of female students, but by 1914, half were supporters. Local church leaders such as the Reverend Hiram Kellogg, head of the Ministerial Association of Columbus, encouraged ministers to offer "fervent support" for suffrage as part of their Mother's Day services, arguing suffrage enabled mothers to better fulfill their duties. Rabbi Joseph Kornfeld of Columbus also frequently spoke in support of the suffrage petition drive.[77]

The state's suffragists were over the first hurdle. They had amassed the signatures needed to initiate another state referendum on women's suffrage. With this heroic effort finally complete, it was time to deliver the petitions to the state capitol. Movement leaders knew this was a prime opportunity for a publicity event. Over 176 men and women—two petition bearers from each county—marched around the capitol building and mounted the state house stairs carrying the petitions in large baskets. A crowd estimated at five thousand gathered to witness

the dramatic ceremony. Local media reported that the procession moved some of the onlookers to tears.[78] The OWSA arranged for the culmination to feature Secretary of State Charles Graves accepting the baskets of petitions on the statehouse steps. Instead, Graves snubbed the suffragists, all the petition-signers, and those gathered to witness the event. He hid in his private office, refusing to come out. Earlier in the day, Graves had held a meeting with some of the state's brewers, who undoubtedly swayed the secretary. Graves instructed two of his deputies to serve as his replacement at the ceremony, but neither were to be found—suffragists and their supporters were rebuffed a second time.[79]

Despite this infuriating experience, quick-thinking Taylor Upton kept her wits. She refused to lose the power of this publicity event or the emotional energy and momentum of the petition drive's conclusion. She resourcefully arranged for the president of the Ohio State University, William Thompson, along with Louis Taber of the state grange, to stand in for the secretary and to accept the petitions. Suffragists may have cleared the first hurdle, but they were well aware their work was just beginning, and after a public snubbing such as this, they fully realized just how hard that work would be. The Ohio women's suffrage amendment, known as Amendment 3, was now on the November ballot. Republicans initially came out favorably but then limited themselves to vague allusions to suffrage. Democrats remained silent on the topic.[80] The OWSA convention in 1914 strategically met in Cincinnati, the liquor-lobby stronghold, to plan and organize statewide support for their referendum.

Garnering that support necessitated significant publicity events such as a large-scale parade in Cleveland. As World War I loomed, some people thought the parade should be canceled, but others held out hope for peace. With preposterously little money, parade organizers moved forward with plans, mounting an impressive display to dramatize women's increasing levels of political activism. Social elites, factory workers, and Yugoslavian and Czech immigrants all joined together for a massive parade of more than ten thousand women and four hundred men. Among the marchers were African American leaders such as Cousins Fleming and Jane Harris Hunter, founder of the Phillis Wheatley Association and the Women's Civic League of Cleveland, as well as a large contingent from the Men's Equal Suffrage League. Participants dressed in suffrage colors of gold and white streamed past an estimated two hundred thousand spectators along Euclid Avenue on foot, on horseback, on floats,

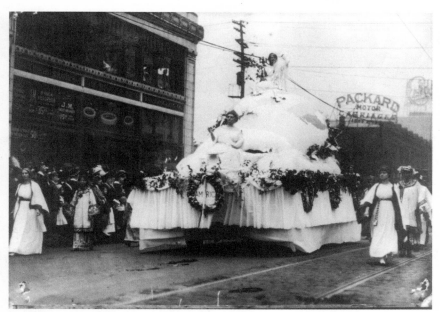

Suffrage parade in Columbus, Ohio, 1914

and in electric cars. Women marchers carried signs that read, "Votes for Women." Some were mothers pushing strollers, others were teachers or clerks. A group of several hundred industrial women workers were expected to march, most of whom were unmarried. The signs they were instructed to carry said, "Protect our Future Mothers." The women deserted in droves, panicked they would be mistaken for unwed mothers.[81] Even though a small minority of anti-suffrage protestors stood on the sidelines, anyone witnessing or marching in the parade that day surely thought success was inevitable.[82] The *Cleveland Plain Dealer* acknowledged, "Awe-stricken cynics are silent as they view mammoth parade."[83]

Following Cleveland's lead, other cities, such Cincinnati, Columbus, Dayton, and Toledo, hosted their own parades. Katharine Wright Haskell, ardent suffragist and sister of Orville and Wilbur Wright, was among the organizers of a 1914 march through the streets of Dayton. Wright Haskell described herself as "very much 'in earnest' about it, to put it mildly."[84] A graduate of Oberlin, Wright Haskell worked as a teacher and helped her brothers launch their careers in flight. She was one of a few US women on which the French government ever bestowed the Legion of Honor award.[85]

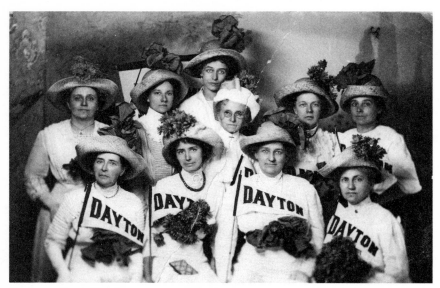

Dayton suffragists, 1914

Orville and their father, Bishop Milton Wright, joined Katharine on the parade route, and they lent their public support for suffrage many times.[86]

Eventually, smaller Ohio cities also hosted parades of their own. A parade in Lima drew fifteen hundred marchers. Organized by Bessie Crayton, the president of the Political Equality Club, the mile-long procession extended down the town's main street and around its public square. At one point, a man carrying a home rule banner snuck into one group of marchers. Crayton, fifty-seven years old at the time and a staunch prohibitionist, ripped the banner from its pole and trampled it under her feet in a dramatic show of resistance. After the parade, Chapman Catt—Crayton's cousin by marriage—spoke at Memorial Hall, along with Taylor Upton, to a standing room–only crowd.[87]

Though Ohio received little outside support for their referendum, Chapman Catt, who would resume control of the NAWSA the following year, did make several trips, often speaking to packed houses and dramatically increasing the campaign's energy levels. In Canton's Courtland Hotel, Chapman Catt, affirmed, "The coming of suffrage for women sooner or later is a settled fact. We do not recognize defeat and if the men say (to) us nay at one election we immediately make plans for another." She continued, "As soon as men recognize the simple justice of it all, that women are human

beings and now many of them are economic units entirely independent of men, that they have been forced into an industrial world with no voice in the making of conditions therein, political equality will speedily come."[88] Chapman Catt returned to Ohio to lecture throughout the state later that year, thus continuing to generate support for the referendum.

Many of the problems facing suffragists in the 1912 campaign contin- ued to stymy them in 1914. Indeed, these challenges intensified. When the liquor industry leaders discovered that a women's suffrage referen- dum would be going directly to the voters, they hastily met with Percy Andreae, an influential anti-prohibitionist who became president of the National Association of Commerce and Labor, to oppose temperance or- ganizations across the country. The agenda for their Cincinnati meeting focused on how best to throw confusion into the campaign. At the time, county governments had the option to make laws regarding liquor sales and distribution. If enough voters in a particular county wanted it to be dry, they could pass a law making it so. The home rule amendment, pro- posed by liquor interests, threatened that law. The wets immediately set out to gather the required signatures on petitions, securing over three hundred thousand within a single month. Once this ballot initiative came to fruition, the Anti-Saloon League immediately abandoned its promise to Ohio's suffragists to stay out of the election. The league leadership felt compelled to forward a prohibition amendment.[89] No longer allies, many drys stopped speaking in support of suffrage, and some even refused to allow suffragists to speak at prohibition meetings.[90]

As if complications related to a prohibition amendment were not enough, Ohio's anti-suffragists also revived their efforts in 1914. Housed in expensive new headquarters on Cleveland's Euclid Avenue, anti-suffragists such as Katherine Houk Talbott and Lucy Price Epstein relied on tactics that had proven successful in the 1912 campaign. Buttressed by the wets, they proved to be formidable foes. A native of Cincinnati, Houk Talbott was the daughter of a congressman and writer, and like most anti-suffragists, she was born into a life of wealth and privilege. "Kitty" loved music, and after studying voice, she helped found the Dayton Symphony Association, the Dayton Civic Music League, and the Dayton Civic Orchestra. Civically minded, she also supported the Salvation Army, the Jewish Girls' Club, the Widows' Home, and a nature club.[91] During the 1914 referendum cam- paign, she found time to direct the assault against the suffrage measure. She strategically divided the state into three parts—northern, central, and

southern—authorizing a field secretary to manage operations in each part. Lucy Price Epstein was the field secretary for Cleveland, Clara Markeson covered Columbus, and Florence Goff Schwarz managed Cincinnati.[92]

In an address to the Rotary Club of Dayton in 1914, Houk Talbott urged, "if suffrage will not do the good that they claim for it, then every mother's son of you ought to stand right straight with the anti-suffragists and see that Ohio is not afflicted with what is in the other states." Houk Talbott then drew a comparison between pro- and anti-suffragists: "I want to say in all fairness, most suffragists and anti-suffragists are after the same thing, the greatest amount of good for the greatest number of people. We believe, on our part, it is far easier to get that result without the vote. . . . Women today stand as a non-partisan body of citizens. . . . Give them the vote and they all automatically become democrats, republicans, progressives, socialists, or what not." She next reiterated two of the most common anti-suffrage arguments, "By what right do they attempt to force political responsibility upon ninety per cent and more of women who have their hearts and hands already full," and, "voting is not an inherent right; it is a matter of expediency." Finally, she emphasized men should do "men's work" and women should do "women's work": "It requires a certain number of citizens to operate the machinery of government. The men being the best fitted for this work, mentally, physically and temperamentally, have been given it to do for many generations." She concluded by predicting, "I do not believe the men in this state of Ohio are going to give the women suffrage."[93]

Many considered Price Epstein the most effective anti-suffrage speaker in the nation. Born in Fremont, Ohio, she studied at Vassar, where she won medals in oratorical contests. She taught in the Fremont school district briefly before becoming a reporter, and then an editor, at the *Fremont Messenger.* Later in her journalism career, she was an editor at the *Cleveland Leader.*[94] Initially Price Epstein favored suffrage, but then she pivoted to become a speaker for the National Association Opposed to Woman Suffrage—one of the few who were paid for this work.[95] Touring the country between 1912 and 1914, she led the battle against the ballot, and she was especially tenacious during the 1914 Ohio campaign.[96] In fact, her addresses in that campaign before the Ohio General Assembly directly contributed to the bill's demise.[97]

In addition to being a skilled orator, Price Epstein was a brilliant debater. During her national travels, she participated in sixty-five debates

across Indiana, Michigan, Pennsylvania, and Ohio.[98] Price Epstein and suffrage supporter Belle Case La Follette debated in front of a capacity crowd at the Akron Chautauqua in 1914. The *Akron Beacon Journal* described Price Epstein as "youthful in appearance, but her charm and attractiveness detracted nothing from the thought and forcefulness of her arguments, and rather accentuated them." The reporter quoted Price Epstein: "Women have been voting for several years in some states. Is politics any cleaner in those states? It is not. The same corruption exists there." She continued, "suffragists seem to think that to be denied a vote is a mark of inferiority. But government is merely a means not an end and men are better equipped to operate it than women."[99] Price Epstein would also confront male opponents. For example, she went head-to-head with Greenwich Village radical and feminist Max Eastman at New York's Cooper Union.[100] The *Pittsburgh Press* reported that she was impossible to rattle; "she remained smiling, calm under a torrent of heckling."[101]

In her speeches and debates, Price Epstein emphasized how women could have positive social influence without the ballot, often insisting that women were more privileged without it than a man was with it. She also attributed increased juvenile delinquency and the rise of socialism to suffrage.[102] She refused to concede that women were oppressed and argued that suffrage was a "backward step" for women. She often insisted only a small minority of women wanted the ballot.[103] After the Nineteenth Amendment passed, Price Epstein redirected her writing and speaking talents to campaign for Ohio's Warren G. Harding in the 1930 election and on behalf of the Women's National Republican Club.[104]

Despite the underhanded tactics of the wets and opposition from anti-suffragists such as Houk Talbott and Price Epstein, Ohio activists remained hopeful. Allen predicted a win, "I have visited more than forty Ohio counties in this campaign. . . . [M]any women opposed to suffrage two years ago now are heartily in favor of it. . . . [M]en are changing from a position of direct opposition or indifference to open espousal."[105] Unfortunately, her wishful thinking was exactly that. Amendment 3 met the same fate as Amendment 23. This time, the campaign won ten fewer counties than it had two years prior. Voters defeated the referendum 518,295 to 335,390. Only 40 percent of voters supported the cause.[106] Ohio suffragists were unable to overcome the entrenched and well-funded liquor industry or to refute anti-suffrage arguments. When many of the drys failed to support suffrage at the ballot box, both the suffrage and prohibition

amendments were defeated. The suffrage amendment received almost eighty-six thousand votes more than it had in the 1912 campaign, but the percentage of people voting for the amendment dropped four points. Only thirteen of the twenty-four counties that voted for the amendment in 1912 did so in 1914. Furthermore, only one county newly voted for the amendment. Even though every county gained votes, those against suffrage increased more. Notably, the five largest cities in the state all defeated suffrage by a wide margin.[107] The message was clear. Male voters had spoken again, and in so doing, ensured the political will of women via the vote would remain silenced.

The nationwide negative reaction toward increased militancy soured voters' attitudes about suffrage, thus undermining the Ohio campaign. Additionally, apathy toward the cause and concern regarding World War I played a significant role in the loss. The lack of money and experienced workers, on top of the usual challenges related to sexism, all converged against the measure as well. As far as Ohio suffragists were concerned, however, the liquor lobby was the number one culprit. "The general report of all field workers was that a wonderful change in sentiment in our favor had taken place in two years and it is perfectly natural that we should confidently have expected victory. This victory we should have achieved but for the injection of the wet and dry issue into the campaign," declared one Ohio suffragist after the defeat.[108] Taylor Upton concurred: "There certainly has been more opposition in this legislature than there has been in years and I think that was because the whiskey men take every stand they possibly can now knowing that they are nearing their end and they are just fighting for their lives."[109]

Down but Not Out

Ohio was not alone in its defeat. State referenda across the country ended in one loss after another. Looking to the federal campaign brought little encouragement. The US Senate held a vote on the Susan B. Anthony amendment in 1914 for the second time in history, but the measure fell eleven votes short of the constitutionally required two-thirds majority.[110] Ohio's senators split—Harold Burton voting in favor and Atlee Pomerene against.[111] Adding insult to injury, the US House of Representatives

thwarted the federal amendment again the following year.[112] Only five of the twenty-two Ohio representatives voted for the defeated measure.[113]

After these losses, Ohio's suffragists naturally were bitter. How many times could they devote themselves so entirely to the cause, only to come up empty-handed? The state's suffragists confronted the agonizing realization that their expert leadership skills, recruitment efforts, fundraising, media savvy, training, lobbying, and political will were not yet sufficient to counter the patriarchal forces that denied them the full expression of their citizenship. Sixty years of activism aimed at the state general assembly, directly at voters, and at their national representatives were not enough to win women the ballot. Ohio's suffragists could not ignore this fact, and the 1914 defeat forced a painful reevaluation of their situation. Leaders made the difficult decision to abandon the idea of carrying a state referendum. Rather than face the Ohio electorate again—and recognizing they could not outspend the liquor lobby—some Ohio suffragists realized it would be easier to sway a hundred legislators than the majority of male voters in the state.[114]

Fortunately, the national movement on behalf of the federal amendment slowly gained traction in 1915 and 1916, largely due to the energy of the NWP. The NWP decided to focus on the federal amendment instead of state campaigns because state campaigns were expensive—not to mention inefficient, since only a federal amendment could enfranchise all women. This organization grew both its membership and visibility. In 1915, forty thousand marchers took to the streets of New York City for an NWP-sponsored parade. Women dressed in white carried placards with names of the states they represented. Of course, Ohio sent its delegation. Out of sheer frustration, more Ohio women embraced the militancy of the NWP, participating in the parade and organizing a Columbus chapter of the CU.[115]

Not to be outdone, the NAWSA also grew at this time, becoming a politically important entity with forty-four state chapters.[116] Chapman Catt, once again at the NAWSA's helm, realized the state-by-state approach to winning the ballot was dragging on for far too long. Ohio's loss made this fact abundantly clear. Moreover, the time had come to stop placating southerners who claimed the federal amendment was an infringement on states' rights. To that end, in 1916, Chapman Catt delivered what became known as her "Winning Plan," comprising a two-pronged approach

pushing simultaneously for passage of the federal amendment and for obtaining the vote at the state level. A new centralized structure would coordinate all the state and national advocacy and fundraising on behalf of the federal amendment. This strategic shift also provided heightened nonpartisan lobbying at the nation's capital.[117]

Despite decades of defeats, Ohio suffragists again tapped into their reservoir of remarkable tenacity to turn the tide. Ohio's Zara DuPont spent six months of 1915 traveling over fifty-five hundred miles, visiting numerous towns to promote the cause.[118] The same year, President Wilson campaigned in Columbus alongside Senator Pomerene, Congressman Clement Brumbaugh, and Governor Willis. At this point, each of these men either opposed women's suffrage or had not yet taken a public stand on its behalf. The chairman of the Franklin County Democratic Club, James Ross, arranged for a delegation of state suffragists to meet with the politicians, anticipating at most two hundred women in attendance at the capitol building's rotunda. The number came closer to a thousand. Wearing their suffrage badges, these single-minded women made their collective way through the reception line, each politely yet emphatically stating, "Remember the Susan B. Anthony Amendment." "Susan" was heard by the president, "B." by Pomerene, and "Anthony" by Willis and Brumbaugh. Ross, overwhelmed by the unexpected turnout and orchestrated messaging, inquired, "Where are they coming from? Are you manufacturing suffragists in the Senate Chamber or are they flying in at the windows?"[119] Ohio suffragists took every opportunity to make a lasting impression on federal and state politicians. Both Willis and his successor, James Cox, publicly supported women's suffrage, though leaders such as Taylor Upton at times doubted their sincerity.[120]

Concurrently, some Ohio suffragists pursued what they perceived to be a more manageable goal—municipal suffrage. From 1914 to 1917, Hauser strengthened the movement's organizational structure in dual roles, serving as both the OWSA Literature Committee chairwoman and Cleveland's Organizational Committee chairwoman. Adopting a city charter strategy in 1916, Hauser and others hoped smaller local wins might generate enough energy to fuel future, more substantial victories. Early attempts focused on amending the charters of East Cleveland, Lakewood, Columbus, and Sandusky.

The Woman's Suffrage Party of Greater Cleveland played an increasingly important role in the state movement at this time. With a membership of

over seventy-five hundred, they began to hold their own annual convention, and they hired Florence Allen to convince the city council to grant women municipal suffrage. Allen was among the attorneys pursuing the East Cleveland case, and she joined with others to lobby city hall members night after night. She stated, "This Amendment, giving women the right to vote in East Cleveland is the key to suffrage for all Ohio women. A favorable court decision would also pave the way for state legislation that would give women the right to vote for all statutory offices." Belle Sherwin also played a key role in the East Cleveland campaign, plastering the city with posters and billboards and promoting the cause in every way she could conceive.[121]

This strategy paid off. On June 6, 1916, East Cleveland became the first city east of the Mississippi River to grant women municipal suffrage. The *Cleveland Plain Dealer* announced, "The proposal carried in every one of the four wards of the city, the total vote being 936 to 508."[122] Of course, no suffrage win could go unchallenged in the state of Ohio. When the county board of elections chose to contest this provision, the Cleveland Woman's Suffrage League found itself in the courts in defense of the measure. By April 1917, the Ohio Supreme Court issued a favorable ruling for the league, thus protecting this small but important win. Lakewood followed suit with a victory, but the Sandusky campaign was not so fortunate. The fight in Columbus was more arduous, but it ultimately succeeded too.[123] Like school suffrage, municipal suffrage had exposed small chinks in the opponents' armor.

A Presidential Suffrage Valentine

Ohio's suffragists found encouragement in these small wins, as well as in the fact twelve states had granted full suffrage to women and that those living in one state had won presidential suffrage. The state's leaders decided it was time to mount another campaign. While New York activists fought for full suffrage, those in Ohio joined Nebraska, North Dakota, and Rhode Island in a fight for presidential suffrage.[124] A full three years had passed since the blistering referendum loss of 1914, and the wounds of many Ohio suffragists had healed sufficiently to allow them to fight another day. Most Ohio suffragists did not want to settle for presidential suffrage, but by this point, many considered it the most viable alternative. National leaders such as Alice Paul knew even presidential suffrage was

an important step, as she explained in a telegram, "Securing presidential suffrage in Ohio will mean great added leverage in campaign of federal amendment in congress and gives us hope for accomplishing passage of national amendment very quickly."[125] Neither the Ohio Republican nor Democratic Party had proven brave enough to stake out a position on the issue, but buttressed by national platforms that now espoused the cause, Ohio politicians finally aligned themselves publicly with the national parties. Representative James A. Reynolds, a Cleveland Democrat, promised to sponsor a bill proposing presidential suffrage. On January 16, 1917, he kept that promise.[126]

State leaders, including Taylor Upton, Allen, Hauser, and Grace Drake, testified in front of the Ohio Senate on behalf of presidential suffrage.[127] Taylor Upton reminded legislators of the promises both major political parties had made to suffragists during the 1916 election, and she warned she was there to make sure they kept those promises. Allen also testified: "We want to say whether the president of the United States shall send our sons, brothers, and fathers into the war trenches, there to be killed or have their legs shot off." The *Cincinnati Post* reported, "Not in years has a house listened to such diversified oratory, ranging from flowery eulogies of womanhood to bitter denunciation of suffrage picketing at Washington."[128] Suffrage arguments at both the state and national level framed the ballot as a just reward for wartime sacrifices.

As expected, the pro-suffrage testimony did not go unanswered. Opponents introduced a measure, which became known as the Holden bill, with two goals in mind—to stall the Reynolds bill in committee and to derail the entire effort by proposing full suffrage. The antis knew a bill proposing full suffrage would be far more difficult to pass than one proposing presidential suffrage. Much to the frustration of suffragists, the wets asked for a hearing. During the hearings, liquor-lobby representatives and anti-suffragists sat together, indicating old allies were up to the same old tricks. The opposition contended that the state's voters had twice already rejected suffrage amendments. Fortunately for suffragists, the Reynolds bill reached the predominantly wet Senate before the Holden bill could be reviewed.[129] Additionally, full suffrage drew nearer to victory via the federal amendment route in the US Congress. Ohio women wanted to save their energies for a speedy ratification of that amendment rather than, at this critical juncture, to be caught up in a political whirlpool at the state polls.[130]

The visibility of the state's suffragists was at its highest in years. At one end of the spectrum, the *Cleveland Plain Dealer* appealed to members of both the Republican and Democratic Parties to support Reynolds' proposition, reminding them that if they did not, they were contradicting their national platforms.[131] At the other end, the *Cincinnati Times-Star* published a lengthy editorial declaring that the national party platforms were vague on the issue and that insisting on support was "carrying the idea of devotion to party emblems to the ultimate limit of absurdity."[132] Before the vote, opponents provided each House member with a copy of this editorial, hoping to influence their positions.

In front of another packed gallery on February 1, the state representatives met to cast their votes. Suffragists looked on, daring to wonder if this time would be different. They steeled themselves for another painful disappointment. After a nearly three-hour debate, the House voted to pass the Reynolds bill by a vote of seventy-two to fifty. More Republicans and drys voted for the bill than Democrats and wets.[133] After a victory in the House, all eyes turned to the Senate. Suffragists knew fifteen senators were on their side, but they also knew the anti-suffrage camp had fifteen in their camp as well—leaving eight undecided senators. Because the bill was to be considered on Valentine's Day, suffragists had sent senators thousands of cards asking, "Vote for me for a valentine."[134] Would this be the year suffragists got their hearts' desire? On Valentine's Day, another rowdy crowd jammed into the gallery to witness the historic event. The tension was palpable. House members, justices of the state supreme court, and various other officials all crowded into the Senate chamber. The drama, nor the stakes, could not have been higher.

As the debates began, a father of ten daughters, Senator T. M. Berry of Allen County, framed his pro-suffrage argument within traditional views of femininity. He linked his daughters' aspirations to be mothers to the necessity of obtaining the ballot as a source of security for the family. Despite that the rationale for women's enfranchisement had long been cloaked in the sanctity of motherhood, Senator J. O'Brien of Cincinnati warned, "When womanhood totters our land is in danger. Your side wants to break up the home."[135] Senator Holden argued women didn't really want the vote. Of course, anyone who had paid attention for the last sixty years knew otherwise. Hearing the same tired arguments likely caused suffrage supporters to shake their heads and to groan inwardly, "not again."

As the debates unfolded, the outcome was anyone's guess. Tension built as the roll call proceeded. Longtime opponent Senator U. G. Murrell of Clinton County cast the deciding ballot. To everyone's surprise, and amid roars of cheering from the gallery, Murrell voted in favor of granting Ohio's women presidential suffrage. No one had expected his about-face. Suffragists must have looked at each other with equal measures of disbelief and joy. The room erupted. Lieutenant Governor Earl Bloom pounded so vigorously to restore order that he broke the handle of his gavel.[136] The decades-long wait for a significant victory had ended. Ohio's suffragists got their valentine. The bill passed, twenty to sixteen. Every Republican senator voted for the measure, except three from Cincinnati, the liquor-lobby holdout. Cox, a longtime supporter of the cause, quickly signed the bill, and he delivered a speech of support on Mother's Day.[137] Ohio suffragists expressed heartfelt gratitude, wanting to believe this would be a sustained victory, both for their own benefit and as further evidence Chapman Catt's Winning Plan was living up to its name. Yet, experience told them not to let their guard down, because wins never went unchallenged. Such suspicions were justified.

A Greater Menace Than War

At the same time hopes regarding the federal amendment were higher than ever, the jubilation of Ohio's suffragists working on behalf of state reforms was once again short lived. Anti-suffragists made good on their threat to pursue a referendum in response to the 1917 presidential suffrage win. After the Ohio legislature passed the measure, Goff Schwarz called a special session of the anti-suffrage association to announce she wished to counter with a referendum.[138] Meeting at Cincinnati's Gibson Hotel, anti-suffragists, mostly men, strategized a way to rescind presidential suffrage for the state's women. After opening headquarters in Columbus, the Ohio Association Opposed to Woman's Suffrage circulated petitions gathering names from counties in support of the referendum.[139] Much to the chagrin of suffragists, the Ohio attorney general supported the antis' position.[140] Cox promised he would do everything in his power to prevent the threatened referendum.[141] He proved unsuccessful. It was time to mount a defense.

The liquor lobby and anti-suffragists once again joined forces. Lawrence Maxwell, of Cincinnati, and Edward Deeds and Harry Talbott, both of Dayton, lead the charge on the referendum. The largest number of petitions came from Hamilton County, the liquor-lobby stronghold.[142] The wets were not above using underhanded tactics such as offering drinks in exchange for petition signatures in bars or outright falsifying signatures. In fact, many petition canvassers were saloon owners or employees.[143] Based on dates recorded on the petitions, it was clear to see that the same man circulated petitions in different counties on the same day—counties geographically too distant from each other to travel in one day. The opposition was again up to its dirty tricks.

Goff Schwarz and Houk Talbott orchestrated the opposition's campaign. Goff Schwarz led the counterattack by describing the Reynolds bill as a conspiracy to overthrow the will of the people, who clearly had spoken by recently rejecting women's suffrage not once but twice. Goff Schwarz sent a resolution to the US Senate on behalf of the Ohio and the Cincinnati and Hamilton County Associations Opposed to Woman's Suffrage, urging them to reject the Susan B. Anthony amendment.[144] Talbott went so far as to exclaim, "We feel suffrage is a greater menace than war. This is the first movement in the history of the world where women have been combatted by women. It is a danger to the entire nation."[145]

Naturally, the state's suffragists were dreadfully concerned about the opposition, having hoped to follow the presidential suffrage win with municipal suffrage wins. After the antis filed their petitions, suffragists devoted themselves painstakingly to verifying signatures, finding many to be highly irregular.[146] Some petitions had pages of fictitious signatures made in the same handwriting, many had no addresses, and some used the names of dead voters. Upon this discovery, suffragists filed lawsuits in six counties demanding fraudulent signatures be discounted.[147] They assumed such dubious fraud would not go unpunished. The OWSA leaders were so confident the court cases would prevent the referendum that they did not prepare a defensive campaign to protect their victory in the legislature. Their confidence was misplaced.

Suffragists won cases in four counties—Scioto, Trumbull, Cuyahoga, and Mahoning—removing eighty-six hundred signatures. However, there were still enough valid signatures in those counties to demand the referendum. Suffragists also attempted to use the local courts in Lucas and

Franklin Counties to force election boards to remove fraudulent signatures. In Franklin County, suffragists pressed the secretary of state not to count the petitions, since the level of fraud was so high, and they demanded a hearing.[148] The secretary of state refused on both counts, leaving them shocked by the possibility that their hard-fought victory could be snatched in such a blatantly underhanded manner. Suffragists first launched a defense in the court of public opinion, distributing circulars to the voters summarizing their case:

> Do these petitions represent the people? No! They represent a special interest. Five hundred and eighty-one petitions were circulated by saloon-keepers and bartenders; 246 were circulated by employees of the breweries, the Personal Liberty League (a "wet" organization) and by others more closely allied with the liquor interests. This referendum is the work of the organized liquor ring. Nearly one-quarter of all the names were obtained in Cincinnati alone (the great brewing city). Circulators had to resort to fraud and forgery to get the petitions filed. Though these petitions were formally filed by the Association Opposed to Woman's Suffrage, not one woman circulated a petition.[149]

Allen then swung into action, quickly mounting a defense in the courts. She presented hard evidence that election boards in sixty-five counties did not scrutinize signatures and in thirty-three counties did not file proper certifications. Allen's arguments resulted in a restraining order against seventeen of the counties that had not properly certified the petitions. Supporters breathed a sigh of relief; however, a judge soon lifted the injunction. Refusing to give up on the idea that justice should be theirs, suffragists filed suit in the state supreme court, with the goal of compelling the secretary of state to hold hearings.[150] Justice denied, suffrage opponents were never held accountable for fraud. Ultimately the suit was dismissed, leaving suffragists with only a week to manage a defense of presidential suffrage at the polls. On the eve of the referendum vote, in a last-ditch effort to defend their win, suffragists placed large advertisements in several newspapers. Playing to patriotic sentiments, one ad read, "While we were engrossed in work for the war, while we were getting our sons and brothers ready to go to the front, while we were organizing the Red Cross work to lessen the suffering of the wounded, while we were doing these things, the

brothel and lowest dives in Ohio, together with their backers, circulated the referendum petition and backed it with fraudulent names."[151]

Everyone knew about the wets' underhanded maneuvers. During this fiasco, Ohio suffragists found support from state politicians and the media alike. The Democratic and Republican Parties both held conventions in Columbus, and both adopted resolutions urging a rejection of the anti-suffrage referendum scheduled later that year. Many important media outlets across the state supported suffragists by denouncing their opponents' dishonest methods. The *Akron Times* reported, "If there is anything that should strengthen the cause of woman suffrage in Ohio, it is the disclosure that the petitions of the antis for a referendum on the Reynolds Act abound in frauds. Fraud is a confession of a weak cause. It ought to condemn its perpetrators in the eyes of all fair-minded voters."[152] Yet, support from politicians and the media was insufficient to counter even this brazen corruption.

Making matters worse, the referendum's wording was so awkward that it was hard to understand either vote option. A "no" vote meant rejecting the presidential suffrage measure, and apparently that wording confused many voters.[153] Additionally, as Election Day approached, anti-suffragists circulated arguments that the legislature had been bullied into passing the Reynolds bill and that the suffrage lobby in Columbus had made life miserable for state politicians.[154] Even though suffragists had framed themselves as humble homemakers devoted to domesticity, anti-suffragists continued to paint them as bossy women bullying hapless legislators into submission. In yet another fear appeal exercised to stir up the emotions of opponents and to motivate them to go to the polls, anti-suffragists drew a comparison between Ohio's suffragists and the militants demonstrating at the nation's capital.

In an all-too-familiar scene, the November 6, 1917, election returns ushered in perhaps the most devastating defeat ever for Ohio's suffragists. Ultimately, the liquor interests proved too powerful. The state prohibition amendment brought out a larger than usual turnout. Voters both repealed presidential suffrage and rejected the prohibition amendment. The latter lost by so small a margin, though, that the drys were motivated to try again the next year. As for suffrage, while 422,262 voters chose to retain presidential suffrage, 568,382 voted against it. Presidential suffrage was upheld in fifteen counties, eleven of which had supported the

cause in three straight elections.[155] Suffragists did manage to win over 42 percent of the vote, and the margin of victory for their opponents declined in fifty-seven counties.[156]

Following the 1912 and 1914 losses, the 1917 loss was all the more crushing. Ohio suffragists were incredulous. They already believed that they had "settled" for presidential rather than full suffrage, so to have this hard-fought victory snatched away was more than many could bear. It had taken decades to get the male legislature to support women's suffrage, and now male voters took away that right before they even had a chance to exercise it. Taylor Upton bemoaned, "How little the world knows of the real bloodshed of that battle! The defeat of 1917 convinced suffragists that there would be no use to try to get suffrage in the state until prohibition was established."[157] Outspending the liquor lobby was a losing battle, so the OWSA turned its full attention to the proposed federal amendment. The OWSA's organization committee, led by Hauser, and the Enrollment Committee, led by Kathleen Simonds, produced results by strengthening existing local organizations. Paid field-workers, with help from WCTU members, generated significant increases in enrollments. By 1919, OWSA membership more than tripled over the course of three years to more than 254,000.[158]

Several significant legal and political hurdles at the state level remained, some of which had national consequence. The wets initiated an amendment that would give the people of Ohio the power of the referendum over the general assembly when ratifying proposed amendments to the US Constitution. The US Constitution specifies that state legislatures have the power of accepting or rejecting federal amendments, but the wets' referendum amendment would mean Ohio voters, and not its legislature, had the final power to ratify federal amendments. While the purpose of this referendum clearly was aimed at preventing a federal prohibition amendment, Ohio suffragists knew this measure, should it succeed, would make them collateral damage. Hopes of gaining full suffrage for Ohio's women via the federal amendment would be slim, since voters were likely to overturn the state legislature's measure again.

The NAWSA also knew that such a move could set a dangerous precedent for other states with similar provisions, possibly derailing the entire ratification process.[159] The NAWSA came to the aid of Ohio suffragists, offering both financial and legal assistance.[160] It helped to file a suit in the name of Edgar Weinland, a prominent Columbus citizen. Weinland's

case stipulated that as a taxpayer he should not have to bear the unnec-
essary expenditure of an election for a measure that was patently uncon-
stitutional. The case made its way to the Ohio Supreme Court, which
avoided a decision, claiming it had no jurisdiction since the election had
not yet taken place.[161]

Though the wets successfully staved off state prohibition efforts in
1914, 1915, and 1917, persistence on the part of the drys paid off. The US
Congress passed the federal prohibition amendment in December 1917.
The energy behind the ratification effort was enough to advance the cause
in Ohio. Taylor Upton got her wish. With prohibition in place, suffrage
finally could be considered on its own merits . . . or so supporters thought.
In November 1918, the state prohibition amendment was carried with 51
percent of the votes. In an ironic twist, the wets both lost and won: the
state prohibition amendment passed but so did the referendum on fed-
eral amendments.[162] In this regard, the wets' attempt to prevent a federal
prohibition amendment resulted in the ability to undermine a suffrage
amendment as well. Ohio's suffragists were dismayed to discover that
even if their work on behalf of the federal amendment and ratification
succeeded, all that labor might prove fruitless because the male voters of
the state could reject the federal amendment.

The state's suffragists did not give up in 1912. They did not give up in
1914. They did not give up in 1917. Surely though, even the most stalwart
among them must have considered the possibility of conceding defeat
gracefully. Deep down, they knew they could not let themselves down,
and they could not let sister suffragists in other states down. They knew
all too well that the outcome in Ohio would have reverberations across
the nation. Failure was not an option.

In January 1918, the US House approved the Susan B. Anthony amend-
ment by the exact two-thirds majority required.[163] Of the twenty Ohio
representatives voting, eight voted yes—including Robert Crosser, who
left his sickbed to do so—and twelve cast ballots against the measure.[164]
Before the vote, Ohio representative Warren Gard offered damaging mo-
tions that, fortunately, were struck down.[165] Suffragists knew that the US
Senate was likely to take up a vote on the Susan B. Anthony amendment
in early February. Experts estimated the amendment was one vote short.
Ohio suffragists pulled out all the stops to provide that one vote. They
convinced state senator F. E. Whittemore of Akron to forward a joint reso-
lution from the state's general assembly calling for Ohio's US senators to

support the amendment. US Senator Warren Harding already did so, but Senator Atlee Pomerene was the holdout. This extraordinary gesture put Ohio in the national spotlight, and it generated headlines such as "Ohio May Seal Fate of National Suffrage Plan." This editorial, printed in the *Cleveland Plain Dealer,* called on Ohio legislators to support the cause:

> But the issue of suffrage strikes at the fundamentals of world democracy. The women of America have carried their share of the burden of the war, have met new responsibilities with courage and devotion without protest or complaint, and have stood with womanly fortitude to their tasks. And now all the women ask for is justice. Let it not be said of America that she alone of all civilized countries still denies to the mothers, wives and sisters of her soldiers of freedom this simple right of suffrage.[166]

Despite this pressure, Pomerene would not be moved. A few days later, the US Senate failed to approve the amendment again, falling one pitiful vote short of the necessary two-thirds majority.[167] Blame was duly placed at Pomerene's feet. The *Cleveland Plain Dealer* asserted, "The single negative vote of Senator Pomerene today was sufficient to kill the amendment and it is more than likely it has postponed nationwide suffrage for several years."[168] The newspaper acknowledged that the senator had regularly voted in favor of the cause as a member of the Ohio General Assembly, but he felt strongly suffrage was a state issue, and thus he could not support a federal amendment.

In May, the US House of Representatives was a different story. It passed the Susan B. Anthony amendment again, 304 to 89. Ohioans helped bring this victory to fruition. Of the Ohio representatives, nineteen voted yes, two voted no, and one did not vote. The no votes came from Ambrose Stephens and Warren Gard.[169] It was now the Senate's turn—again. As usual, suffragists packed the gallery that June day. The last four-hour debate ended. The roll was called. On the third try, after forty-one years of debate, the US Senate finally approved the amendment, with two votes to spare.[170] Fifty-six senators voted yes, twenty-five voted no, and fourteen did not vote. Ohio's Pomerene, longtime opponent of suffrage, was unavoidably detained and thus did not vote. His counterpart, Warren Harding, went on the record voting in favor.[171] The standing ovation lasted five minutes.[172] By the end of the year, Michigan, South Dakota, and Oklahoma also would adopt state women's suffrage measures.

Taylor Upton was one of six suffragists to see the House speaker and the vice president sign the Nineteenth Amendment.[173] Maud Younger, of the NWP, later recollected, "There was no excitement. The coming of the women, the waiting of the women, the expectancy of the women, was an old story."[174] The moment seemed anticlimactic, and suffrage leaders knew the last and perhaps biggest battle remained—the amendment would now go to the states for ratification. It was time for Chapman Catt and Paul to mobilize their armies for the final time.

The Fifth Star Shines Brightly

June 16, 1919, was the most important day in the history of Ohio's long suffrage movement. Governor Cox called together Ohio's representatives to outline three reasons the Nineteenth Amendment should be ratified: women should have had this right long before this point, the ballot was a partial reward for wartime service, and the nation needed women's special moral fortitude as an added safety measure against pending evils.[175] The Ohio legislature eagerly ratified the Nineteenth Amendment, making Ohio the fifth state to do so, following Illinois, Wisconsin, Michigan, and Kansas. The historic vote was seventy-three to six in the House and twenty-seven to three in the Senate.[176]

In perhaps one of history's most ironic twists of fate, both chambers restored presidential suffrage lost in the 1918 referendum on the same day as they ratified Nineteenth Amendment. Earlier, state legislators Reynolds and C. H. Fouts had cosponsored a presidential suffrage bill, whose goal was to ensure Ohio women could vote in the 1920 presidential election even if the Nineteenth Amendment was not yet ratified. The bill passed seventy-five to five in the House and twenty-seven to three in the Senate.[177] Ohio became one of twelve states granting women presidential suffrage prior to the Nineteenth Amendment.[178] Taylor Upton described the scene: "Women who heretofore had always witnessed legislative action from the gallery, were on the floor and the leaders escorted them through the legislative passageway, which always heretofore had been closed to them, to the Senate chamber where the senators immediately ratified." She added, "Later in the day the Senate passed the presidential suffrage bill."[179]

Ohio had become the fifth star on the NWP's ratification banner of purple, white, and gold—the colors of the movement. Each time a state

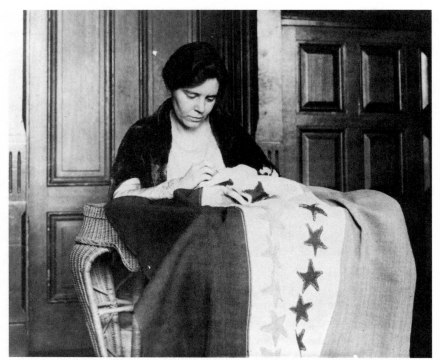

Alice Paul sews star on Nineteenth Amendment ratification banner.

ratified the amendment, an NWP suffragist threaded a needle with great care and reverently sewed another star on the banner. Each star was cause for celebration, a hopeful sign that the movement was one step closer to victory. Ohio suffragists could now visualize a symbol of their success. After seventy years of struggle, women of Ohio were closer than ever to winning the ballot, and they expressed gratitude for the Ohio men who had fought beside them over those many years. On this momentous occasion, Hauser, as editor of OWSA's *Bulletin*, documented, "We had finished the suffrage fight in Ohio as Mrs. Upton had always wanted to finish it, with love, good will and harmony in our own ranks, and, so far as we were able to judge, with nothing but good will from the men with whom we had worked since the present stage of the contest was inaugurated in 1912."[180]

Many suffragists received the news quietly, and no one planned a formal celebration. Politicians seemed more jubilant publicly than the suffragists. Governor Cox exclaimed, "The civilization of the world is saved," and Sen-

ator Harding declared, "I look upon the enfranchisement of women as an accomplishment rated along with our achievement of independence, preservation of the union (and) our emancipation of the slave."[181] Perhaps the suffragists knew better. Once again, Ohio women had won the fight for presidential suffrage, but would it be theirs to keep this time? The state's suffragists had little reason to believe this time would be any different. Taking nothing for granted, they smartly prepared for the counterattack.

Ohio's Last Suffrage Referendum

As expected, anti-suffragists did not accept their loss gracefully. Cincinnati attorney John Druffel led the final assault. The required signatures were gathered on petitions to force another referendum vote, thus potentially suspending the second Reynolds bill. Druffel predicted, "The results of the election will show Ohio standing firmly for male suffrage and refusing to follow the lead of some of her more flighty sister states."[182] One of the leading Cincinnati anti-suffragists, Beatrice Shillito, sent a letter to candidate Warren Harding outlining reasons she and other women were opposed to women's suffrage: it would double the cost of elections and increase the tax burden; it violated states' rights; on four previous occasions, the voters of Ohio had rejected votes for women; and a poll indicated 90 percent of the women did not want the ballot. She also sought a personal interview with Governor Cox to make her case. Other anti-suffragists highlighted the CU's militancy in Washington, DC, and accused the group of sedition.[183]

As expected, the liquor lobby joined forces with the anti-suffragists. This time, the fate of the Nineteenth Amendment was tied to the Eighteenth Amendment. Ohio's wets secured four measures related to prohibition for the November election. Amendment 1 defined *intoxicating liquor*. Amendment 2 repealed this statewide prohibition of alcohol. Referendum 1 ratified the federal prohibition amendment. Referendum 2 provided for the Prohibition Enforcement Act.[184] According to the results, Ohio's wet majority successfully staved off ratification of the federal prohibition amendment, and, strangely, the drys prevented the repeal of the state prohibition law. Voters also defeated the Prohibition Enforcement Act. The outcome of this election had an important impact on the issue of

suffrage. As Chapman Catt and Nettie Rogers Shuler later described, "Petitions to refer the Ohio Legislature's ratification of the Federal Suffrage Amendment and grant of presidential suffrage were also circulated by the same wet army that circulated the others, the time of filing was carefully planned so as to fall short of the required sixty days before election." They further explained, "This was to bring the two suffrage referenda to vote in 1920, a fact which the wets hoped would prevent a proclamation of ratification of the Federal Suffrage Amendment before the presidential election of 1920."[185]

Ohio suffragists, once again on defense, turned to the courts to protect their win, arguing the referendum was unconstitutional. All eyes turned to Ohio as a crucial test case with national implications. Twenty-two other states had similar laws granting electors the right of referendum on federal amendment ratification.[186] Under intense pressure, suffragists across the nation focused on two tasks: getting the last few states needed to ratify the amendment and maintaining ratifications in states threatening to nullify via referenda. In Ohio, suffragists halfheartedly returned to the tedious work of documenting the number of Ohio women who did want to vote. They had learned all too painfully that the courts could let them down and the referendum could go through.[187]

Waiting for the court ruling was excruciating. Ohio suffragists needed a way to manage their fears and doubts. Decades previously, the women of South Newbury had planted an acorn as a symbol of their determination to win rights for women. By 1919, that acorn was a mighty oak. Ohio suffragists made a pilgrimage to this hallowed site to rededicate themselves to their cause.[188] Speaking at this event, Taylor Upton did not mince words, warning, "But we must not sit and fan ourselves and wait for the states to ratify. . . . The wets are determined to have one more hit at us."[189] She knew her enemy well, and her words proved prophetic.

Hopes were dashed when, in September 1919, the Ohio Supreme Court decided a referendum on the ratification of an amendment to the federal constitution was valid.[190] Once again, the state's courts undermined the cause of suffrage. Now, not only was the future of the movement in jeopardy statewide, so was the progress of the entire national ratification drive. After a collective groan of disbelief, there was little choice but to take the fight to the US Supreme Court. Perhaps because few suffragists in other states had fought so valiantly for so long, Ohio's women were more determined than ever to leave nothing on the field.

State drys realized there would not be enough time to secure an opinion from a higher court before the November election, so they concentrated their efforts on the election itself. This choice left suffragists to fight the judicial battle on their own. There was a significant legal barrier. The goal of the original case related to the prohibition amendment was to prevent the expense of an election for an unconstitutional measure. The fact that the election already had taken place made the point moot. Ohio taxpayers may have suffered damages, but a court ruling could no longer provide redress. Suffragists searched desperately for a different legal angle on which to build a case.

George Hawke, a Cincinnati lawyer, devised a compelling alternative. He saw an opportunity to question Ohio's referendum provision relating to federal amendments by focusing on the Nineteenth Amendment, since it was still pending. Hawke agreed to partner with the NAWSA and with a more experienced and better funded attorney, J. Frank Hanley, to pursue this course of action.[191] The NWP also filed a brief with the US Supreme Court asking it to reverse the action of the Ohio State Supreme Court in refusing to grant an injunction against the referendum Hawke sought.[192] Much to the surprise of many, the US Supreme Court selected the Hawke case on which to base its decision. At the heart of the matter was one question: "What is a legislature?" In *Hawke v. Smith, Secretary of the State of Ohio,* the court ruled, "The power to ratify a federal amendment rests with the legislature and cannot be passed on by voters."[193] In June 1920, the justices declared that ratification of a federal amendment is not subject to action by voters, stating the provision was "invalid, unnecessary and in conflict with constitutional provisions empowering state legislature to ratify such amendments."[194] The decision was front-page news across the country. Most importantly, the high court's opinion prevented the referendum on ratification of the Nineteenth Amendment in Ohio, and it prohibited further referenda elsewhere. The threat was over. Legislators would have the final say on the amendment's ratification. Moreover, this decision crucially made possible the ratification of the federal amendment by the thirty-sixth state, Tennessee, just weeks before legislators were scheduled to vote. Suffragists across the nation breathed a collective sigh of relief with the removal of this enormous obstacle. The promise and possibility of the Susan B. Anthony amendment was now within reach.

The Final Battleground

Ohio's suffragists won their battle, but they knew the war waged on. Taking little time to rejoice and no time to rest, the state's leaders quickly pivoted to the national ratification campaign. Ohio took a prominent role in this endeavor. Both candidates in the 1920 presidential campaign—Cox and Harding—were from Ohio. Suffragists across the nation thus divided their attention between Tennessee and Ohio during the final push for the Nineteenth Amendment, and they zealously urged public support for the Nineteenth Amendment from both candidates. The strategy worked, and it had the added bonus of garnering media attention. In a political cartoon titled *Waiting for the Young Lady of the House,* both candidates were depicted standing outside the door of the Tennessee legislature, with Cox holding a box of candy and Harding proffering a bouquet of flowers, each prepared to court the women's vote.[195]

Democratic nominee, and then governor, James Cox was a longtime vocal supporter of women's suffrage. Republican nominee, and then senator, Warren Harding was not on the record as such. Both candidates were well aware of the increasingly important role women's enfranchisement could play in the outcome of the 1920 election, and should they momentarily forget this, suffragists were quick to remind them. NWP and NAWSA delegations regularly traveled to Ohio, to join Harding on his front porch in Marion and Cox at his home in Dayton.

Cox happily met with suffrage leaders, both moderate and militant, at his home as well as in Columbus and Washington, DC. A newspaperman by trade, Cox knew the importance of media coverage for his campaign, and he consistently issued statements in support of suffrage to steal the day's headlines. While on the campaign trail, Cox also employed staffers to represent him in Nashville while the Tennessee legislature prepared for the ratification vote.[196] He paid a price for this open support, often enduring haranguing antis who urged him to ignore Chapman Catt's and Paul's pleas. He agreed to meet with antis, but he did so rarely, and he stuck by his decision to support the amendment—occasionally with wavering conviction. As the campaign proceeded, Cox began to worry about his pro-suffrage position. Enfranchising women would double the Republican vote in Ohio, thus potentially leading to his defeat. Paul sensed his growing hesitation, and she did not wait to confront Cox when he began to vacillate. Chapman Catt also made sure to keep him in line.[197]

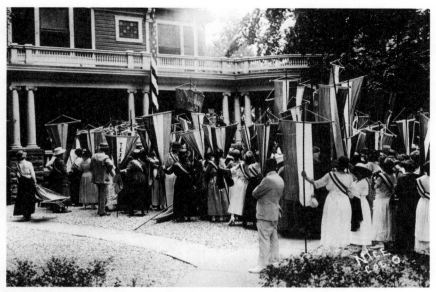

Warren G. Harding with National Woman's Party members in Marion, Ohio

Harding did his best to strategically waffle on this issue throughout most of his campaign. He repeatedly promised Chapman Catt "good news" on this front, but he remained silent to avoid the wrath of the antis. Furthermore, Harding was slow to commit to a direct intervention on behalf of the cause in Tennessee. Eventually, he sent Chapman Catt a telegram tentatively indicating, "If any of the Republican members of the Tennessee Assembly should ask my opinion as to their course, I would cordially recommend an immediate favorable action."[198]

Harding's handlers feared Paul and her picketers more than the NAWSA, and they were willing to make compromises to avoid bad press. When the day came for Harding to formally announce his front porch campaign, the NWP negotiated to send two representatives to deliver him short statements on the porch in exchange for calling off picketers.[199] It also sent five hundred purple, white, and gold banners and two trunks of suffrage regalia from Washington, DC, to headquarters set up five blocks from Harding's home.[200] The NWP delegation, dressed in white, carried the suffrage banners while marching single file through the streets of Marion, accompanied by a brass band, until they reached Harding's front porch. After forming a semicircle several rows deep, two delegates stepped forward to make their statements. Later that day, in Harding's acceptance

speech, he stated, "It is my earnest hope, my sincere desire, that the one needed State vote be quickly recorded in affirmative of the right of equal suffrage." Paul was not impressed, telling reporters, "If Sen. Harding refuses to live up [to] the suffrage plan and contents himself merely with 'earnestly hoping' and 'sincerely desiring,' how can we expect the country to take seriously the other planks in his platform?"[201]

The antis quickly expressed their displeasure too. Shillito, a long-time vocal opponent of suffrage, did not mince words. The daughter of a wealthy Cincinnati department store owner, she already had made herself quite a media darling in Ohio. She joined other anti-suffrage leaders at their Nashville headquarters in the Hermitage Hotel to conspire against the cause, and she gave speeches throughout the city to that end.[202] Harding continued to be courteous to the antis, regularly granting them meetings. Republican strategists worried that if Tennessee failed to ratify, their party would be blamed. Party members began to pressure Harding to take a more active role in Tennessee, despite anti-suffragists' warning to the contrary. The candidate resisted this pressure—he also resisted pressure from Chapman Catt, who sent regular wires to both candidates appealing for support in Tennessee.

To create some space between himself and the controversies surrounding suffrage, Harding chose Taylor Upton, then the Republican National Executive Committee vice chair, to lead his party's ratification effort at the national level. The chair of the party then asked Taylor Upton to travel to Nashville in August 1920. Her marching orders were to persuade Tennessee Republicans to become the thirty-sixth state to ratify, thus enfranchising women across the country. Harding telegrammed Taylor Upton, granting her permission to speak on his behalf to Republican members of the Tennessee General Assembly: "It will be highly pleasing to have the Republicans of that State play their full and becoming part in consummating the constitutional grant of woman suffrage. . . . It is a matter of Republican contribution to a grant of suffrage to which our party is committed, and for which our party is in the main responsible."[203]

Suffragists and anti-suffragists from across the nation descended on Nashville in droves. The final battleground might have been Tennessee, but Ohio women were there, fighting to the end.[204] Chapman Catt wired Taylor Upton to encourage her to hasten to Nashville as soon as possible. The NAWSA set up headquarters at the Hermitage Hotel, and Chapman Catt was relieved to have her friend beside her for the final battle. Taylor

Upton and Chapman Catt had fought side by side for thirty years, and both had been "Aunt Susan's girls."[205] Taylor Upton knew both presidential candidates well; she had even sat on Harding's front porch the day he announced his candidacy while other suffrage leaders watched from the lawn. Chapman Catt relied on her friend's experience and judgment, but both realized Tennesseans considered them northern outsiders—two Yankee women meddling in southern affairs. Both women agreed to keep a low profile, remaining in the background so as not to become a distraction or fodder for the antis.

As the day of the Tennessee assembly vote approached, Harding shocked everyone by condoning state legislators' rejection of the amendment. In a letter to Judge G. Tillman of Nashville, he wrote, "Please say to the Republican members that I cannot ask them to vote for ratification." Suffrage leaders were enraged, and media across the nation pounced on the story. Taylor Upton quickly telegrammed Harding to vent her frustration and concern: "Not only Republican but Democratic votes at state. . . . Imperative that you should send message that having been convinced constitutional objection is not well founded you still urge Republicans to vote for ratification. That message must come before ten o'clock Wednesday morning. Notify me."[206] She received no reply from Harding, and he never quite understood his fellow party members' and strategists' negative reaction to the letter. Fortunately, Tennessee Republicans did not abandon their pledged support of the amendment, despite Harding's free pass to do so.

The day finally came for Tennessee's state senate to consider the ratification resolution. Chapman Catt did not attend the vote in person. Instead, she and Taylor Upton endured the wait together at the Hermitage Hotel, listening out the window for occasional shouts from the statehouse.[207] The vote resulted in a tie, until a young senator, Harry Burn—in what now is suffrage lore—took his mother's advice and changed his vote to break the tie. On August 18, 1920, Tennessee became the thirty-sixth state to ratify the Nineteenth Amendment.[208] A page ran to the Hermitage Hotel to deliver the joyful news to those who had waited a lifetime to hear it, but Chapman Catt and Taylor Upton, listening to the cheers coming from the capitol building, already knew they had won the war and women across the nation had finally won their political freedom.

The stars had aligned. Tennessee's star would now grace the NWP ratification banner, which Alice Paul unfurled over the second-floor balcony of the NWP headquarters in Washington, DC, for all to see. After

Tennessee ratified the Nineteenth Amendment, Taylor Upton, Chapman Catt, and other national leaders joined together for a victory celebration in Chattanooga and then traveled to Washington, DC, by train, hoping to witness the official signing at the nation's capital.[209] Naturally, the triumphant win and its dramatic history were front-page news across Ohio and every state. The *Columbus Evening Dispatch* featured the headline "American Women Finally Get Vote," and "Women Granted Suffrage" blazed in huge letters across the front page of the *Dayton Daily News*.[210] Not all newspapers framed the story optimistically. The *Cincinnati Times Star* quipped sarcastically, "Let the great moral wave of female suffrage inundate the republic even if we have to put mirrors and powder puffs and lipstick in the voting booths."[211] Such headlines no longer mattered to most suffragists. Let disgruntled editors say all they wanted, because now women across the country would have their say at the ballot box.

On Saturday, June 21, 1919, the NWP's official weekly magazine, the *Suffragist,* marked the passage of Nineteenth Amendment with a special cover. A drawing of two women, one labeled American Womanhood and the other Justice, embrace each other tightly, holding the amendment in their hands. The headline comprised two simple words: "At last."[212] The final five years of the suffrage movement, in Ohio and across the nation, were as dramatic as any of those leading up to that point. The contours of the last battleground loomed on the horizon.

Before ratification, fifteen states already had granted women the vote, but the Nineteenth Amendment extended the franchise across the nation. Meanwhile, opponents attempted unsuccessfully to rescind the ratification on technicalities. Movement leadership did not worry about the last gasps of a dying anti-suffrage campaign. The *New York Times* lead story about the amendment's successful ratification quoted Taylor Upton, reassuring readers, "I regard the suffrage victory in Tennessee as perfectly safe right now and nothing can undo it. Otherwise, Mrs. Catt and I would never have left Nashville and come to Washington."[213]

The governor of Tennessee sent documentation of the state's ratification vote by registered mail to US Secretary of State Bainbridge Colby. After certifying the documentation, Colby signed the proclamation enshrining women's suffrage into the US Constitution in the privacy of his home, denying suffrage leadership the opportunity to witness the historic moment. Though unrelenting opponents had tried, not once but twice, to question the constitutionality of the Nineteenth Amendment in *Lesser*

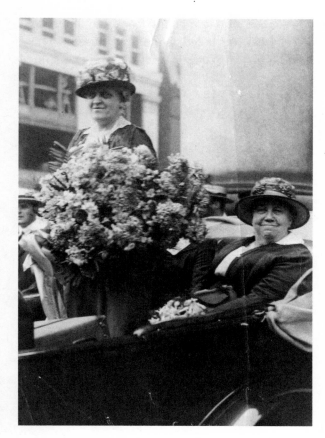

Carrie Chapman Catt and Harriet Taylor Upton at Nineteenth Amendment ratification victory parade

v. Garnett and in *Fairchild v. Hughes,* the US Supreme Court sustained its important place in history. "Votes for Women" was no longer a slogan—it was the law of the land. The United States became the twenty-seventh country to grant women the vote.[214] After seventy-two years, the war was over. Now 26 million additional citizens, including those of Ohio, could vote regardless of their sex.

The celebrations would continue for months. Taylor Upton left the capitol to travel with Chapman Catt and Chari Williams, vice chair of the National Democratic Executive Committee, by train to New York City. The governor met the women at the train station, along with hundreds of other suffragists, to congratulate them on their win.[215] A victory parade through the streets of the city duly marked the occasion, with Chapman Catt, Williams, and Taylor Upton riding in an open limousine sporting suffrage colors. Ohioans still were celebrating the following spring. In

May, after the final OWSA convention, a jubilant Taylor Upton enjoyed the honor of presiding over what was billed as the Joy Dinner.[216] There was much to celebrate, and to those in attendance, the fifth star shined the brightest that night.

Not One Home Ruined

In its 1920 election news coverage, the *Cincinnati Enquirer* reported, "Some women took their dogs along and mothers carried their babies to the polls and handed them over to an obliging policeman or a willing Girl Scout, while they disappeared into the booths to mark their ballots."[1] Apparently, women managed to balance domestic and childrearing duties with voting after all, and they did so with aplomb. The *Cincinnati Post's* front-page article attested to this fact, quipping, "Contrary to fears formerly expressed by anxious politicians, woman suffrage did not ruin one home Tuesday, or even spoil a meal."[2] Though social expectations regarding women's domestic duties may not have changed after the Susan B. Anthony amendment's ratification, that they could express their political will via the ballot was a remarkable change. The election of 1920, the first in which women in every state were legally eligible to cast ballots, was significant for another reason. In that election cycle, both leading presidential candidates, Warren G. Harding and James Cox, were Ohioans.[3] How special it must have been for Ohio women, in particular, to cast a vote in the presidential election that year!

Sadly, only 36 percent of eligible women turned out to the polls—far fewer than the 68 percent of men who did that year. According to political historian Brian Williams, "While women displayed a certain amount of independence in their voting behavior, they did not bring about a new political order nor significantly alter voting patterns."[4] Generations of opponents feared women would constitute a powerful voting bloc and that

male politicians would have to cater to their will, spending too much time and energy on so-called women's issues. Those fears were unsubstantiated. The first gender gap in a national election did not occur until 1980. Assumptions about women's voting behavior that had kept the ballot out of their hands for decades were, in the end, proven wrong.

The low turnout can be attributed to a variety of reasons, not least among them was the persistent belief that voting was an inappropriate behavior for women. Women voters received no encouragement, and political parties and presidential administrations did not welcome their participation.[5] That perception would change. Even anti-suffragist Florence Goff Schwarz conceded to Cincinnati's *Commercial Tribune*, "By reason of the fact that the 19th Amendment is now part and parcel of the laws of the land, it must be heeded by all former anti-suffragists. . . . They must all come out and register to vote."[6] With each passing election, the citizenry became more accustomed to seeing women vote. Yet, it would be 1984 before women recorded a higher turnout than men.[7]

The low participation rate was also attributable to the many barriers constructed to limit the votes of women and minorities—barriers such as literacy tests, residency requirements, poll taxes, intimidation, and state-sponsored violence. The Nineteenth Amendment did not guarantee women the right to vote, it only forbid states from passing laws that would deny them the ballot. Even after the ratification of the federal amendment, many women still could not vote. It would take another forty years for Native American women to win their rights. Asian American women waited until the 1962 Immigration and Nationality Act to secure their full span of rights. African American women, particularly those living in the South, waited until the 1965 Voting Rights Act for protection of their ballots.[8] It is important to remember that the Nineteenth Amendment was a significant, yet imperfect, milestone in the nation's history of voting rights.

The Movement Continues amid New Rivalries

The US women's movement obviously did not end with the ratification of the Nineteenth Amendment. Alice Paul, among others, did not believe the ballot would be sufficient to ensure that both men and women stood equal before the law. In 1921, the National Woman's Party (NWP) announced a campaign for the Equal Rights Amendment (ERA)—a campaign that con-

tinues to this day. Sometimes referred to as the Lucretia Mott amendment, its original text stated, "No political, civil, or legal disabilities or inequalities on account of sex or on account of marriage, unless applying equally to both sexes, shall exist within the United States or any territory subject to the jurisdiction thereof."[9] Senator Charles Curtis, a Native American and future vice president, and Representative Daniel R. Anthony, Susan B. Anthony's nephew, brought the ERA to the US Congress that year. Legislators chose not to vote.[10] The stall tactics were back in full force once again.

The National American Woman Suffrage Association (NAWSA) quickly transformed into the League of Women Voters (LWV), with an emphasis on voter education as well as legal, economic, and educational advancements for women. The last Ohio Women's Suffrage Association (OWSA) convention met in 1920, prior to ratification of the Susan B. Anthony amendment. The majority of the two hundred women present voted to reestablish themselves as the League of Women Voters of Ohio. One of the nation's first LWV chapters opened in Cleveland later that year, after the Cuyahoga County Women's Suffrage Party disbanded and turned over its roster of eighty thousand names to the new organization. Like most chapters, the Cleveland league was nonpartisan, and it became the first to poll candidates on issues and publish their position, a standard strategy LWV still employs today.[11]

As the women's movement transformed, Ohio women continued to provide leadership. Belle Sherwin (1869–1955) assumed the LWV presidency, and she helped register over forty thousand women voters for the 1920 election.[12] Sherwin was born in Cleveland to Francis Mary Smith and Henry Alden Sherwin, the founder of the Sherwin-Williams Company—a man who supported women's leadership positions within his business from its beginning.[13] Sherwin graduated Phi Beta Kappa from Wellesley College, studied history for one year at Oxford, and later received three honorary degrees. She taught school after graduation because she "burned to do something that was considered wicked."[14] Although more and more women joined the US labor force at this time, paid employment for society women such as Sherwin would have raised eyebrows. After her brief career teaching in Boston, Sherwin returned home to serve as the first president of the Consumers League of Ohio, a lobbying group concentrating on fair wages and safe working conditions for women. She was also a board member of a variety of other civic and philanthropic organizations.[15]

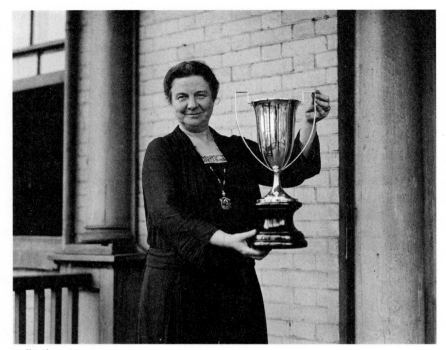

Belle Sherwin

Sherwin reluctantly joined the cause of women's enfranchisement because "her conscience would not allow her to receive suffrage as a gift."[16] After meeting Maud Wood Park in 1910, she joined the College Equal Suffrage League, and eventually she met national leaders such as Carrie Chapman Catt. During the 1912 suffrage campaign, she delivered soapbox speeches, bravely enduring heckling and insults. She was often spotted driving the family car all around Cleveland to cover the city in suffrage posters.[17] Earnest as she was on behalf of the cause, Sherwin always believed suffrage was a means to an end, not the end itself.[18]

Sherwin was well known for her excellent administrative skills, and she became a role model of executive leadership. She defined leadership as the "art of getting things done." In 1916, she joined other prominent women to cofound the Cleveland Women's City Club, which became an immediate success, boasting seventeen hundred members.[19] During World War I, she led the Ohio branch of the Woman's Committee of the Council of National Defense. Sherwin was also the vice president of the National Municipal League, a member of the General Advisory Council

of the American Association for Labor Legislation, and the vice president for North America of the Inter-American Union of Women. Her most important leadership position was as president of the National League of Women Voters, which she occupied for ten years, starting in 1924. Sherwin worked on behalf of legislation that ended child labor and provided a minimum wage for working-class women.[20] President Franklin Roosevelt later appointed her to the Consumer Advisory Board of the National Recovery Administration and to the Federal Advisory Council of the US Employment Service. Sherwin became active in the International Alliance of Women for Suffrage and Equal Citizenship, and she led the US delegations in 1926 and in 1929.[21] When she stepped down from the LWV presidency in 1934, newspapers described her as "Washington's wisest woman."[22] Sherwin returned to Cleveland, where she engaged with a variety of other civic issues. She died in 1955.[23]

Unsurprisingly, other Ohio women played key roles in nurturing the LWV. Born in Canton in 1878, Louisa Kimball Fast rose from her humble beginnings as an orphan to gain national and international recognition for women's rights activism. After graduating from Smith College, Kimball Fast dedicated herself to the rebuilding effort after World War I. In 1920, she met leaders such as Sherwin, Lucia Malcolm McBride, and Florence Allen, and she quickly joined the LWV to accept a position traveling across the state to form local chapters of the league. She was so successful that, in 1923, she moved to New York to work in the International Relations Branch, alongside leaders such as Chapman Catt. She played an instrumental role planning the 1935 International Alliance of Women for Suffrage and Equal Citizenship conference held in Istanbul. Kimball Fast then moved to Tiffin, Ohio, where she played a pivotal role in establishing a chapter of the American Association of University Women and a local LWV chapter. She died in 1979, a beloved member of the local community who became known as "the First Lady of Tiffin."[24]

The LWV and the NWP differed in terms of both goals and strategies. The LWV focused on a wider range of humanitarian and civic goals, spanning from child welfare to world peace. It strategically established and nurtured relationships with other women's groups, and it was more conservative in its approach. Most former OWSA members joined the LWV, especially those who took issue with the NWP's militancy. When the NWP lobbied the state Republican Party to include the ERA on its platforms in 1924 and 1928, OWSA president Harriet Taylor Upton rejected the plan.[25]

In contrast, the NWP was less interested in voting and civic duties than promoting the election of women candidates and challenging discriminatory laws. Its approach clearly was more feminist, and its strategies were more militant. The NWP did not reach out to network with other women's organizations except to coordinate the promotion of legislative measures. In Ohio, onetime members of the state Congressional Union for Woman Suffrage chapters, as well as career women, tended to join the NWP. As was the case in other states, the NWP chapters in Ohio were small, by design. The organization did not attempt to recruit new members simply to show strength in numbers; rather, the NWP limited its membership to those women truly committed to action. NWP membership in Ohio dropped from 472 in 1920 to 52 just two years later. Determined to rebuild the organization, Dr. Gillette Hayden, founder of the American Academy of Periodontology, reached out to the national office for assistance, and within a few years, membership had rebounded to over four hundred. Daytonian Helen Clegg Winters, chair of the Ohio NWP at the time, and Mary Davis Brite, NWP Cincinnati district chair, played an important part in gathering some of the earliest endorsements of the ERA.[26]

The Ohio NWP chapter was effective. As a case in point, it rallied behind Lucile Atcherson Curtis's appointment to diplomatic foreign service. Atcherson Curtis had been an active suffragist in Franklin County, and she was well known and respected in the area. With the help of the local NWP and the Columbus Women's Association of Commerce, she became the first American woman in the service, serving as a diplomat to Switzerland.[27] Anita Pollitzer, an officer in the national NWP office, emphasized, "In Ohio, perhaps more than any other state in the country, political leaders realize the need of giving women Equal Rights, which is the next step in their emancipation."[28]

Pollitzer was not exaggerating. The Ohio legislature passed six laws challenging discrimination against women in 1923 alone. After seventy years of stubbornly denying women's rights, the state legislature passed inheritance rights, guardianship rights, consent laws, child-support laws, and a law determining women's domicile for voting purposes all in one year. Unfortunately, after the initial volley, support for women's rights fell off in the state general assembly. Laws proposed to guarantee equal pay for equal work and prevent employment discrimination in public offices, as well as other measures designed to curtail legal restrictions on women's employment, all failed throughout the remainder of that decade.[29]

The momentum created by the passage of the Nineteenth Amendment was short lived, and defeats for women's rights resumed.

A significant philosophical difference between the LWV and the NWP emerged, undermining the ERA's success. The LWV supported protective legislation, whereas the NWP pursued full equality between men and women. Most members of the LWV believed women needed and deserved special protections ensured by the government, such as those related to workplace safety or financial support after divorce. The NWP stood against protectionist policies because they violated the ultimate goal of true equality before the law.[30] In this regard, the ERA did not have the full support of all women's rights activists. The YMCA, Women's Christian Temperance Union, and LWV all opposed the ERA, fearing the loss of protectionist policies they considered necessary for safeguarding women.[31] Once again, the women's movement found itself pulled in two different directions by rival national organizations. Fundamental differences resulted in unnecessary duplication of effort and waste of money and, ultimately, undercut the potential success of the women's movement as a whole. It would take until 1972 before the ERA made its way from the Congress to the states for ratification. The measure ultimately fell three states short of the thirty-eight required, even after an extension on the ratification deadline to 1982. In fact, five states voted to rescind their prior ratification by the end of the seventies. More recently, Nevada ratified the ERA in 2017, Illinois in 2018, and Virginia in 2020. Today, the ERA's status remains in limbo, both in the courts and in Congress.[32]

When Women Became Politicians

The position of women in politics changed after the ratification of the Nineteenth Amendment, not only in terms of their enfranchisement but also in their role as both elected and appointed political officers. Women were eager to become part of the political machinery at the local and state levels. Ohio women were among the first to seek office. On the day the Nineteenth Amendment passed, two Cleveland women—Anna Herbruck and Isabelle Alexander—both tossed their hats into the ring to run for city council. Both lost.[33] However, Florence Allen became the first woman elected to the common pleas court the same year, and she eventually became the first woman elected to the Ohio Supreme Court and appointed

to the federal bench.[34] Mary Grossman, an active suffragist, ran unsuccess-
fully for a municipal judge seat in 1921. Not one to give up easily, she ran
again two years later and became the first woman municipal judge in the
United States. She served on Cleveland's municipal court until she retired
at age eighty.[35] Within a year of the Nineteenth Amendment's ratification,
Dr. Amy Kauknen, of Fairport Harbor, Ohio, became Ohio's first female
mayor. In 1923, two women served in the Ohio Senate: Maude Com-
stock Waitt of Cuyahoga County and Netti Bromley Loughead of Hamil-
ton County; and four women served in the Ohio House: Nettie McKenzie
Clapp of Cuyahoga County, Lu Lu Thomas Gleason of Lucas County, Ade-
laide Sterling Ott of Mahoning County, and May Martin Van Wye of Ham-
ilton County.[36]

Virginia Darlington Green ran for the US Senate in 1922, the first
woman from Ohio to be so bold. She ran, though unsuccessfully, as an
independent, because she believed both Democrats and Republicans were
too power hungry. Afterward, the *Cincinnati Enquirer* quoted Darlington
Green, "My campaign was one of protest against the inordinate and ex-
cessive use of money in buying elections and a protest against the use
of political power."[37] Taylor Upton continued her political career by be-
coming the first female member of the Republican National Executive
Committee. At age seventy, she ran, though unsuccessfully, for the US
House of Representatives in 1926. She did not give up on politics after her
loss, serving as an assistant state campaign manager in 1928.[38] Without a
doubt, Ohio's earliest officeholding women created a new electoral visibil-
ity that directly benefits today's political hopefuls.

As was the case in most states, increasing the number of women
elected to office in Ohio was slow going. The momentum generated af-
ter women initially won the ballot came to a grinding halt as attentions
turned to surviving the Great Depression and World War II. Not until
many years later, in 1970, was a woman elected to a statewide office in
Ohio. Gertrude Walton Donahey became state treasurer that year. Nancy
Putnam Hollister became the state's first female lieutenant governor in
1994, and she served as the first woman governor of Ohio for eleven days
in 1998. In 2002, Jennette Bradley also served as lieutenant governor,
becoming the first African American woman in the nation to occupy that
position. Ann Davidson was the first woman elected Speaker of the Ohio
House of Representatives the following year. In 2011, Maureen O'Connor
became the first Ohio chief justice of the state supreme court. Despite

these impressive accomplishments, a hundred years after women won the ballot, Ohio still has only 31 percent female representation in the state government, making it twenty-fifth in the country on this measure.[39]

The Legacy of the Suffrage Movement

Perhaps one of the most important legacies of the Nineteenth Amendment, as historian Allison Sneider has argued, is that, ultimately, "adding political rights for women to the list of markers symboliz[es] the achievement of 'civilization' on a global stage. In the negotiation of global power relations across the twentieth century and into the present, political rights for women continue to function as a marker of success for experiments in expanding democracy."[40] Yet, women's rights are threatened around the globe and their opportunities to provide political leadership remain limited. According to the World Economic Forum's research, only 22 percent of the political power gender gap had closed by 2022. Across the 146 countries examined in this research, women held only 26.1 percent of parliamentary seats. According to UNWomen, only twenty-eight countries had a woman head of state or head of government in 2022.[41] The World Economic Forum estimated it will take 132 years to achieve gender parity in politics.[42] The rate of progress for women's rights was much too slow during the suffrage movement, and it remains too slow today.

Ohio suffragists' fight for the ballot first began at the 1850 state constitutional convention. For seventy years, they lost at the polls. They lost in the state legislature. They lost in the courts. They were not alone in these defeats. Suffrage campaigns in most states lost, but they were not failures. By the time the federal amendment was ratified in 1920, thirty different states had considered a total of 854 ballot measures.[43] Just fifteen states took the action necessary to enfranchise their wives, daughters, sisters, and mothers. It would be too easy to lay blame at the feet of anti-suffrage women or those women too apathetic or incapable of recognizing their own oppression. Male voters, legislators, and judges, however, had multiple opportunities to bring to bear the full promise of democracy, yet they chose not to do so. Refusing to consider reasonable, logical arguments or those grounded in the nation's core values, caving in to special interest groups such as the liquor lobby, and succumbing to sexism all point to the fact that the failure was theirs, not the nation's

women. While many men in every state fought valiantly for women's enfranchisement—and those men serve as important role models for today's pro-feminist men—the fact remains that most men unrelentingly used their power to deny women the most basic expression of citizenship over the course of decades.

The gendered nature of politics most certainly degraded US democracy during the suffrage movement, and—despite progress in creating more equitable opportunities for women's political leadership—it still does today. The United States saw the election of its first woman vice president, Kamala Harris, in 2021. However, female candidates continue to face a wide array of obstacles ranging from misogynistic social media attacks to sexist double standards related to "likeability" and the gender gap in campaign fundraising. Ironically, as the nation did its best to honor the hundredth anniversary of the Nineteenth Amendment during the global COVID-19 pandemic, stark gender inequities in relation to employment, domestic and child-rearing labor, pay equity, and other issues became all the more painfully apparent.[44] The unfinished work of the women's rights movement calls on each citizen to address these issues, for the sake of women and for the sake of the nation.

While 2020 marked the centennial of the Nineteenth Amendment, it was also an election year and a scheduled national census. False claims about widespread voter fraud, conspiracy theories purporting that the presidential election was stolen, and the shameful January 6 attack on the US Capitol represent the most serious threats to American democracy since the Civil War. Furthermore, inconsistencies in the 2020 national census and rampant gerrymandering reveal an effort to disenfranchise voters.[45] Unprecedented voter suppression threatens the strength of US democracy. Between the 2020 and 2022 elections, nineteen states passed thirty laws restricting voter rights.[46] Current voter suppression efforts include onerous voter identification laws, reduced early voting, limited polling place hours, and purging voter rolls. These tactics often disproportionately target specific groups such as people of color, people with disabilities, low-income Americans, the elderly, and students. More recent congressional attempts to protect voting rights have made little headway. As of 2022, the John Lewis Voting Rights Advancement Act has passed the House, but it failed in the Senate twice, and the Freedom to Vote Act also stalled.

Like many other states, voting rights in Ohio have generated controversy. In 2015, with the goal of increased fairness in the electoral system,

Ohio citizens overwhelmingly supported a constitutional amendment to create an independent Ohio Redistricting Commission. Unfortunately, the commission approved redistricting maps so gerrymandered that the state supreme court ruled them unconstitutional—not once, not twice, but five times. Stall techniques once again prevailed; Ohio citizens were still waiting fair legislative maps even after the 2022 primaries concluded.[47] Moreover, state legislators proposed bills that same year that would permit Ohioans to cast ballots only if they have photo identification cards, prohibit placing ballot drop boxes anywhere but at board of election offices, eliminate one day of early voting, and limit the time for requesting mail-in ballots.[48]

Neither the Nineteenth Amendment nor the voting rights acts of the 1960s were triumphant ends; rather, they were mileposts in the history of American democracy. Numerous civic organizations across the nation, including the LWV, are taking a stand against voter suppression and gerrymandering, and in so doing, they honor the legacy of all voting rights campaigns, including those of the women's suffrage movement. Contemporary Ohioans devoted to the protection of voting rights can draw inspiration from those who preceded them. If we listen closely enough, we can hear the voices of Ohio's suffragists echoing across the decades, reminding women they must stake their claim to political power and to do so with persistence, using the fifth star as their guiding light.

Notes

Introduction

1. "The Memorial of the Ladies of Steubenville, Ohio Against the Forcible Removal of the Indians without Limits of the United States," H.R. Rep. 209, 21st Cong., 1st Sess., Rep. No. 209 (1830).

2. Mary Hershberger, "Mobilizing Women, Anticipating Abolition: The Struggle against Indian Removal in the 1830s," *Journal of American History* 86, no. 3 (1999): 25–26.

3. Amy Dunham Strand, *Language, Gender, and Citizenship in American Literature, 1789–1919* (New York: Routledge, 2009), 45.

4. Strand, *Language, Gender, and Citizenship in American Literature*, 45–46.

5. Strand, *Language, Gender, and Citizenship in American Literature*.

6. For a detailed discussion of the gendered nature of early Indian removal and antislavery petitioning, see Alisse Portnoy, *Their Right to Speak: Women's Activism in the Indian and Slave Debates* (Cambridge, MA: Harvard Univ. Press, 2009).

7. Strand, *Language, Gender, and Citizenship in American Literature*, 50; "'Congress Took No Further Action': Women and the Right to Petition," *Whereas: Stories from the People's House, History, Art, and Archives US House of Representatives* (blog), June 5, 2017, https://history.house.gov/Blog/2017/June/06_05_2017/; Robert V. Hine and John Mack Faragher, *The American West, a New Interpretive History* (New Haven: Yale Univ. Press, 2000), 176.

8. Brenda Stalcup, *Women's Suffrage* (San Diego, CA: Greenhaven Press, 2000), 61–62.

9. Hershberger, "Mobilizing Women," 35–40.

10. Jean Fagan Yellin and John C. Van Horne, *The Abolitionist Sisterhood: Women's Political Culture in Antebellum America* (Ithaca, NY: Cornell Univ. Press, 1944), 183n10.

11. For a discussion of Ohio's Black Codes, see Steven Middleton, *The Black Laws: Race and the Legal Process in Early Ohio* (Athens: Ohio Univ. Press, 2005).

12. For studies of the role of race in the women's movement, see, for example, Lisa Tetrault, *The Myth of Seneca Falls: Memory and the Women's Suffrage*

Movement, 1848–1898 (Chapel Hill: Univ. of North Carolina Press, 2014); Martha S. Jones, *Vanguard: How Black Women Broke Barriers, Won the Vote, and Insisted on Equality for All* (New York: Basic Books, 2020); Louise Michele Newman, *White Women's Rights: The Racial Origins of Feminism in the United States* (New York: Oxford Univ. Press, 1999).

13. Kathryn Kish Sklar, *Women's Rights Emerges within the Antislavery Movement 1830–1870: A Brief History with Documents* (Boston: Bedford/St. Martin's, 2019); Yellin and Van Horne, *Abolitionist Sisterhood*.

14. Greta Anderson, *More Than Petticoats: Remarkable Ohio Women* (Guilford, CT: Globe Pequot Press, 2005), 22.

15. Genevieve G. McBride, *On Wisconsin Women: Working for Their Rights from Settlement to Suffrage* (Madison: Univ. of Wisconsin Press, 1993), 61.

16. Jeffry P. Brown and Andrew R. Cayton, *The Pursuit of Public Power: Political Culture in Ohio, 1787–1861* (Kent, OH: Kent State Univ. Press, 1994), 136.

17. Nancy Isenberg, *Sex and Citizenship in Antebellum America* (Chapel Hill: Univ. of North Carolina Press, 1998), 154.

18. For a biography of Frances Wright, see Celia Morris, *Frances Wright: Rebel in America* (Cambridge, MA: Harvard Univ. Press, 1984); Susan Snowden McLeod, "The 'Red Harlot of Infidelity': The Life and Works of Frances Wright" (master's thesis, Texas Woman's University, 2000).

19. Jacqueline Smith, "Frances Wright: Unsung Heroine of the Suffrage Movement," *New York Historical Society Museum and Library History Detectives,* Mar. 19, 2014, https://www.nyhistory.org/blogs/frances-wright-unsung-heroine -of-the-suffrage-movement. For a discussion of Frances Wright's contributions to early feminism, see Molly Abel Travis, "Frances Wright: The Other Woman of Early American Feminism," *Women's Studies* 22, no. 3 (1993): 389–97; Kathleen Edgerton Kendall and Jeanne Y. Fisher, "Frances Wright on Women's Rights: Eloquence versus Ethos," *Quarterly Journal of Speech* 60, no. 1 (1974): 58–68.

20. Summary page, Weld-Grimké Family Papers, Clements Library, University of Michigan, Ann Arbor, available at https://quod.lib.umich.edu/c/clementsead/ umich-wcl-M-400wel?byte=31607593;focusrgn=bioghist;subview=standard;view= reslist.

21. For a detailed discussion of the role the Grimkés made in the women's and abolitionist movements, see Carol Berkin, *Civil War Wives: The Lives and Times of Angelina Grimké Weld, Varina Howell Davis, and Julia Dent Grant* (New York: Vintage, 2010); Stephen H. Browne, *Angelina Grimké: Rhetoric, Identity, and the Radical Imagination* (East Lansing: Michigan State Univ. Press, 1999); Debra Michals, "Angelina Grimké Weld," National Women's History Museum website, 2015, https:// www.womenshistory.org/education-resources/biographies/angelina-grimke-weld.

22. David M. Gold, "Natural Rights and the Admission of Women to the Ohio Bar," *Ohio History Journal* 110 (Summer–Autumn 2001): 171.

23. "A Noble Woman—Mrs. Sarah G. Haines Passes to Her Reward," *Alliance (OH) Daily Review,* Mar. 8, 1903.

24. For a detailed discussion of Lucy Stone's contribution to women's rights activism, see Alice S. Blackwell, *Lucy Stone: Pioneer of Woman's Rights* (Whitefish, MT: Literary Licensing, 2014); Sally Gregory McMillen, *Lucy Stone: An Unapologetic Life* (Oxford: Oxford Univ. Press, 2015); Debra Michals, "Lucy Stone," National Women's History Museum website, 2017, https://www.womenshistory.org/education-resources/biographies/lucy-stone; Wendy Hamand Vent, *Neither Ballots nor Bullets: Women Abolitionists and the Civil War* (Charlottesville: Univ. of Virginia Press, 1991), 4.

25. Brown and Cayton, *The Pursuit of Public Power,* viii, 117.

26. For a discussion of perspectives on race in Ohio during Reconstruction, see Robert D. Sawrey, *Dubious Victor: The Reconstruction Debate in Ohio* (Lexington: Univ. Press of Kentucky, 2015).

27. For a discussion of how Ohio was perceived geographically, see Carrie B. Zimmerman, *Ohio: The Gateway of the West* (Columbus: F. J. Heer Printing, 1931).

28. Allen G. Noble, "Landscapes and People," in *The American Midwest: An Interpretive Encyclopedia,* ed. Andrew R. Cayton, Chris Zacher, and Richard Sisson (Bloomington: Indiana Univ. Press, 2006), 1556.

29. For a discussion of perspectives on immigration in Ohio in the 1800s, see Brown and Cayton, *Pursuit of Public Power,* ix; Andrew R. L. Cayton and Stuart D. Hobbs, eds., *The Center of a Great Empire: The Ohio Country in the Early American Republic* (Athens: Ohio Univ. Press, 2005).

30. Marjorie Spruill Wheeler, *One Woman, One Vote: Rediscovering the Woman Suffrage Movement* (Troutdale, OR: New Sage Press, 1995), 62.

31. Kayla Metzger on behalf of Ohio History Service Corps and Program Manager Ohio History Service Corps, "Lake Erie College," *Clio: Your Guide to History,* May 15, 2020, https://www.theclio.com/tour/1621/2.

32. "Caroline Mccullough Everhard Scrapbook 1890–1891," 2, Caroline Mccullough Everhard Papers Collection of the Massillon Museum (BC 2154.1), Massillon, OH.

33. Sawrey, *Dubious Victor,* n.p.

34. Ellen C. DuBois, *Harriot Stanton Blatch and the Winning of Woman Suffrage* (New Haven: Yale Univ. Press, 1999), 89.

35. "Factory Inspection Legislation," US Department of Labor website, accessed July 20, 2022, https://Www.Dol.Gov/General/Aboutdol/History/Mono-Regsafepart02.

36. "Women in the Industrial Workforce," *Ohio History Central,* Ohio History Connection website, accessed July 20, 2022, https://ohiohistorycentral.org/w/Women_in_the_Industrial_Workforce.

37. Eric Foner, *Free Soil, Free Labor, Free Men: The Ideology of the Republican Party Before the Civil War* (New York: Oxford Univ. Press, 1995), 147.

38. Kenneth J. Winkle, "A Social Analysis of Voter Turnout in Ohio, 1850–1860," *Journal of Interdisciplinary History* 13, no. 3 (1983): 421.

39. Corinne McConnaughy, *The Woman Suffrage Movement in America* (Cambridge: Cambridge Univ. Press, 2013), 249.

40. Though many of the men and women described in this book did not use the term *feminist* to describe themselves, the word is used here to indicate any person who believes in the principle of human equality among people of different genders and who challenges patriarchy.

41. For a discussion of racism within the first US women's movement, see, for example, Anne Myra Benjamin, *Women against Equality: A History of the Anti-Suffrage Movement from 1895–1920* (Morrisville, NC: Lulu, 2014); Faye E. Dudden, *Fighting Chance: The Struggle over Woman Suffrage and Black Suffrage in Reconstruction America* (Oxford: Oxford Univ. Press, 2014).

42. For a discussion of legal restrictions facing women in the 1800s, see Linda K. Kerber, *No Constitutional Right to Be Ladies: Women and the Obligations of Citizenship* (New York: Hill & Wang, 1998).

43. Tom Rosenstiel, "Reluctant Suffragettes: When Women Questioned Their Right to Vote," Pew Research website, Mar. 18, 2009, https://www.pew research.org/2009/03/18/reluctant-suffragettes-when-women-questioned-their-right-to-vote/.

44. Isenberg, *Sex and Citizenship in Antebellum America*, xiii.

45. Ellen DuBois, "The Radicalism of the Woman Suffrage Movement: Notes toward the Reconstruction of Nineteenth-Century Feminism," *Feminist Studies* 3 (Autumn 1975): 63–71.

46. Stuart John Galloway, "The American Equal Rights Association, 1866–1870: Gender, Race, and Universal Suffrage" (master's thesis, University of Leicester, 2014), 47.

47. Cheris Kramarae and Ann Russo, *The Radical Women's Press of the 1850s* (New York: Routledge, 1991), 195.

48. Susan Zaeske, "The 'Promiscuous Audience' Controversy and the Emergence of the Early Woman's Rights Movement," *Quarterly Journal of Speech* 81, no. 2 (1995): 191.

49. Not all US clergy sought to silence women. For example, Reverend Charles Grandison Finney, a Presbyterian and Congregationalist minister during the Second Great Awakening (1790–1840s), allowed women to pray aloud in gatherings of men and women.

50. Beth Salerno, *Sister Societies: Women's Antislavery Organizations in Antebellum America* (DeKalb: Northern Illinois Univ. Press, 2008), 144–45.

51. "Chapter VI: Ohio," in *The History of Woman Suffrage:* vol. 1 of 6, *1848–1861*, ed. Elizabeth Cady Stanton, Susan B. Anthony, and Matilda Joslyn Gage (New York: Fowler & Wells, 1889), 119.

52. "Records of the Past, Justice to Ohio," *Woman's Journal*, Oct. 15, 1870.

53. Emilius Oviatt Randall and Daniel Joseph Ryan, *History of Ohio: The Rise and Progress of an American State* (Madison, WI: Century History Company, 1912), 329.

54. Harriet Taylor Upton, "The Woman Suffrage Movement in Ohio," in *History of Ohio*, ed. Charles Burleigh Galbreath, 5 vols. (Washington, DC: American Historical Society, 1925), 2:329.

55. Richard L. Dana, "Northeast Ohio: The Birthplace for Women's Suffrage?," ed. Mia Owens, July 17, 2020, https://static1.squarespace.com/static/5b3538b3f93 fd4a174517d5c/t/60368210f992362cc9d97156/1614184976778/Richard+Dana+ -+Womens+Suffrage+in+Northeast+Ohio%5B1%5D.pdf.

56. For histories of the Seneca Falls convention, see Deborah Kent, *The Seneca Falls Convention: Working to Expand Women's Rights* (New York: Enslow Publishing, 2017); Sally G. McMillen, *Seneca Falls and the Origins of the Women's Rights Movement* (New York: Oxford Univ. Press, 2008); Tetrault, *Myth of Seneca Falls;* Judith Wellman, *The Road to Seneca Falls: Elizabeth Cady Stanton and the First Woman's Rights* Convention (Urbana: Univ. of Illinois Press, 2004).

57. Tetrault, *Myth of Seneca Falls.*

58. For example, see claims by Steven M. Buechler in *The Transformation of the Woman Suffrage Movement: The Case of Illinois, 1850–1920* (New Brunswick, NJ: Rutgers Univ. Press, 1986), 21; Salerno, *Sister Societies*, 144–45.

59. Isenberg, *Sex and Citizenship in Antebellum America,* ix.

60. Sara Egge, *Woman Suffrage and Citizenship in the Midwest 1870–1920* (Iowa City: Univ. of Iowa Press, 2018), 5.

61. Elaine Weiss, *The Woman's Hour: The Great Fight to Win the Vote* (New York: Penguin, 2019), xvii.

62. McConnaughy, *Woman Suffrage Movement in America,* 2–3.

63. McConnaughy, *Woman Suffrage Movement in America,* 3.

64. Carrie Chapman Catt and Nettie Rogers Shuler, *Woman's Suffrage and Politics: The Inner Story of the Suffrage Movement* (New York: C. Scribner & Sons, 1923), 107.

65. "Chapter XXXIV: Ohio," in *The History of Woman Suffrage:* vol. 6 of 6, *1900–1920,* ed. Ida Husted Harper (New York: National American Woman Suffrage Association, 1922), 508.

66. "Chapter IX: National American Convention 1909," in *The History of Woman Suffrage,* vol. 5 of 6, *1900–1920,* ed. Ida Husted Harper (New York: National American Woman Suffrage Association, 1922), 252.

1. Ohio on the Vanguard of Women's Rights

1. "A Jaw Cracker for a Cold Morning," *Ohio Democrat and Dover Advertiser,* Feb. 7, 1840.

2. Ellen Carol DuBois, *Feminism and Suffrage: The Emergence of an Independent Woman's Movement in America, 1848–1869* (Ithaca, NY: Cornell Univ. Press, 1978), 21.

3. Nancy Isenberg, *Sex and Citizenship in Antebellum America* (Chapel Hill: Univ. of North Carolina Press, 1998), 20.

4. The term *feminist consciousness-raising* refers here to the practice of using personal stories of lived experiences to reveal and illustrate systemic sexism; it is an activist tool used to raise awareness and increase understanding of social injustices related to gender.

5. Stacey M. Robertson, *Betsy Mix Cowles: Champion of Equality* (New York: Taylor & Francis, 2018), 89.

6. Linda Geary, *Balanced in the Wind: A Biography of Betsey Mix Cowles* (Lewisburg, PA: Bucknell Univ. Press, 1989), 50–59, 69–72; Keith E. Melder, "Betsey Mix Cowles," in *Notable American Women, 1607–1950: A Biographical Dictionary*, ed. Edward T. James, Janet Wilson James, and Paul S. Boyer, 3 vols. (Cambridge, MA: Belknap Press of Harvard Univ. Press, 1971), 1:393.

7. "Betsy M. Cowles," *Ohio History Central*, Ohio History Connection, accessed July 20, 2022, https://ohiohistorycentral.org/w/Betsy_M._Cowles; Geary, *Balanced in the Wind*, 69.

8. Jacqueline Jones Royster, *Profiles of Ohio Women: 1803–2003* (Athens: Ohio Univ. Press, 2003), 182.

9. Betsy Mix Cowles to Sister, Aug. 11, 1839, box 1, Betsy Mix Cowles Papers, Special Collections and Archives, Kent State University, Kent, OH, available at the Ohio Memory Collection website, https://ohiomemory.org/digital/collection/p267401coll136/id/2385/rec/7.

10. Robertson, *Betsy Mix Cowles*.

11. "Ohio Women's Rights Association," *Ohio History Central*, Ohio History Connection, accessed July 20, 2022, https://ohiohistorycentral.org/w/Ohio_Women%27s_Rights_Association.

12. Abby Kelley to Stephen Symonds Foster, Feb. 5, 1845, Abby Foster Papers, Quaker & Special Collections, HC.MC-1139, Haverford College Libraries, Haverford, PA.

13. Keith E. Melder, "Jane Elizabeth Hitchock Jones," in James, James, and Boyer, *Notable American Women*, 2:285–86.

14. "Convention of Women," *Anti-Slavery Bugle* (Salem, OH), Mar. 30, 1850.

15. "Forming the Movement," in *Women's Suffrage*, ed. Brenda Stalcup (San Diego, CA: Greenhaven, 2000), 77.

16. "A Brief History of the Women's Suffrage Movement," in Stalcup, *Woman's Suffrage*, 17.

17. Diane Van Skiver Gagel, "Ohio Women Unite: The Salem Convention of 1850," in *Women in Ohio History*, ed. Marta Whitlock (Columbus: Published for the Ohio American Revolution Bicentennial Advisory Commission by the Ohio Historical Society, 1976), 5.

18. Betsey Cowles, *The Salem, Ohio 1850 Women's Rights Convention Proceedings* (Salem, OH: Salem Area Bicentennial Committee, 1976), 52; Jane Elizabeth Jones, "The Wrongs of Woman: An Address," *Anti-Slavery Bugle* (Salem, OH), May 4, 1850.

19. "Ohio Women's Convention Minutes," *Anti-Slavery Bugle* (Salem, OH), Apr. 27, 1850; James Parton, *Eminent Women of the Age: Being Narratives of the Lives and Deeds of the Most Prominent Women of the Present Generation* (Hartford, CT: S. M. Betts, 1868), 387.

20. Cowles, *Salem, Ohio 1850 Women's Rights Convention Proceedings*, 42–43, 35, 37–39.

21. Cowles, *Salem, Ohio 1850 Women's Rights Convention Proceedings*, 23, 24–25.

22. "Memorial," *Anti-Slavery Bugle* (Salem, OH), Apr. 27, 1850.

23. Cowles, *Salem, Ohio 1850 Women's Rights Convention Proceedings*, 26–28.

24. Gagel, "Ohio Women Unite," 6.

25. "Chapter VI: Ohio," in *The History of Woman Suffrage:* vol. 1 of 6, *1848–1861*, ed. Elizabeth Cady Stanton, Susan B. Anthony, and Matilda Joslyn Gage (New York: Fowler & Wells, 1889), 110.

26. Florence E. Allen and Mary Welles, *The Ohio Woman Suffrage Movement: "A Certain Unalienable Right": What Ohio Women Did to Secure It* (N.p.: Committee for the Preservation of Ohio Woman Suffrage Records, 1952), 14; Robertson, *Betsy Mix Cowles*, 98.

27. Nettie Rogers Shuler and Carrie Chapman Catt, *Woman Suffrage and Politics: The Inner Story of the Suffrage Movement* (New York: C. Scribner's Sons, 1923), 78; Michael Kassell, "Wyoming First to Grant Women Right to Vote but It Almost Didn't Happen," *Wyoming Eagle*, Nov. 10, 2019.

28. "The Rights of Women," *Anti-Slavery Bugle* (Salem, OH), May 11, 1850.

29. Allen and Welles, *Ohio Woman Suffrage Movement*, 15.

30. "The Wrongs of Woman," *Anti-Slavery Bugle* (Salem, OH), Apr. 27, 1850; Gagel, "Ohio Women Unite," 6.

31. "Letter from Parker Pillsbury," *Anti-Slavery Bugle* (Salem, OH), Nov. 16, 1850.

32. Isenberg, *Sex and Citizenship in Antebellum America*, 15.

33. Barbara A. Terzian, "Frances Dana Gage and Northern Women's Reform Activities in the Nineteenth Century," in *Builders of Ohio: A Biographical History*, ed. Michael Cain Pierce, Michael Dale Pierce, Warren Van Tine (Columbus: Ohio State Univ. Press, 2003), 110; Carol Steinhagen, "The Two Lives of Frances Dana Gage," *Ohio History Journal* 107 (Winter–Spring 1988): 23.

34. For a detailed discussion of Gage's position on gender roles, see Carol Steinhagen, "The Two Lives of Frances Dana Gage," *Ohio History Journal* 107 (Winter–Spring 1988): 22–38.

35. Cowles, *Salem, Ohio 1850 Women's Rights Convention Proceedings*, 41.

36. Linus Pierpont Brockett and Mary C. Vaughan, *Woman's Work in the Civil War: A Record of Heroism, Patriotism and Patience* (Boston: Zeigler McCurdy & Company, 1867), 683–90.

37. Dorothy May Emerson, *Standing Before Us: Unitarian Universalist Women and Social Reform, 1776–1936* (Boston: Skinner House Books, 2000), 40.

38. Brockett and Vaughan, *Woman's Work in the Civil War*, 683–90.

39. "Chapter VI: Ohio," 117.

40. Terzian, "Frances Dana Gage and Northern Women's Reform Activities," 114.

41. Barbara A. Terzian, "Ohio's Constitutions: An Historical Perspective," *Cleveland State Law Review* 51 (2004): 373.

42. "Chapter VI: Ohio," 117–18.

43. Allen and Welles, *Ohio Woman Suffrage Movement*, 17.

44. Steinhagen, "Two Lives of Frances Dana Gage," 27.

45. Isenberg, *Sex and Citizenship in Antebellum America*, 15–17.

46. Cowles, *Salem, Ohio 1850 Women's Rights Convention Proceedings*, 35.

47. David Carl Shilling, "Women's Suffrage in the Constitutional Convention of Ohio," *Ohio History* 25 (1916): 168–70.

48. "'Honest Independence': The Life of Norton Strange Townshend," *Abolition and Politics,* William L. Clements Library, University of Michigan, Ann Arbor, accessed July 20, 2022, https://clements.umich.edu/exhibit/townshend/.

49. Lisa Tetrault, "Winning the Vote," *Humanities: The Magazine of the National Endowment of the Humanities* 40 (Summer 2019), https://www.neh.gov/article/winning-vote-divided-movement-brought-about-nineteenth-amendment.

50. David M. Gold, "Natural Rights and the Admission of Women to the Ohio Bar," *Ohio History Journal* 110 (Summer–Autumn 2001): 177.

51. DuBois, *Feminism and Suffrage,* 44–47.

52. "Chapter VI: Ohio," 122.

53. Sarah Miller Little, "A Woman of Property: From Being It to Controlling It—A Bicentennial Perspective on Women and Ohio Property Law, 1803–2003," *Hastings Women's Law Journal* 16 (2005): 190.

54. "Chapter VI: Ohio," 118.

55. "Cutler, Hannah Maria Tracy," *Appleton's Cyclopædia of American Biography* (United States: D. Appleton, 1887), 46; Doris Weatherford, *Victory for the Vote: The Fight for Women's Suffrage and the Century That Followed* (Coral Gables, FL: Mango Publishing, 2020), 59.

56. Elizabeth Warbasse, "Cutler, Hannah Maria Conant Tracy," in James, James, and Boyer, *Notable American Women,* 1:427–29.

57. Hannah Tracy Cutler to Lucy Stone, Oct. 26, 1846, reel 6:327–29, National American Woman Suffrage Association Records, Library of Congress.

58. "Appendix—Chapter IX," in Stanton, Anthony, and Gage, *History of Woman Suffrage,* 1:853–54.

59. Little, "Woman of Property," 188.

60. *The Proceedings of the Woman's Rights Convention, Held at Akron, Ohio, May 28 and 29, 1851* (Cincinnati: Ben Franklin Book & Job Office, 1851).

61. Terzian, "Frances Dana Gage and Northern Women's Reform Activities," 114.

62. "Chapter VI: Ohio," 112.

63. "Chapter VI: Ohio," 113.

64. *The Proceedings of the Woman's Rights Convention, Held at Akron, Ohio, May 28 and 29, 1851,* 8–10, 31–32.

65. Winifred Conkling, *Votes for Women! American Suffragists and the Battle for the Ballot* (Chapel Hill, NC: Algonquin Young Readers, 2018), 49.

66. Michael Phillips-Anderson, "Sojourner Truth, 'Address at the Woman's Rights Convention in Akron, Ohio,'" *Voices of Democracy* 7 (2012): 21.

67. Terzian, "Frances Dana Gage and Northern Women's Reform Activities," 114.

68. Leslie Podell, "Compare the Two Speeches," *The Sojourner Truth Project,* accessed July 20, 2022, https://www.thesojournertruthproject.com/compare-the-speeches.

69. "Chapter VI: Ohio," 116.

70. Lucy Stone, "Sojourner Truth," *Woman's Journal,* Aug. 1876; "Appendix—Chapter XVIII," 928.

71. Phillips-Anderson, "Sojourner Truth," 34; Nell Irvin Painter, *Sojourner Truth: A Life, a Symbol* (New York: W. W. Norton, 1996).

72. Weatherford, *Victory for the Vote*, 54; *The Proceedings of the Woman's Rights Convention Held at Worcester, October 23 & 24* (Boston: Prentiss & Sawyer, 1851).

73. "Chapter XIV: New York," in Stanton, Anthony, and Gage, *History of Woman Suffrage*, 1:530.

74. "Second National Women's Rights Convention," *Worcester Women's History Project Newsletter* 2 (Fall 2001), https://www.wwhp.org/News/Newsletters/01fall.html.

75. Sally G. McMillen, *Lucy Stone: An Unapologetic Life* (Oxford: Oxford Univ. Press, 2015), 117.

76. "Chapter XIV: New York," 540–42.

77. McMillen, *Lucy Stone*, 113.

78. "Appendix—Chapter VI," in Stanton, Anthony, and Gage, "*History of Woman Suffrage*, 1:817.

79. "Appendix—Chapter VI," 817

80. Allen and Welles, *Ohio Woman Suffrage Movement*, 17.

81. "Chapter VI: Ohio," 123.

82. Sylvia D. Hoffert, *When Hens Crow: The Woman's Rights Movement in Antebellum America* (Bloomington: Indiana Univ. Press, 1995), 109.

83. Jack S. Blocker, "Separate Paths: Suffragists and the Women's Temperance Crusade," *Signs* 10, no. 10 (1985): 462.

84. Stephane Elise Booth, *Buckeye Women: The History of Ohio's Daughters* (Athens: Ohio Univ. Press, 2001), 97.

85. "Chapter VI: Ohio," 119.

86. Sara Egge, *Woman Suffrage and Citizenship in the Midwest 1870–1920* (Iowa City: Univ. of Iowa Press, 2018), 70.

87. For a discussion of Ohio's antislavery activism, see Damian Alan Pargas, *Fugitive Slaves and Spaces of Freedom in North America* (Gainesville: Univ. Press of Florida, 2018); "Ohio Anti-Slavery Society," *Ohio History Central*, Ohio History Connection, accessed July 20, 2022, https://ohiohistorycentral.org/w/Ohio_Anti-Slavery_Society.

88. Wendy Hamand Vent, *Neither Ballots nor Bullets: Women Abolitionists and the Civil War* (Charlottesville: Univ. of Virginia Press, 1991), 14.

89. Steven M. Buechler, *The Transformation of the Woman Suffrage Movement: The Case of Illinois, 1850–1920* (New Brunswick, NJ: Rutgers Univ. Press, 1986), 63.

90. Leslie LaVonne, *The History of the National Association of Colored Women's Clubs, Inc.: A Legacy of Service* (Bloomington, IN: Xlibris, 2012); "About NACWC," National Association of Colored Women website, 2019, https://www.nacwc.com/.

91. Egge, *Woman Suffrage and Citizenship in the Midwest*, 70.

92. Caroline M. Seymour Severance and Ella Giles Ruddy, *The Mother of Clubs: Caroline M. Seymour Severance: An Estimate and an Appreciation* (Los Angeles: Baumgardt Publishers, 1906).

93. Diana Tittle, "Significant Others: The Defining Domestic Life of Caroline Seymour Severance," *California History* 88, no. 1 (2010): 30.

94. For further biographical information about Caroline Severance, see Virginia Elwood-Akers, *Caroline Severance* (New York: iUniverse, 2010); Mary S. Gibson, *Caroline M. Severance, Pioneer* (Los Angeles: Friday Morning Club, 1925).

95. Isenberg, *Sex and Citizenship in Antebellum America*, 185.

96. Weatherford, *Victory for the Vote*, 137.

97. Celeste DeRoche, "Caroline Severance," *Dictionary of Unitarian and Universalist Biography*, accessed July 20, 2022, https://uudb.org/articles/caroline severance.html.

98. Weatherford, *Victory for the Vote*, 157.

99. *Annals of Cleveland* (Cleveland: Cleveland W. P. A. Project, 1937), 155–56; "Ohio Women's Rights Association."

100. Hoffert, *When Hens Crow*, 109.

101. Mara Ann Pinto Oess, *An Index to the National Citizen and Ballot Box* (Toledo, OH: Toledo-Lucas County Public Library, 1976), 1–4.

102. "Chapter VI: Ohio," 122.

103. Weatherford, *Victory for the Vote*, 75.

104. For a detailed discussion of media coverage of the women's suffrage movement, see Linda Steiner, Carolyn Kitch, and Brooke Kroeger, eds., *Front Pages, Front Lines: Media and the Fight for Women's Suffrage* (Urbana: Univ. of Illinois Press, 2020); Katherine Durack, "Strong-Minded She-Rowdies," Feb. 28, 2020, episode 19 of *The Genius of Liberty Podcast*, Mercantile Library, 5:50 minutes, https://mercantilelibrary.com/geniusofliberty/.

105. *Proceedings of the National Women's Rights Convention Held at Cleveland, Ohio, on Wednesday, Thursday, and Friday, October 5th, 6th, and 7th, 1853* (Cleveland: Gray, Beardsley Spear, & Company, 1854).

106. "Chapter VI: Ohio," 1:132.

107. *Proceedings of the National Woman's Rights Convention Held at Cleveland, Ohio, on Wednesday, Thursday, and Friday, October 5th, 6th, and 7th, 1853*, 95–97.

108. *Proceedings of the National Woman's Rights Convention Held at Cleveland, Ohio, on Wednesday, Thursday, and Friday, October 5th, 6th, and 7th, 1853*, 129.

109. *Proceedings of the National Woman's Rights Convention Held at Cleveland, Ohio, on Wednesday, Thursday, and Friday, October 5th, 6th, and 7th, 1853*, 24–32.

110. Durack, "Strong-Minded She-Rowdies."

111. Allen and Welles, *Ohio Woman Suffrage Movement*, 20.

112. Hoffert, *When Hens Crow*, 110.

113. "Chapter X: Pennsylvania," in Stanton, Anthony, and Gage, *History of Woman Suffrage*, 1:380.

114. Gold, "Natural Rights and the Admission of Women to the Ohio Bar," 178.

115. Caroline M. Severance, "Memorial of Mrs. Caroline M. Severance, of Cleveland, on Behalf of Woman's Rights, in Respect to Property, and the Exercise of the Elective Franchise, Mar. 23, 1854," *Ohio Senate Journal Appendix* 51 (1854): 2, 5.

116. Allen and Welles, *Ohio Woman Suffrage Movement*, 20.

117. Julius Yanuck, "The Garner Fugitive Slave Case," *Mississippi Valley Historical Review* 40, no. 1 (1953): 47–66; Katherine Durack, "The Slave Mother,"

Feb. 28, 2020, episode 18 of *The Genius of Liberty Podcast*, Mercantile Library, 6:00 minutes.

118. *Proceedings of the National Woman's Rights Convention Held at Cleveland, Ohio, on Wednesday, Thursday, and Friday, October 5th, 6th, and 7th, 1853,* 165–67.

119. "National Convention in Cincinnati," *New York Daily News,* Oct. 23, 1855.

120. "Early Suffragette Deserves Cincinnati Marker," *Cincinnati Enquirer,* Mar. 19, 2015.

121. Hoffert, *When Hens Crow,* 96.

122. "Chapter VI: Ohio," 164.

123. Eleanor Flexner and Ellen F. Fitzpatrick, *Century of Struggle: The Woman's Rights Movement in the United States* (Cambridge, MA: Belknap Press of Harvard Univ. Press, 1996), 139.

124. "Lucy Stone (1818–1893) and Henry Blackwell (1825–1909) Marriage Protest, May 1, 1855," Blackwell Family Papers, Manuscript Division, Library of Congress (020.00/00).

125. Henry Morse, "Genius of Liberty: Full Run of the Early 19th Century Newspaper Filmed for the Collection," *Broadside: The Magazine of the Library of Virginia* (Spring 2010): 11; Katherine Durack, "The Genius of Liberty," July 2, 2019, episode 2 of *The Genius of Liberty Podcast,* Mercantile Library, 6:15 minutes.

126. Ann Russo, *The Radical Women's Press of the 1850s,* ed. Cheris Kramarae (New York: Routledge, 1991), 22.

127. Durack, "Genius of Liberty."

128. Jeff Suess, "Cincinnati's Forgotten Women's Suffrage Heroes: Lucy Stone, Margaret Longley, and Cornelia Cassady Davis, *Cincinnati Enquirer,* Apr. 2, 2022; Katherine Durack, "Spelling Reform, Phonetic Type, and Woman Suffrage," Jan. 7, 2020, History blog, Ohio History Connection, https://www.ohiohistory.org/spelling-reform-phonetic-type-and-woman-suffrage/.

129. Suess, "Cincinnati's Forgotten Women's Suffrage Heroes."

130. Margaret Vater Longley, *Constitutional Argument for Woman Suffrage by Mrs. M. Vater Longley* (Los Angeles: Farmers Alliance, ca. 1910), available in Ann Lewis Women's Suffrage Collection, https://lewissuffragecollection.omeka.net/items/show/1240.

131. "Sketch of the Life of Elias Longley," *Bulletin of Eclectic Shorthand* 2, no. 3 (1899): 11–13.

132. Russo, *Radical Women's Press of the 1850s,* 12.

133. "When Bloomers Became All the Rage," *Mansfield (OH) News Journal,* Dec. 13, 2014.

134. Weatherford, *Victory for the Vote,* 68.

135. Joanne Ellen Passet, *Sex Radicals and the Quest for Women's Equality* (Champaign: Univ. of Illinois Press, 2003), 79–82.

136. Passet, *Sex Radicals and the Quest for Women's Equality,* 85–87.

137. Philip Gleason, "From Free-Love to Catholicism: Dr. and Mrs. Thomas L. Nichols at Yellow Springs," *Ohio Historical Quarterly* 70 (Oct. 1961): 283–307.

138. "Appendix—Chapter XIV," in Stanton, Anthony, and Gage, *History of Woman Suffrage,* 1:870–71

139. "Report of the Select Committee of the Ohio Senate, on Giving the Rights of Suffrage to Females, 1857," *Anti-Slavery Bugle* (Salem, OH), Mar. 14, 1857.

140. "Chapter VI: Ohio," 167; David M. Gold calls into question that the vote was tied. See "Natural Rights and the Admission of Women to the Ohio Bar," 177n32.

141. Ellen DuBois, "The Radicalism of the Woman Suffrage Movement: Toward the Reconstruction of Nineteenth-Century Feminism," *Feminist Studies* 3 (Autumn 1975): 63–71.

142. Conkling, *Votes for Women!;* Allison K. Lange, "From Mannish Radicals to Feminist Heroes: Suffragists in Popular Culture," National Park Service website, accessed July 20, 2022, https://www.nps.gov/articles/from-mannish-radicals-to -feminist-heroes-suffragists-in-popular-culture.htm.

143. Isenberg, *Sex and Citizenship in Antebellum America*, 114.

144. William John Tossell, *Reports of Cases Argued and Determined in the Ohio Circuit Courts* (Norwalk: Ohio Law Publishing Company, 1921), 40:15.

145. Little, "Woman of Property," 183.

146. Joseph R. Swan and Leander J. Critchfield, *The Revised Statutes of the State of Ohio, of a General Nature, in Force August 1, 1860 . . .* (Cincinnati: Robert Clarke & Company, 1869), 693.

147. Warbasse, "Cutler, Hannah Maria Conant Tracy," 426–27.

148. Jane Elizabeth Jones, "Do Not Marry Young," *Delaware (OH) Gazette*, July 18, 1862.

149. Jane Elizabeth Jones, "Equal Rights," *Cleveland Daily Leader*, Dec. 17, 1860.

150. Isenberg, *Sex and Citizenship in Antebellum America*, 178.

151. Isenberg, *Sex and Citizenship in Antebellum America*, 178

152. Little, "Woman of Property," 194.

153. Buechler, *Transformation of the Woman Suffrage Movement*, 59.

2. The Ohio Women's Rights Movement during Reconstruction

1. "Chapter XL: Ohio," in *The History of Woman Suffrage:* vol. 3 of 6, *1876–1885*, ed. Elizabeth Cady Stanton, Susan B. Anthony, and Matilda Joslyn Gage (Rochester, NY: Susan B. Anthony, 1881), 491.

2. Linus P. Brockett and Mary C. Vaughan, *Woman's Work in the Civil War: A Record of Heroism, Patriotism and Patience* (Boston: Zeigler McCurdy & Co., 1867), 545.

3. Brockett and Vaughan, *Women's Work in the Civil War*, 683–90, 545; James Alan Marten, *Civil War America: Voices from the Home Front* (Santa Barbara, CA: ABC-CLIO, 2003), 138.

4. Annie L. Dean, "A Report on the Ladies of Amesville," in *Ohio's War: The Civil War in Documents*, ed. Christine Dee (Athens: Ohio Univ. Press, 2014), 72–73.

5. "Republican Women in Salt Creek Take Action," in Dee, *Ohio's War*, 81–182.

6. Stephanie Michaels, "For the Benefit of the Soldiers: The United States Sanitary Commission," *Ohio Memory*, Ohio History Connection, Apr. 26, 2019, https://ohiomemory.ohiohistory.org/archives/4799; Charles Janeway Stillé, *History of the United States Sanitary Commission, the General Report of Its Work*

during the War of the Rebellion (Philadelphia: J. B. Lippincott & Company, 1866), 140–50.

7. Jeanie Attie, *Patriotic Toil: Northern Women and the American Civil War* (Ithaca, NY: Cornell Univ. Press, 1998), 2–3.

8. *Proceedings of the Meeting of the Loyal Women of the Republic, Held in New York, May 14, 1863* (New York: Phair & Company, 1863), 62–63; Wendy Hamand Vent, *Neither Ballots nor Bullets: Women Abolitionists and the Civil War* (Charlottesville: Univ. of Virginia Press, 1991), 10.

9. John D. Wright, "Griffing, Josephine Sophia White 1814–72," *The Routledge Encyclopedia of Civil War Era Biographies* (New York: Routledge, 2013), 242.

10. Keith E. Melder, "Angel of Mercy in Washington: Josephine Griffing and the Freedmen, 1864–1872," *Records of the Columbia Historical Society* 63–65 (Historical Society of Washington, DC, 1963), 243–72.

11. Bernadette Cahill, *No Vote for Women: The Denial of Suffrage in Reconstruction America* (Jefferson, NC: McFarland, 2019), 158–59.

12. Josephine White Griffing to Elizabeth Cady Stanton, Dec. 27, 1870, in *The Selected Papers of Elizabeth Cady Stanton and Susan B. Anthony:* vol. 1 of 6, *In the School of Anti-Slavery, 1840–1866,* ed. Ann D. Gordon (New Brunswick, NJ: Rutgers Univ. Press, 1977), 380–91.

13. John Stuart Galloway, *The American Equal Rights Association, 1866–1870: Gender, Race, and Universal Suffrage* (Leicester, UK: Univ. of Leicester, 2014), 3–35.

14. Rebecca E. Zietlow, *The Forgotten Emancipator: James Mitchell Ashley and the Ideological Origins of Reconstruction* (Cambridge: Cambridge Univ. Press, 2017); "James Ashley," Ohio History Central, accessed July 21, 2022, https://ohio historycentral.org/index.php?title=James_Ashley&rec=129.

15. Gerald N. Magliocca, *American Founding Son: John Bingham and the Invention of the Fourteenth Amendment* (New York: New York Univ. Press, 2013).

16. Gabriel J. Chin, "Ratifying the Fourteenth Amendment in Ohio," *Western New England Law Review* 28, no. 2 (2005–6): 179–98.

17. Robert D. Sawrey, *Dubious Victory: The Reconstruction Debate in Ohio* (Lexington: Univ. Press of Kentucky, 205), 142. For further discussion of Ohio's role in Reconstruction, see Felice A. Bonadino, *North of Reconstruction Ohio Politics, 1865–1870* (New York: New York Univ. Press, 1970).

18. Sawrey, *Dubious Victory,* 15.

19. *Journal of the House of Representatives of the State of Ohio* (Columbus: Columbus Printing Company, State Printers, 1867), 10, 554.

20. Ellen Carol DuBois, *Feminism and Suffrage: The Emergence of an Independent Women's Movement in America, 1848–1869* (Ithaca, NY: Cornell Univ. Press, 2019), 63–65.

21. Eleanor Flexner and Ellen F. Fitzpatrick, *Century of Struggle: The Woman's Rights Movement in the United States* (Cambridge, MA: Harvard Univ. Press, 1996), 151–52.

22. "Chapter XXX: Congressional Debates and Conventions, 1882–1883," in Stanton, Joslyn, and Gage, *History of Woman Suffrage,* 3:173.

23. Galloway, *American Equal Rights Association,* 77–78.

24. DuBois, *Feminism and Suffrage,* 68.

25. "Letter from Mrs. Gage," *National Anti-Slavery Standard* (New York), July 21, 1866.

26. Ana Stevenson, *The Woman as Slave in Nineteenth-Century American Social Movements* (London, UK: Palgrave Macmillan, 2020), 222.

27. Allison L. Sneider, *Suffragists in the Imperial Age: U.S. Expansion and the Woman Question 1870–1929* (New York: Oxford Univ. Press, 2008), 13.

28. Stevenson, *Woman as Slave,* 227.

29. "Letter from Frances Gage," *Anti-Slavery Standard* (New York), Nov. 25, 1865.

30. "Chapter VII: Reminiscences by Clarina I. Howard Nichols," in *The History of Woman Suffrage:* vol. 1 of 6, *1841–1861,* ed. Elizabeth Cady Stanton, Susan B. Anthony, and Matilda Josyln Gage (Rochester, NY: Susan B. Anthony, 1881), 114

31. "The Aristocracy of Sex—Notes from Miss Susan B. Anthony," *New York Times,* June 5, 1869.

32. "Chapter XL: Ohio," 493, 503.

33. DuBois, *Feminism and Suffrage,* 174.

34. "Chapter VII: Reminiscences by Clarina I. Howard Nichols," 191.

35. "Chapter XXVI: American Woman Suffrage Association," in *The History of Woman Suffrage:* vol. 2 of 6, *1861–1876,* ed. Elizabeth Cady Stanton, Susan B. Anthony, and Matilda Joslyn Gage (New York: Fowler & Wells, 1881), 757–60, 761.

36. Elizabeth C. Stanton, Susan B. Anthony, and Ann D. Gordon, *The Selected Papers of Elizabeth Cady Stanton and Susan B. Anthony: Against an Aristocracy of Sex, 1866 to 1873* (New Brunswick, NJ: Rutgers Univ. Press, 2000), 284–85.

37. Samuel Tamburro, "Frances Jennings Casement and the Equal Rights Association of Painesville, Ohio: The Fight for Women's Suffrage, 1883–1889," *Ohio History Journal* 108 (Summer–Winter 1999): 168; Carol Lasser, "Party, Propriety, Politics, and Woman Suffrage in the 1870s: National Developments and Ohio Perspectives," in *New Viewpoints in Women's History: Working Papers from the Schlesinger Library 50th Anniversary Conference, March 4–5, 1994,* ed. Susan Ware (Cambridge, MA: Radcliffe College, 1994), 153.

38. Kathryn Mary Smith, "The 1912 Constitutional Campaign and Woman's Suffrage in Columbus, Ohio" (master's thesis, Ohio State University, 1980), 4.

39. Finding aid, Toledo Woman's Suffrage Association Records, 1903–27, MSS-091, Ward M. Canaday Center for special collections, University of Toledo, Dec. 1992, available at https://www.utoledo.edu/library/canaday/HTML_finding aids/MSS-091.html.

40. Lisa Tetrault, "The Incorporation of American Feminism: Suffragists and the Postbellum Lyceum," *Journal of American History* 96, no. 4 (2010): 1028, 1036n24.

41. Carl David Mead, *Yankee Eloquence in the Middle West: The Ohio Lyceum, 1850–70* (East Lansing: Michigan State College Press, 1951).

42. "Timeline: The Senate and the 19th Amendment," *Woman Suffrage Centennial,* US Senate website, accessed July 21, 2022, https://www.senate.gov

/artandhistory/history/People/Women/Nineteenth_Amendment_Vertical_Time line.htm.

43. "Chapter XVII: Congressional Action," in Stanton, Anthony, and Gage, *History of Woman Suffrage*, 2:117.

44. Center for American Women and Politics, "Women's Suffrage in the U.S. by State," *Teach a Girl to Lead*, Rutgers Eagleton Institute of Politics, accessed Aug. 27, 2022, https://tag.rutgers.edu/wp-content/uploads/2014/05/suffrage-by-state.pdf.

45. "Chapter XL: Ohio," 492.

46. *Journal of the House of Representatives of the State of Ohio* (Columbus: Columbus Printing Company, State Printers, 1869), 161.

47. "Chapter XL: Ohio," 492, 501–2.

48. *Journal of the House of Representatives of the State of Ohio*, 571.

49. *Journal of the House of Representatives of the State of Ohio*, 573.

50. "Woman Suffrage," *Tiffin Tribune*, July 23, 1869.

51. "Mrs. Lucy Stone at Pike's Hall. Her Lecture Last Night," *Cincinnati Commercial Tribune*, Jan. 27, 1869.

52. "Mrs. Lucy Stone at Pike's Hall."

53. *Annals of Cleveland, 1818–1935: A Digest and Index of the Newspaper Record of Events and Opinions* 52 (Cleveland: Cleveland Public Works, 1936), 617.

54. Cong. Globe, 40th Cong., 3rd Sess. 6 (1868).

55. Senator Samuel Pomeroy (R-KS) to Anna Dickinson, Oct. 16, 1867, available at US Senate website, https://www.senate.gov/artandhistory/history/common/image/1867PomeroyLettertoDickinson.htm.

56. Grace Clarke and Julian Giddings, eds., "George W. Julian's Journal: The Assassination of Lincoln," *Indiana Magazine of History* 11 (Dec. 1915): 149.

57. Sarah Stook, "How America's Presidents Viewed Women's Suffrage," *Elections Daily*, July 23, 2020, https://elections-daily.com/2020/07/23/how-americas-presidents-viewed-womens-suffrage/; Godfrey D. Lehman, "Susan B. Anthony Cast Her Ballot for Ulysses S. Grant," *American Heritage* 37 (Dec. 1985), https://www.amer icanheritage.com/susan-b-anthony-cast-her-ballot-ulysses-s-grant#10.

58. Aileen S. Kraditor, *The Ideas of the Women Suffrage Movement, 1890–1920* (New York: Columbia Univ. Press, 1965), 3.

59. Steven M. Buechler, *The Transformation of the Woman Suffrage Movement: The Case of Illinois, 1850–1920* (New Brunswick, NJ: Rutgers Univ. Press, 1986), 117.

60. Lasser, "Party, Propriety, Politics, and Woman Suffrage in the 1870s," 153.

61. "Chapter XL: Ohio," 494.

62. Louise Michele Newman, *White Women's Rights: The Racial Origins of Feminism in the United States* (New York: Oxford Univ. Press, 1999), 69.

63. Katherine Durack, "Strong-Minded She-Rowdies," Feb. 28, 2020, episode 19 of *The Genius of Liberty Podcast*, Mercantile Library, 5:50 minutes, https://mer cantilelibrary.com/geniusofliberty/.

64. Paul A. Tenkotte, "Our Rich History: In 1869 Lucy Stone Lectures in Cincinnati, Refuting Stereotypes of Her Day," *Northern Kentucky Tribune* (Covington), June 3, 2019.

65. U.S. Reports: Minor v. Happersett, 88 US. 21 Wall. 162. 1874, available at Library of Congress website, www.loc.gov/item/usrep088162.

66. US Constitution, Amendment 14, section 2.

67. Angela A. Ray and Cindy Koenig Richards, "Inventing Citizens, Imagining Gender Justice: The Suffrage Rhetoric of Virginia and Francis Minor," *Quarterly Journal of Speech* 93, no. 4 (2007): 375–402.

68. Mary Gabriel, *Notorious Victoria: The Life of Victoria Woodhull, Uncensored* (Chapel Hill, NC: Algonquin Books of Chapel Hill, 1998), 66.

69. Victoria Woodhull, "Constitutional Equality," *Woodhull & Claflin's Weekly,* Jan. 2, 1871.

70. Greta Anderson, *More Than Petticoats: Remarkable Ohio Women* (Guilford, CT: Globe Pequot Press, 2005), 46.

71. Jason Jones, "Breathing Life into a Public Woman: Victoria Woodhull's Defense of Woman's Suffrage," *Rhetoric Review* 28, no. 4 (2009): 360.

72. Kate Havelin, *Victoria Woodhull: Fearless Feminist* (Minneapolis, MN: Twenty-First Century Books, 2006), 43.

73. Anderson, *More Than Petticoats,* 45.

74. Mark R. Brewer, *Moments in History: People and Events Worth Remembering* (Bloomington, IN: Xlibris, 2019) 219.

75. Havelin, *Victoria Woodhull,* 44.

76. Winifred Conkling, *Votes for Women: American Suffragists and the Battle for the Ballot* (Chapel Hill, NC: Algonquin Books, 2018), 114–15.

77. Havelin, *Victoria Woodhull,* 45.

78. Gabriel, *Notorious Victoria,* 76.

79. Benjamin Shaw, "Mrs. Woodhull Goes to Washington: The First Female Presidential Candidate Petitions for Women's Suffrage," *Boundary Stones: WETA's Local History Website,* June 12, 2015, https://boundarystones.weta.org/2015/06/12/mrs-woodhull-goes-washington-first-female-presidential-candidate-petitions-womens.

80. Marjorie Spruill Wheeler, *One Woman, One Vote: Rediscovering the Woman Suffrage Movement* (Tillamook, OR: New Sage Press, 1995), 74–75.

81. Susan Cordray, "Victoria Claflin Woodhull," in *Women Public Speakers in the United States, 1800–1925: A Bio-Critical Sourcebook,* ed. Karlyn Kohrs Campbell (Westport, CT: Greenwood, 1993), 91.

82. Mark J. Price, "Local History: Ohio Woman Who Ran for U.S. President in 19th Century Was Considered a Threat to Society," *Akron Beacon Journal,* July 24, 2016.

83. "German Communism—Manifesto of the German Communist Party," *Woodhull & Claflin's Weekly,* Dec. 30, 1871, 3–9.

84. Joanne Ellen Passet, *Sex Radicals and the Quest for Women's Equality* (Champaign: Univ. of Illinois Press, 2003), 110, 91.

85. Gabriel, *Notorious Victoria,* 208.

86. Buechler, *Transformation of the Woman Suffrage Movement.*

87. Jerome Nadelbaft, "Alcohol and Wife Abuse in Antebellum Male

Temperance Literature," *Canadian Review of American Studies* 25 (Spring 1995): 15–44.

88. For a detailed discussion of the relationship between the US women's suffrage movement and the Prohibition Party, see Kenneth D. Rose, *American Women and the Repeal of Prohibition* (New York: New York Univ. Press, 1996).

89. Richard H. Chused, "The Temperance Movement's Impact on Adoption of Women's Suffrage," *Akron Law Review* 53, no. 2 (2019): 365–86.

90. Jack S. Blocker, "Separate Paths: Suffragists and the Women's Temperance Crusade," *Signs* 10 (1985): 470.

91. Genevieve C. McBride, *On Wisconsin Women: Working for Their Rights from Settlement to Suffrage* (Madison: Univ. of Wisconsin Press, 1993), 61.

92. For a detailed discussion of temperance in Hillsboro, Ohio, see Mary McArthur Thompson Tuttle et al., *Hillsboro Crusade Sketches and Family Records* (Cincinnati: Cranston & Curts, 1896); "Temperance Movement," *Ohio History Central*, Ohio History Connection, accessed July 21, 2022, https://ohiohistorycen tral.org/w/Temperance_Movement.

93. "Odd Ohio: Heart of Temperance Movement Once Beat in Westerville," *Akron Beacon Journal*, Aug. 13, 2016.

94. Blocker, "Separate Paths," 461–62.

95. Martha McClelland Brown suffrage lecture announcement, Martha McClellan Brown Papers, MS147, Wright State Univ., Dayton, OH.

96. Frances E. Willard and Mary A. Livermore, eds., *A Woman of the Century: Fourteen Hundred-Seventy Biographical Sketches Accompanied by Portraits* (New York: Charles Wells Moulton, 1893), 127–29.

97. "Chapter XXX: Congressional Debates and Conventions, 1882–1883," 227.

98. Michelle Schweickart, "Martha McClellan Brown," *The Woman's Suffrage Movement: Dayton, Ohio (1890–1920)* (blog), Apr. 14, 2015, site unavailable as of July 21, 2022, https://womenssuffragemovementindayton.wordpress. com/2015/04/14/martha-mcclellan-brown/.

99. "Chapter XL: Ohio," 501.

100. Barbara A. Terzian, "Ohio's Constitutions: An Historical Perspective," *Cleveland State Law Review* 35 (2004): 379.

101. Emilius Oviatt Randall and Daniel Joseph Ryan, *History of Ohio* (Madison, WI: Century History Company, 1912), 321.

102. Terzian, "Ohio's Constitutions," 380.

103. *Official Report of the Proceedings and Debates of the Third Constitutional Convention of Ohio*, recorded by J. G Adel (Cleveland: W. S. Robison & Company, 1873–74), 617.

104. Florence E. Allen and Mary Welles, *The Ohio Woman Suffrage Movement: "A Certain Unalienable Right": What Ohio Women Did to Secure It* (N.p.: Committee for the Preservation of Ohio Woman Suffrage Records, 1952), 31–32.

105. Chused, "Temperance Movement's Impact on Adoption of Women's Suffrage," 365.

106. "Chapter XIV: New York," in Stanton, Anthony, and Gage, *History of Woman Suffrage*, 1:506.

107. *Official Report of the Proceedings and Debates of the Third Constitutional Convention of Ohio*, 2747.

108. Terzian, "Ohio's Constitutions," 381.

109. Gabriel, *Notorious Victoria*, 134; Tetrault, "Incorporation of American Feminism," 1039.

110. Patricia A. Cunningham, *Reforming Women's Fashion, 1850–1920: Politics, Health, and Art* (Kent, OH: Kent State Univ. Press, 2003), 45.

111. Ann Dexter Gordon, *The Trial of Susan B. Anthony* (Washington, DC: Federal Judicial Center, Federal Judicial History Office, 2005), 2.

112. "Chapter XL: Ohio," 502.

113. Virginia Clark Abbott, "History of Woman Suffrage and League of Women Voters in Cuyahoga County 1911–1945," *Teaching Cleveland Digital* (blog), June 17, 2016, https://teachingcleveland.org/history-of-woman-suffrage-and-league-of-women-voters-in-cuyahoga-county-1911–1945-by-virginia-clark-abbott/.

114. Joan Rusek, "South Newbury Union Chapel Honored: Was Key to Women's Suffrage Movement," *Sun News* (Cleveland), Oct. 11, 2012.

115. Allen and Welles, *Ohio Woman Suffrage Movement*, 27–29; Erin Esmont, "Cradle of Equal Suffrage: South Newbury Union Chapel," *Echoes* (Mar.–Apr. 2020): 39–41.

116. "Chapter XL: Ohio," 503.

117. Katherine Durack, "Legally Responsible Women," Sept. 27, 2019, episode 12 of *The Genius of Liberty Podcast*, Mercantile Library, 5:50 minutes.

118. "Chapter XL: Ohio," 507.

119. "Chapter XL: Ohio," 508

120. "1776," *Ballot Box* (Toledo, OH) 1, no. 6 (Sept. 1876); 1.

121. *Proceedings of the Republican National Convention Held at Cincinnati, Ohio June 14, 15, and 16, 1876*, reported by M. A. Clancy and William Nelson (Ann Arbor: Univ. of Michigan Library, 2004), 31–32.

122. Russell L. Mahan, *Lucy Webb Hayes: A First Lady by Example* (Hauppauge, NY: Nova Science Publishers, 2011); "First Lady Biography: Lucy Hayes," *National First Ladies Library*, accessed July 21, 2022, http://www.firstladies.org/biographies/firstladies.aspx?biography=20.

123. Stook, "How America's Presidents Viewed Women's Suffrage."

3. The Ohio Women's Rights Movement during the Gilded Age

1. "National Woman Suffrage Convention," *Jackson (OH) Standard*, Jan. 24, 1878.

2. Ken Drexler and Mary Champagne, "19th Amendment to the U.S. Constitution: Primary Documents in American History," last updated Sept. 13, 2019, Library of Congress website, https://guides.loc.gov/19th-amendment.

3. Rebecca J. Mead, *How the Vote Was Won: Woman Suffrage in the Western United States, 1868–1914* (New York: New York Univ. Press, 2004).

4. Bonnie Dow, "'The 'Womanhood' Rationale in the Woman Suffrage Rhetoric of Frances E. Willard," *Southern Communication Journal* 56, no. 4 (1991): 30.

5. Frances E. Willard, *Glimpses of Fifty Years: The Autobiography of an American Woman* (Chicago: Woman's Temperance Publication Association, 1889), 351.

6. Frances E. Willard, *Home Protection Manual: Containing an Argument for the Temperance Ballot for Woman and How to Obtain It, as a Means of Home Protection* (New York: Independent, 1979), 31.

7. Kathryn Kish Sklar, "Temperance & Suffrage," *Not for Ourselves Alone*, PBS, accessed July 21, 2022, https://www.pbs.org/kenburns/not-for-ourselves-alone/temperance-suffrage/.

8. Lee Ann Banaszak, *Why Movements Succeed or Fail: Opportunity, Culture, and the Struggle for Woman Suffrage* (Princeton, NJ: Princeton Univ. Press, 1996), 108.

9. Allison L. Sneider, *Suffragists in the Imperial Age: U.S. Expansion and the Woman Question 1870–1929* (New York: Oxford Univ. Press, 2008), 6.

10. "Chapter XXVI: American Woman Suffrage Association," in *The History of Woman Suffrage:* vol. 2 of 6, *1861–1876,* ed. Elizabeth Cady Stanton, Susan B. Anthony, and Matilda Joslyn Gage (New York: Fowler & Wells, 1881), 855.

11. "Chapter XXVI: American Woman Suffrage Association," 855.

12. Patricia Anne Cunningham, *Reforming Women's Fashion, 1850–1920* (Kent, OH: Kent State Univ. Press, 2003), 45.

13. Daniel Segur Sr., "Biographical Sketches," Segur Family Papers, Toledo Lucas County Public Library, Mss. Coll. 19, https://tlcpllochhis.omeka.net/items/show/123.

14. "Ohio Woman Suffragists," *Akron Beacon Journal,* May 20, 1890.

15. Elisabeth J. Hauser, "The Woman Suffrage Movement in Ohio," *Ohio Magazine* 4 (Feb. 1908): 89–90.

16. "Noted Women Suffragist," *Eagle* (Bryan, TX), Dec. 28, 1906.

17. Osman Castle Hooper, *History of the City of Columbus, Ohio: From the Founding of Franklinton in 1797, through the World War Period, to the Year 1920* (Columbus: Memorial Publishing, 1920), 65–66.

18. Frances E. Willard and Mary A. Livermore, eds., *A Woman of the Century: Fourteen Hundred-Seventy Biographical Sketches Accompanied by Portraits* (New York: Charles Wills Moulton, 1893), 189.

19. Leslie Blakenship, "The Legacy of Elizabeth Greer Coit," *Local Historian* (Mar.–Apr. 2021): 6–7.

20. Erica Thompson, "Historian Honors Suffrage Movement by Portraying Key Columbus Leader," *Columbus Dispatch,* Feb. 16, 2020; mayorarnett (Arnett Howard), "Belle Coit Kelton, Suffragette," *Columbus Bicentennial* (blog), June 10, 2012, http://columbusbicentennial.blogspot.com/2012/06/belle-coit-kelton-suffragette.html.

21. Samuel J. Tamburro, "Frances Jennings Casement and the Equal Rights Association of Painesville, Ohio: The Fight for Women's Suffrage, 1883–1889," *Ohio History Journal* 108 (Summer–Winter 1999): 163.

22. Frances Jennings Casement Speech Regarding Woman Suffrage, ca. 1880, box 1, folder 58, Frances Casement Collection, MSS 510, available at *Ohio*

History Connection Selections, Ohio History Connection, https://ohiomemory.org
/digital/collection/p267401coii32/id/2183/.

23. Tamburro, "Frances Jennings Casement," 170.

24. Jacqueline Jones Royster, *Profiles of Ohio Women: 1803–2003* (Athens:
Ohio Univ. Press, 2003), 181.

25. Tamburro, "Frances Jennings Casement," 172.

26. Royster, *Profiles of Ohio Women,* 181.

27. Tamburro, "Frances Jennings Casement," 175.

28. Susan B. Anthony Letters to Frances Casement Regarding Suffrage
Petitions, Feb. 27, 1884, 1887, box 1, folder 48, Frances Casement Collection,
MSS 510, available at *Ohio History Connection Selections,* Ohio History
Connection, https://ohiomemory.org/digital/collection/p267401coii32/id/5006/.

29. Susan B. Anthony to Frances Casement Regarding Suffrage Leadership,
Jan. 29, 1904, box 1, folder 48, Casement Collection, https://ohiomemory.org/
digital/collection/p267401coii32/id/4854/rec/29.

30. *Fortieth Annual Report of the National American Woman Suffrage Association
[Convention], Held at Buffalo, October 15th to 21st 1908* (Warren, OH: National
American Woman Suffrage Association, 1908), 187.

31. "Ohio Woman Suffrage Association," *Ohio History Central,* Ohio History
Connection, accessed July 21, 2022, https://ohiohistorycentral.org/w/Ohio_
Woman_Suffrage_Association

32. Elizabeth Cady Stanton and Susan Brownell Anthony, *Proceedings of the
Annual Convention of the National American Woman Suffrage Association, Held
in Louisville 19th to 25th 1911* (New York: National American Woman Suffrage
Association, 1912), 96.

33. Tamburro, "Frances Jennings Casement," 164.

34. "Chapter LVIII: Ohio," in *The History of Woman Suffrage:* vol. 4 of 6,
1883–1900, ed. Susan B. Anthony and Ida Husted Harper (Indianapolis, IN:
Hollenbeck Press, 1902), 878.

35. Sara Egge, "How Midwestern Suffragists Won the Vote by Attacking
Immigrants," *Smithsonian Magazine,* Sept. 17, 2018, https://www.smithsonian
mag.com/history/how-midwestern-suffragists-won-vote-by-attacking-immigrants
-180970298/.

36. Greg Hand, "Battling the Political Machine in 1884," *Cincinnati
Magazine,* July 1, 2020, https://www.cincinnatimagazine.com/bouncing-
back-2020/battling-the-political-machine-in-1884/.

37. Lisa M. F. Andersen, *The Politics of Prohibition: American Governance and
the Prohibition Party, 1869–1933* (Cambridge: Cambridge Univ. Press, 2013), 67, 91.

38. Andersen, *Politics of Prohibition,* 86–90, 208–10.

39. Adam Chamberlain, Alixandra B. Yanus, and Nicholas Pyeatt, "The Con-
nection between the Woman's Christian Temperance Union and the Prohibition
Party," *Sage Open* 6 (Dec. 1, 2016), https://doi.org/10.1177/2158244016684373.

40. "Chapter III: Congressional Debates and Conventions 1882–1883," in *The
History of Woman Suffrage;* vol. 3 of 6, *1876–1885,* ed. Elizabeth Cady Stanton, Susan
B. Anthony, and Matilda Joslyn Gage (Rochester, NY: Susan B. Anthony, 1881), 186.

41. Edward B. Dickinson, *Official Proceedings of the National Democratic Convention Held in Cincinnati, O., June 22d, 23d and 24th, 1880* (Dayton: Daily Journal, 1882), 126.

42. Anne Myra Benjamin, *Women against Equality: A History of the Anti-Suffrage Movement from 1895–1920* (Morrisville, NC: Lulu, 2014), 184.

43. Sarah Stook, "How America's Presidents Viewed Women's Suffrage," *Elections Daily,* July 23, 2020, https://elections-daily.com/2020/07/23/how-americas-presidents-viewed-womens-suffrage/.

44. Geneva Fulgham and Elizabeth Silverthorne, *Women Pioneers in Texas Medicine* (College Station: Texas A&M Univ. Press, 1997), 68.

45. Stook, "How America's Presidents Viewed Women's Suffrage."

46. Edith Mayo and William Seale, "First Lady Caroline Harrison," *C-SPAN,* June 3, 2013, https://www.c-span.org/video/?310739-1/lady-caroline-harrison. For biographical information on Harrison, see Anne Chieko Moore, *Caroline Lavinia Scott Harrison* (Hauppauge, NY: Nova History, 2005).

47. US Congress, *Congressional Action in the First Session of the 48th Congress, 1884* (Washington, DC: GPO, 1884).

48. "Chapter III: Congressional Hearings and Reports of 1884," in Anthony and Harper, *History of Woman Suffrage,* 4:33.

49. Susan B. Anthony to the Senate Select Committee on Woman Suffrage, Mar. 7, 1884, *Congressional Action in the First Session of the 48th Congress 1883, 1884* (Washington, DC: GPO, 1884), 16.

50. *Report of the Select Committee on Woman Suffrage in the First Session of the 47th Congress June 5, 1882* (Washington, DC: GPO, 1882), 1.

51. US Congress, House, Ezra B Taylor et al., *Woman Suffrage: Views of the Minority* (Washington, DC: GPO, 1886), 2–3.

52. Elizabeth C. Larson, "Women's Suffrage: Fact Sheet," July 8, 2019, updated Feb. 22, 2021, report # R45805, 1, Congressional Research Service, https://crsreports.congress.gov/product/pdf/R/R45805.

53. "History," *Report of the International Council of Women,* accessed July 21, 2022, http://www.icw-cif.com/01/03.php.

54. Harriet Taylor Upton, "The Woman Suffrage Movement in Ohio," in *History of Ohio,* ed. Charles Burleigh Galbreath, 5 vols. (Washington, DC: American Historical Society, 1925), 2:331.

55. Caroline McCullough Everhard scrapbook, Massillon Museum, available via the museum's Flickr account, https://www.flickr.com/photos/massmuarchives/48916081652/in/album-72157711384817387/.

56. Upton, "Woman Suffrage Movement in Ohio," 331.

57. "Constitutional Amendment in Ohio," *Woman's Journal,* Aug. 18, 1888, 259.

58. Everhard scrapbook.

59. Ohio General Assembly, House of Representatives, *Journal of the House of Representatives of the State of Ohio* (Columbus: Nevins & Myers, State Printers, 1873), 482–85, 142, 174.

60. Kathryn A. Nicholas, "Reexamining Women's Nineteenth-Century Political Agency: School Suffrage and Office-Holding," *Journal of Policy History* 30, no. 3 (2018): 463–67.

61. Sarah Miller Little, "A Woman of Property: From Being It to Controlling It—A Bicentennial Perspective on Women and Ohio Property Law, 1803–2003, *Hastings Women's Law Journal* 16 (Summer 2005): 198.

62. George Klosko, *The Struggle for Women's Rights: Theoretical and Historical Sources* (Hoboken, NJ: Prentice Hall, 1999), 143.

63. Marian Morton, "Winning the Ballot," in *Women in Cleveland: An Illustrated History* (Bloomington: Indiana Univ. Press, 1995), 75.

64. Morton, "Winning the Ballot," 31.

65. Mrs. Harriet Taylor Upton to Mrs. Oscar Davisson, undated, box 2, folder 5, Dayton Woman's Suffrage Association Records, Dayton Metro Library.

66. Marjorie Spruill Wheeler, ed., *One Woman, One Vote: Rediscovering the Woman Suffrage Movement* (Tillamook, OR: New Sage Press, 1995), 138.

67. Allison Lange, "National Association of Colored Women," *Crusade for the Vote*, Fall 2015, http://www.crusadeforthevote.org/nacw. For a history of this organization, see LaVonne Leslie, *The History of the National Association of Colored Women's Clubs, Inc.: A Legacy of Service* (Bloomington, IN: Xlibris, 2012).

68. For biographical information about Mary Church Terrell, see Alison M. Parker, *Unceasing Militant: The Life of Mary Church Terrell* (Chapel Hill: Univ. of North Carolina Press, 2020).

69. "Because of Her Story: Activist and Suffragist Mary Church Terrell," National Museum of African American History and Culture website, Smithsonian Institution, accessed July 21, 2022, https://nmaahc.si.edu/explore/stories/because -her-story-activist-and-suffragist-mary-church-terrell.

70. "Frances Ellen Watkins Harper," Ohio Center for the Book website, Nov. 15, 2017, https://ohiocenterforthebook.org/2017/11/15/harper-frances-ellen-watkins/. For a rhetorical analysis of Frances Watkins's oratory, see Michael Stancliff, *Frances Ellen Watkins Harper: African American Reform Rhetoric and the Rise of a Modern Nation State* (Milton Park, UK: Taylor & Francis, 2010). For an anthology of her work, see Frances Ellen Watkins Harper, *A Brighter Coming Day: A Frances Ellen Watkins Harper Reader* (New York: Feminist Press at the City Univ. of New York, 1990).

71. Louise Daniel Hutchinson, *Anna J. Cooper: A Voice from the South* (Washington, DC: Anacostia Neighborhood Museum of the Smithsonian Institution, 1981), 35; "Cooper, Anna," in *African American Women: A Biographical Dictionary*, ed. Dorothy C. Salem (New York: Garland, 1993), 124–26.

72. Karen Johnson, *Uplifting the Woman and the Race: The Lives, Educational Philosophies and Social Activism of Anna Julia Cooper and Nannie Helen Burroughs* (New York: Taylor & Francis, 2013), 68, 86.

73. Vivian M. May, "Anna Julia Cooper (1858–1964): Black Feminist Scholar, Educator, and Activist," in *North Carolina Women: Their Lives and Times,* ed. Michele Gillespie and Sally McMillen (Athens: Univ. of Georgia Press, 2014),

192–212. For a book-length discussion by the same author, see also Vivian May, *Anna Julia Cooper, Visionary Black Feminist: A Critical Introduction* (New York: Routledge, 2012).

74. "Anna Haywood Cooper," *Voices from the Gaps,* 2009, University of Minnesota, https://conservancy.umn.edu/bitstream/handle/11299/166130/Cooper,%20Anna%20Julia.pdf?sequence=1&isAllowed=y.

75. Anna Julia Cooper, *A Voice from the South: By a Black Woman of the South* (Xenia, OH: Aldine Printing House, 1892), 78.

76. Mary Ellen Snodgrass, *American Women Speak: An Encyclopedia and Document Collection of Women's Oratory* (Santa Barbara, CA: ABC-CLIO, 2016), 160.

77. Shirley Moody-Turner, "Preface: Anna Julia Cooper: A Voice beyond the South," *African American Review* 43 (2009): 7. For additional biographical information, see Karen Baker-Fletcher, *A Singing Something: Womanist Reflections on Anna Julia Cooper* (New York: Crossroad, 1994).

78. Cooper, *Voice from the South,* 32, 123.

79. Anna J. Cooper, "'Woman Versus the Indian,'" *Voice from the South,* 80–126; Katherine Durack, "Woman Versus the Indian," July 24, 2019, episode 8 of *The Genius of Liberty Podcast,* Mercantile Library, 6:04 minutes, https://mercantilelibrary.com/geniusofliberty/.

80. "Hallie Quinn Brown," in *Black Women in America,* ed. Darlene Clark Hine, 3 vols. (New York: Oxford Univ. Press, 2005), 1:168–70.

81. James T. Hally, "Hallie Quinn Brown," *Afro-American Encyclopedia: Or, the Thoughts, Doings, and Sayings of the Race* (Nashville, TN: Halley & Florida, 1895), 581–83.

82. "Hallie Quinn Brown," *Today in History—March 10,* Library of Congress, https://www.loc.gov/item/today-in-history/march-10.

83. Ronald L. Jackson II and Sonja M. Brown Givens, "Hallie Quinn Brown," *Black Pioneers in Communication Research* (Thousand Oaks, CA: Sage, 2006), 64–83.

84. "Our Legacy: About Hallie Quinn Brown," Hallie Q. Brown Community Center website, 2022, http://www.hallieqbrown.org/site/index.php/about/our-legacy/.

85. Martha S. Jones, *Vanguard: How Black Women Broke Barriers, Won the Vote, and Insisted on Equality for All* (New York: Hachette, 2020), 194–97.

86. Cathleen D. Cahill, *Recasting the Vote: How Women of Color Transformed the Suffrage Movement* (Chapel Hill: Univ. of North Carolina Press, 2020), 213–14.

87. Ali Pierce et al., "Hallie Quinn Brown," *Voices from the Gaps,* Minneapolis, Univ. of Minnesota Digital Conservancy, 2000, https://hdl.handle.net/11299/166107; Hallie Quinn Brown, *Elocution and Physical Culture: Training for Students, Teachers, Readers, Public Speakers* (Wilberforce, OH: Homewood Cottage, n.d.); Hallie Q. Brown, *Homespun Heroines and Other Women of Distinction* (Xenia, OH: Aldine Printing House, 1926).

88. Lisa Powel, "Booming Voice for Social Change: The Life of Hallie Q. Brown," *Dayton Daily News,* Feb. 22, 2021.

89. Michelle Schweickart, *Through the Eyes of Pioneers: Accounts of the Women's Suffrage Movement in Dayton, Ohio: 1890–1920* (master's thesis, Wright State University, 2015), 52.

90. Geoffrey C. Ward, *Not for Ourselves Alone, the Story of Elizabeth Cady Stanton and Susan B. Anthony: An Illustrated History* (New York: A. A. Knopf, 1999), 4.

91. Penny Colman, *Elizabeth Cady Stanton and Susan B. Anthony: A Friendship That Changed the World* (New York: Henry Holt, 2013), 198–99.

92. Gary Brown, "The Monday After: Caroline McCullough Everhard Was Voice for Women's Rights," *Canton Repository,* Sept. 24, 2018.

93. "Everhard, Mrs. Caroline McCullough," in *A Woman of the Century: Fourteen Hundred-Seventy Biographical Sketches Accompanied by Portraits of Leading American Women in All Walks of Life,* ed. Frances Willard and Mary Ashton Livermore (Buffalo, NY: Charles Wells Moulton, 1893), 280.

94. Oct. 29, 1890, Caroline McCullough Everhard Journal, Jan. 1890–Sept. 1901, Caroline McCullough Everhard Papers Collection of the Massillon Museum (BC 2154.1), 23, Massillon Museum, available via the museum's Flickr account, https://www.flickr.com/photos/massmuarchives/sets/72157658124338506.

95. "Woman Suffrage: An Association Organized in Canton to Expound Its Claims," Caroline McCullough Everhard Scrapbook, June 25, 1889, 80, Everhard Papers.

96. Gary Brown, "Massillon Native Was State Suffrage Leader and Banking Industry Innovator," *Canton Repository,* Sept. 24, 2018.

97. Jan. 2, 1892, Everhard Journal, 46.

98. Edward Thornton Heald, *The Stark County Story* (Canton, OH: Stark County Historical Society, 1949), 628.

99. "The Women's Hour," *Evening Star* (Washington, DC), Jan. 28, 1896.

100. Harriet T. Upton, *Harriet Taylor Upton's Random Recollections,* ed. Lana Dunn Eisenbraun (Warren, OH: Harriet Taylor Upton Association, 2004), chap. 22, 1–2; chap. 17, 2.

101. Virginia Clark Abbott, "History of Woman Suffrage and League of Women Voters in Cuyahoga County 1911–1945," 11, *Teaching Cleveland Digital* (blog), June 17, 2016, http://teachingcleveland.org/history-of-woman-suffrage-and-league-of-women-voters-in-cuyahoga-county-1911–1945-by-virginia-clark-abbott/.

102. Elaine Weiss, *The Woman's Hour: The Great Fight to Win the Vote* (New York: Penguin, 2018), 200.

103. Susan B. Anthony to Frances Casement Regarding Suffrage Leadership, Jan. 29, 1904, Casement Collection, https://ohiomemory.org/digital/collection/p267401coll32/id/4854/rec/29.

104. Florence Allen and Mary Welles, *The Ohio Woman Suffrage Movement: "A Certain Unalienable Right": What Ohio Women Did to Secure It* (N.p.: Committee for the Preservation of Ohio Woman Suffrage Records, 1952), 38.

105. Upton, *Harriet Taylor Upton's Random Recollections,* chap. 8, 2.

106. Philip R. Shriver, "Harriet Taylor Upton," in *Notable American Women:*

A Biographical Dictionary, ed. Edward T. James and Janet Wilson James, 5 vols. (Cambridge, MA: Belknap Press of Harvard Univ. Press, 1971), 3:502; "Mrs. H. T. Upton, Suffragist, Dead," *New York Times,* Nov. 4, 1945; Harriet Taylor Upton, *A Twentieth Century History of Trumbull County Ohio: A Narrative Account of Its Historical Progress, Its People and Its Principal Interests,* vols. 1 and 2 (Chicago: Lewis Publishing, 1909); Harriet Taylor Upton, *History of the Western Reserve,* vols. 1 and 2 (Chicago: Lewis Publishing, 1910).

107. Shriver, "Harriet Taylor Upton," 50.

108. Sara M. Evans, *Born for Liberty: A History of Women in America* (New York: Free Press, 1989), 153; Eleanor Flexner and Ellen F. Fitzpatrick, *Century of Struggle: The Woman's Rights Movement in the United States* (Cambridge, MA: Harvard Univ. Press, 1996), 248.

109. Kathryn Kish Sklar, "Ohio 1903: Heartland of Progressive Reform," in *Ohio and the World, 1753–2053: Essays Toward a New History of Ohio,* ed. Geoffrey Parker, John Richard Sisson, and William Russell Coil (Columbus: Ohio State Univ. Press, 2005), 118–19.

110. Aileen S. Kraditor, *The Ideas of the Women Suffrage Movement 1890–1920* (New York: Columbia Univ. Press, 1965), 153n48.

111. "The Upton House," Harriet Taylor Upton House website, accessed July 22, 2022, www.uptonhouse.org.

112. Paul E. Fuller, *Laura Clay and the Woman's Rights Movement* (Lexington: Univ. Press of Kentucky, 2021), 162

113. "Mrs. Upton Resigns," *New York Times,* June 6, 1924.

114. Jacqueline Jones Royster, *Profiles of Ohio Women, 1803–2003* (Athens: Ohio Univ. Press, 2003), 197.

115. "Harriet Taylor Upton," Harriet Taylor Upton House website, accessed July 22, 2022, http://www.uptonhouse.org/HTayor.html.

116. "Chapter LVIII: Ohio," 885; "History of the Ohio Federation of Women's Clubs," Dayton Federation of Women's Clubs Records, Special Collections and Archives, MS-187, Wright State Univ., Dayton.

117. Annie Laws, ed., *History of the Ohio Federation of Women's Clubs for the First Thirty Years, 1894–1924* (Cincinnati: Ebert & Richardson Co., n.d.).

118. Frances Harper worked briefly as a sewing instructor in Ohio and became the first female faculty member at Union Seminary. Later, she raised her children on a farm outside Columbus, before starting a reform career that included women's suffrage.

119. Sarah Hunter Graham, *Woman Suffrage and the New Democracy* (New Haven: Yale Univ. Press, 1996), 23.

120. Ella P. Stewart, "Ohio Association of Colored Women Photo," *Student Digital Gallery,* Bowling Green State University Libraries, accessed July 22, 2022, https://digitalgallery.bgsu.edu/student/items/show/8866.

121. Elizabeth D. Katz, "Nellie G. Robinson and Women's Right to Hold Public Office in Ohio," *Akron Law Review* 53 (2019): 314–15, 329, 327–28.

122. Katz, "Nellie G. Robinson," 333.

123. *Reports of Cases Argued and Determined in the Supreme Court of Ohio*, reported by Emilious O. Randall (Norwalk: Laning Printing Company, 1898), 58:612.

124. Susan E. Marshall, *Splintered Sisterhood: Gender and Class in the Campaign against Woman Suffrage* (Madison: Univ. of Wisconsin Press, 1997), 24–25.

125. Susan Goodier, *No Votes for Women: The New York State Anti-Suffrage Movement* (Champaign: Univ. of Illinois Press, 2013), 4, 33–34.

126. "The Remonstrance," *Accessible Archives*, accessed July 22, 2022, https://www.accessible-archives.com/collections/womens-suffrage/the-remonstrance/.

127. "Women's Suffrage Timeline," American Bar Association website, accessed July 22, 2022, https://www.americanbar.org/groups/public_education/programs/19th-amendment-centennial/toolkit/suffrage-timeline/.

128. "Chapter VIII: International Council of Women—Hearing of 1888," in Anthony and Harper, *History of Woman Suffrage*, 4:137.

129. For a discussion of suffragist contributions to the Populist Party, see Jack S. Blocker Sr., "The Politics of Reform: Populists, Prohibition, and Woman Suffrage, 1891–1892," *Historian* 34 (Aug. 1972): 614–32.

130. Ruth Bordin, *Frances Willard: A Biography* (Chapel Hill: Univ. of North Carolina Press, 1986), 219.

131. Michael Pierce, "Farmers and the Failure of Populism in Ohio, 1890–1891," *Agricultural History* 74 (Winter 2000): 77.

132. For a history of the Populist Party in Ohio, see Michael Cain Pierce, *Striking with the Ballot: Ohio Labor and the Populist Party* (Dekalb: Northern Illinois Univ. Press, 2010).

133. Pierce, "Farmers and the Failure of Populism in Ohio," 77.

134. Jon Grinspan, "How a Ragtag Band of Reformers Organized the First Protest March on Washington, D.C.," *Smithsonian*, May 1, 2014, https://www.smithsonianmag.com/smithsonian-institution/how-ragtag-band-reformers-orga nized-first-protest-march-washington-dc-180951270/.

135. Osman C. Hooper, "The Coxey Movement in Ohio," *Ohio Archeological and Historical Quarterly* 9, no. 2 (1900): 155–76; David Palmquest, "The Jacob Sechler Coxey Collection in the Massillon Museum," Massillon Museum website, accessed July 22, 2022, https://massillonmuseum.org/190; Mikaela Lefrak, "Suffragists Were Responsible for the First Peaceful March on Washington," WAMU 88.5, American University Radio, Mar. 28, 2019, https://wamu.org/story/19/03/28/suffragists-were-responsible-for-the-first-peaceful-march-on-washington/.

136. Ohio Women's Suffrage Minutes, 33, Everhard Papers.

137. Marian Morton, "How Cleveland Women Got the Vote and What They Did with It," *Teaching Cleveland Digital* (blog), Jan. 18, 2016, www.teachingcleveland.org/how-cleveland-women-got-the-vote-by-marian-morton/.

138. Gerda Lerner, *The Female Experience: An American Documentary* (New York: Oxford Press, 1992), 358.

139. *Proceedings of the Thirty-Fourth Annual Convention of the National American Woman Suffrage Association and First International Woman Suffrage*

Conference, Held in the First Presbyterian Church, Washington, D.C., February 12th–18th, 1902 (Warren, OH: National Woman Suffrage Association, 1902) 84–85; Kathleen L. Endres, *Akron's "Better Half": Women's Clubs and the Humanization of the City, 1825–1925* (Akron: Univ. of Akron Press, 2006), 85–89.

140. "Chapter LVIII: Ohio," 881.

141. "Chapter LVIII: Ohio," 881.

142. State ex rel. Mills v. Board of Elections of the City of Columbus, 9 Ohio C. C. 134, Dec. 1894.

143. State ex rel. Mills v. Board of Elections of the City of Columbus.

144. Doris Weatherford, *A History of Women in the United States: Nevada-South Dakota* (Ann Arbor, MI: Univ. of Michigan, 2004), 211; Everhard Journal.

145. Allen and Welles, *Ohio Woman Suffrage Movement*, 35.

146. Brown, "Massillon Native Was State Suffrage Leader and Banking Industry Innovator."

147. Allen and Welles, *Ohio Woman Suffrage Movement*, 37.

148. Sally Farran Bulford, "Ohio Continues Lead for Women's Rights," *Columbus Business First*, Sept. 8, 1997.

149. Upton, "Woman Suffrage Movement in Ohio," 333.

150. *The Weekly Law Bulletin and the Ohio Law Journal:* vol. 35, *January 1–June 31, 1896,* conducted by Carl G. Jahn (Columbus: n.p., 1896), 113.

151. Lerner, *Female Experience*, 357–60.

152. Rosa Segur, Toledo Woman's Suffrage Association report, Oct. 1866, Casement Collection, https://ohiomemory.org/digital/collection/p267401coll32/id/28146.

4. *The Ohio Women's Rights Movement during the Progressive Era*

1. "Ohio Women's School Vote," *Woman's Column,* Apr. 7, 1900.

2. Glenda Gates Riley, "The Subtle Subversion: Changes in the Traditionist Image of American Women," *Historian* 32 (Feb. 1970): 210.

3. "Why Women Want the Vote," *Stark County Democrat* (Canton, OH), Apr. 20, 1900.

4. Martha G. Stapler, ed., *The Woman Suffrage Yearbook* (New York: National Woman Suffrage Publishing Company, 1917), 169.

5. Sara Egge, *Woman Suffrage and Citizenship in the Midwest, 1870–1920* (Iowa City: Univ. of Iowa Press, 2018), 262.

6. Egge, *Woman Suffrage and Citizenship in the Midwest,* 76–77.

7. Trisha Franzen, *Anna Howard Shaw: The Work of Woman Suffrage* (Urbana: Univ. of Illinois Press, 2014), 122, 127, 12, 65.

8. Franzen, *Anna Howard Shaw,* 22, 125, 142.

9. Kathryn Kish Sklar, "Ohio 1903: Heartland of Progressive Reform," in *Ohio and the World, 1753–2053: Essays Toward a New History of Ohio,* ed. Geoffrey Parker, Richard Sisson, and William Russell Coil (Columbus: Ohio State Univ. Press, 2005), 118–19.

10. Eileen R. Rausch, "Let Ohio Women Vote: The Years to Victory, 1900–1920" (PhD diss., University of Notre Dame, 1984), 80.

11. Cathleen D. Cahill, *Recasting the Vote: How Women of Color Transformed the Suffrage Movement* (Chapel Hill: Univ. of North Carolina Press, 2020), 60.

12. Linda M. Carter, "Carrie Williams Clifford," in *Notable Black American Women,* book 1, ed. Jessie Carney Smith and Shirelle Phelps (Detroit, MI: Gage Research, 1992), 105–7; Einav Rabinovitch-Fox, updated, "Carrie Williams," in *Encyclopedia of Cleveland History,* ed. John J. Grabowski, Case Western Reserve Univ., 2022, https://case.edu/ech/articles/c/clifford-carrie-williams.

13. Cahill, *Recasting the Vote,* 62, 128.

14. Cahill, *Recasting the Vote,* 67.

15. "Clifford, Carrie Williams," in *African American Women: A Biographical Dictionary,* ed. Dorothy C. Salem (New York: Garland, 1993), 110–12.

16. Cahill, *Recasting the Vote,* 108.

17. Martha S. Jones, "The US Suffragette Movement Tried to Leave out Black Women: They Showed up Anyway," *Guardian* (New York), July 7, 2020, https://www.theguardian.com/us-news/2020/jul/07/us-suffragette-movement-black-women-19th-amendment.

18. "New York Negroes in Silent Parade Protest Lynching," *Evening World* (New York), July 28, 1917.

19. Carter, "Carrie Williams Clifford," 105–7.

20. "Hunter, Jane Edna (Harris)," in Grabowski, *Encyclopedia of Cleveland History,* https://case.edu/ech/articles/h/hunter-jane-edna-harris. For a biography of Hunter, see Adrienne L. Jones, *Jane Edna Hunter: A Case Study of Black Leadership, 1910–1950* (Brooklyn, NY: Carlson Publishing, 1990).

21. Darlene Clark Hine, *Hine Sight: Black Women and the Re-construction of American History* (Bloomington: Indiana Univ. Press, 1997), 118.

22. Salem, "Hunter, Jane Edna," 261–63; John Hansan, "Jane Edna Hunter (1882–1971)—Social Worker, Advocate for Women and Founder of the Phillis Wheatley Association," *Social Welfare History Project,* Virginia Commonwealth Univ., 2014, http://socialwelfare.library.vcu.edu/eras/great-depression/hunter-jane-edna/.

23. Jones, *Jane Edna Hunter,* 52.

24. Jane Edna Hunter, *A Nickel and a Prayer* (Nashville: Parthenon Press, 1940).

25. Virginia R. Boynton, "Jane Edna Hunter and Institution Building in Ohio," in *Builders of Ohio: A Biographical History,* ed. Michael Cain Pierce, Michael Dale Pierce, and Warren R. Van Tine (Columbus: Ohio Univ. State Press, 2003), 239.

26. "Jewelia Ann Galloway Higgins," *Profiles in Leadership,* West Dayton YWCA website, accessed July 22, 2022, https://www.ywcadayton.org/black-history-month/.

27. "Mrs. Jewelia Higgins Dies; West Side Civic Leader," *Dayton Journal Herald,* Dec. 16, 1955.

28. Pauline Steinem, "Why I Am a Suffragist," *Toledo Blade,* Oct. 28, 1914.

29. Perlmutter Steinem's birth date varies among sources; some indicate 1863, others 1864, and others 1886.

30. "Pauline Steinem Opts for Woman Suffrage and Theosophy," in *The American Jewish Woman: A Documentary History,* ed. Jacob Rader Marcus (New York: KTAV, 1981), 697.

31. Marta Whitlock, ed., *Women in Ohio History,* Ohio American Revolution Bicentennial Conference series, no. 2 (Columbus: Ohio American Revolution Bicentennial Advisory Commission, by the Ohio Historical Society, 1976), 15.

32. Lisa Wood, "The Inspiring Pauline Perlmutter Steinem," History blog, Ohio History Connection, Aug. 17, 2021, https://www.ohiohistory.org/the-inspiring-pauline-perlmutter-steinem/.

33. Gloria Steinem, "Pauline Perlmutter Steinem," *Shalvi/Hyman Encyclopedia of Jewish Women,* Jewish Women's Archive, Dec. 31, 1999, https://jwa.org/encyclopedia/article/steinem-pauline-perlmutter.

34. "Wouldn't Have Husbands Do the Thinking for Wives," *Dayton Herald,* Mar. 22, 1911.

35. Wood, "Inspiring Pauline Perlmutter Steinem."

36. "Toledo's Steinem Was Early Woman Leader," *Xenia Daily Gazette,* Apr. 29, 1976.

37. Whitlock, *Women in Ohio History,* 18.

38. Aileen S. Kraditor, *The Ideas of the Woman Suffrage Movement, 1890–1920* (New York: W. W. Norton, 1981), 224.

39. Sarah Hunter Graham, *Woman Suffrage and the New Democracy* (New Haven: Yale Univ. Press, 1996), 41n27; Sara Hunter Graham, "The Suffrage Renaissance: A New Image for a New Century, 1896–1910," in *One Woman, One Vote: Rediscovering the Woman Suffrage Movement,* ed. Marjorie Spruill Wheeler (Tillamook, OR: New Sage Press, 1995), 166–67.

40. "Tilt at Teachers' Meeting," *Marion Daily Mirror,* July 1, 1910.

41. "Pauline Steinem Opts for Women's Suffrage and Theosophy," 700.

42. "Pauline Steinem of Toledo Dies," *Newark Advocate,* Jan. 6, 1940; Sandra Gurvis, "Toledo Trendsetter: Pauline Perlmutter Steinem," *Pathways* 30 (Winter 2019), 10.

43. Greta Anderson, *More Than Petticoats: Remarkable Ohio Women* (Guilford, CT: Globe Pequot Press, 2005), 96.

44. Florence Allen, *To Do Justly* (Cleveland: Press of Western Reserve Univ., 1940), 9–10.

45. Jeannette E. Tuve, *First Lady of the Law: Florence Ellinwood Allen* (Boston: Univ. Press of America, 1984), 10; Morton, "Florence E. Allen."

46. Anderson, *More Than Petticoats,* 101.

47. "Florence Ellinwood Allen," in *Notable American Women: The Modern Period—A Biographic Dictionary,* ed. Barbara Sicherman and Carol Hurd Green (Cambridge, MA: Belknap Press of Harvard Univ. Press, 1980), 11–13.

48. "Florence Ellinwood Allen," Supreme Court of Ohio & the Ohio Judicial System website, accessed Aug. 4, 2022, https://www.supremecourt.ohio.gov/SCO/formerjustices/bios/allen.asp.

49. Allen, *To Do Justly,* 43–44, 28.

50. Anderson, *More Than Petticoats*, 105.

51. Morton, "Florence E. Allen"; Sicherman and Green, *Notable American Women*, 11–13.

52. Tracy A. Thomas, "The Jurisprudence of the First Woman Judge, Florence Allen: Challenging the Myth of Women Judging Differently," *William & Mary Journal of Race, Gender, and Social Justice* 27, no. 2 (2020–21): 296.

53. Thomas, "Jurisprudence of the First Woman Judge, Florence Allen," 293, 306.

54. "Florence Ellinwood Allen," National Women's Hall of Fame, website, accessed Aug. 30, 2022, https://www.womenofthehall.org/inductee/florence-ellin wood-allen/

55. "Hauser, Elizabeth," in Grabowski, *Encyclopedia of Cleveland History*, https://case.edu/ech/articles/h/hauser-elizabeth; Joan E. Organ, "Florence E. Allen and 'Great Changes in the Status of Women,'" in Pierce, Pierce, and Van Tyne, *Builders of Ohio*, 222; Elizabeth J. Hauser, "The Woman Suffrage Movement in Ohio," *Ohio Illustrated Magazine* (Feb. 1908): 83–92.

56. Rausch, "Let Ohio Women Vote," 51–52.

57. Rausch, "Let Ohio Women Vote," 51–52; Virginia Clark Abbott, "History of Woman Suffrage and League of Women Voters in Cuyahoga County 1911–1945," 12, *Teaching Cleveland Digital* (blog), June 17, 2016, http://teachingcleveland.org/history-of-woman-suffrage-and-league-of-women-voters-in-cuyahoga-county-1911 –1945-by-virginia-clark-abbott/.

58. Abbott, "History of Woman Suffrage and League of Women Voters," 14–15.

59. Hauser, "Woman Suffrage Movement in Ohio."

60. "Du Pont, Zara," in Grabowski, *Encyclopedia of Cleveland History*, https://case.edu/ech/articles/d/du-pont-zara; Florence Luscomb and Sharon Hartman Strom, *Political Woman: Florence Luscomb and the Legacy of Radical Reform* (Philadelphia: Temple Univ. Press, 2001), 112.

61. Rausch, "Let Ohio Women Vote," 124.

62. Abbott, "History of Woman Suffrage and League of Women Voters," 20–21.

63. Rosalyn Terborg-Penn, "African American Women and the Woman Suffrage Movement," in Wheeler, *One Woman, One Vote*, 148.

64. Marjorie Spruill Wheeler, *New Women of the New South: The Leaders of the Woman Suffrage Movement in the Southern States* (New York: Oxford Univ. Press, 1993), 120.

65. Franzen, *Anna Howard Shaw*, 119.

66. Dianne G. Bystrom and Barbara C. Burell, eds., *Women in the American Political System: An Encyclopedia of Women as Voters, Candidates, and Office Holders* (Santa Barbara, CA, ABC-CLIO, 2018), 327.

67. Jacqueline Ching and Juliet Ching, *Women's Rights* (New York: Rosen, 2001), 47, 64.

68. Ching and Ching, *Women's Rights*, 66, 56.

69. "Chapter LVIII: Ohio," in *The History of Woman Suffrage:* vol. 4 of 6, *1883–1900*, ed. Susan B. Anthony and Ida Husted Harper (Indianapolis, IN: Hollenbeck Press, 1902), 879–80.

70. "State Correspondence—Ohio," *Woman's Journal*, June 24, 1905.

71. Rausch, "Let Ohio Women Vote," 68, 69, 71.

72. Steven M. Buechler, *The Transformation of the Woman Suffrage Movement: The Case of Illinois, 1850–1920* (New Brunswick, NJ: Rutgers Univ. Press, 1986), 200.

73. Cynthia Wilkey, "Diversity and Woman Suffrage: A Case Study of the Dayton Woman Suffrage Association in the 1912 Referendum Campaign," *Ohio History* 112 (Winter–Spring 2003): 31–32.

74. Marjorie Spruill Wheeler, "A Short History of the Woman Suffrage Movement in America," in Wheeler, *One Woman, One Vote*, 13.

75. Sara Egge, "How Midwestern Suffragists Won the Vote by Attacking Immigrants," *Smithsonian Magazine*, Sept. 17, 2018, https://www.smithsonianmag.com/history/how-midwestern-suffragists-won-vote-by-attacking-immigrants-180970298/.

76. Graham, *Woman Suffrage and the New Democracy*, 68.

77. Wilkey, "Diversity and Woman Suffrage," 29–30.

78. Egge, *Woman Suffrage and Citizenship in the Midwest*, 76–77.

79. Harriet Taylor Upton to Vadae V. Meekison, June 20, 1912, MS 211, Vadae G. Meekison Collection: Transcripts (1912), *Finding Aids*, Bowling Green State Univ. Libraries, May 7, 2014, Lib.bgsu.edu/finding_aids/items/show/1902.

80. Katherine M. Marino, *Feminism for the Americas: The Making of an International Human Rights Movement* (Chapel Hill: Univ. of North Carolina Press, 2019).

81. Graham, *Woman Suffrage and the New Democracy*, 24.

82. *Proceedings of the Thirty-Sixth Annual Convention of the National American Woman Suffrage Association, Held at Washington, D.C., February 11th to 17th, 1904* (Warren, OH: William Ritezel & Company, 1904), 94.

83. Rausch, "Let Ohio Women Vote," 53.

84. Harriet Taylor Upton to Vadae G. Meekison, Aug. 14, 1912, MS 211, Vadae G. Meekison Collection: Transcripts (1912), *Finding Aids*, Bowling Green State Univ. Libraries.

85. Wilkey, "Diversity and Woman Suffrage," 32, 35, 29.

86. "Negro Citizens Hold a Suffrage Meeting," *Dayton Daily News*, Aug. 17, 1912.

87. Boynton, "Jane Edna Hunter and Black Institution Building in Ohio," 234.

88. Virginia Boynton, "Contested Terrain: The Struggle over Gender Norms for Black Working-Class Women in Cleveland's Phillis Wheatley Association, 1920–1950," *Ohio History Journal* 103 (Winter–Spring 1994): 8–9.

89. Ellen Carol DuBois, "Working Women, Class Relations, and Suffrage Militance: Harriot Stanton Blatch and the New York Woman Suffrage Movement, 1894–1909," in Wheeler, *One Woman, One Vote*, 225–26.

90. Diane Balser, *Sisterhood and Solidarity: Feminism and Labor in Modern Times* (Boston: South End Press, 1987), 35.

91. *The Mothers' Pension Act: A Law Providing for Pensions for Needy Mothers, Codifying the Child Labor Laws and Providing Aid for Needy Blind Persons* (Columbus: F. J. Heer Printing Company, 1913).

92. Joan Marie Johnson, "Following the Money: Wealthy Women, Feminism, and the American Suffrage Movement," *Journal of Women's History* 27, no. 4 (2015): 67.

93. Rausch, "Let Ohio Women Vote," 118.

94. "Chapter XXXIV: Ohio," in *The History of Woman Suffrage:* vol. 6 of 6, *1900–1920*, ed. Ida Husted Harper (New York: National American Woman Suffrage Association, 1922), 511.

95. Rausch, "Let Ohio Women Vote," 119.

96. Osman Castle Hooper, *History of the City of Columbus, Ohio: From the Founding of Franklinton in 1797, through the World War Period, to the Year 1920* (Columbus: Memorial Publishing, 1920), 66.

97. "Still Standing," *Dayton Magazine*, Nov. 19, 2019, https://www.thedayton magazine.com/still-standing/.

98. Emily Reth, "Newspapers and the Public's Perception," *Out of the Box* (blog), Wright State Univ. Libraries and Special Collections, Apr. 6, 2018, https://www.libraries.wright.edu/community/outofthebox/2018/04/06/newspapers-and-the-publics-perception/.

99. Elli Mambakidis, "Women's Suffrage Association and League of Women Voters: A Special Collection of Historical Materials at the Dayton & Montgomery County Public Library, Dayton, Ohio, 1998," 10, 23, MS-004.

100. "Quinby, H. Anna," in *Woman's Who's Who of America: A Biographical Dictionary of Contemporary Women of the United States and Canada, 1914–1915*, ed. John William Leonard (New York: American Commonwealth Company, 1914), 668.

101. Ohio Taxpayers League, *Equal Franchise Bulletin* 1, no. 4 (Aug. 1, 1912): 5, in Belva Ann Lockwood Papers, SCPC-DG-098, Swarthmore College Peace Collection, Lockwood-0095, Swarthmore, PA.

102. Abbott, "History of Woman Suffrage and League of Women Voters," 12–13.

103. Jessica R. Pliley, "Voting for the Devil: Unequal Partnerships in the Ohio Women's Suffrage Campaign of 1914," *Ohio History* 115 (2008): 17; Elizabeth J. Hauser, "A Few Facts in Ohio's History," *Woman Voter*, Aug. 1912, 8–9.

104. Lee Rinsky, "The Cincinnati Suffrage Movement" (master's thesis, University of Cincinnati, 1968), 51.

105. Pliley, "Voting for the Devil," 17.

106. *Journal of the Constitutional Convention of the State of Ohio* (Columbus: F. J. Heer Printing Company, 1912), 277.

107. Buechler, *Transformation of the Woman Suffrage Movement*, 171.

108. Egge, *Woman Suffrage and Citizenship in the Midwest*, 15.

109. Victoria Bissell Brown, "Jane Addams, Progressivism, and Woman Suffrage: An Introduction to 'Why Women Should Vote,'" in Wheeler, *One Woman, One Vote*, 180–81.

110. Buechler, *Transformation of the Woman Suffrage Movement*, 192.

111. Karen J. Blair, "The State of Research on Pacific Northwest Women," *Frontiers: A Journal of Women Studies* 22, no. 3 (2001): 50.

112. Carl Sferrazza Anthony, *Ida McKinley: The Turn-of-the-Century First Lady through War, Assassination, and Secret Disability* (Kent, OH: Kent State Univ. Press, 2013), 19.

113. Anthony, *Ida McKinley*, 183.

114. "Mrs. McKinley Makes Clothes for Doll Baby," *Philadelphia Inquirer*, Nov. 30, 1900.

115. "First Lady Ida McKinley," *C-SPAN*, June 10, 2013, https://www.c-span.org /video/?310740–1/lady-ida-mckinley.

116. Ida Husted Harper, Carrie Chapman Catt, and National American Woman Suffrage Association (Library of Congress), *The Life and Work of Susan B. Anthony* (Indianapolis, IN: Bowen-Merrill, 1898–1908), 1169, 1272–73.

117. Sarah Stook, "How America's Presidents Viewed Women's Suffrage," *Elections Daily*, July 23, 2020, https://elections-daily.com/2020/07/23/how-americas -presidents-viewed-womens-suffrage/.

118. Louise Knight, "Theodore Roosevelt and the Campaign for Women's Suffrage," YouTube video, 1:07:16, Theodore Roosevelt 2016 Symposium, Theodore Roosevelt Center, Mar. 7, 2017, posted by Theodore Roosevelt Center at Dickinson Univ., youtu.be/Alxmk-BmNiM.

119. Sylvia Morris, *Edith Kermit Roosevelt: Portrait of a First Lady* (New York: Random House, 2009), 98; "First Lady Biography: Edith Roosevelt," *National First Ladies Library*, accessed Aug. 4, 2022, http://www.firstladies.org/biographies /firstladies.aspx?biography=26; "First Lady Biography: Lucy Hayes," *National First Ladies Library*, accessed July 21, 2022, http://www.firstladies.org/biographies/first ladies.aspx?biography=20.

120. "President Taft Hissed by Woman Suffragists," Apr. 15, 1910, newspaper clipping, available in Ann Lewis Women's Suffrage Collection, 2012–15, https:// lewissuffragecollection.omeka.net/items/show/1313.

121. Stook, "How America's Presidents Viewed Women's Suffrage."

122. Alana S. Jeydel, *Political Women: The Women's Movement, Political Institutions, the Battle for Women's Suffrage and the ERA* (New York: Routledge, 2004), 126–27.

123. "Debs and Women's Rights—A Lifetime Commitment," Debs Foundation website, Debsfoundation.org/index.php/landing/debs-biography/womens-right.

124. Josephine Congen-Kanego, "The Significance of the Defeat in Ohio," *Progressive Woman*, Oct. 1912, 6–7.

125. Graham, *Woman Suffrage and the New Democracy*, 17–18.

126. DuBois, "Working Women, Class Relations, and Suffrage Militance," 241.

127. Greg Hand, "Cincinnati's Suffragettes: More Polite Than England, but Frightening to Cincinnati Men," *Cincinnati Magazine*, Mar. 28, 2016, https:// www.cincinnatimagazine.com/citywiseblog/cincinnatis-suffragettes-polite-eng land-frightening-cincinnati-men/.

128. Abbott, "History of Woman Suffrage and League of Women Voters," 18.

129. Abbott, "History of Woman Suffrage and League of Women Voters," 19, 20.

130. "Ohio," *Woman's Journal*, Jan. 14, 1911.

131. Harriet Taylor Upton, "The Woman Suffrage Movement in Ohio," in *History of Ohio*, ed. Charles B. Galbreath, 5 vols. (Chicago: American History Society, 1925), 2:334.

132. "The Woman Voter," n.d., newspaper clipping in Carrie Chapman Catt Papers, reel 8, Library of Congress.

133. "Chapter XVII: National American Convention of 1917," in *The History of Woman Suffrage*, vol. 5 of 6, *1900–1920*, ed. Ida Husted Harper (New York: National American Woman Suffrage Association, 1922), 538.

134. "Mary Hutchinson Page to Fellow Members of Boston Equal Suffrage Association for Good Government, May 27, 1914," Breckenridge Family Papers, box 702, Library of Congress; "State Suffrage School," Madison, WI, June 18–24, 1914, broadside, available at *WorthPoint.com*, https://www.worthpoint.com/worthopedia/1914-wisconsin-womans-suffrage-15739086.

135. "Chapter XXXIV: Ohio," 509.

136. Wheeler, "Short History of the Woman Suffrage Movement in America," 14.

137. Eleanor Flexner and Ellen F. Fitzpatrick, *Century of Struggle: The Woman's Rights Movement in the United States* (Cambridge, MA: Belknap Press of Harvard Univ. Press, 2000), 256.

138. Jessica Derleth, "Chivalrous or Cowardly? Suffragists, Antisuffragists, and Competing Definitions of American Manhood," American Historical Association Conference, Jan. 5–8, 2017, Denver, CO.

139. Allison Lange, "National Association Opposed to Woman Suffrage," National Women's History Museum website, Fall 2015, http://www.crusadeforthe vote.org/naows-opposition. For a discussion of anti-suffragism during the Progressive Era, see Manuela Thurner, "Better Citizens without the Ballot: American Anti-Suffrage Women and Their Rationale during the Progressive Era," *Journal of Women's History* 5 (Spring 1993): 33–60.

140. National Association Opposed to Woman Suffrage, *Some Reasons Why We Oppose Votes for Women* (New York: National Association Opposed to Woman Suffrage, 1894).

141. Leslie J. Harris, "'Whores' and 'Hottentots': Protection of (White) Women and White Supremacy in Anti-Suffrage Rhetoric," *Quarterly Journal of Speech* 106, no. 3 (2020): 253–57.

142. Kathryn Smith, "The 1912 Constitutional Campaign and Woman's Suffrage in Columbus, Ohio" (master's thesis, Ohio State University, 1980), 51.

143. Patty DeVoe, "Profile: Susan Platt Hubbard and Anti-Suffragism in Old Lyme," Florence Griswold Museum, https://florencegriswoldmuseum.org/profile -susan-platt-hubbard-and-anti-suffragism-in-old-lyme/; "Hubbard, Susan Platt," in *Woman's Who's Who of America*, ed. John W. Leonard (New York: American Commonwealth Company, 1914), 411.

144. Susan Hubbard, "Power without Responsibility—The Certain Consequence of Equal Suffrage," *Ohio Journal of Commerce* (Columbus), Jan. 6, 1912, 228.

145. Susan Hubbard, "Too Sweeping, Says Anti-Suffragettes," *New Long Day* (New London, CT), Mar. 18, 1919.

146. DeVoe, "Profile."

147. DeVoe, "Profile."

148. "1912: Competing Visions for America," Ohio State Univ. Department of History website, accessed Aug. 30, 2022, https://ehistory.osu.edu/exhibitions /1912/default.

149. "Women of Ohio Protest against Use of 'War Meetings' to Raise Funds for Susan B. Anthony Bill," *Woman Patriot,* June 15, 1918.

150. "Florence Goff Schwartz Dies; Clubwoman Wrote Poetry; Was Active Anti-Suffragist," *Cincinnati Enquirer,* Aug. 15, 1946.

151. "Is Woman Man's Equal," in "Comparison in Verse," *1912: Competing Visions for America,* Ohio State Univ. Department of History website, accessed Aug. 30, 2022, https://ehistory.osu.edu/exhibitions/1912/womens_suffrage/ ComparisonsVerse.

152. David M. Dismore, "Today in Feminist History: The Temporary Halt in Ohio," *Ms. Magazine,* Sept. 3, 2020, https://msmagazine.com/2020/09/03/today -in-feminist-history-the-temporary-halt-in-ohio-september-3-1912/.

153. "Harm to Women and the Race Would Result from Giving Suffrage to 'Weaker Sex,' Declares Mrs. Scott at Massive Meeting of Anti-Suffragettes," *Cincinnati Enquirer,* June 26, 1912.

154. *Comparison of the Laws of Ohio and Colorado* (Cincinnati: Cincinnati and Hamilton County Association Opposed to Woman Suffrage, n.d.); *Suffrage and Socialism: The Deadly Parallel* (Cincinnati: Cincinnati and Hamilton County Association Opposed to Woman Suffrage, n.d.).

155. Frances Maule, Annie Porritt, and Carrie Chapman Catt, *The Blue Book: Woman Suffrage History, Arguments and Results* (New York: National Woman Suffrage Publishing Co., 1917), 127.

156. *Proceedings and Debates of the Constitutional Convention of the State of Ohio—1912,* 2 vols. (Columbus: F. J. Heer Printing Company, 1912), 1:1–19.

157. Rausch, "Let Ohio Women Vote," 95.

158. Kenneth Florey, *Women's Suffrage Memorabilia: An Illustrated Historical Study* (Jefferson, NC: McFarland, 2013), 211.

159. "Women Organize Fight for Votes," *Cleveland Plain Dealer,* Nov. 12, 1910.

160. "Organize to Open Fight for Ballot," *Cleveland Plain Dealer,* Dec. 2, 1910.

161. "Will Ohio Be Sixth," *Cleveland Plain Dealer,* Nov. 11, 1910.

162. Rausch, "Let Ohio Women Vote," 77.

163. Rausch, "Let Ohio Women Vote," 66.

164. Florey, *Women's Suffrage Memorabilia,* 44.

165. Marian Morton, "Winning the Ballot," *Women in Cleveland: An Illustrated History* (Bloomington: Indiana Univ. Press, 1995), 174.

166. "Ohio," *Woman's Journal,* Dec. 31, 1910.

167. Rinsky, "Cincinnati Suffrage Movement," 442.

168. "Take No Stand on Votes for Women," *Cleveland Plain Dealer,* Oct. 20, 1911; Ohio Federation of Women's Clubs, *History of the Ohio Federation of Women's Clubs for the First Thirty Years,* ed. Annie Laws (Cincinnati: Ebbert & Richardson, 1925), 230.

169. Herbert Seely Bigelow, *Journal of the Constitutional Convention of the State of Ohio: Convened January 9, 1912; Adjourned June 7, 1912; Reconvened and Adjourned without Delay August 26, 1912* (Columbus: F. J. Heer Printing Company, 1912), 152; Elizabeth Schmidt, "Biographical Sketch of Clara Snell Wolfe," Center for the Historical Study of Women and Gender website, State University of New York, Binghamton, https://chswg.binghamton.edu/WASM-US/crowdsourcing/CaraSnellWolfe.html.

170. "Take No Stand on Votes for Women."

171. Marian Morton, "Elizabeth J. Hauser: The Woman Who Wrote Tom L. Johnson's Autobiography," *Teaching Digital Cleveland* (blog), Feb. 6, 2021, https://teachingcleveland.org/elizabeth-j-hauser-the-woman-who-wrote-tom-l-johnsons-autobiography-by-marian-j-morton/.

172. Smith, "1912 Constitutional Campaign and Woman's Suffrage in Columbus, Ohio," 53, 71.

173. Abbott, "History of Woman Suffrage and League of Women Voters," 17–18.

174. "Ohio Women Are Seeking Votes," *Woman's Journal*, 20 Jan. 1912, 21.

175. Susan B. Anthony and Elizabeth Cady Stanton, *Proceedings of the Annual Convention of the National American Woman Suffrage Association* (New York: NAWSA, 1912), 64.

176. Rausch, "Let Ohio Women Vote," 103.

177. Smith, "1912 Constitutional Campaign and Woman's Suffrage in Columbus, Ohio," 30.

178. "Bigelow Facing an Insurrection," *Cleveland Plain Dealer*, Feb. 8, 1912.

179. Barbara A. Terzian, "Ohio's Constitutions: An Historical Perspective," *Cleveland State Law Review* 35 (2004): 390.

180. "Anti-Suffrage Fight Started: Columbus Women to Oppose Votes for Fair Sex," *Democratic Banner* (Mt. Vernon, OH), Feb. 13, 1912.

181. Rausch, "Let Ohio Women Vote," 107.

182. DeVoe, "Profile"; Ralph Mikesell, "The Woman Suffrage Movement in Ohio, 1910–1920" (master's thesis, Ohio State University, 1934), 33.

183. "A Hot Time in Ohio," *Woman's Journal*, Mar. 2, 1912.

184. Barbara A. Terzian, "Let Us Agitate," in *The History of Ohio Law*, vol. 1, ed. Michael Les Benedict and John F. Winkler (Athens: Ohio Univ. Press, 2004), 390.

185. "Chapter XXXIV: Ohio," 511.

186. Hubbard, "Power without Responsibility," 228.

187. Smith, "1912 Constitutional Campaign and Woman's Suffrage in Columbus, Ohio," 31, 19.

188. "Scott, Bertha Lane," in Leonard, *Woman's Who's Who of America*, 723.

189. Egge, *Woman Suffrage and Citizenship in the Midwest*, 36.

190. "Hope for Aid of Suffrage Leader—Chiefs of Movement Here Expect Mrs. Pankhurst Will Help," *Cleveland Plain Dealer*, Oct. 19, 1911; "Suffragist Chief Holds Big Crowd," *Cleveland Plain Dealer*, Oct. 21, 1911.

191. Jane Purvis, *Emmeline Pankhurst: A Biography* (New York: Routledge, 2003), 173.

192. Smith, "1912 Constitutional Campaign and Woman's Suffrage in Columbus, Ohio," 32.

193. *Proceedings and Debates of the Constitutional Convention of the State of Ohio*, 607.

194. Upton, "Woman Suffrage Movement in Ohio," 333.

195. Upton, "Woman Suffrage Movement in Ohio," 333.

196. "Tied to an Apron String After All," *Cleveland Gazette*, Apr. 6, 1912.

197. Smith, "1912 Constitutional Campaign and Woman's Suffrage in Columbus, Ohio," 39.

198. *Proceedings and Debates of the Constitutional Convention of the State of Ohio*, 443, 559, 854.

199. Elizabeth Katz, "'A Woman Stumps Her State': Nellie G. Robinson and Women's Right to Hold Public Office in Ohio," *Akron Law Review* 53 (2019): 350, 342.

200. Maureen O'Connor would become the first woman chief justice in Ohio in 1992.

201. *Ohio Constitutional Convention 1912: Proposals for Amendments as Introduced*, Proposal No. 163 (1912), appendix, available at Ohio Supreme Court website, https://www.supremecourt.ohio.gov/LegalResources/LawLibrary/resources/appendix.pdf; Katz, "Woman Stumps Her State," 353.

202. Katz, "Woman Stumps Her State," 350.

203. Smith, "1912 Constitutional Campaign and Woman's Suffrage in Columbus, Ohio," 20.

204. *Proceedings and Debates of the Constitutional Convention of the State of Ohio*, 614.

205. *Proceedings and Debates of the Constitutional Convention of the State of Ohio*, 600–639.

206. Terzian, "Ohio's Constitutions," 393n205.

207. Abbott, "History of Woman Suffrage and League of Women Voters," 18; D. C. Shilling, "Women's Suffrage in the Constitutional Convention of Ohio," *Ohio History* 25 (1916): 173–74.

208. Smith, "1912 Constitutional Campaign and Woman's Suffrage in Columbus, Ohio," 207.

209. "Ohio the Seventh!," *Woman's Journal*, Mar. 16, 1912.

210. "Cleveland Workers Will 'Show Them,'" *Woman's Journal*, Apr. 13, 1912.

211. Ruth Y. White, *We Too Built Columbus* (Columbus: Stoneman Press, 1936), 387.

212. Smith, "1912 Constitutional Campaign and Woman's Suffrage in Columbus, Ohio," 53.

213. Allen, *To Do Justly*, 32.

214. Anderson, *More Than Petticoats*, 98.

215. "Darlington Green Dies in Cleveland," *Zanesville Times Recorder*, May 21, 1909.

216. "Suffragists Plan Party," *Cincinnati Times Star*, Jan. 13, 1912.

217. Abbott, "History of Woman Suffrage and League of Women Voters," 21.

218. Abbott, "History of Woman Suffrage and League of Women Voters," 13.

219. Abbott, "History of Woman Suffrage and League of Women Voters," 12–16, 20–21, 22.

220. Rausch, "Let Ohio Women Vote," 141, 33–43.

221. "Hurrah for Ohio!," *Woman's Journal*, June 8, 1912.

222. "On the Road to Victory," *Woman's Journal*, July 13, 1912.

223. Abbott, "History of Woman Suffrage and League of Women Voters," 147–49.

224. Abbott, "History of Woman Suffrage and League of Women Voters," 23–24.

225. Mikesell, "Woman Suffrage Movement in Ohio," 29.

226. Smith, "1912 Constitutional Campaign and Woman's Suffrage in Columbus, Ohio," 49.

227. Rausch, "Let Ohio Women Vote," 133.

228. Abbott, "History of Woman Suffrage and League of Women Voters," 25.

229. Smith, "1912 Constitutional Campaign and Woman's Suffrage in Columbus, Ohio," 50.

230. "Discard Autos to March in Big Suffrage Parade," *Salem News*, Aug. 23, 1912.

231. "10,000 Feet for Freedom: Ohio's 1912 Women's Suffrage Parade," *Southeast Ohio History Center* (blog), accessed Aug. 4, 2022, https://athenshistory.org/10000-feet-for-freedom-ohios-1912-womens-suffrage-parade-march-26-2020-530pm-to-730pm/.

232. Mikesell, "Woman Suffrage Movement in Ohio," 26.

233. Pliley, "Voting for the Devil," 13.

234. Rausch, "Let Ohio Women Vote," 127.

235. Abbott, "History of Woman Suffrage and League of Women Voters," 22.

236. "Woman Dotes on Crowds Secured by Opposition," *Dayton Herald*, Aug. 12, 1912.

237. "Calls Ohio Voters Just on Suffrage," *Cleveland Plain Dealer*, Aug. 14, 1912.

238. "Suffragette Worker Speaks to Large Akron Audience," *Akron Beacon Journal*, July 29, 1912.

239. Elisa Miller, "Biographical Sketch of Louise Hall," in *Mainstream Suffragists—National American Woman Suffrage Association*, part 3, available at *AlexanderStreet.com*, accessed Aug. 4, 2022, https://documents.alexanderstreet.com/d/1010596358; "Big Suffrage Meeting," *Hamilton Evening Journal*, July 12, 1912.

240. Morton, "Winning the Ballot," 180.

241. Susan Ware, *Why They Marched: Untold Stories of the Women Who Fought for the Right to Vote* (Cambridge, MA: Harvard Univ. Press, 2019), 218.

242. Sarah Eisenstein, *Give Us Bread but Give Us Roses: Working Women's Consciousness in the United States, 1890 to the First World War* (New York: Routledge, 1983), 32.

243. Alice Kessler-Harris, *Gendering Labor History* (Urbana: Univ. of Illinois Press, 2007), 76.

244. Annelise Orleck, *Common Sense and a Little Fire: Women and Working-Class Politics in the United States, 1900–1965* (Chapel Hill: Univ. of North Carolina Press, 2017), 105.

245. *Sixth Report of the Boston Equal Suffrage Association for Good Government, 1910–1912*, Women's Rights Collection, folder 716, Arthur and Elizabeth Schlesinger Library, Radcliffe Institute for Advanced Study, Harvard University.

246. NAWSA, *Victory: How Women Won It* (Whitefish, MT: Literary Licensing, 2012), 78.

247. "Ohio in Line for Suffrage," *San Francisco Call*, June 16, 1912.

248. Rinsky, "Cincinnati Suffrage Movement," 51.

249. "Girl Workers Cheer Plea for Suffrage," *Cincinnati Post*, May 9, 1912.

250. "Chapter XXXIV: Ohio," 510.

251. Charles H. Graves, *Annual Statistical Report of the Secretary of State to the Governor and General Assembly of the State of Ohio for the Year Ending November 15, 1912* (Springfield: Springfield Publishing Company, 1913), 674–75. According to this report, the final vote tally by most populated counties regarding proposed amendment 23 were

	For	Against
Cuyahoga (Cleveland):	22, 927	38,858
Franklin (Columbus):	12,284	14,851
Hamilton (Cincinnati):	13,615	42,669
Lucas (Toledo):	11,234	8,977
Montgomery (Dayton):	8,479	14,949

252. Katz, "Woman Stumps Her State," 353.

253. "Ohio Constitution—Law and History: Table of Proposed Amendments," originally published in *Ohio Constitution Handbook*, ed. Thomas R. Swisher (Cleveland: Banks-Baldwin Law Publishing, 1990), 597, available at Cleveland-Marshall College of Law Library website, https://guides.law.csuohio.edu/c.php?g=190570&p=1258419.

254. Harriet Taylor Upton to an Unnamed Friend, Jan. 14, 1913, MS 211—Vadae G. Meekison Collection: Transcripts (1913), Finding Aids.

255. Strom, *Political Woman*, 92.

256. Anne Myra Benjamin, *Women against Equality: A History of the Anti-Suffrage Movement from 1895–1920* (Morrisville, NC: Lulu, 2014), 184–85.

257. Upton, "Woman Suffrage Movement in Ohio," 334.

258. Benjamin, *Women against Equality*, 156.

259. "Suffrage Denied Women as Ohio Adopts New Constitution," *Cleveland Plain Dealer*, Sept. 4, 1912; "Suffragist Urges Strike of Her Sex," *Cleveland Plain Dealer*, Sept. 5, 1912.

260. Gregory S. Wilson and Kevin F. Kern, *Ohio: A History of the Buckeye State* (Hoboken, NJ: John Wiley & Sons, 2013), 342.

261. Smith, "1912 Constitutional Campaign and Woman's Suffrage in Columbus, Ohio," 61.

262. Benjamin, *Women against Equality*, 182.

263. Mikesell, "Woman Suffrage Movement in Ohio," 41.

264. "Chapter XXXIV: Ohio," 511–12.

265. "Suffrage Denied Women as Ohio Adopts New Constitution," *Cleveland Plain Dealer,* Sept. 4, 1912.

5. The Fifth Star Rises

1. "Woman's Beauty, Grace, and Art Bewilder the Capital," *Washington (DC) Post,* Mar. 4, 1913.

2. "Women Battle Hostile Mobs in Capital Parade," *New-York Tribune,* Mar. 4, 1913.

3. "Ohio Woman Suffrage Association Letter Regarding Governor Cox and the 1913 Flood, April 17, 1913," available at Ohio History Connection, https://ohio memory.org/digital/collection/p267401coi136/id/16500.

4. Jessie C. Glasier, "Suffragists to Fete Legislators," *Cleveland Plain Dealer,* Feb. 27, 1917; Eileen Rausch, "Let Ohio Women Vote: The Years to Victory, 1900–1920" (PhD diss., University of Notre Dame, 1984), 263.

5. Zoe Miller, "When Women Got the Right to Vote in 25 Places around the World," *Insider,* updated Mar. 8, 2020, https://www.insider.com/when-women -around-the-world-got-the-right-to-vote-2019-2.

6. "Tactics and Techniques of the National Woman's Party Suffrage Campaign," *Women of Protest: Photographs from the Records of the National Woman's Party,* 1, Library of Congress, https://www.loc.gov/collections/women-of-protest /articles-and-essays/tactics-and-techniques-of-the-national-womans-party-suffrage -campaign/.

7. J. D. Zahniser and Amelia R. Fry, *Alice Paul: Claiming Power* (New York: Oxford Univ. Press, 2014), 189.

8. "Suffragists Arrested," *Xenia Daily Gazette,* June 27, 1917.

9. "Elizabeth Stuyvesant," Turning Point Suffrage Memorial website, accessed Aug. 8, 2022, https://suffragistmemorial.org/elizabeth-stuyvesant/; "Elizabeth Stuyvesant," in *These Modern Women: Autobiographical Essays from the Twenties,* ed. Elaine Showalter (New York: Feminist Press at the City Univ. of New York, 1989), 92–96.

10. Doris Stevens, *Jailed for Freedom* (New York: Boni & Liveright, 1920), 233.

11. Christine A. Lunardini, *From Equal Suffrage to Equal Rights: Alice Paul and the National Woman's Party, 1910–1928* (Bloomington, IN: IUniverse, 2000), 8.

12. "Suffragette Ready for Ohio Campaign," *Dayton Daily News,* Oct. 24, 1913; "Reporter Makes Early Call on Pankhurst: Gets Scare of His Life," *Dayton Herald,* Oct. 25, 1913.

13. "Suffragists Veto Attack on Congress," *New York Times,* June 6, 1915.

14. Frances S. Hensley, "Change and Continuity in the American Women's Movement, 1848–1930: A National and State Perspective" (PhD diss., Ohio State University, 1988), 60–61.

15. "Detailed Chronology of National Woman's Party History," 7–8, *American Memory*, Library of Congress website, https://www.loc.gov/static/collections /women-of-protest/images/detchron.pdf.

16. Lunardini, *From Equal Suffrage to Equal Rights*, 74–76, 82.

17. Ralph Mikesell, "The Woman Suffrage Movement in Ohio, 1910–1920" (master's thesis, Ohio State University, 1934), 72–73.

18. "Band to Welcome Visitors," *Wichita (KS) Eagle*, Apr. 13, 1916, 8.

19. "Ohio Suffragists Deny Report Sent from Washington by Their Enemies," *Greenville Journal*, Oct. 29, 1914, 8.

20. Amelia R. Fry and Jill Diane Zahniser, *Alice Paul: Claiming Power* (New York: Oxford Univ. Press, 2014), 194.

21. "Won't Invite Miss Pankhurst to Ohio," *Marion Star*, Oct. 16, 1914.

22. "Seeks to Lift Fog in Suffrage Fight," *Washington Times*, Jan. 26, 1914.

23. "Women's Suffrage in the U.S. by State," Center for American Women and Politics, Rutgers University, Aug. 2014, https://tag.rutgers.edu/wp-content /uploads/2014/05/suffrage-by-state.pdf.

24. Michelle Schweickart, "Through the Eyes of Pioneers: Accounts of the Women's Suffrage Movement in Dayton, Ohio, 1890–1920" (master's thesis, Wright State University, 2015), 13–14.

25. Stephane Booth, *Buckeye Women: The History of Ohio's Daughters* (Athens: Ohio Univ. Press, 2001), 70.

26. Lisa Powell, "Dayton Marched for Suffrage: 'I Hope I Shall Not Die Before the American Women Are Emancipated,'" *Dayton Daily News*, Aug. 18, 2020.

27. "Mrs. Davisson," *Journal Herald*, June 30, 1940.

28. "Fleming, Lethia Cousins," in *Encyclopedia of Cleveland History*, ed. John J. Grabowski, Case Western Reserve Univ., 2022, https://case.edu/ech/articles/f /fleming-lethia-cousins; "Fleming, Lethia, C.," in *The African American National Biography*, ed. Henry Louis Gates and Evelyn Brooks Higginbotham (Oxford: Oxford Univ. Press, 2008), 288.

29. "Fleming, Lethia," in *African American Women: A Biographical Dictionary*, ed. Dorothy C. Salem (New York: Garland, 1993), 187–88.

30. "Fleming, Lethia," 187–88; Bettye Collier-Thomas, *Jesus, Jobs, and Justice: Afri-can American Women and Religion* (New York: Knopf Doubleday, 2010), 298–99.

31. Carol Lasser, "Celebrating Lethia Cousins Fleming," History blog, Mar. 12, 2020, Ohio History Connection, https://www.ohiohistory.org/celebrating -lethia-cousins-fleming/.

32. Virginia Clark Abbott, "History of Woman Suffrage and League of Women Voters in Cuyahoga County 1911–1945," *Teaching Digital Cleveland* (blog), 22, June 17, 2016, http://teachingcleveland.org/history-of-woman-suffrage-and -league-of-women-voters-in-cuyahoga-county-1911–1945-by-virginia-clark-abbott/.

33. "McBride, Lucia McCurdy," in Grabowski, *Encyclopedia of Cleveland History*, https://case.edu/ech/articles/m/mcbride-lucia-mccurdy; Thea Gallo Becker, *Legendary Locals of Cleveland* (Cleveland: Legendary Locals, 2012), 40.

34. Abbott, "History of Woman Suffrage and League of Women Voters," 102.

35. "Women in Philanthropy and Charity in Cleveland and Northeast Ohio," Western Reserve Historical Society website, accessed Aug. 8, 2022, https://www.wrhs.org/research/library/library-exhibits/women-in-philanthropy/.

36. "McBride, Lucia McCurdy."

37. "Suffragette Dead at 89," *Akron Beacon Journal*, Jan. 20, 1970.

38. Vadae G. Harvey, "The Law and the Lady," speech, Lawyers' Banquet, Valparaiso Univ., June 5, 1906, box 1, folder 5, MS 211, Vadae G. Meekison Collection: Transcripts (Speeches), *Finding Aids*, Bowling Green State Univ. Libraries, May 7, 1914, https://lib.bgsu.edu/finding_aids/items/show/1909.

39. Jeanette E. Tuve, "Florence E. Allen, First Woman State Supreme Court Judge," *Gamut: A Journal of Ideas and Information* 11 (Winter 1984): 51–60.

40. Margaret L. Fole to Vadae E. Meekison, June 18, 1912, MS 211, Vadae G. Meekison Collection: Transcripts (1912), *Finding Aids*, Bowling Green State Univ. Libraries, May 7, 2014. https://lib.bgsu.edu/finding_aids/items/show/1902.

41. MS 211, Vadae G. Meekison Collection (collection introduction), *Finding Aids*, Bowling Green State Univ. Libraries, Feb. 26, 2020, https://lib.bgsu.edu/finding_aids/items/show/997; "Veteran Attorney Vadae Meekison Dead," *Defiance Crescent*, Aug. 5, 1891.

42. Clarence H. Cramer, *Newton D. Baker: A Biography* (Cleveland: World, 1961), 54; "Newton Diehl Baker," in Grabowski, *Encyclopedia of Cleveland History*, https://case.edu/ech/articles/b/baker-newton-diehl.

43. "Why Ohio Women Should Vote," *Public: A National Journal of Fundamental Democracy and a Weekly Narrative of History in the Making*, Aug. 23, 1912, 797.

44. Elizabeth Cobbs, "For the Female Phone Operators of World War I, a Woman's Place Was on the Front Lines," *Zocalo Public Square*, Arizona State University, June 1, 2017, https://www.zocalopublicsquare.org/2017/06/01/female-phone-operators-world-war-womans-place-frontlines/chronicles/who-we-were/.

45. Frances F. Bushea, "Newton D. Baker Had Faith in Business Women," *Baltimore & Ohio Magazine*, May 1938, 19–20; Beth Behn, "Woodrow Wilson's Conversion Experience: The President and the Federal Women's Suffrage Amendment" (PhD diss., University of Massachusetts, 2012), 172.

46. "Gov. James Middleton Cox," National Governors Association website, accessed Aug. 8, 2022, https://www.nga.org/governor/james-middleton-cox/.

47. Roger W. Babson, *Cox—The Man* (New York: Brentano's, 1920), 68–70.

48. David Dismore, "Today in Herstory: Democratic Nominee for President Urges His Party to Reconsider Suffrage," *Feminist Majority Foundation*, July 7, 2015, https://feminist.org/news/today-in-herstory-democratic-nominee-for-president-urges-his-paty-to-reconsider-suffrage/.

49. Babson, *Cox*, 68–70.

50. "Ohio Suffrage Bill Signed by Governor: Antis Threaten to Call for a Referendum on the Law—Action Taken in Other States," *New York Times*, Feb. 22, 1917.

51. David Dismore, "Aug. 14, 1920," Facebook, Aug. 14, 2017, https://www.facebook.com/Equalitarian/posts/10210337130568186.

52. "Ohio Woman's Suffrage Association Yearbook, 1914," Bowling Green State Univ. Student Digital Gallery, https://digitalgallery.bgsu.edu/student/items/show/12707.

53. Harriet T. Upton, *Harriet Taylor Upton's Random Recollections*, ed. Lana Dunn Eisenbraun (Warren, OH: Harriet Taylor Upton Association, 2004).

54. Abbott, "History of Woman Suffrage and League of Women Voters," 21.

55. "Ohio Woman Suffrage Association Correspondence Regarding Donation of a Diamond Ring," *Ohio Memory*, Ohio History Connection, Aug. 1914, https://ohiomemory.org/digital/collection/p267401coll36/id/16643.

56. "Will Carry Cause to Labor's Outing," *Cleveland Plain Dealer*, Sept. 4, 1914; "Labor Endorses Home Rule and Vote for Women," *Akron Evening Times*, Oct. 16, 1914.

57. "Ohio Woman's Suffrage Association Yearbook, 1914," 20.

58. "Suffrage Speakers to Come Next Week," *News Journal* (Mansfield, OH), Oct. 7, 1914.

59. "Ohio Woman's Suffrage Association Yearbook, 1914," 21.

60. Carol Lasser, "Bending to the Color Line: The Fight for Women's Suffrage in Ohio," July 29, 2020, YouTube video, 1:04:27, posted by League of Women Voters of Greater Cleveland.

61. Martha S. Jones, "What the 19th Amendment Meant for Black Women," *Politico*, Aug. 26, 2020, https://www.politico.com/news/magazine/2020/08/26/19th-amendment-meant-for-black-women-400995.

62. Anne Myra Benjamin, *Women against Equality: A History of the Anti-Suffrage Movement in the United States from 1895 to 1920* (Morrisville, NC: Lulu, 2014), 184–85.

63. Abbott, "History of Woman Suffrage and League of Women Voters," 29.

64. Osman Castle Hooper, *History of the City of Columbus, Ohio: From the Founding of Franklinton in 1797, through the World War Period, to the Year 1920* (N.p.: Memorial Publishing, 1920), 66.

65. Abbott, "History of Woman Suffrage and League of Women Voters," 37.

66. "Ohio Woman's Suffrage Association Yearbook, 1914," 2.

67. "Ohio Woman's Suffrage Association Yearbook, 1914," 2.

68. Florence E. Allen and Mary Welles, *The Ohio Woman Movement: "A Certain Unalienable Right": What Ohio Women Did to Secure It* (N.p.: Committee for the Preservation of Ohio Woman Suffrage Records, 1952), 46–47.

69. "Chapter XXXIV: Ohio," in *The History of Woman Suffrage*: vol. 6 of 6, *1900–1920*, ed. Ida Husted Harper (New York: National American Woman Suffrage Association, 1922), 512–13.

70. "Ohio Woman's Suffrage Association Yearbook, 1914," 16–17.

71. "Ohio Woman's Suffrage Association Yearbook, 1914," 13–14.

72. Jessica R. Pliley, "Voting for the Devil: Unequal Partnerships in the Ohio Women's Suffrage Campaign of 1914," *Ohio History* 115 (2008): 17.

73. Eleanor Flexner and Ellen F. Fitzpatrick, *Century of Struggle: The Woman's Rights Movement in the United States* (Cambridge, MA: Belknap Press of Harvard Univ. Press, 1996), 41.

74. Harriet Taylor Upton, "The Woman Suffrage Movement in Ohio," in *History of Ohio*, ed. Charles B. Galbreath, 5 vols. (Chicago: American History Society, 1925), 2:334.

75. "Women to Hear Meaning of Vote," *Cleveland Plain Dealer*, Mar. 11, 1913; "Mrs. Carrie Chapman Catt Praises Enlistment of Men at Election, *Cleveland Plain Dealer*, Mar. 12, 1913; "Asks Ohio Voters to Lead Suffrage," *Cleveland Plain Dealer*, Mar. 13, 1913.

76. "Suffragists Plan Cleveland School," *Cleveland Plain Dealer*, Nov. 20, 1913.

77. Pliley, "Voting for the Devil," 17, 14–16; "Columbus Women Doctors Endorse," *Woman's Journal*, May 9, 1914.

78. "Chapter XXXIV: Ohio," 512.

79. "Vigourous Fight in Buckeye State," *Woman's Journal*, Oct. 3, 1914.

80. "Chapter XXXIV: Ohio," 512.

81. Abbott, "History of Woman Suffrage and League of Women Voters," 39.

82. Laura DeMarco, "Women's History Month: Cleveland Suffragettes, Protests and Parades since 1869," *Cleveland Plain Dealer*, Mar. 7, 2017.

83. Abbott, "History of Woman Suffrage and League of Women Voters," 38, 16; Marian Morton, *Women in Cleveland: An Illustrated History* (Bloomington: Indiana Univ. Press, 1995), 172.

84. K. Wright to H. J. Haskell: Oct. 10–Nov. 25, 1924, KC263, MFM-117–2, folder 7, Western Historical Manuscript Collection: Kansas City.

85. For a biography of Katharine Wright Haskell, see Richard Maurer, *The Wright Sister: Katharine Wright and Her Famous Brothers* (New York: Square Fish Roaring Brook Press, 2016).

86. Mary McCarty, "The Empowering Story of How Dayton Was at the Forefront," *Dayton Daily News*, Aug. 18, 2020.

87. Greg Hoersten, "The Persistent Bessie Crayton," *Lima News*, Mar. 19, 2019.

88. Gary Brown, "The Monday After: Carrie Chapman Catt Came to Canton," *Canton Repository*, Mar. 19, 2018.

89. Carrie Chapman Catt and Nettie Rogers Shuler, *Woman Suffrage and Politics: The Inner Story of the Suffrage Movement* (New York: C. Scribner's Sons, 1923), 197–98.

90. "Ohio Woman's Suffrage Association Yearbook, 1914," 15–19.

91. Nancy Horlacher, "Woman's Suffrage Pro or Con? Two Dayton Women Present Their Views on the Woman's Right to Vote," 6–7, 2019, Dayton Metro Library, http://content.daytonmetrolibrary.org/digital/collection/p16669coll7/id/82/; Benjamin, *Women against Equality*, 186.

92. Everett P. Wheeler, *The Case against Woman Suffrage: A Manual for Speakers, Debaters, Lecturers, Writers, and Anyone Who Wants the Facts* (New York: Man Suffrage Association Opposed to Extension of Political Suffrage for Women, 1915), 72.

93. Horlacher, "Woman's Suffrage Pro or Con," 8, 9, 10, 13.

94. "Price, Lucy Catharine," *Woman's Who's Who of America: A Biographical Dictionary of Contemporary Women of the United States and Canada, 1914–1915*, ed. John William Leonard (New York: American Commonwealth Company, 1914), 662.

95. Susan Goodier, *No Votes for Women: The New York State Anti-Suffrage Movement* (Urbana: Univ. of Illinois Press, 2013), 76.

96. Sharon Hazard, "The Roosevelts Disagree: The Debate about Women's Suffrage," *The Ultimate History Project,* accessed Aug. 8, 2022, http://ultimatehi storyproject.com/womens-anti-suffrage-movement.html.

97. "Price, Lucy Catharine," 662.

98. Goodier, *No Votes for Women,* 76.

99. "Crowd Cheers Alternately as Women Speakers Clash in Suffrage Debate," *Akron Beacon Journal,* July 10, 1914.

100. Goodier, *No Votes for Women,* 153

101. "Miss Lucy Price Youngest Anti-Suffrage Worker," *Pittsburgh Press,* Apr. 11, 1915.

102. "Women Gain More without Suffrage," *New York Times,* Feb. 14, 1913.

103. Carol Kammen, "Falling Forward," n9, *Historian Notes,* New York State Museum, Dec. 15, 2016, http://www.nysm.nysed.gov/research-collections/state -history/notes/falling-forward.

104. Goodier, *No Votes for Women,* 153.

105. "Predicts Women Win," *Cleveland Plain Dealer,* Oct. 10, 1914.

106. *Annual Report of the Secretary of State to the Governor and General Assembly of the State of Ohio, 1914* (Springfield: Springfield Publishing Company, State Printers, 1915), 257–58. According to this report, this was the final vote tally, by most populated counties, for and against proposed amendment 3:

	FOR	AGAINST
Cuyahoga (Cleveland)	31,635	64,536
Franklin (Columbus)	17,325	26,570
Hamilton (Cincinnati)	14,456	69,245
Lucas (Toledo)	13,845	21,887
Montgomery (Dayton)	10,554	20,890

107. Lee Ann Rinsky, "The Cincinnati Suffrage Movement" (master's thesis, University of Cincinnati, 1968), 81–86.

108. "Ohio Woman's Suffrage Association Yearbook, 1914," 18.

109. Harriet Taylor Upton to Mrs. Vadae G. Meekison, Apr. 14, 1915, MS 211— Vadae G. Meekison Collection: Transcripts (1915), *Finding Aids,* Bowling Green State Univ. Libraries, May 7, 2014, lib.bgsu.edu/finding_aids/items/show/1905; Vadae G. Meekison Collection (collection introduction).

110. "Timeline: The Senate and the 19th Amendment," *Woman Suffrage Centennial,* US Senate website, accessed Aug. 8, 2022, https://www.senate.gov/art andhistory/history/People/Women/Nineteenth_Amendment_Vertical_Time line.htm.

111. Senate Roll-Call Vote Tally for S. J. res. 1, Mar. 19, 1914, Records of the US Senate, National Archives, https://www.senate.gov/artandhistory/history/resources /pdf/SJRes11913.pdf.

112. "Women of Protest: Photographs from the Records of the National Woman's Party," Library of Congress, accessed Aug. 8, 2022, https://www.loc.gov/collections/women-of-protest/articles-and-essays/historial-timeline-of-the-national-womans-party/1915-to-1916/.

113. Upton, "Woman Suffrage Movement in Ohio," 336.

114. "Chapter XXXIV: Ohio," 513, 517.

115. "Chapter XXXIV: Ohio," 517.

116. "Carrie Chapman Catt (1859–1947)," Turning Point Suffrage Memorial website, accessed Aug. 8, 2022, https://suffragistmemorial.org/carrie-chapman-catt-1859–1947/.

117. Terry D. Croy and Carrie Chapman Catt, "The Crisis: A Complete Critical Edition of Carrie Chapman Catt's 1916 Presidential Address to the National American Woman Suffrage Association," *Rhetoric Society Quarterly* 28 (Summer 1998): 71.

118. Kathryn Mary Smith, "The 1912 Constitutional Campaign and Woman's Suffrage in Columbus Ohio" (master's thesis, Ohio State University, 1980), 236.

119. *Suffragist* (Washington, DC), Dec. 15, 1915.

120. "Cox Promises Help in Giving Women Votes," *Cincinnati Post,* Jan. 4, 1917.

121. Abbott, "History of Woman Suffrage and League of Women Voters," 43, 46.

122. DeMarco, "19th Amendment That Gave Woman Right to Vote Was Ratified 100 Years Ago Today; President Trump Pardons Susan B. Anthony in Honor," *WKYC,* Aug. 18, 2020, https://www.wkyc.com/article/news/history/19th-amendment-woman-vote-ratified-100-years-president-trump-susan-b-anthony/95-954484df-e538-4e9a-a149-b98f1aa9212a.

123. "Chapter XXXIV: Ohio," 513–14.

124. Center for American Women and Politics, "Women's Suffrage in the U.S. by State," *Teach a Girl to Lead,* Rutgers Eagleton Institute of Politics, accessed Aug. 27, 2022, https://tag.rutgers.edu/wp-content/uploads/2014/05/suffrage-by-state.pdf.

125. "Starts Fight to Let Women Vote in City Elections Councilman Krueger Proposes Charter Amendment," *Cleveland Plain Dealer,* Feb. 16, 1917.

126. Cameron Knight, "100 Years Ago: Ohio Voted to Keep Drinking, and More," *Cincinnati Enquirer,* Nov. 6, 2017.

127. "Woman Suffrage Advocates Speak for Pending Bill," *Sandusky Star-Journal,* Jan. 25, 1917.

128. "Suffrage Bill before Senate," *Cincinnati Post,* Feb. 2, 1917.

129. "Chapter XXXIV: Ohio," 515.

130. Catt and Shuler, *Woman Suffrage and Politics,* 204.

131. "Progress on Reynolds Bill," *Cleveland Plain Dealer,* Feb. 1, 1917.

132. "Who Rules in Ohio," *Cincinnati Times-Star,* Jan. 30, 1917.

133. "Chapter XXXIV: Ohio," 515.

134. "Women Asking for Votes in Ohio," *Cincinnati Post,* Jan. 25, 1917.

135. "Suffrage Is Nearer to Women," *Cincinnati Enquirer,* Feb. 15, 1917.

136. A. E. McKee, "Measure Is Enacted by 4 Majority," *Cleveland Plain Dealer*, Feb. 15, 1917.

137. "Chapter XXXIV: Ohio," 515.

138. "Referendum on Suffrage Brewing," *Cincinnati Enquirer*, Feb. 17, 1917.

139. "Suffrage," *Woman Citizen* (New York), Sept. 29, 1917.

140. Catt and Shuler, *Woman Suffrage and Politics*, 418.

141. "Ohio Suffrage Bill Signed by Governor; Antis Threaten to Call for a Referendum on the Law—Action Take in Other States," *New York Times*, Feb. 22, 1917.

142. "Ohio Women Fight Vote: League Opposing Suffrage Starts Referendum Petitions," *Cleveland Plain Dealer*, Mar. 15, 1917.

143. Rausch, "Let Ohio Women Vote," 271; Schweickart, "Through the Eyes of Pioneers," 8.

144. "Resolutions to Be Submitted to the United States Senate by the Ohio and Cincinnati and Hamilton County Associations Opposed to Woman Suffrage, June 26, 1918," Records of the US Senate, available at the Docs Teach website, Library of Congress, accessed Aug. 8, 2022, https://www.docsteach.org/documents/document/cincinnati-opposed-suffrage.

145. "Menace above War's Is Women's Cry," *Cincinnati Enquirer*, Jan. 21, 1917.

146. Upton, "Woman Suffrage Movement in Ohio," 336

147. Schweickart, "Through the Eyes of Pioneers," 36.

148. "Chapter XXXIV: Ohio," 516.

149. Catt and Shuler, *Woman Suffrage and Politics*, 206.

150. Catt and Shuler, *Woman Suffrage and Politics*, 204–6; Rausch, "Let Ohio Women Vote," 272.

151. Walker Buel, "All Sides See Victory as Voting Time Nears: Wets, Drys, Suffragists and Anti Confident," *Cleveland Plain Dealer*, Nov. 4, 1917.

152. Catt and Shuler, *Woman Suffrage and Politics*, 206.

153. Upton, "Woman Suffrage Movement in Ohio," 333.

154. "Who Rules in Ohio," *Cincinnati Times-Star*, Oct. 25, 1917.

155. Upton, "Woman Suffrage Movement in Ohio," 336; "Chapter XXXIV: Ohio," 517.

156. Rinsky, "Cincinnati Suffrage Movement," 93–94.

157. Upton, "Woman Suffrage Movement in Ohio," 336.

158. *Handbook of the National American Woman Suffrage Association* (New York: National American Woman Suffrage Association, 1919), 289–90

159. "Antis Begin Fight on Ohio Suffrage," *Cleveland Plain Dealer*, Aug. 20, 1919.

160. Mikesell, "Woman Suffrage Movement in Ohio," 73–74.

161. "In Various States," *Woman Citizen* (New York), Sept. 7, 1918; Catt and Shuler, *Woman Suffrage and Politics*, 207.

162. "Ohio Constitution—Law and History: Table of Proposed Amendments," originally published in *Ohio Constitution Handbook*, ed. Thomas R. Swisher (Cleveland: Banks-Baldwin Law Publishing, 1990), 597, available at Cleveland-Marshall College of Law Library website, https://guides.law.csuohio.edu/c.php?g=190570&p=1258419.

163. US House of Representatives, "The House's 1918 Passage of a Constitutional Amendment Granting Women the Right to Vote," *Historical Highlights*, History, Art, and Archives, https://history.house.gov/Historical-Highlights/1901–1950/ The-House-s-1918-passage-of-a-constitutional-amendment-granting-women-the -right-to-vote/.

164. Rausch, "Let Ohio Women Vote," 287.

165. Doris Weatherford, *Victory for the Vote: The Fight for Women's Suffrage and the Century That Followed* (Coral Gables, FL: Mango Publishing, 2020), 230–31.

166. Walker Buel, "Ohio May Seal Fate of Nation Suffrage Plan," *Cleveland Plain Dealer,* Feb. 5, 1919.

167. US Senate, "Timeline."

168. Ben F. Allen, "Suffrage Dies by Pomerene's Vote in Senate," *Cleveland Plain Dealer,* Feb. 10, 191.

169. "Woman Suffrage (H. J. Res. 1)," Cong. Rec., 66th Cong., 1st Sess. (1919).

170. US Senate, "Timeline."

171. "Report Proposal: H. J. Res. 1 (Committee on Woman Suffrage Report)," Quill Project at Pembroke College (2020), Event 135681, https://www.quillproject .net/event_visualize/135681.

172. David Dismore, "Today in Feminist History: 19th Amendment Gains Approval," *Ms.,* June 4, 2020, https://msmagazine.com/2020/06/04/today-in -feminist%E2%80%8B-history-19th-amendment-gains-bicameral-approval-june -4-1919/.

173. Flexner and Fitzpatrick, *Century of Struggle,* 214–315.

174. "Part III: The Last Trench," *Woman Suffrage Centennial,* US Senate website, accessed Aug. 8. 2022, https://www.senate.gov/artandhistory/history/ People/Women/Part3_TheLastTrench.htm.

175. Walker Buel, "Ohio Legislators Ratify Suffrage," *Cleveland Plain Dealer,* June 17, 1919.

176. "Nineteenth Amendment," *Ohio History Central,* Ohio History Connection, accessed Sept. 15, 2022, http://ohiohistorycentral.org/w/Nineteenth_Amendment.

177. "Chapter XXXIV: Ohio," 517.

178. "Centuries of Citizenship: A Constitutional Timeline," National Constitution Center website, 2006, https://constitutioncenter.org/timeline/html/cw08_ 12159.html.

179. Upton, "Woman Suffrage Movement in Ohio," 336.

180. "Chapter XXXIV: Ohio," 518.

181. Sandra Weber, *The Woman Suffrage Statue: A History of Adelaide Johnson's Portrait Monument to Lucretia Mott, Elizabeth Cady Stanton and Susan B. Anthony at the United States Capitol* (Jefferson, NC: McFarland, 2016), 81; Brian Williams, "Petticoats in Politics: Cincinnati Women and the 1920 Election," *Cincinnati Historical Society Bulletin* 35, no. 1 (1977): 51.

182. Williams, "Petticoats in Politics," 47.

183. Rausch, "Let Ohio Women Vote," 270–73.

184. Rausch, "Let Ohio Women Vote," 270–73.

185. Catt and Shuler, *Woman Suffrage and Politics*, 199.

186. "Ohio Test Case," *Suffragist* (Washington, DC), Feb. 1920, 21.

187. Catt and Shuler, *Woman Suffrage and Politics*, 210.

188. Allen and Welles, *Ohio Woman Suffrage Movement*, 51.

189. Jessie C. Glasier, "Newbury Fete Gives New Zeal to Leaders in Cause of Suffrage for Women," *Cleveland Plain Dealer*, Aug. 31, 1919.

190. Catt and Shuler, *Woman Suffrage and Politics*, 414; "Suffrage Issue to Go to Polls," *Cleveland Plain Dealer*, Nov. 12, 1919.

191. Catt and Shuler, *Woman Suffrage and Politics*, 414–21.

192. "Suffragists File Ohio Brief," *Washington (DC) Post*, Mar. 19, 1920.

193. Hawke vs. Smith, Secretary of the State of Ohio, 253 U.S. 221 (40 S.Ct. 495, 64 L.Ed. 871); "Chapter XXXIV: Ohio," 518–19.

194. Flexner and Fitzpatrick, *Century of Struggle*, 321; "Court Kills Ohio Liquor Referendum to Stop Vote on Suffrage Amendment State Legislatures' Action Final," *Cleveland Plain Dealer*, June 2, 1920.

195. "Waiting for the Young Lady of the House," *Cincinnati Post*, Aug. 16, 1920.

196. "August 8, 1920," Turning Point Suffrage Memorial website, accessed Aug. 8, 2022, https://suffragistmemorial.org/august-8-1920/.

197. Elaine Weiss, *The Woman's Hour: The Great Fight to Win the Vote* (New York: Penguin, 2018), 234.

198. Weiss, *Woman's Hour*, 100.

199. Weiss, *Woman's Hour*, 104.

200. "Militants Send 500 Banners and Regalia for Use in Picketing Harding's Home," *New York Times*, July 20, 1920.

201. Weiss, *Woman's Hour*, 113.

202. "Miss Shillito Here to Fight Ratification," *Tennessean* (Nashville), Aug. 5, 1920.

203. "Tennessee: The 16th," *Suffragist* (Washington, DC), Sept. 1920.

204. Upton, "Woman Suffrage Movement in Ohio," 337; "Chapter XXXIV: Ohio," 519.

205. Weiss, *Woman's Hour*, 200.

206. Weiss, *Woman's Hour*, 254, 293.

207. Weiss, *Woman's Hour*, 293.

208. Scott Bomboy, "The Vote That Led to the 19th Amendment," *Constitution Daily*, National Constitution Center, Aug. 18, 2021, https://constitutioncenter.org/blog/the-man-and-his-mom-who-gave-women-the-vote/.

209. "Colby Proclaims Woman Suffrage," *New York Times*, Aug. 27, 1920.

210. "American Women Finally Get Vote," *Columbus Evening Dispatch*, Aug. 26, 1920; "Women Granted Suffrage," *Dayton Daily News*, Aug. 27, 1920.

211. Williams, "Petticoats in Politics," 53–70.

212. The National Woman's Party, "At Last," *Suffragist* (Washington, DC), June 21, 1919; Allison Lange, "19th Amendment," Fall 2015, National Women's History Museum website, http://www.crusadeforthevote.org/19-amendment.

213. "Says State Did Not Ratify," *New York Times*, Aug. 27, 1920; "Gov. Smith to Greet Mrs. Carrie C. Catt," *New York Times*, Aug. 27, 1920.

214. "The Final Push," *Digital History,* 2021, https://www.digitalhistory.uh.edu /disp_textbook.cfm?smtID=2&psid=3207.

215. "Gov. Smith to Greet Mrs. Carrie C. Catt."

216. "Leagues of the Middle West," *Woman Citizen* (New York), May 8, 1920.

Conclusion

1. "Scratched Tickets Are Rule Where Women Cast Ballots," *Cincinnati Enquirer,* Nov. 3, 1920.

2. Greg Hand, "Cincinnati's Suffragettes: More Polite Than England, but Frightening to Cincinnati Men," *Cincinnati Magazine,* Mar. 28, 2016, https:// www.cincinnatimagazine.com/citywiseblog/cincinnatis-suffragettes-polite-eng land-frightening-cincinnati-men/.

3. Greg Hand, "17 Curious Facts about the 1920 Election," *Cincinnati Magazine,* Nov. 3, 2020, https://www.cincinnatimagazine.com/article/17-curious -facts-about-the-1920-election/.

4. Brian Williams, "Petticoats in Politics: Cincinnati Women and the 1920 Election," *Cincinnati Historical Society Bulletin* 35 (Spring 1977): 66.

5. Sarah Hunter Graham, *Woman Suffrage and the New Democracy* (New Haven: Yale Univ. Press, 1996), 154.

6. "Mrs. Schwarz Urges Women to Register," *Cincinnati Commercial Tribune,* Sept. 18, 1920; Williams, "Petticoats in Politics," 51.

7. Ruth Igielnik, "Men and Women in the US Continue to Differ in Voter Turnout Rate, Party Identification," Pew Research Center website, Aug. 18, 2020, https://www.pewresearch.org/fact-tank/2020/08/18/men-and-women-in-the-u-s -continue-to-differ-in-voter-turnout-rate-party-identification/.

8. Melissa Block, "Yes, Women Could Vote after the 19th Amendment—But Not All Women. Or Men," *National Public Radio,* Aug. 20, 2020, https://www .npr.org/2020/08/26/904730251/yes-women-could-vote-after-the-19th-amend ment-but-not-all-women-or-men.

9. US Commission on Civil Rights, *The Equal Rights Amendment: Guaran- teeing Equal Rights for Women under the Constitution* (Washington, DC: GPO, 1981).

10. "The Proposed Equal Rights Amendment: Contemporary Ratification Issues," Congressional Research Service, Dec. 23, 2019, https://sgp.fas.org/crs/ misc/R42979.pdf.

11. Ralph Mikesell, "The Woman Suffrage Movement in Ohio, 1910–1920" (master's thesis, Ohio State University, 1934), 84–85; Marian Morton, "Winning the Ballot," in *Women in Cleveland: An Illustrated History* (Bloomington: Indiana Univ. Press, 1995), 181.

12. Einav Rabinovitch-Fox, "Sherwin, Belle," in *Encyclopedia of Cleveland His- tory,* ed. John Grabowski, Case Western Reserve Univ., 2022, https://case.edu/ ech/articles/s/sherwin-belle.

13. Barbara Sicherman and Carol Hurd Green, eds., *Notable American Women:*

The Modern Period—A Biographic Dictionary (Cambridge, MA: Belknap Press of Harvard Univ. Press, 1980), 647–48; Rabinovitch-Fox, "Sherwin, Belle."

14. Virginia Clark Abbott, "History of Woman Suffrage and League of Women Voters," *Teaching Cleveland Digital* (blog), June 17, 2016, http://teaching cleveland.org/history-of-woman-suffrage-and-league-of-women-voters-in-cuya hoga-county-1911–1945-by-virginia-clark-abbott/.

15. Barbara Stuhler, *For the Public Record: A Documentary History of the League of Women Voters* (Westport, CT: Praeger, 2020), 112. For a historical overview of the League of Women Voters, see Marguerite M. Wells, *A Portrait of the League of Women Voters* (Washington, DC: Overseas Education Fund of the League of Women Voters, 1962); Louise M. Young and Ralph A. Young, *In the Public Interest: The League of Women Voters, 1920–1970* (New York: Greenwood, 1989).

16. Abbott, "History of Woman Suffrage and League of Women Voters."

17. Sicherman and Green, *Notable American Women,* 647–48; Rabinovitch-Fox, "Sherwin, Belle."

18. Einav Rabinovitch-Fox, "The Making of a Suffragist: Belle Sherwin and Women Activism," History blog, Ohio History Connection, May 1, 2020, https://www.ohiohistory.org/learn/collections/history/history-blog/may-2020/suffrage 100blogseries_may2020.

19. "Women's City Club," in Grabowski, *Encyclopedia of Cleveland History,* https://case.edu/ech/articles/w/womens-city-club

20. Rabinovitch-Fox, "Sherwin, Belle."

21. "Biography," Belle Sherwin Papers, 1880–1955, folder A-62, Schlesinger Library, Radcliffe Institute, Harvard Univ., accessed Aug. 8, 2022, https://id.lib .harvard.edu/ead/sch00198/catalog.

22. Shirley Wajda, "Belle Sherwin: Teaching Women to Vote and Lead," *Pathways* (Winter 2019), http://www.ohiohumanities.org/wp-content/uploads /2020/03/Belle-Sherwin-Shirley-Wajda.pdf.

23. Sicherman and Green, *Notable American Women,* 647–48.

24. "Louisa Fast," *Ohio Women's Hall of Fame,* Ohio History Center website, 2018, https://resources.ohiohistory.org/womenshof/; Myron Bruce Barnes, "Louisa K. Fast Biography," Seneca County Digital Library website, accessed Sept. 9, 2022, https://www.ohiomemory.org/digital/collection/p15005coii127/id/22644.

25. Frances Sizemore Hensley, "Change and Continuity in the American Women's Movement, 1848–1930: A National and State Perspective" (PhD diss. Ohio State University, 1981), 81.

26. Hensley, "Change and Continuity in the American Women's Movement," 162–63, 174–76, 172.

27. Homer L. Calkin, *Women in American Foreign Affairs* (N.p.: Department of State, 1977), 74–77; "Breaking Ground: Lucile Atcherson," *Her Diplomacy Spotlight,* National Museum of American Diplomacy, accessed Aug. 8, 2022. https://diplo macy.state.gov/explore-online-exhibits/herdiplomacy/lucile-atcherson/.

28. "New from the Field," *Equal Rights,* Apr. 14, 1923.

29. Hensley, "Change and Continuity in the American Women's Movement," 174–75.

30. Peter Geidel, "Origins of the Equal Rights Amendment, 1920–1923," *Historian* 42 (Aug. 1980): 557.

31. "Did You Know? Alice Paul Versus Carrie Chapman Catt," National Park Service website, accessed Aug. 8, 2022, https://www.nps.gov/articles/dyk-alice -paul-carrie-catt.htm; Morton, "Winning the Ballot," 181.

32. Jon O. Shimabukuro, "The Equal Rights Amendment: Recent Develop-ments," Congressional Research Service, Apr. 25, 2022, https://crsreports.congress .gov/product/pdf/LSB/LSB10731.

33. Morton, "Winning the Ballot," 184.

34. "Florence E. Allen," *Ohio History Central,* Ohio History Connection, accessed Aug. 9, 2022, https://ohiohistorycentral.org/w/Florence_E._Allen.

35. Finding Aid, Mary Belle Grossman Papers, 1921–68, Western Reserve Historical Society, accessed Aug. 8, 2022, http://catalog.wrhs.org/collections/ view?docId=ead/MS3660.xml; "Grossman, Mary B.," in Grabowski, *Encyclopedia of Cleveland History,* https://case.edu/ech/articles/g/grossman-mary-b.

36. "Ladies' Gallery," Ohio Statehouse Museum website, 2022, http://www .ohiostatehouse.org/museum/ladies-gallery/about; Barbara Palmer, Center for Women & Politics of Ohio website, Baldwin Wallace Univ., accessed Aug. 8, 2022, https://www.bw.edu/centers/women-and-politics-of-ohio/.

37. "Mrs. Virginia Darlington Green," in *A History of Cuyahoga County and the City of Cleveland,* ed. William R. Coates, 3 vols. (Chicago: American Historical Society, 1924), 3:161–63; "Darlington Green Dies in Cleveland," *Zanesville Times Recorder,* May 21, 1909.

38. Robert Cooney, *Winning the Vote: The Triumph of the American Woman Suffrage Movement* (Cheshire, CT: American Graphic Press, 2005), 446.

39. Center for American Women and Politics, "Women's Suffrage in the U.S. by State," *Teach a Girl to Lead,* Rutgers Eagleton Institute of Politics, accessed Aug. 27, 2022, https://tag.rutgers.edu/wp-content/uploads/2014/05/suffrage-by -state.pdf.

40. Allison L. Sneider, *Suffragists in an Imperial Age: Us Expansion and the Woman Question, 1870–1929* (New York: Oxford Univ. Press, 2008), 136.

41. "Women's Power Index," last updated Mar. 29, 2021, Council on Foreign Relations website, https://www.cfr.org/article/womens-power-index; "Facts and Figures: Women's Leadership and Political Participation," UNWomen website, accessed Nov. 6, 2022, https://www.unwomen.org/en/what-we-do/leadership-and -political-participation/facts-and-figures.

42. "Global Gender Gap Report 2021," Mar. 30, 2021, World Economic Forum website, https://www.weforum.org/reports/global-gender-gap-report-2021/digest.

43. "State Women's Suffrage Ballot Measures," *Ballotpedia,* accessed Aug. 8, 2022, https://ballotpedia.org/State_women%27s_suffrage_ballot_measures.

44. Michelle Milford Morse and Grace Anderson, "The Shadow Pandemic:

How the Covid-19 Crisis Is Exacerbating Gender Inequality," United Nations Foundation blog, Apr. 14, 2020, https://unfoundation.org/blog/post/shadow-pandemic-how-covid19-crisis-exacerbating-gender-inequality/.

45. Juana Summers, "Trump Push to Invalidate Votes in Heavily Black Cities Alarms Civil Rights Groups," *All Things Considered*, National Public Radio, Nov. 24, 2020, https://www.npr.org/2020/11/24/938187233/trump-push-to-invalidate-votes-in-heavily-black-cities-alarms-civil-rights-group; James Rainey, "'There Is a Voter-Suppression Wing': An Ugly American Tradition Clouds the 2020 Presidential Race," *Los Angeles Times*, Oct. 24, 2020.

46. Nick Corasanti, "Voting Battles of 2022 Take Shape as GOP Crafts New Election Bills," *New York Times*, Dec. 4, 2021; "Voting Laws Roundup: May 2022," Brennan Center for Justice, https://www.brennancenter.org/our-work/research-reports/voting-laws-roundup-may-2022.

47. Haley BeMiller, "Ohio Voting Rights Advocates Dealt Blow after Federal Election, Redistricting Bill Stalls," *Columbus Dispatch*, Jan. 21, 2022; Morgan Trau, "Trump-Appointed Federal Court Judges End Ohio's Redistricting Battle, Side with GOP," *News 5 Cleveland*, https://www.news5cleveland.com/news/politics/ohio-politics/trump-appointed-federal-court-judges-end-ohios-redistricting-battle-side-with-gop.

48. Morgan Trau, "Ohio Law Would Tighten Voter Requirements, Require Photo ID," *Ohio Capital Journal* (Columbus), Apr. 11, 2022; Julie Carr Smyth, "Ohio Is Latest State to See GOP-Backed Voting Law Rewrite," *AP News*, May 6, 2021.

Index